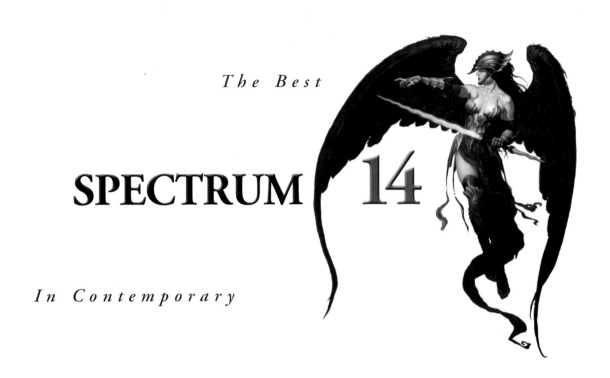

The Best

SPECTRUM 14

In Contemporary

Fantastic Art

edited by
Cathy Fenner *&* Arnie Fenner

Underwood Books
Nevada City, CA

Trade Softcover Edition ISBN 1-59929-007-3
Hardcover Edition ISBN 1-59929-006-5

10 9 8 7 6 5 4 3 2 1

Artists, art directors, and publishers interested in receiving entry information for the next Spectrum competition should send their name and address to:
Spectrum Design, P.O. Box 4422, Overland Park, KS 66204
Or visit the official website for information & printable
PDF entry forms: **www.spectrumfantasticart.com**
Call For Entries posters (which contain complete rules, list
of fees, and forms for participation) are mailed out in October each year.

Published by
UNDERWOOD BOOKS
P.O. BOX 1919
NEVADA CITY, CA 95959
www.underwoodbooks.com
TIM UNDERWOOD/*Publisher*

art by Shelly Wan
(see page 184)

CONTENTS

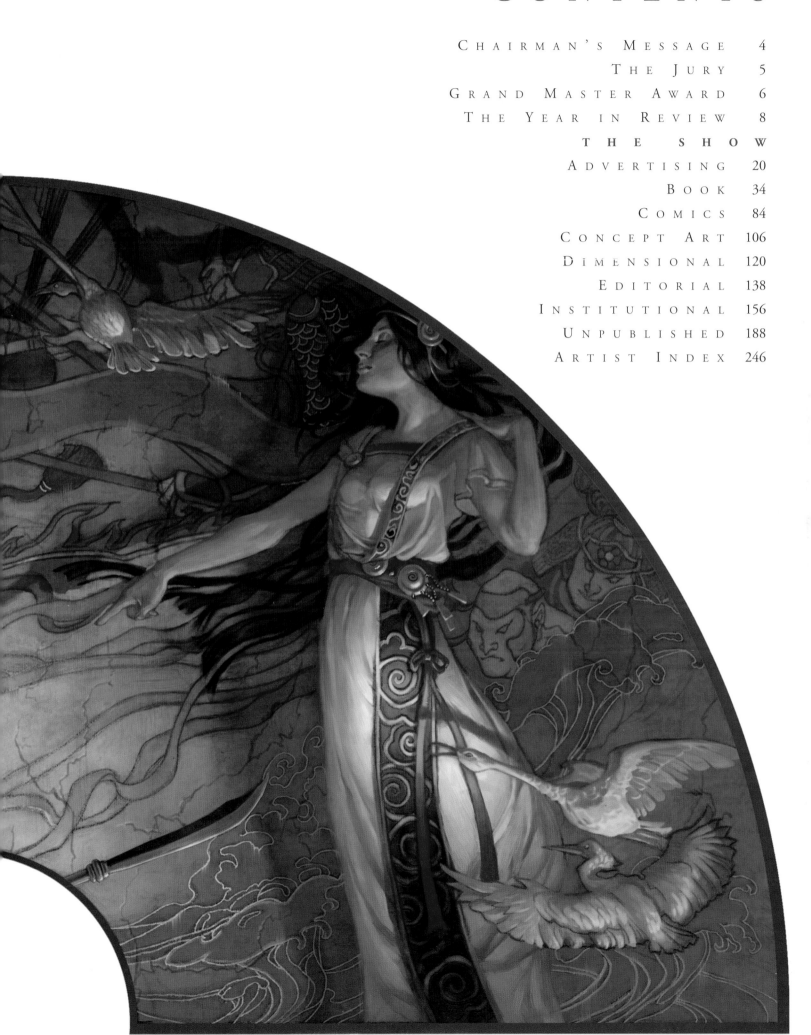

Cathy Fenner/Co-Director

Photograph by Arnie Fenner

As Dylan sang, the times they are a'changin', and so it is with *Spectrum*. At least, a little bit. Each year brings opportunities and challenges and we try to recognize them and refine the annual (and how we do it) accordingly to keep moving forward. Our goal is to remain fresh, to grow, and to better serve the artists and the field as a whole.

Some time back Donato Giancola had suggested that we break "concept art" out of the Institutional category and into one of its own. Over Thai food and drinks one evening during Comic-Con last year, Arnie and I discussed the pros and cons with Donato and Stephan Martiniere and the decision was made to give it a try. The field of Concept Art has grown so much in recent years that it seemed the natural next step to give it its own section. A big thank you goes out to Donato for the original suggestion, Stephan for the help he provided in establishing directions to give the jurors prior to judging, and to all of the artists and companies that supported the idea by submitting their entries to #14. Hopefully this category will continue to grow in the years to come.

Throughout 2006 we received some letters and emails expressing the writers' concerns that *Spectrum* was featuring too much digital art. Everyone has their own likes and dislikes, but we think some people have misunderstood *Spectrum's* purpose: it's all about celebrating the *art,* not the tool used to create it. Whether using a sable or digital brush, clay or a 3D program (or a camera, for that matter), art is art. The tool can't do it for you. If you lack skill and imagination, your computer art will lack skill and imagination. If you can create dazzling digital art that means you have all the abilities necessary to achieve similar successes in paint. Regardless of their preferred media, we feel *Spectrum* is for all artists, traditional or digital—they just have to make the jury's cut.

Speaking of the digital world, within the last year we took on the complex task of redesigning our website. The new *Spectrum* Internet domain is a now a far more complete source for information about the annual competition, about new projects we are involved in, and about the fantastic art community in general. The FTP site facilitated delivery of art selected for inclusion in #14 (while saving people some FedEx money) and should make things even easier in the future as we fine-tune the process. The website will have frequent news updates, a calendar of events, and even an occasional editorial. We were aided in this endeavor by Arlo Burnett: he has taken on the job as administrator for the website while also serving as supervisor of the team that helps us during the judging event each year. If you sent any email questions prior to this year's competition, it was Arlo who responded and quickly took care of any problems.

The judging this year was held the weekend of February 23–25 at our now-traditional venue of Kansas City's Hyatt Regency. All the judges arrived safely and, for the most part, a bit ahead of schedule. Weather in other parts of the country made things a little dicey for departures on Sunday and Dan dos Santos was forced to stay over until Monday when his flight was cancelled. (Which gave us the opportunity for a little more time with Dan, so it wasn't *all* bad.)

Saturday the 24th was the day the jurors showed their chops. From 8:30 A.M. to 6 P.M. (with a respite for lunch, naturally) they looked at art. And *more* art. *And more art.* Each judge voted anonymously, could not vote for their own works, and was ineligible for awards. There *were* some diversions to break up the day, though. We got to watch the buses for Christina Aguilera and The Pussycat Dolls pull up and unload the "Dolls," who were staying at the hotel prior to a concert that evening. A break in the judging allowed *some* of us (I won't say *who*) to go exploring and "accidentally" discover where the dancers were rehearsing. During other breaks, while the room was being reset, the jurors shared projects, portfolios, and industry gossip with each other. As the day wore on a wedding took place in the room across the hall from our event. There was a steady parade of wedding planners and participants scurrying around—happy, mad, frantic, and ultimately relieved—followed by lots of aunts and uncles dressed in their finest. You can't say *Spectrum* doesn't provide our guests with entertainment! At the conclusion of the judging we all adjourned to a private room at one of Kansas City's finest restaurants and ate, drank, and talked late into the night.

The team assisting Arnie and I this year tabulating votes, setting and resetting the room, and keeping the proceedings moving at a rapid clip were Will Leathem, Terry Lee, Lucy Moreno, Gillian Titus, the afore-mentioned Arlo Burnett, and Jason Ryberg. Without a great crew who willingly gives up their whole Saturday every year to help us *Spectrum* would not be possible: Arnie and I simply could not do it alone.

But, of course, we couldn't do it without *you*, too. This book is only made possible by the active and continuing participation of the artists and the creative community and through the enthusiasm and support of the readers and the art directors that use it as a resource for talent. This book belongs to *all* of you. Thanks for letting us do this every year.

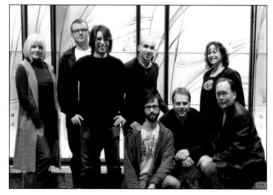

Fenner, Ragnar, Gabbana, dos Santos, Rex, Chiarello, Murin, Fenner

Leathem, Lee, Moreno, Titus, Burnett, Ryberg

THE JURY

Mark Chiarello, Dan dos Santos, Marc Gabbana, Dawn Murin, Ragnar, Adam Rex

Mark Chiarello/Jury Chairman
artist/editor & art director DC Comics

Dan dos Santos/artist

Marc Gabbana/artist

Dawn Murin/art director
Wizards of the Coast

Ragnar/artist

Adam Rex/artist

Grand Master Award
SYD MEAD

born July 18, 1933/St. Paul, MN

"There's a large abuse of the word [fantasy]," says Syd Mead. "Fantasy is anything that isn't real. You can have a project (and I've worked on many of them) aimed at eventually producing a real object. Everything is very carefully thought out and then pictures—either renderings or sketches—are made. The project may encompass a very real problem and I may arrive at a very real solution, but if it never comes to pass, no matter how logical or carefully the planning is done, it's still fantasy or a dream if it never exists as an object."

Is Syd Mead an artist or an oracle? Certainly, the answer is "both!"

Born July 18, 1933 in St. Paul, MN, to Kenneth and Margaret Ann Mead, Sydney Jay was the oldest of two children. After completing high school in 1951 he worked briefly in animation before enlisting in the Army and serving with distinction in Okinawa. Upon his discharge he enrolled at the Art Center in Los Angeles, graduating with "Great Distinction" in 1959. Almost immediately he was hired by the Ford Motor Company's Advanced Styling Center in Dearborn, MI, and it was for them—and shortly thereafter, U.S. Steel—that Syd Mead/Futurist came to the forefront.

Extrapolating what the future might hold through paintings of vehicles, architecture, environments, or social settings was not only his forté, but his passion. Mead's futures were (and are) optimistic, streamlined wonderlands: his houses combined space with elegance, his massive working machines embodied power and function, while his cars, planes, and spacecraft were all chromed-steel aerodynamic speed demons. And above all, they were *logical*: they all made sense. Of *course* Hollywood took notice. The walking trucks he visualized in the 1960s were reinterpreted (in a round-about fashion) as the ATATs in *The Empire Stikes Back*; Syd directly brought style and panache to *Star Trek: The Motion Picture*, an atmosphere of despair to the "retro-deco" and incredibly influential world of *Blade Runner*, and precision and plausibility to the automations of *Tron, Aliens, Mission to Mars,* and *Mission Impossible III.* But Mead is not content with working in one arena nor in being easily categorized. He's too restless, too inquisitive, too creative for that. "When I was in school," Syd remarks, "people were trained to have a linear career. You were going to be a package designer, a car designer. Today, the skill-sets are merging, so it's a much more fascinating, rich world that we're working in. I've done work for superyachts, nightclub interiors. Now, I'm doing theme parks, hotels, video games. Films are only about 20% of what I do."

At the age of 74 Syd Mead looks forward to the tomorrows ahead. Naturally. He's not only already *seen* the future, he's helped to *shape* it. •

At right: THE RUNNING OF THE SIX DRGGX. "This painting was commissioned by the promoters of the first (and last!) Tokyo International Sports Fair," Syd explains. "It depicts six huge robot 'dogs' coming around the turn on a racetrack scaled up for their 12O foot height. **Oblagon, Inc.** produced a limited print series of this illustration and they sold out within the year." www.sydmead.com

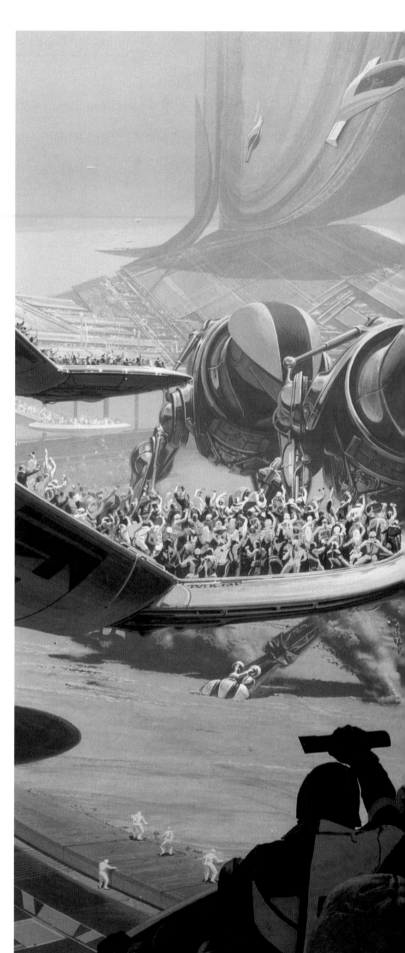

Previous Grand Master Award Honorees

Frank Frazetta

Don Ivan Punchatz

Leo & Diane Dillon

James E. Bama

John Berkey

Alan Lee

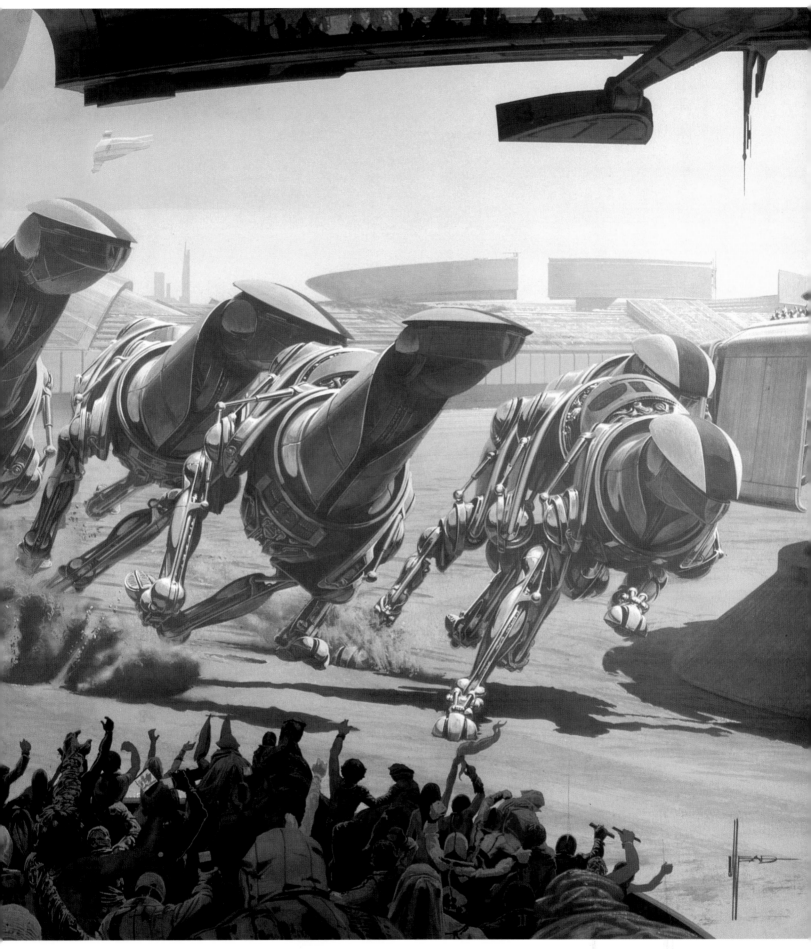

Jean "Moebius" Giraud

Kinuko Y. Craft

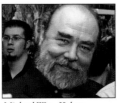
Michael Wm. Kaluta

Michael Whelan

H.R. Giger

Jeffrey Jones

"The people have spoken. The *bastards*."
—*Kinky Friedman commenting on his defeat in the Texas gubernatorial election*

"I see London, I see France, she's not wearing underpants."
—*Jesse Baker commenting on the media's fascination with Britney Spears' going commando in "The Best Non-News Stories of 2006", 12/31/06 on NPR*

2006 The Year *in* Review

by Arnie Fenner

Well...crud. If asked to summarize 2006 as briefly as possible, I think I'd be able to do it in, oh, three words:

It kinda sucked.

Oh, sure, there were plenty of positives: lots of great events, wonderful people, engaging products, and stimulating activities, but all the "good" seemed to always be counterbalanced by the "bad." War, crime, and natural disasters took turns being the "top story" each day on a rotating basis; liars, dolts, hypocrites, and fools had more forums and got more attention—and, amazingly, popularity—than they deserved.

The occupation of Iraq increasingly began to look like a remake of *The Battle For Algiers* and cast a pall over the national psyche: regardless of which insurgent leader was captured or killed, regardless of any attempt to improve security and quell sectarian violence, a conclusion to the conflict did not appear to be on the horizon. As suicide bombers targeted Baghdad's civilian population and IEDs took their toll on American troops, the demands for a policy change—and time-line for pull-out—swelled in both volume and intensity in the U.S. In the meantime, the Taliban continued to remind the populace of Afghanistan (and the NATO troops searching for al-Qaeda operatives and providing support for Hamid Karza's government) that they were still lurking about and capable of backing up their threatening rhetoric with an occasional car bomb. Israel and Hezbollah kept up the game of "Stop Touching Me: I'm Not Touching You" until it exploded (literally) in a month-long war in Lebanon. Iran continued to add to regional tensions through it's support for the afore-mentioned Hezbollah (at the expense of its own shaky economy), covert arms shipments to Iraqi militants,

At right: This funny, noirish painting (probably rated R for the cigarettes these days) was created by David Groff last year. You can find more terrific samples of his art at www.groffillustration.com or at his rep Jennifer Vaughn's site, www.jenvaughnart.com.

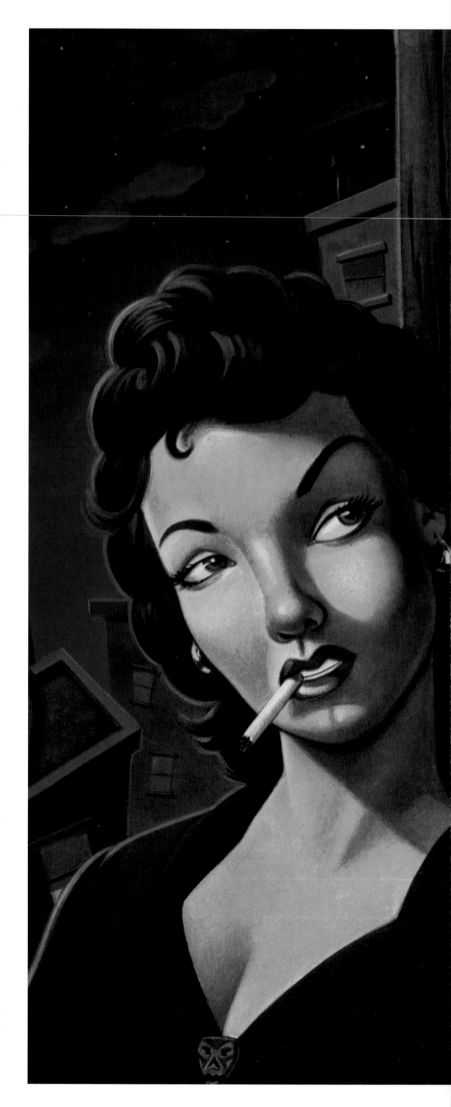

and nose-thumbing responses to the U.N.'s calls to abandon its attempts to become a nuclear power.

Kim Jong Il's North Korea, of course, couldn't be left out of the news and tested a small nuke just to make sure no one had forgotten them. The Sudan government laughed off condemnation of their continuing pogrom in Darfur, Venezuela's Hugo Chavez played his favorite game of blaming the U.S. for all the world's woes (it worked for Castro) to divert attention from the consolidation of his dictatorial control of his country, and there were riots around the world because of...cartoons?

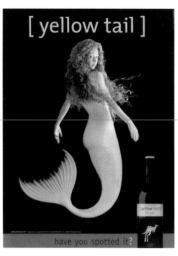

There was a lot of fantastic imagery used in advertising in '06, such as this PhotoShop mermaid for the Yellow Tail Vineyard. Quite a tasty wine, too.

Artistic depictions of Muhammad are a big no-no to Muslims: when Danish and French newspapers published several cartoons caricaturing the Prophet, Islamic crowds attacked editors and newspaper offices, illustrators were put on death lists, embassies in Iran and Jordan were firebombed, and even vendors of Danish and Norwegian *foods* were attacked: it was almost like a Monty Python skit gone wrong. Proof that the pen is mightier than the sword! (But it's a little difficult to draw when you have to duck those pesky molotov cocktails.) All of the international *sturm und drang* had the oil companies clucking their tongues in mock concern while prices shot through the ceiling and they pocketed record profits. With every increase in the price of crude, retailers jumped the price up at the pump—even though the gas in their storage tanks had been purchased at significantly lower cost months before. But there was no gouging going on, right? Oh, and your check's in the mail, too.

Early summer floods ravaged the mid-Atlantic region of the U.S., illegal immigration continued to be a hot-button issue, the recovery of New Orleans was hampered by slow clean-up, high crime, and divisive comments from Mayor Ray Nagin, while political scandals and corruption (Randy "Duke" Cunningham, Mark Foley, William Jefferson, Tom DeLay—not a Jimmy Stewart in the whole bunch!) eroded what little confidence people still had in their electorate. Oh, and V.P. Dick Cheney shot his friend in the face during a quail hunting excursion—which at least provided late-night comedians with some fresh material.

Celebrities satisfied the paparazzi by popping out babies or adopting African-orphans ("Oh, you just *have* to get one, *darling*, they're so *cute!*"), getting arrested, getting divorced, showing folks their *schmooie*, or going into rehab (for Britney Spears it was multiple choice). Madonna got the clergy fussing *again* with her Confession tour's mock-crucifixion, Rolling Stone Keith Richards fell out of a tree and landed on his head (we all *know* it'll take more than *that* to kill Keith!), Pope Benedict XVI got Muslims revved up by quoting a 14th century Byzantine emperor's criticisms of Muhammad (*hsssst,* Joe: ix-nay on the uhammad-May remarks—look what happened with those damned cartoonists!), and former *Road Warrior* and über Catholic Traditionalist Mel Gibson informed the officers that had pulled him over for DUI that the Jews were responsible for all the world's wars and that female cops had boobs made of sugar. Who knew?

So there really was a lot of discord in 2006, a lot of anger and disharmony. Mention stem cell research, global warming, or evolution (among any number of other topics) and you could guarantee an argument. Voters tossed out a lot of Republicans in the Fall elections (making Nancy Pelosi the first female Speaker of the House and arguably the most powerful woman in America... next to Oprah, as James Frey discovered) and astronomers likewise tossed Pluto out of the league of planets, relegating it to sit at the kiddie table with Eris, Dysnomia, and other dwarf planetoids. School shootings, doping allegations in a variety of sports, a sluggish economy (hurt by a down-turn in the housing market, fishy mortgage lenders, and weak sales for domestic auto makers) all contributed to making '06 one majorly crappy year.

What's all that got to do with fantastic art? Oh, I guess...*everything.* Art, fantasy and otherwise, reflects and responds to cultural and world events: reality is a springboard for the imagination and creativity in turn (regardless of fantasy-leanings) is the catalyst for societal problem-solving. And, of course, artists aren't immune to the trials and tribulations everyone faces: they pay the same amount for gas and food, worry about global strife, watch the same films, and laugh at the same jokes. Some readers have mentioned to us that a fair bit of the art in the last few volumes of *Spectrum* have had a decidedly "dark" tone: given recent world events, is it any wonder? Artists *can* be our entertainers, to be sure, delighting us and wowing us and thrilling us. But they're not our pet monkeys, either, here solely to amuse us with tricks. They can, and often do, act as commentators and something of a public conscience: they prod, they challenge, they remind. They help us to stop and consider, to take the time to *think.*

Perhaps when it was all said and done the happiest folks last year were Tsunemi Kubodera of the National Science Museum of Japan (who finally got video of an adult giant squid), Chad

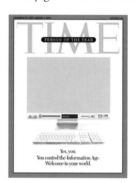

Time magazine hosed me with a joke last year. Let's just leave it at that and move on...

Hurley and Steve Chen (who sold their Internet creation, YouTube, to Google for $1.65 billion) and...me. Why me? Well, as if you didn't know! *I* was selected as *Time* magazine's Person of the Year, face on the cover (though admittedly a tad distorted) and everything. What? It was a *gimmick*, a mirrored cover that made *everybody* Person of the Year...?

Okay! Now 2006 *really* has me pissed!

A D V E R T I S I N G
▾▾

The joke around the office (and there's more truth to it than I like to admit) is that I'm the last to know anything. When it comes to the ad world, I'm beyond last. Years ago I was a junior partner at an agency and did jobs for the Marriott Hotels, Universal Studios, and any number of others: I knew people in the biz and had a pretty good handle on who was doing what for whom. These days? I'm lost.

It used to be that the ad biz was pretty straight forward: put your pitch in front of the most eyes (either in print or on TV) and watch the revenues climb. Now days with hundreds of cable stations, thousands of magazines, maybe tens of thousands of websites—and don't forget marketing via fax, email, cell phones, and even as "entertainment" in movie theaters *before* the coming attractions—it has become increasingly difficult to capture the consumer's attention. One sure-fired method (other than inadvertently causing a bomb-scare, as happened with the "guerrilla" ad clowns working for the Cartoon Network in early '07) is to use fantas-

Flesk Publications brought out this absolutely terrific retrospective of Jim Bama's commercial work. The deluxe edition also included a DVD of Paul Jilbert's definitive Bama documentary.

tic imagery as part of a multi-faceted campaign to make people sit up and take notice. And even then there were no guarantees of success: I call your attention to *Snakes On a Plane*. The most hyped and anticipated film of the year—thanks to web chatter and promotion—crashed and burned on opening day. Proof (if any were needed) that even the best advertising program can fail if nobody wants what you're selling. And...fanboy love can only take you so far.

Transitions used futuristic cityscapes (that sure looked at least *inspired* by Stephan Martiniere's work) to sell their sun-darkening lenses, Dodge Ram went toe-to-toe with a full-sized Rock-'em-Sock-'em Robot, bad boys messed with Bigfoot in a series of humorous ads for Jack's Links Beef Jerky, and woe to the people in the houses underneath the rampaging giant Godzilla-inspired monsters (including a 50-foot Amazon with diarrhea!) in a spot promoting the wonders of Pepto-Bismol.

Print-wise, ads tended to rely almost exclusively on Photoshop magic (which is pretty much the standard these days) or CGI cartoon characters (like Neal Adams's French bee for Nasonex). Exceptions to the trend were some gorgeous Jody Hewgill theater posters for Arena Stage, neat Halloween sculptures by Red Nose Studio for Frito Lay, and some great scratchboard illos by Cathie Bleck for Sony.

B o o k s

The lament (for almost as long as I can remember) has been that no one is reading anymore—which helps to explain why people are so damn dumb these days. Ok, that isn't quite fair or true: not *all* people are dim (only the ones who tailgate, talk on cell phones non-stop, or appear on reality TV shows, and maybe a few others) and if they weren't reading, the Internet, email, blogging, and text messaging wouldn't be as popular as they are. But, yeah, when it comes to *books*...well, it's actually hard to know. Sales went into something of a slight-if-steady slide for the last six months of the year and yet, when the dust had settled, there were more new books published in '06 with a total sales increase of 3.1% ($38.08 billion). E-books sales rose a healthy 24.1%, or $54.4 million—which didn't mean there was an influx of new readers, just a shifting of some consumers from the traditional format to a digital one. Despite the increases, the challenges still left analysts scratching their heads. Some of the hurdles to overcome are attributable to changes in society and the culture. The abundance of choices and the range of entertainment and information options available when combined with an increasing populace-of-the-disinterested makes being a publisher these days something of a rollercoaster ride. Increased energy prices meant that it cost more to print and ship books which meant that publishers had to charge more to cover their expenses which meant that readers had to make more cautious purchases in consideration of their own crunched budgets which meant that fewer copies per title sold which made it harder for the sellers which likewise made it tougher for publishers, their artists, and writers. *Whew!* It's *all* connected.

We received our own kick in the pants on

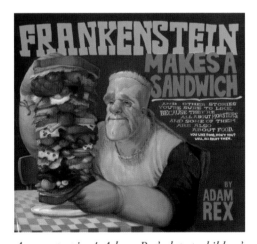

A monsterpiece! Adam Rex's latest children's book was both exquisitely illustrated and a hoot to read. And if you ever wanted a poem about Godzilla poo, look no further!

December 29, thanks to the unexpected bankruptcy of the parent company (Advanced Marketing Services) of the on-its-own-otherwise-profitable distributor for our publisher's titles. Though a new company stepped in to take over the business, the delays in shipping books to the stores while it was all sorted out didn't help sales (customers can only buy something if it's on the shelf)—and the loss of monies owed the publishers (on average, each lost 30% or more of what they were owed for sales of their Fall titles) hurt everyone, us included. How bad? We'll see.

But, naturally, there were happy aspects to 2006, as well—meaning there were some *great* books released. At the top of my list of personal favorites were Flesk Publication's *James Bama: American Realist* by Brian M. Kane and *Mark Schultz: Various Drawings Volume 2*. The Bama collection was a pretty thorough appreciation of Jim's illustration career (and the deluxe edition included a DVD of Paul Jilbert's excellent documentary) while the Schultz volume fittingly showcased an artist who comfortably bridges the divide between "classic" and "contemporary." *Famous Monster Movie Art of*

If you grew up with Famous Monsters of Filmland *(or snuck peeks at your dad's "man's adventures" sweat mags), the Basil Gogos collection from Vanguard was an absolute must have.*

Basil Gogos edited by Kerry Gammill and J. David Spurlock [Vanguard] provided a nicely spooky stroll down memory lane and was easily one of the best retrospective titles of the year. Arguably the top futurist doing covers and multi-media designs today was admirably displayed in his second book, *Quantumscapes: The Art of Stephan Martiniere* [Design Studio Press] while *The Future Was Fab: The Art of Mike Trim* by Trim and Anthony Taylor [Hermes] shined a spotlight on a lesser-known, but equally influential illustrator. Ashley Wood was busy, busy, busy throughout 2006 with a brace of volumes

Haunted Paradise: The Art of Glenn Barr *was the lastest low-brow gathering of paintings populated with robots, vixens, and a Cadillac-driving Jesus. A real knock-out.*

produced by IDW: *Grande Finale, Sencilla Finale*, and *Sparrow 1: Ashley Wood* all featured a wonderfully and enjoyably manic selection of work. *Vernaculis* [Baby Tattoo] was the second hep potpourri of babes and beasts (including a stunning Halloween-themed series) by the equally hep Ragnar, *Frank Cho Women: Selected Drawings And Illustrations* [Image] nicely exhibited the technique of one of comics hottest young illustrators, while *The Art of Brian Bolland* [also from Image] was big, definitive and entertaining. *The Art of Michael Parkes* [Swan King] was a lovely addition to the series of volumes devoted to the K.U.-trained painter, *Haunted Paradise: The Art of Glenn Barr* [Last Gasp] was simultaneously shocking *and* hilarious, *Tommyrot: The Art of Ben Templesmith* [IDW] was a ghoulishly delicious collection, *The Union of Hope and Sadness: The Art of Gail Potocki* [Olympian] was eerily affecting, and *Cover Story: The Art of John Picacio* [Monkey Brain] highlighted the recent work of one of the science fiction field's fan favorites. *The Fabulous Women of Boris Vallejo and Julie Bell* [Collins Design] was a nice gathering of pumped-up pulchritude, Luis Royo's *Dark Labyrinth* [NBM] and *Subversive Beauty* [Heavy Metal] both featured darker (if no less alluring) selections of deadly beauties, *Coffin: The Art of Vampire Hunter D* and *Faeries* [both from Dark Horse] showcased the luminous art of Yoshitaka Amano, Donato produced the new installment in his slim-but-lovely series of booklets, *Donato Giancola: Painted and Drawn Works 2006*, while *The Art of Greg Capullo* [Image] nicely collected the energetic art of the man responsible for all those moody *Spawn* covers. If you wanted funny, then *An Orgy of Playboy's Eldon Dedini* by Eldon Dedini or *Chicken Fat: Drawings, Sketches, Cartoons and Doodle*s by *Mad's* Will Elder [both from Fantagraphics] filled the bill; if you wanted bios or critical studies, *Carl Barks and the Disney Comic Book: Unmasking the Myth of Modernity*

by Thomas Andrae [UPM], *Charles Addams: A Cartoonist's Life* by Linda H. Davis [Random House], and (though hampered with some production problems) *Wally's World: The Brilliant Life and Tragic Death of Wally Wood, the World's 2nd Best Comic Book Artist* by Steve Starger and J. David Spurlock [Vanguard] all provided some very interesting reading. And sketchbooks: *woof!* there were tons. My favorites included *Greatest Hits* by Adam Hughes (which I could only get by eye-gouging and toe-stomping my way through a mob of admirers crowding around his table at Comic-Con), *Some Drawings* by Mike Mignola (truly amazing stuff), *Frank Cho: Sketches and Scribbles, Alex Nino: This Is My World, Eric Powell: Drawings, Sketches, & Such Book 2, Derekmonster Annual 2006* by Derek Thompson, and *Warm Ups and Waiting* by Dok Whitson.

Mentioned without comment (other than that we were extremely proud to do them) are a pair of color art books Cathy and I put together for Underwood Books: *Origins: The Art of John Jude Palencar* and *r/evolution: The Art of Jon Foster* (for which Tor's Irene Gallo pitched in as co-editor).

Multiple-artist books that made their way to my bookshelf last year were *Illustrators 47* [Collins Design] (a no-brainer, not only because it's the *best* annual overview of the illustration field, but also because I've got volumes 1-46—can't stop now!), *ASFA Presents 108 Drawings* [Allen Spiegel Fine Art], which featured Jon J Muth, Phil Hale, George Pratt, Kent Williams, etc., *Concept Design 2* [Design Studio Press]—which included some gorgeous work by Ryan Church, Oliver Scholl, and Stephan Martiniere among other worthies—and *The Winston Effect* by Jody Duncan [Titan], an eye-popping look at the art of spfx wizard Stan Winston and his creative staff. *Exposé 4,* edited by Daniel P. Wade and Paul Hellard, was the latest in Ballistic Publishing's pantheon of digital art anthologies and included some excellent work; *The Art Of H.P. Lovecraft's Cthulhu Mythos* [Fantasy Flight Games], edited by Jeremy McHugh, gathered lots of gill-flapping art from the collectible card game (including properly eldritch paintings by Michael Komarck, Thomas Denmark, James Ryman, and Linda Bergkvist); but my favorite *had* to be *Beasts!* compiled by Jacob Covey [Fantagraphics], which captured a

The popularity of Beasts!, *a marvelously designed and illustrated guide to creatures great and slimly, caught the publisher by surprise and they had to rush it back to press to satisfy demand.*

Deceptively reserved and relying on heavy blacks and spare lines, Mike Mignola's '06 sketchbook once again proved that his composition and design style is second to none. I love Mike's art!

gilt-edged menagerie of creatures as depicted by the likes of Jeff Soto, Dave Cooper, Sam Weber, and James Jean among others.

When it came to illustrated fiction titles, I thoroughly enjoyed Dave McKean's work for *The Homecoming* by Ray Bradbury [Collins Design], Yvonne Gilbert's for *The Ice Dragon* by George R.R. Martin [Starscape], Barry Moser's for *Scary Stories* (tales by Poe, HPL, King, etc.) [Chronicle Books], Justin Sweet's for *Kull: Exile of Atlantis* by Robert E. Howard [Del Rey], and Jae Lee's for *The Illustrated Dracula* by Bram Stoker, naturally [Penguin]. In the arena of children's books you simply couldn't ask for better than *Frankenstein Makes a Sandwich* by Adam Rex [Harcourt], *Mommy?* by Maurice Sendak, Arthur Yorinks, and Matthew Reinhart [Scholastic], *Flotsam* by David Wiesner, *The Demon Hunter's Handbook* by "Abelard (*not* Abraham) Van Helsing" (Steve Bryant) and illustrated by Miles Teves [Barnes & Noble], *G Is for One Gzonk!: An Alpha-number-bet Book* and, with Holly Black, *Care & Feeding of Sprites* by Tony DiTerlizzi [both S&S], *Here There Be Dragons* by James A. Owen [S&S], and *Probuditi!* by Chris Van Allsburg [Houghton Mifflin].

In the cover department I was greatly impressed by some outstanding work by Patrick Arrasmith (*Brother to Dragons, Companion to Owls* by Jane Lindskold [Orb]), Julie Bell (*Wolf Hunting* by Jane Lindskold [Tor]), Greg Call (*Peter and the Shadow Thieves* by Dave Barry and Ridley Pearson [Hyperion]), D.M. Cornish (*Monster Blood Tattoo, Book One: Foundling* by D.M. Cornish [Putnam]), Tony DiTerlizzi (*Peter Pan in Scarlet* by Geraldine McCaughrean [Simon & Schuster]), John Jude Palencar (*Widdershins* by Charles de Lint [Tor]), Robert McGinnis (*Spider Kiss* by Harlan Ellison [M Press]), Paul Youll (*Shadowed by Wings* by Janine Cross [Roc]), Justin Sweet (*Return to Quag Keep* by Andre Norton and Jean Rabe [Tor]), Todd Schorr (*Shuteye for the Timebroker* by Paul Di Filippo [Thunder's Mouth]), Rick Sardinha (*Pirate Curse* by Kai Meyer [McElderry]), Jon Foster (*Dragonfrigate Wizard Halcyon Blithe* by James M. Ward [Tor]), and Bill Mayer (*Wintersmith* by Terry Pratchett [Harper])—and that's really only scratching the surface. Add in Chris McGrath, Rick Berry, Tom Canty, Raymond Swanland, Donato Giancola, Jean Pierre Targete, Stephan Martiniere, and a host of others and you'd

quickly come to the conclusion that book covers have never been so diverse or exciting.

Other than losing some money (thanks to the distributor follies), there was very little to raise my Irish in the book world last year...until I read Claus Brusen's intro to *Dreamscape: The Best of Imaginary Realism.* Now Claus, bless him, had been in an earlier volume of *Spectrum* and I knew that he had a similar sort of project in the works—which I'm all for (I *love* art books, in case you didn't notice). And I thought Claus and his partner had put together a good, if a bit uneven, collection with some genuinely nice work that I would have gladly plugged—and then he had to ruin it by writing: "We both admired the books done by Paper Tiger back in the seventies and eighties as well as the annual American *Spectrum.* In our opinion, however, the focus of these books is too broad. We felt the need to create something that didn't include 'illustration art' which is very much popular in America, but mostly looked upon as kitsch in Europe and not taken seriously."

Oh *really?*

Now I might have been willing to give Claus a pass if his book's content didn't prove his comments to be a lot of baloney. Not only

Stephan Martiniere's follow up to '04's Quantum Dreams *was a panoply of astonishing art. Information can be found at www.designstudiopress.com.*

does *Dreamscape* include "illustration art" (*the scandal!*) as well as "fine art" that has been used as illustration, but it also features more than a few painters who regularly appear in...*Spectrum.* Hmmm.

Look, I understand (though don't condone) the idea of playing yourself up by putting others down (we've all endured high school) and that's not what I'm trying to do here. But it's the combination of arrogance, pretense, and ignorance in his introduction that had me hopping around the office doing my best imitation of Donald Duck on a tear. But Cathy suggested that I be gentle in expressing my ire at Brusen's comments, so I'll simply reiterate some things I've said through the years.

There really is no such thing as "Fine Art." Distinctions between it and Illustration are the artificial creations of a relatively few pretentious boobs—and are a fairly recent conceit at that—who wanted to take on an air of somehow being "superior" to others. *All* art that is offered for sale or is commissioned, whether for or through a gallery or by a patron, can be considered commercial work, created with the intent of making money. Weren't Leonardo da Vinci, Raphael, and Donatello the paid illustrators of the Medicis? What is the Sistine Chapel but an oversized illustration job by Michelangelo? I mean, it's illustrating a great *book*, right? But that's all really beside the point: in all honesty,

99.99% of the public *do not care* about arbitrary classifications: they only care about what they like, about what "speaks" to them. When I can buy *this* anthology featuring a Michael Parkes on the cover or *that* necktie sporting a Picasso, how is their work better than *this* book jacket painting which also hangs in a gallery or *that* magazine cover which is also available as a limited edition print? The answer, certainly, is: they aren't. To elevate one as a "Fine Artist" while dismissing another—who creates with the same heart, emotional investment, and intellectual depth—as a "kitschy" illustrator is a disingenuous attempt to buy into, foster, and perpetuate a pseudo class system. These obstreperous jamooks want to decide which artists wear the berets and which ones sit in the back of the cultural bus and I say *bullshit*.

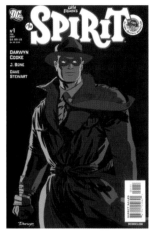

Darwyn Cooke's update of Will Eisner's perpetually-bemused crime fighter was an unexpected triumph.

What the art "says" is far more important than where it first appeared of who it may have been done for. But if anyone is really determined to split hairs I'll play along and agree that there are indeed two categories of art.

There's Good Art and there's Bad Art.

Claus may believe that the pictures of naked gals with butterfly wings (including several that—*huh*, what a surprise—*he* painted) in his book are somehow superior because they were created by his misguided definition of an *artisté* instead of by some paltry illustrator. That's fine. But I've got news for him and for anyone who shares similar condescending and pontifical viewpoints and attitudes:

They're *not*.

C O M I C S

The comics business is always one of feast or famine, a cyclical industry that is, let's face it, pretty unpredictable. Creators come and go, trends wax and wane, a book that's hot today is canceled for lack of readers tomorrow. But after a period of market blahs (with the only bright spot being the infusion of manga translations), 2006 definitely was a turn-around year. Sales for periodical comics increased a whopping 15% over '05 stats while graphic novel sales were up a respectable 9%—and those figures were only for the *direct* market. Factor in traditional bookstores and overall backlist sales and we're talking reasonably Happy Days for publishers and creators. How long it will last...?

DC just wowed me in '06, both with their monthly titles and with their handling (and repackaging) of backlist material and original graphic novels. Though the *Superman Returns* film from their parent company, Warner Bros., didn't satisfy fans hoping for 120 minutes of superhero slug-fests or break any hoped-for boxoffice records, DC's *Infinite Crisis*, *52*, and *Justice League of America* events not only arrived on schedule, but delivered the goods (so to speak) as well. Their Johnny DC imprint nurtured the next generation of readers and their CMX line addressed the market's hunger of manga storylines. I honestly didn't expect the revisioning of Will Eisner's classic *The Spirit* to succeed and was delighted to be proven wrong. Darwyn Cooke's updating (ably assisted by J. Bone) felt so incredibly *right* that I'm sure Eisner would've been proud. Likewise, I could not have asked for covers better than those Adam Hughes provided for *Catwoman* throughout the year: wry, sexy, charming, and iconic, Hughes was creating at the top of his form. Alex Ross collaborated as writer with Jim Krueger and as artist with Doug Braithwaite on the *Justice* maxi-series while Matt Wagner added some graphic panache to his *Batman and the Mad Monk* mini. *Man-Bat* (scripted by Bruce Jones) featured stylish art by Mike Huddleston, Paul Pope impressed with his story and art for the *Batman: Year One Hundred* special, and James Jean topped himself month after month with his astoundingly diverse covers for the *Fables* series. And what can I say about the hefty, over-sized, definitive "Absolute" books? *Absolute Dark Knight*, *Absolute Kingdom Come*, *Absolute Sandman*, and, my favorite, *Absolute DC: The New Frontier* were all excellent and worthwhile additions to any library. Less physically imposing, but also a have-to-have was *Showcase Presents: The Haunted Tank Vol. 1*—a bargain at $17! DC featured some stand-out art by Lee Bermejo, Daniel Acuña, Jock, Frank Quitely, Charles Vess, and a host of others. About the only thing I can think of that disappointed me last year was the cancellation of the *Solo* series. Editor Mark Chiarello had put together an exceptional showcase focusing on one artist per issue handling a wide variety of stories and subjects: unfortunately, there weren't enough readers who tumbled to just how special the experiment was. Maybe it will come back at some future date.

Marvel, the 800 pound gorilla of franchise superhero comics publishers, also had a stellar year (which should surprise no one). Their *X-Men: The Last Stand* was only their latest major film hit, their repackaged backlist titles increased in market-share, and their across-the-line *Civil War* event not only racked up major sales, but generated a lot of media attention as well. If they experienced any hiccups it was in keeping up with their ambitious schedule: a delay in completion and shipping near the end of 2006 had retailers howling and scrambling for product to fill the holes on their shelves otherwise intended for all of the *Civil War*-related titles. The various "zombie" spin-offs (most featuring covers by Arthur Suydam) continued to be incredibly hot while Neil Gaiman collaborated with John Romita Jr. (beneath covers by Rick Berry) on *The Eternals* mini-series. Marvel's *Halo* graphic novel adaptation of the hit video game (and *maybe* movie)—featuring multiple writers and artists, including Simon Bisley and Moebius—boasted an energetic cover painting by Phil Hale (the original for which was immediately snatched up by MicroSoft where it now hangs in their corporate offices). I noted dazzling art work for various titles by Tim Bradstreet (can't beat his *Punisher* covers), Leinil Francis Yu, Jae Lee, Brandon Peterson, Frank Cho, Clayton Crain, Chris Bachalo, some especially dynamic *Blade* covers by Marko Djurdjevic, and even a cover or two by EOC Joe Quesada.

Dark Horse greatly benefited from their relationship with Frank Miller: all of the *Sin City* backlist graphic novels continued to do extremely well, thanks in no small part to the residual popularity of Robert Rodriguez's 2005 film. Anticipation for Zack Snyder's '07 adaptation of *300* pushed demand for Miller's stylish retelling of the battle of Thermopylae from 1999 through the roof (reportedly in excess of 300,000 copies sold). The multiple *Star Wars* comics had legs, particularly in the mass market, while under-

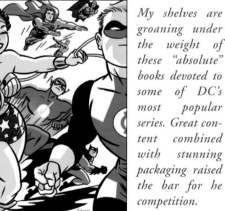

My shelves are groaning under the weight of these "absolute" books devoted to some of DC's most popular series. Great content combined with stunning packaging raised the bar for he competition.

ground legend Richard Corben collaborated with Mike Mignola on a two-issue special, *Hellboy: Makoma*. And speaking of Mignola, *Strange Places* was the first Hellboy collection since the release of 2004's excellent film translation by Guillermo del Toro and it showed Mike's maturity as both a writer and as an artist. The pair of melancholy (and, conversely, mordantly funny) tales were beautifully drawn

and complexly plotted, exploring the power and resonance of myth. Timothy Truman became the new scripter for DH's *Conan* series, which continued to be admirably illustrated by Cary Nord; Alexis Briclot provided some outstanding covers for *Hellgate*; *The Escapist* featured some great work by Jason Alexander and James Jean; and Eric Powell (who also drew a fill-in *Conan* tale in '06) fleshed out the adventures of his tough-guy characters in his horror-gangster parody, *The Goon*. My vote for the best last year, though, would have to go to Scott Allie's *The Dark Horse Book of Monsters*, an elegant little hardcover that featured exceptional art and stories by Gary Gianni, Paul Lee and Brian Horton, and a great new *Hellboy* story by Mignola.

IDW was one of the most visually sophisticated comics publishers of last year and featured memorable work by Ashley Wood, David Hartman, Ben Templesmith, and Jeremy Geddes. Image Comics released some cool titles, including *Occult Crimes Taskforce* (written by David Atchison and actress Rosario Dawson with art by Tony Shasteen), *Astro* (written and illustrated by Nilson), *The Portent* (written and illustrated by Peter Bergting) and the latest additions to Frank Cho's *Liberty Meadows* series. Burlyman Entertainment featured new installments in their *Shaolin Cowboy* series, written by the Wachowski Brothers and illustrated by Geof Darrow, Drawn & Quarterly released Chris Ware's *Acme Novelty Library Vol. 17*, Ballantine produced the anthology, *Flight 3*, Abrams published the very-interesting *Art Out of Time: Unknown Comics Visionaries 1900-1969* by Dan Nadel, and Paquet offered the exceptional *Out of Picture*, a book of comics stories by concept artists from Blue Sky Studios, including Greg Couch, Vincent Nguyen, Michael Knapp, Daniel Lòpez, and Peter de Sève. Fantagraphics spent part of the year trying to stave a complicated defamation/trademark misuse case filed against them by Harlan Ellison (the culmination of decades of animosity between Ellison and the company's owner, Gary Groth) while publishing some striking books including *Krazy & Ignatz 1937-1938: Shifting Sands Dusts its Cheeks in Powdered Beauty* by George Herriman, *Arf Museum* edited by Craig Yoe, *Innocence and Seduction: The Art of Dan DeCarlo* edited by Bill Morrison, and *Popeye Vol. 1: I Yam What I Yam* by E. C. Segar.

After hitting a couple of speed bumps in 2005, all things Manga came roaring back in '06, with various volumes of *Naruto*, *Fruits*

Basket, and *Bleach* taking turns at the top of the bestseller lists. The strong f e m a l e - r e a d e r demographic also created a huge market for Yaoi Hentai titles (explicit stories about androgenous-looking Gay men), but caused Wal-Mart executives to blush when news stories appeared questioning the contents of some of the titles the conservative retail giant was selling on-line. (Someone wasn't paying attention.)

Marvel snagged some knockout covers last year, including those by Phil Hale (for the Halo *GN, above) and by Claire Windling (*X-Men Fairy Tales *#3 at left)*

The comics-focused magazines—*Back Issue*, *Wizard*, *Comics International*, *Comics Buyer's Guide*, *Comics Revue*, *The Comics Journal*, *Alter Ego*, and *Draw!*—all appeared on schedule (or close to it), though circulations continued to slip as more and more readers migrated to the web for news and features (hey, it may lack depth, but it's free). The *Publisher's Weekly* on-line comics newsletter served nicely as a professional trade journal for the field while there were numerous articles about the industry in newspapers and magazines on a fairly regular basis. Budding artists could look with envy at *Drawing Comics Is Easy! (Except When It's Hard)*, the first how-to book (in hardcover, no less) by Alexa Kitchen, age 7—admittedly she had an "in" with DKP's publisher, Denis Kitchen aka Daddy. Comic-Con International in San Diego (which Heidi MacDonald calls the "Nerd Prom," but I much prefer my own title of "Nerdvana") was bigger than ever and the first year of the NYC Comic-Con was so successful that the Fire Marshalls had to stop letting people in.

So, beyond a snarky blog posting or two from various nitwits, I couldn't think of too much in the comics arena that raised my hackles in 2006...until I pulled my *EC Picto Fiction Library Complete Set* [Gemstone] out of the mailer and started fussing. Not because I thought the $150 price-tag was too stiff for four hardcovers in a slipcase—I didn't—and not because I wasn't happy to finally have all of the super-rare art by Reed Crandall, Jack Davis, and George Evans among others all in in one place—I was. Nor was a bothered by the hackneyed (even for their time) stories by Al Feldstein, Jack Oleck, and Daniel Keyes (best remembered for *Charly*, the movie based on his short

story "Flowers for Algernon"). Nope, what bugged me was the absolutely *abysmal* printing of Frank Frazetta's unfinished illos for the story "Came the Dawn": the reproduction of all the other art in the four books is top-notch, which makes comparing those pages to the muddy, murky pages with Frank's art (the originals for which are really splendid) something akin to getting a kiss followed by a thumb in the eye. I would've rather just had the smooch.

DIMENSIONAL

Anyone familiar with these review essays knows that Cathy and I have shelves-full of various 3D items: statues, action figures, and busts; robots, soldiers, superheroes, and barbarians; mini-lunchboxes, tanks, even a lighted glass jellyfish (it's pretty tasty, lemme tell you). Subsequently, we try to avoid buying any more of this stuff (it's hell to dust)—and fail. DC Direct didn't help our resolve in 2006 by releasing some irresistible pieces. The Adam Hughes-designed/John G. Matthews-sculpted *Women of the DC Universe* series of busts (no jokes, please) were uniformly excellent: "Harley Quinn," "Hawkgirl," and "Poison Ivy" were particularly well-done. Likewise there were some exciting Dark Knight statues, including "Paul Pope's Batman: Black & White," (sculpted by Jean St. Jean), "Kelly Jones' Batman: Black & White" (sculpted by Ray Villafane), and the "All Star Batman & Robin Statue" designed by Jim Lee and Scott Williams and sculpted by John G. Matthews. Karen Palinko delivered a spot-on interpretation of the Alex Ross-designed "Superman Forever #1" statue then switched gears and sculpted an equally definitive series of figures based on the Cartoon Network's hit, *Foster's Home for Imaginary Friends*. And there was more, dammit, more, including nice figures by Karen Palinko, Jonathan Matthews and Tim Bruckner to crowd our shelves.

For me, the Marvel figures and busts tend to be pretty

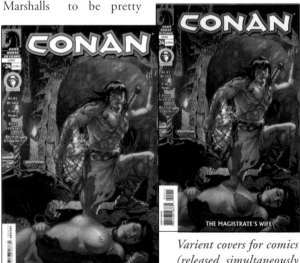

Varient covers for comics (released simultaneously with the regular edition as an instant "collectible") made something of a come-back last year, none more surprising than Tony Harris' nude attention-grabber for Dark Horse's Conan.

hit-and-miss each year, with winners battling losers for first place. The "hits" (again, from my perspective) of 2006 were Barsom's "Electra Bust," Carl Surges's "Original Iron Man Bust," "The Scorpion" statue by Mark Newman (this guy is g-o-o-d), "The Rhino" statue by the Shiflett Bros., and the "Namor: The Sub-Mariner" and "Red Skull" (with your choice of two heads) by Randy Bowen.

William Paquet produced several first-rate statues based on Frank Miller's *Sin City* ("Marv" and "Nancy," naturally) for Dynamic Forces while ReelArt's cool releases included "Flash Gordon" (sculpted by Ruben Procopio), "William Stout's Number One" and "The Phantom & Devil King" (both sculpted by Shawn Nagle), and "William Stout's Dino Girl" (crafted by Jason Spyda Adams). Clayburn Moore's interpretation of Frank Cho's "Brandy" was a delight and bronze of David Mack's "Kabuki" a stunner. I liked Tony Cipriano's "Hellboy Animated" [Dark Horse]; virtually all of the life-like *Star Wars* and *Robocop* figures from Japan's Kotobukiya; Lawrence Northey's metal rayguns and 24" tall "Dave the Robot"; David Horvath's "Ugly

This cute "Poison Ivy" was sculpted by John G. Matthews and designed by Adam Hughes for DC Direct's Women of the DC Universe *line.*

Dolls" (they're hilarious); the dragons from Todd McFarlane Toys; and the definitive version of Dave Stevens' "The Rocketeer" from Medicom. On the downside, retailer Musicland's demise took several studios down with them, including Palisades Toys.

I saw fewer "garage kits" last year (probably because I wasn't paying as much attention as I should), but of the ones I *did* see and liked included "Count Orlock" by Randy Lambert [Spoiled Brat Models], "Edgar Allen Poe" by Mark Newman [Mark Newman Sculptures], "The Axe" by Andrea Jula and Luca Marchetti [Pegaso Models], and the quite funny "Nosfera-stew" (*Family Guy's* Stewie as a vampire) by Phil Sera and Gabe Perna [Killing Time kits]. *Amazing Figure Modeler* continued to be the best regular resource for anyone interested in the hobby.

Really, with all this wonderful stuff, there couldn't possibly be anything in the 3D world that ruffled my feathers, right? Don't be so sure. Let me point to the near-perfect translation of the classic cover for *Nick Fury Agent of Shield #5* into a gorgeous statue sculpted by Gabriel Marquez and released by DST. The 1960s spy heaters are there, the eye-patch is there, the Fury snarl is there; about the only thing missing is *credit for the artist that created the iconic art the figure is based on!* Nowhere, not on the base, the box, or in the advertising is Jim Steranko's name mentioned: sure, his *signature* is present on the comic cover included on the package, but only because it's part of the art. There is no *proper* acknowledgement of the man responsible for the drawing that made the goddam statue possible in the first place. How hard is it to show even a *modicum* of respect? Apparently the answer is: *incredibly* hard.

E D I T O R I A L
▼▼▼▼▼▼▼▼▼▼▼▼▼▼▼▼▼▼▼▼▼▼▼▼▼▼▼▼▼

Almost an annual ritual among genre analysts is the gnashing of teeth and rending of garments as the circulation figures of various magazines are compiled, posted, and evaluated: sales are down, subscriptions are slipping, its the end of the world as we know it. And don't start suggesting that web-only magazines are the wave of the future or the statistics will slap you colder than a wet mackerel: except for porn, *no* publisher, regardless of size, staff, intent, or deep pockets has been able to convince enough people to pay for content that would make such endeavors profitable.

Does that mean magazines in *any* form are dead? Ppffit. Take a look at the racks overflowing with periodicals for every taste and interest at your local bookstore and I think you'll have your answer. (Many local newspapers are in trouble, but that's another issue entirely.) I think it's oddly optimistic when you can find titles devoted to pirates, fairies, and sex with C'thullu regularly on the racks: if *somebody* wasn't buying them, they'd disappear in a snap.

The problem is more that the often-mentioned fragmentation in society means that people are satisfying their curiosity or need for information through sources specializing in their particular interests. Which translates into the Big Boys (with their more generalized approach in an effort to attract everyone) having their readers siphoned-off by smaller, more niche-friendly competitors. Fewer readers means lower ad rates—and it's only through advertising revenues that large magazines make money. The Internet certainly competes with—and usually beats—traditional magazines for timely content, but it's not leaching away *paying* customers, just the ones who read an entire *Time* in the bookstore, puts it back on the rack, and walks out without buying anything.

Regardless of the pessimists, people obviously *like* magazines (duh—there wouldn't be so many otherwise): the key to success is in regularly providing content in an entertaining and

informative fashion that is unavailable anywhere else. See? It's that simple. Problem solved. Could someone send me my consultant's check, please?

I don't know what the hell I'd do with it, but I want this Man-Melter raygun that Sideshow sneak-peeked at Comic-Con International.

Realms of Fantasy was still the genre fiction magazine with the most visual punch in the field last year; though the covers tended to be reprints from illustrators' folios or were media-related, the interior art by the likes of Tom Kidd, Tiffany Prothero, and Andrea Wicklund really stood out. *Isaac Asimov's SF*, once the flagship of the digests, seemed to be sputtering as their circulation continued to drop: their few original covers paled in comparison to some excellent reprints of paintings by Donato Giancola, Michael Whelan, and Kinuko Craft. Bob Eggleton provided some nice covers for *Analog*, *Interzone* featured excellent pieces by Jim Burns and Dan dos Santos, and *The Magazine of F&SF's* included some fine work by Maurizio Manzieri and Cory and Catska Ench. *Rue Morgue*, *Dark Realms*, *Weird Tales*, *Fantasy*, and *Cemetery Dance* sported some decent works mixed in with much that wasn't.

With the exception of *Realms of Fantasy* (which is ably helmed by Carl Gnam and Laura Cleveland), virtually all of the genre fiction magazines desperately need—besides art budgets—professional art directors, people with design and communication skills. Frankly, too many of the magazines look old, tired, and amateurish: its embarrassing that a field that celebrates the imagination is often represented by typography, layouts, and art that looks more like 1967 than 2007.

Strictly 21st Century was *ImagineFX: Fantasy & Sci-Fi Digital Art* with its interviews, profiles, reviews, and tutorials, all aimed at making computer artists better...artists (www.imaginefx.com). I learned about the careers of many painters—the famous *and* the forgotten—with Dan Zimmer's excellent *Illustration* (www.illustration-magazine.com), kept on top of the ultra-hip "outsider" scene by reading *Juxtapoz*, and was provided invaluable insight into emerging trends, hot artist studios,

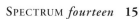

The 18th issue of Richard Klemensen's Hammer Films fanzine, Little Shoppe of Horrors *sported this nifty Bruce Timm cover.* littleshoppeofhorrors.com

continued on page 18

STANLEY MELTZOFF
1917-2006

Twelve (or somewhere around there) is supposed to be the magical age when someone discovers fantasy or science fiction and becomes a reader for life; I suppose the same basic rule applies to aficionados of fantastic art as well. Frazetta and Bama certainly hooked my friends and me at twelve, appealing to both our youthful inquisitiveness and our testosterone-fueled urges, but their work also nurtured an appreciation for a classicist's approach to genre subject-matter. Frank and Jim didn't talk down to us, didn't treat Conan or Doc Savage as "kid's stuff," didn't embarrass us, but instead *validated* our interests and encouraged our enthusiasm.

But if Frazetta and Bama had me excited and feeling grown-up at twelve, at thirteen Stanley Meltzoff effectively introduced me to a level of artistic sophistication that was both startling and revelatory and which has remained with me in all the decades since. His painting of a sea battle between the Romans and Carthaginians for *National Geographic*'s 1968 book, *Greece and Rome: Builders of Our World*, was as powerful as a sock on the the jaw, an epic work of both scope and immediacy. But the knock-out punch was his cover for the Signet paperback edition of Robert Heinlein's *The Puppet Masters*. Dark, oppressive, and horrific, exhibiting all of the craft and slyly manipulative emotion of the Dutch painters,

Vincent Di Fate describes Meltzoff's oil as a masterpiece and I heartily agree.

Stanley received his Bachelors Degree from Townsend Harris/City College of New York, and his MFA from the New York University Institute of Fine Art. He was a veteran of World War II: he saw action in North Africa, stormed the beach at Anzio, and participated in the liberation of Rome. Meltzoff acted as art editor for the military's newspaper, *Stars & Stripes*, working closely with legendary cartoonist Bill Mauldin. He bounced around Italy in a jeep, a .45 on his hip and a pencil stub behind his ear, sketching the war from the front and exploring and absorbing the country's art and culture during lulls in the fighting. In a villa outside Florence, while a Canadian platoon exchanged mortar fire with the Germans, Stanley discovered a pile of paintings. "A rooster was perched on a stack of panels in front of which was the 'Primavera' of Botticelli," he recalled in an article for *Illustration* magazine. "Flora, life-size, was scattering her flowers. As in my dreams I stepped up and kissed my ideal of beauty full on the lips without response."

Following the war he created illustrations for *Argosy*, *Life*, *The Saturday Evening Post*, and the *National Geographic* among many others. Just like his close friend James Avati, he painted covers for the "new" concept in book publishing, the paperback; though his output was far from prodigious in comparison to his contemporaries, his paintings were all virtually unforgettable. Meltzoff only produced something like seventeen SF covers

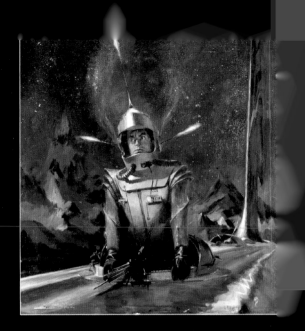

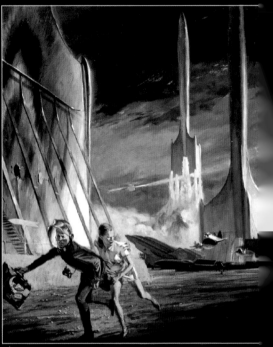

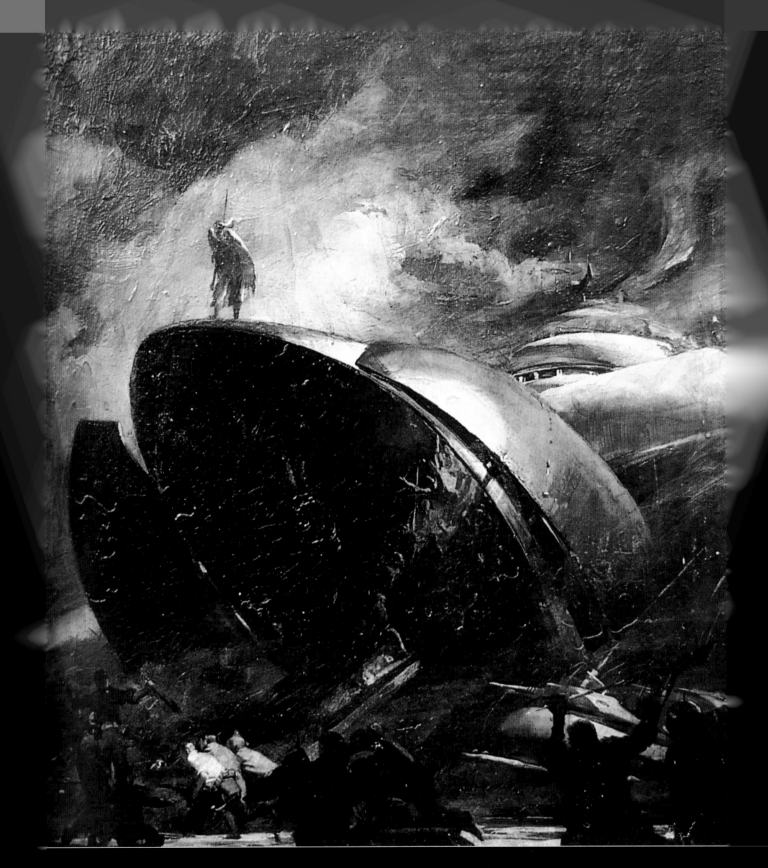

in his career (give or take a reprint or two) before moving on to advertising, teaching at Pratt, and painting marine life for *Sports Illustrated* and gal-, but their resonance, their *importance*, ndeniable and evidenced by the rever- both readers and his fellow artists have canley and his science fiction art.
He was funny. He was talented. He was anding, contradictory, sarcastic, and,

every so often, a cantankerous pain in the ass. He was also *tenacious*: in 2005, after years of arm-twisting, Stan (with the help of Robert Weiner) was successful in getting a publisher to return his paintings that had been gathering dust in their warehouse for 40 years—and also had them give back nearly 60 pieces to Robert McGinnis while they were at it!

He was an inspiration to all who knew him, to all who took his painting classes, and to all who experienced his work. "Genius" is a term that is maybe too casually applied these days, but that's precisely what is on

vivid display when standing in front of o Stanley's oils. He is, perhaps, the fantasti world's equivalent to literature's Harper or Walter M. Miller: it's not the quantity the *quality* of his work that reverberates will continue to bring people back to ap ciate the art of a genuine master.

Opposite page, top to bottom: *Cover to* *Heinlein's* Tomorrow, the Stars; *cover to Isaac As* Currents of Space; *and "Roman Plank" for* Nat Geographic. This page, top to bottom: *Co* *Heinlein's* The Puppet Masters; *Stanley Meltzoff*

continued from page 15

and new technology by picking up issues of *Communication Arts, How,* and *Print.*

Sci Fi (the magazine of the cable channel) hooked me as a subscriber in '06: as a general interest magazine for the field they did an outstanding job covering new films, television, books, and games (and, yes, looked good doing it). *Playboy* may be fifty+ years old, but it was still the impeccably designed leader on the newsstand and boasted some of the best editorial art created last year. James Gurney was given the cover feature on the November issue of *American Artist,* and fantasy illustration continued to find a frequent home at *Newsweek, Time, Vanity Fair, Cricket, Spin, Rolling Stone, Spirituality & Health, Entertainment Weekly, Scientific American,* and *Discover.*

But what, oh what in the magazine world could have ticked me off in 2006? Considering my tone in this year's essay, I'm sure Karen Haber (the biased and unqualified art book reviewer for the excellent *Locus*) has steeled herself for a much-deserved ass-whuppin', but she was only a minor irritant. I still recommend that *everyone* subscribe to *Locus* to stay informed (just skip Karen's column): visit www.locusmag.com for details. Anyway, truth be told, nothing really steamed me last year in the magazine world—but I *was* saddened by one development. The venerable *National Geographic* made the decision to shift away from using illustration in it's pages, replacing their lush paintings of historical events and pre-

![Photograph of a woman seen from behind with an elaborate tattoo covering her back]

Marianne Martin earned Brom's "My Favorite Fan Award" for 2006 by having his "Peace" painting tattooed on her back. Devin Ferguson of Liquid Courage in Omaha, NE, was the artist. Photo by Stephen Dahl, Kearney, NE.

historic life with photos of artifacts, maps, and graphs. Their seasoned art department disappeared virtually over night. Just as many of NASA's scientists and astronauts got interested in space exploration by reading science fiction (it's true, kids), many of today's top artists were inspired by the paintings—created by everyone from Charles R. Knight, Tom Lovell, and N.C. Wyeth to Bob McGinnis, Jim Gurney, and Greg Manchess—that filled the *Geographic* for decades. That legacy was reinforced by a stunning retrospective show of art from the magazine at the Rockwell Museum in 2005. To suddenly decide that traditional illustration no longer was a vital or needed part of the magazine not only was depressing, but (as I think they'll discover) also a serious miscalculation of what their readers appreciate, value, and ultimately want. An era has ended.

INSTITUTIONAL

It's getting to be that talking about works that fall into the Institutional category (even with Concept Art breaking out on its own) is almost as tough as discussing "advertising," not because it's anonymous, but because there is *so much* to keep track of. I know, regardless of effort, I do a crappy job. Cards, posters, games, mailers, and any number of other artworks fall into the Institutional arena, so I'll use the shotgun approach and try to hit as much as I can without aiming too carefully (like the V.P.) as I wrap up.

There were a *lot* of great exhibitions and gallery shows last year. Eric Joyner had at least two, one at The Modern Gallery in Palm Springs and again at The Shooting Gallery in San Francisco. Rick Berry appeared at Gallery 263 in Cambridge, MA, and with Darrel Anderson, at Art Neuro in Pueblo, CO. Jeff Soto was at the Blk/Mrkt Gallery in Culver City, Cristina Vergano was featured at the Woodward Gallery in New York, and the Berman/Turner Projects in Santa Monica sponsored the "Friendly Fire" group show that highlighted the art of Ray Caesar, Al Fosik, Dan Kennedy, and Jonathan Weiner. Art Out Loud demos were held at the Society of Illustrators and the MicroVisions project auctioned mini-paintings by Jon Foster, Adam Rex, and Julie Bell, among others as a benefit for the Society's Student Scholarship fund (www.societyillustrators.org). The great Geppi Entertainment Museum opened in Baltimore, but struggled to attract visitors. For info and directions visit www.geppismuseum.com.

Dark Horse continued to produce a wide variety of ephemera featuring fantasy art (stationery, journals, even poker chips) by the likes of Coop, Tara McPherson, Mike

Mignola, and others. There were quite a few nicely designed calendars released last year including keepers by Michael Parkes, John Jude Palencar, Luis Royo, and Alex Ross. The Post Office released a set of stamps featuring DC

If your paper isn't carrying the Lió *strip by Mark Tatulli, you might suggest they do. Its almost like a marriage between Sergio Aragones and Gary Larson.*

superheroes (Marvel will get theirs in '07). There were tons of posters, folios, and prints offered throughout the year: most artists were selling their own giclees via their websites and I suggest googling the names of your favorites to see what's available. If you collect original art you can visit a reputable gallery's or dealer's website such as Worlds of Wonder at www.wow-art.com, Heritage Galleries at www.heritagecomics.com, or Pat Wilshire's collectors' confab at the Illustration Exchange, www.munchkinpress.com.

REQUIEM

In 2006 we lost these talented creators:
Semih Balcioglo [b 1928] *comic artist*
Ed Benedict [b 1912] *animation artist*
Bob Carlos Clarke [b 1950] *photographer*
Dave Cockrum [b 1943] *comic artist*
Eldon Dedini [b 1921] *cartoonist*
Jacques Faizant [b 1918] *cartoonist*
Sergio Fedriani [b 1949] *cartoonist*
Seth Fisher [b 1972] *comic artist*
Ed Franklin [b 1921] *cartoonist*
Tim Hildebrandt [b 1939] *illustrator*
Rin Inumaru [b 1923] *cartoonist*
Jack Jackson [b 1941] *comic artist*
Yoshiro Kato [b 1925] *cartoonist*
Jack Kirkbride [b 1923] *cartoonist*
Bob Laughlin [b 1925] *comic artist*
Gugliemo Letteri [b 1926] *comic artist*
Norm McCabe [b 1911] *animation artist*
John McLusky [b 1923] *comic artist*
Stanley Meltzoff [b 1917] *illustrator*
Bob McCausland [b 1916] *cartoonist*
Martin Nodell [b 1915] *comic artist*
Donald Reilly [b 1933] *cartoonist*
Paul Rigby [b 1924] *cartoonist*
Jean Roba [b 1930] *cartoonist*
Dick Rockwell [b 1920] *comic artist*
R.K. Sloane [b 1952] *artist*
Friedel Stern [b 1917] *cartoonist*
Rene Sterne [b 1952] *comic artist*
John Styrk Jr. [b 1974] *comic artist*
Fernando Tacconi [b 1922] *comic artist*
Hilda Terry [b 1914] *cartoonist*
Romeo Tan Togonon [b 1951] *cartoonist*
Alex Toth [b 1928] *comic artist*
Michelle Urry [b 1939] *Playboy* cartoon editor †

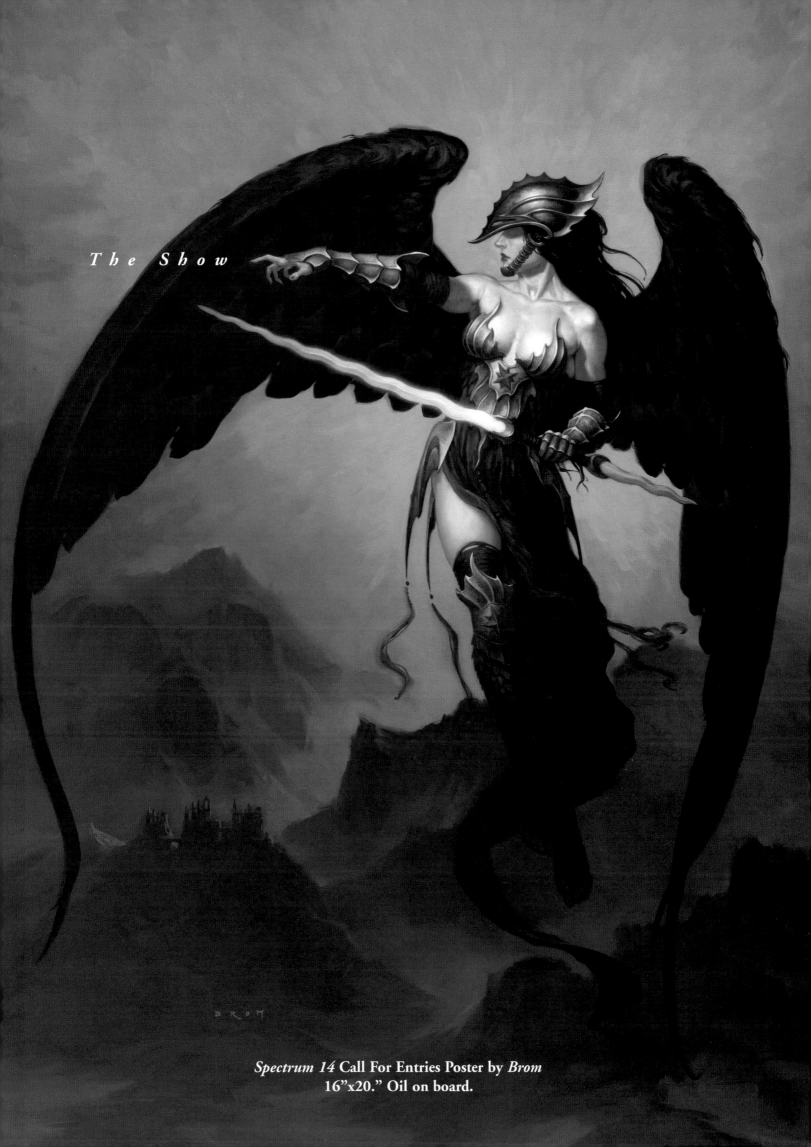

The Show

Spectrum 14 Call For Entries Poster by *Brom*
16"x20." Oil on board.

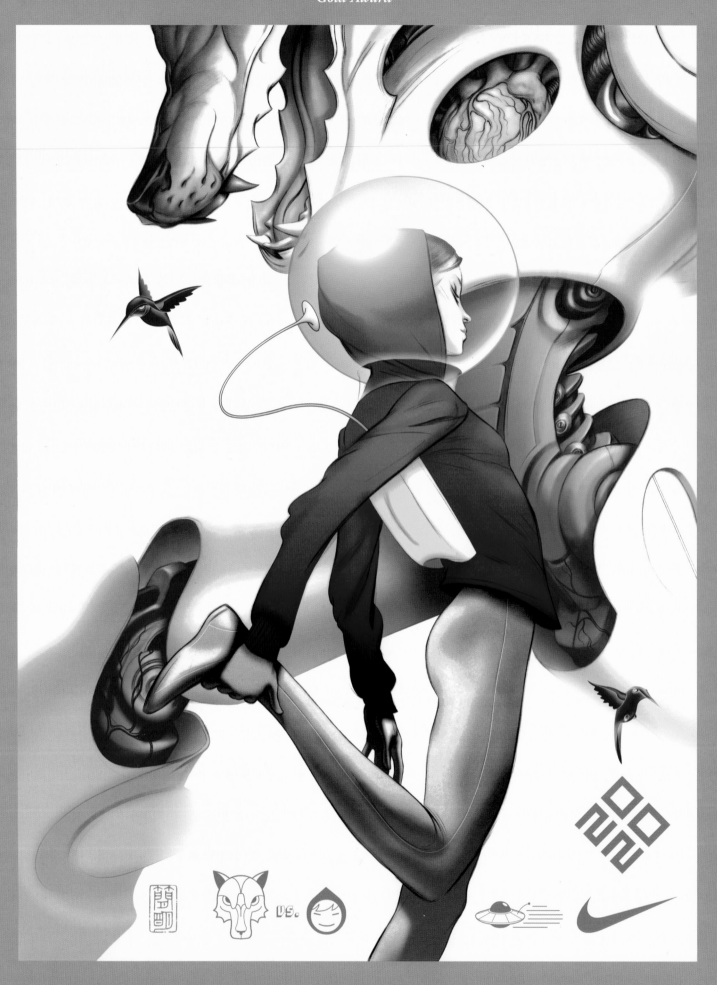

artist: **James Jean**

art director: Mark Thede *client:* Nike *title:* Spacerace 2020 *size:* 18"x24" *medium:* Digital

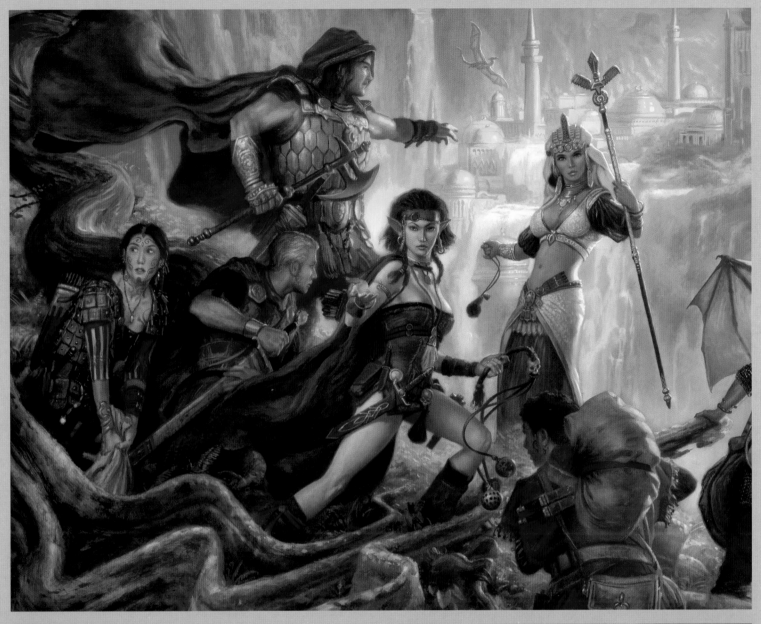

artist: **Donato Giancola**

art director: David Gilbertson *client:* Sigil Games Online *title:* Vanguard: Saga of Heroes *medium:* Oil on paper on panel *size:* 60"x25"

1
artist: **Wayne Lo*** [final]
art director: Wayne Lo
client: Factor 5/Sony Marketing
title: Lair [POP art]
medium: Digital
3D artists: Alessandro Briglin, Andrea Blasich, Kursad
Karatas, Anthony Reveno, Danny Lei. *2D/Texture artists:*
Cory Strader, Magnus Hollance, Anthony Ermio, Pat
Presley.

2
artist: **Mark Evans**
art director: Brian Mitchell
client: Lone Wolf Development
title: Experiment
medium: Digital
size: 6"x13 1/2"

3
artist: **Jeffery Scott (1019)**
client: Baby Tattoo Books
title: Machinery, Freedom,
 and Visual Literature
medium: Photography/digital
model: Cristina Maxwell
size: 19"x25"

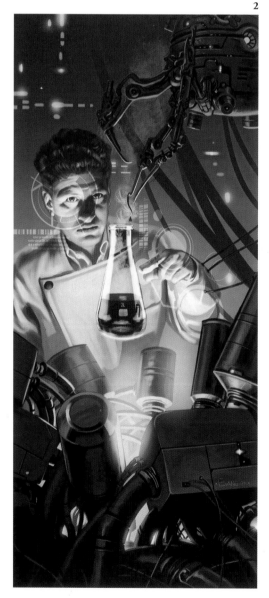

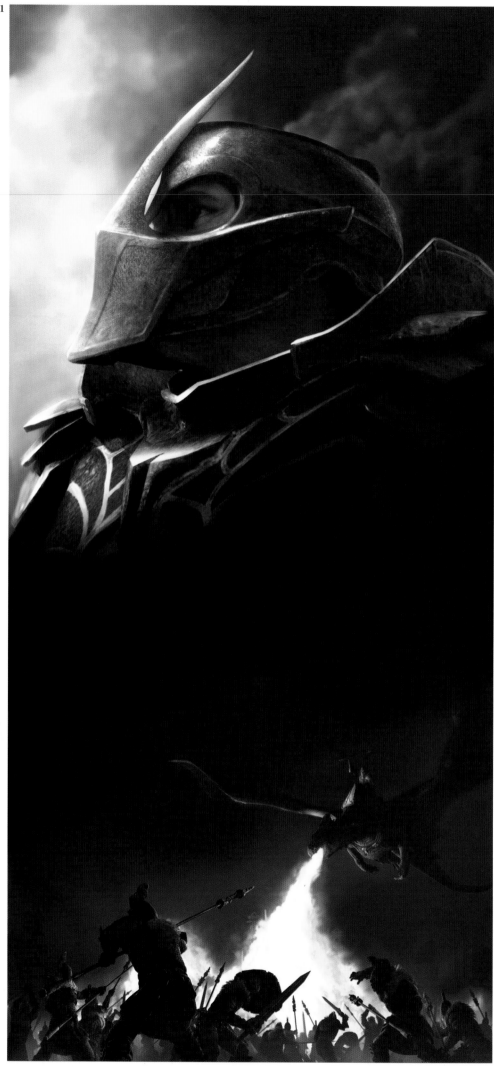

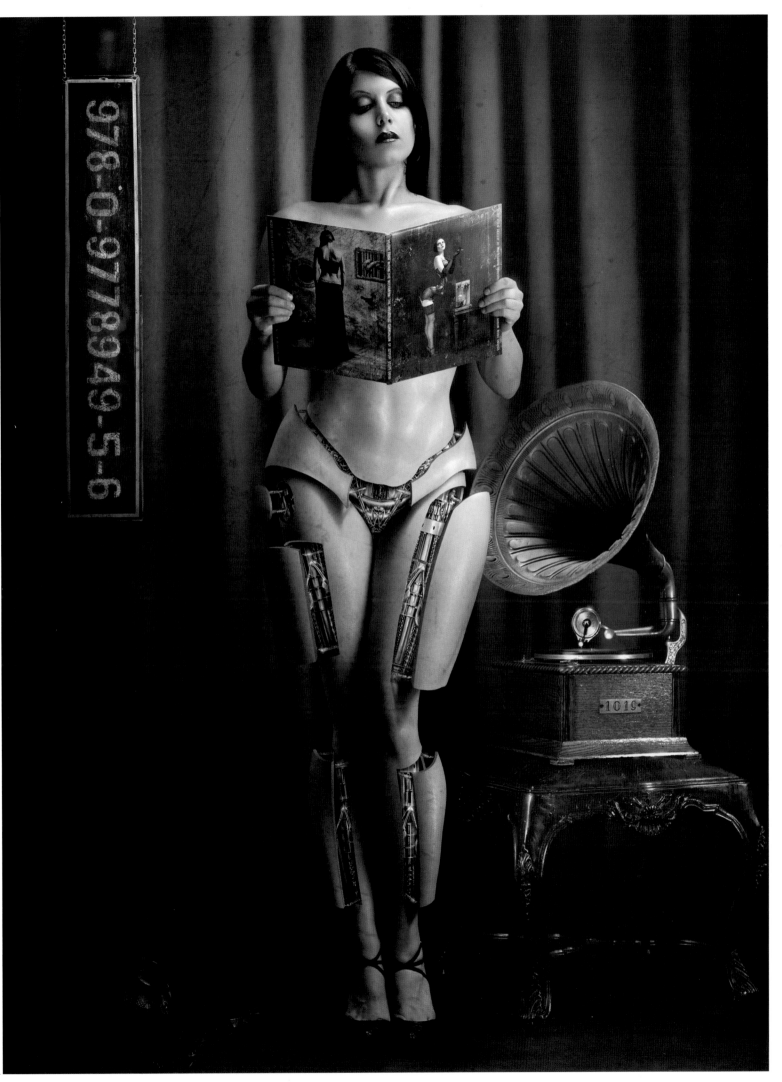

1
artist: **Christopher Moeller**
art director: Melissa Rapier
client: Wizards of the Coast
title: From the Pit
medium: Acrylic
size: 16"x18"

2
artist: **Victor Togliani**
art director: Victor Togliani
client: Baby Records
title: Medusa Spite
medium: Acrylic
size: 50cm x 50cm

3
artist: **Jonathan Wayshak**
client: Morrow Snowboards
title: Nailed
medium: Mixed

4
artist: **Ted Pendergraft**
art director: Jon Rainbow
client: COS Theatre Arts Dept.
title: Macbeth: The Opera
medium: Digital
size: $6^{1}/2$"x$18^{1}/4$"

5
artist: **Henry Fong**
art director: Ian D'sa & Henry Fong
designer: Henry Fong
client: Atlantic Records
title: Worker Bees
medium: Digital
size: $10^{1}/4$"x$5^{1}/2$"

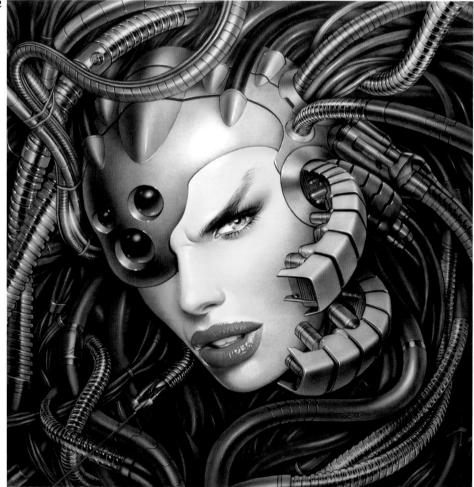

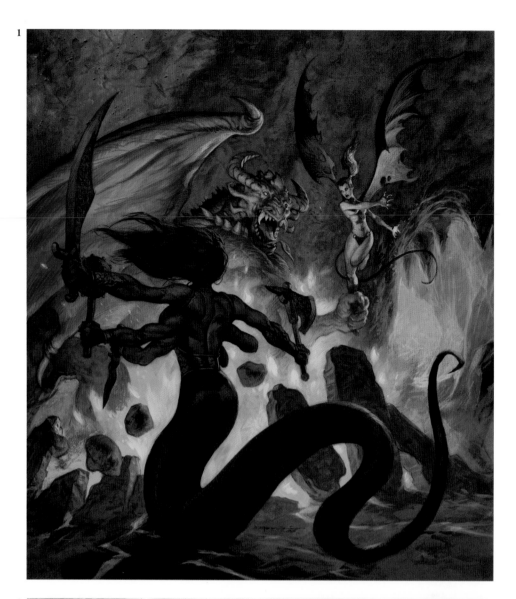

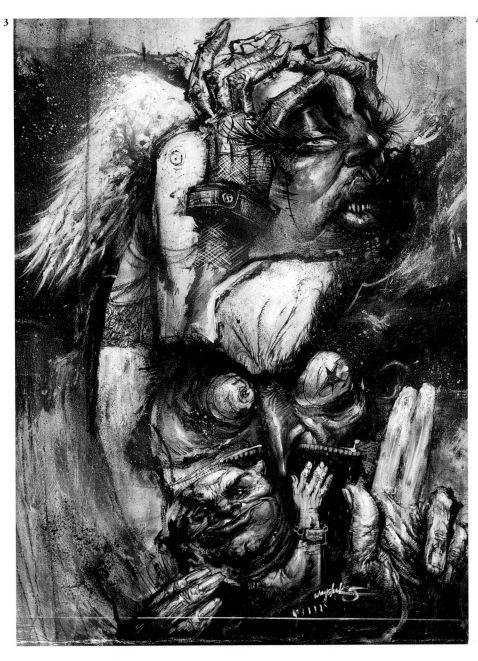

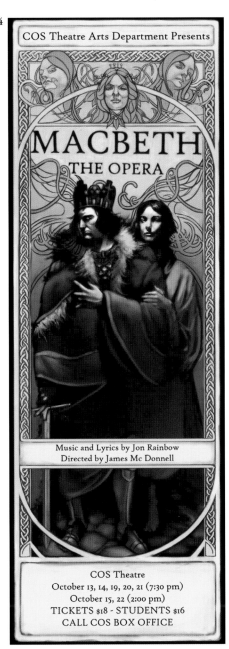

COS Theatre Arts Department Presents

MACBETH
THE OPERA

Music and Lyrics by Jon Rainbow
Directed by James Mc Donnell

COS Theatre
October 13, 14, 19, 20, 21 (7:30 pm)
October 15, 22 (2:00 pm)
TICKETS $18 - STUDENTS $16
CALL COS BOX OFFICE

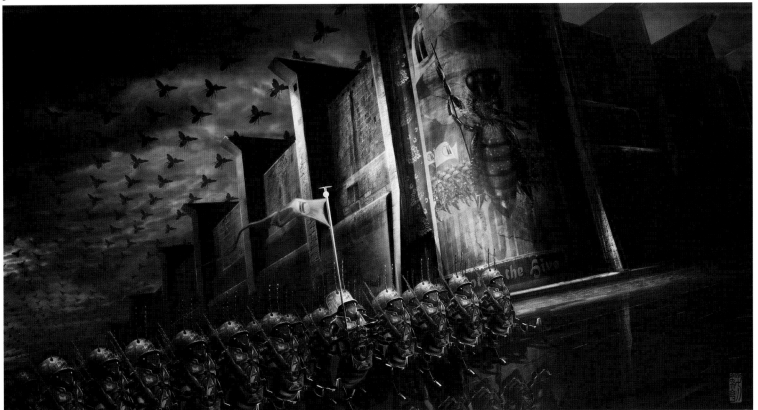

1
artist: **Robert Carter**
art director: Jeff Carter
client: Puncture Vine
title: Ignite
medium: Oil on masonite
size: 20"x20"

2
artist: **David Hartman**
art director: David Hartman
client: Rob Zombie
title: American Witch
medium: Mixed/digital
size: 8"x12"

3
artist: **Miss Mindy**
client: Baby Tattoo Books
title: Buy Our Books
medium: Mixed
size: 12"x9¹/2"x2"

4
artist: **Kirk Reinert**
art director: Kirk Reinert
client: The Five Points Band
title: Ida the Spider and the
 American Dream
medium: Acrylic
size: 25"x23"

1

2

3

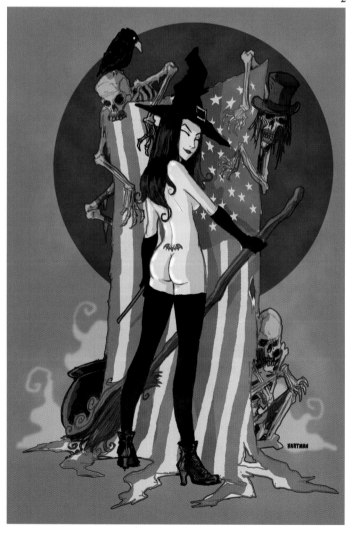

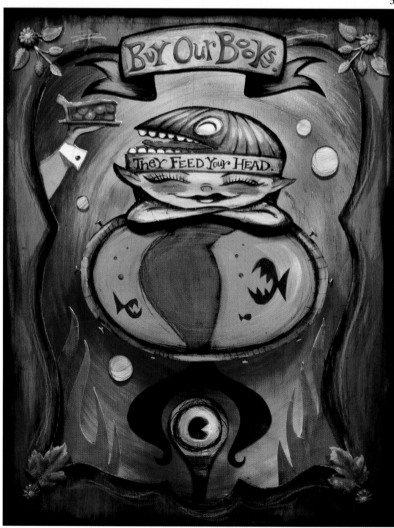

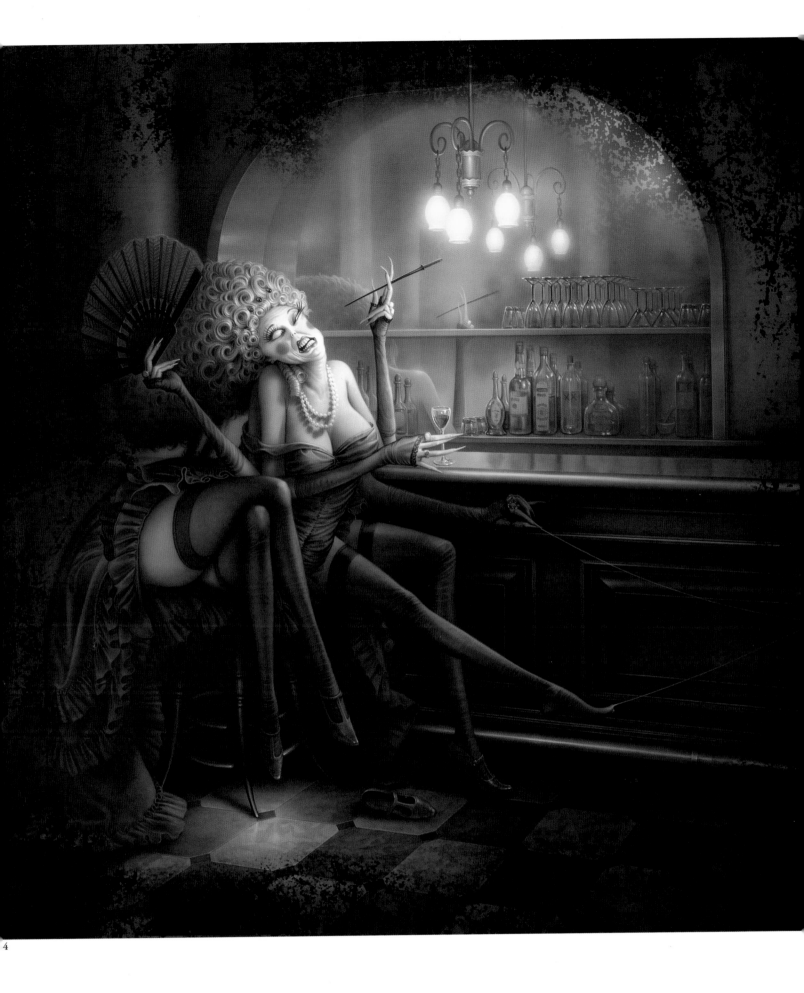

1
artist: **Keith Thompson**
client: Thac0 Records
title: Pestilential
medium: Mixed
size: 20"x18"

2
artist: **Hoang Nguyen**
client: Liquidbrush Productions
title: Little Red
medium: Digital/Photoshop
size: 13"x9"

3
artist: **Andrew Jones**
 aka "Android"
art director: Spirit
client: The Collective
 Unconsciousness
title: The Divine Mother
medium: Pure energy
size: 11$^{1}/_{2}$"x15"

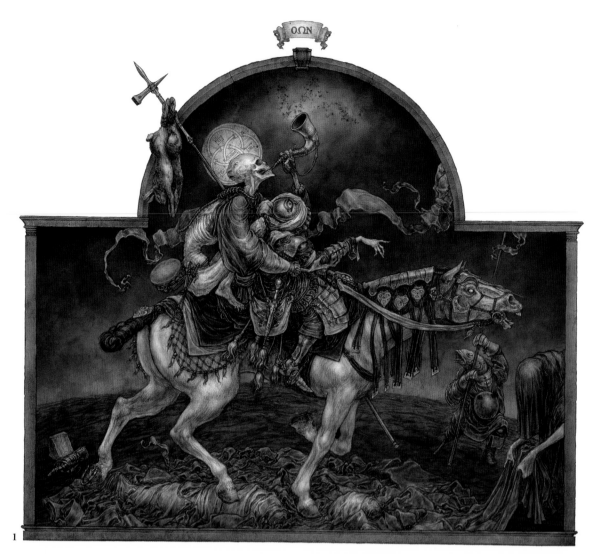

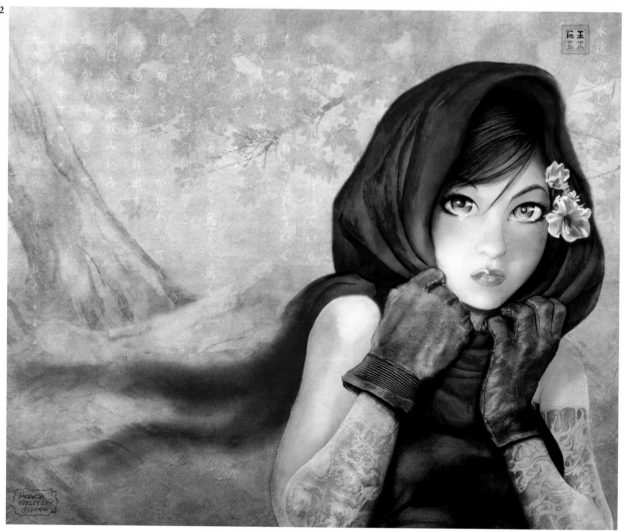

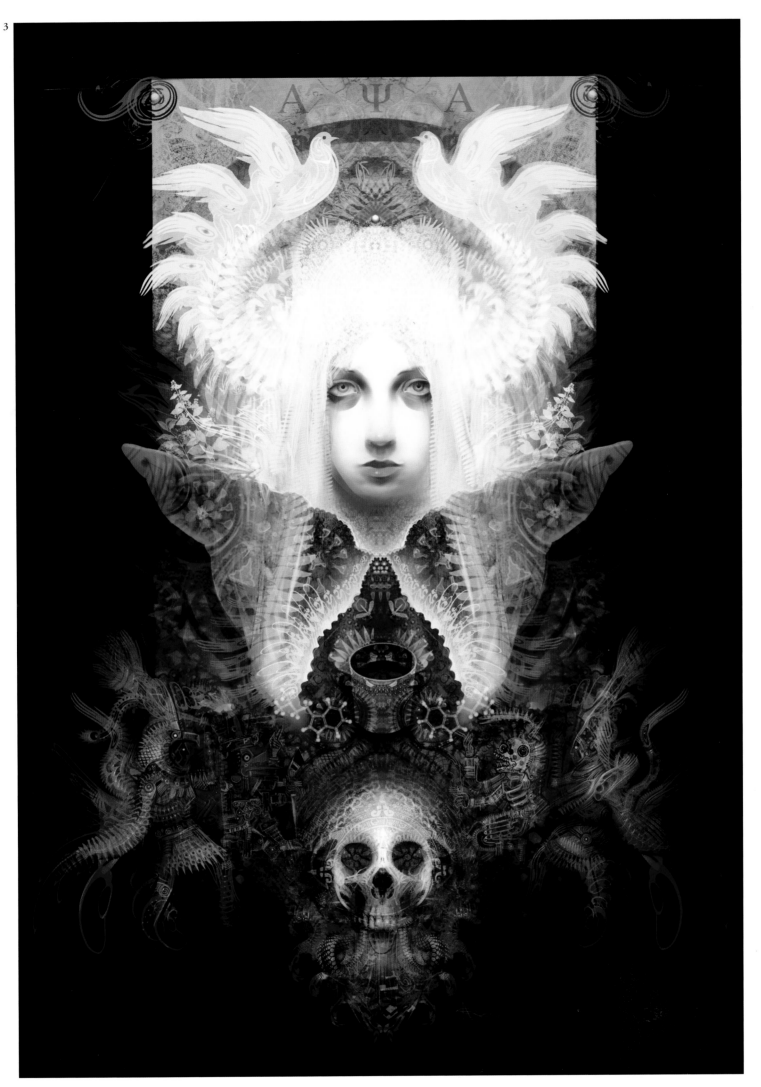

1
artist: **Vance Kovacs**
art director: Melissa Rapier
client: Wizards of the Coast
title: Blood War
medium: Digital

2
artist: **Jeff Slemons**
art director: Monique Favreau
client: Digispec
title: Fisherman Hairsylist
medium: Gouache
size: 19"x13^1/$_2$"

3
artist: **Robert Gonzales/Glen Schultz**
3D artist: Steve Argyle
art director: Origins Studios SLC
client: Sony Online Entertainment
title: Dark Kingdom 2
medium: Digital
size: 9"x10^1/$_2$"

4
artist: **Steve Prescott**
art director: Sean Glenn
client: Dragon Magazine
title: Tiamat
medium: Acrylic
size: 18"x25"

5
artist: **J.P. Targete**
art director: J.P. Targete
client: The Gnomon Workshop
title: Dark Riders
medium: Digital
size: 24"x8"

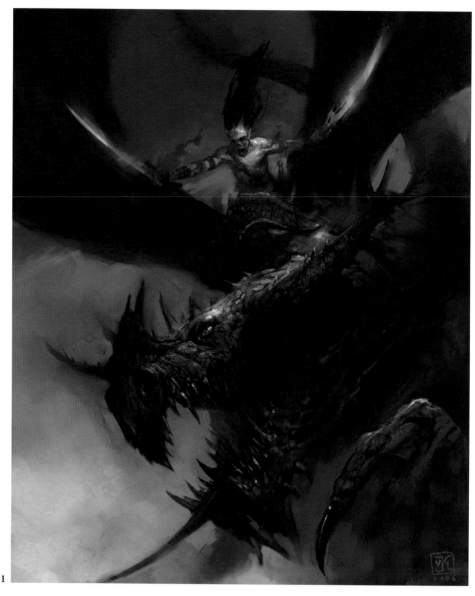

1

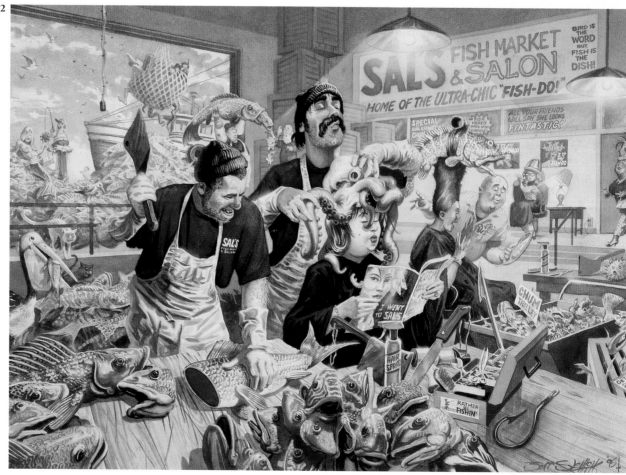

2

3

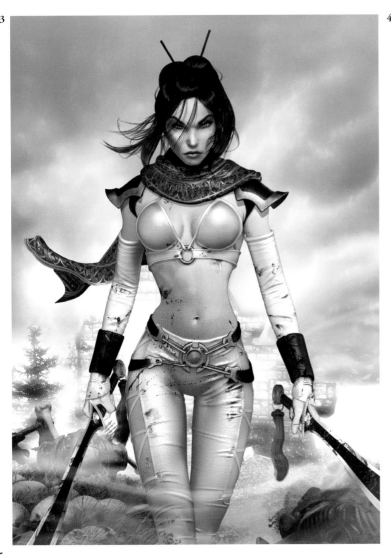

4

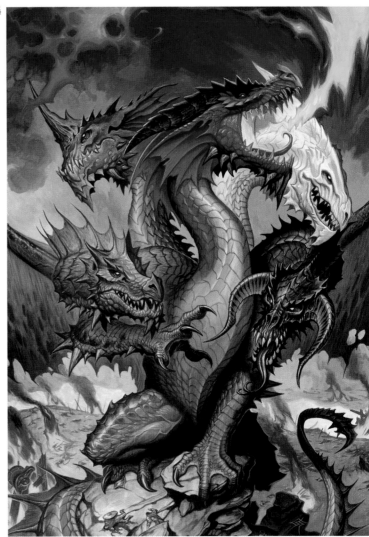

5

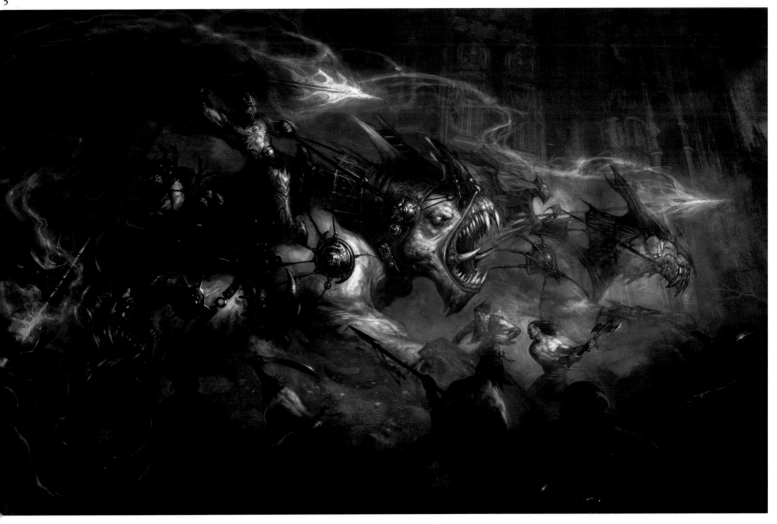

1
artist: **Dan Seagrave**
art director: Ryan Clark
client: Solid State Records
title: Demon Hunter's "Tryptych"
medium: Acrylic on board
size: 15"x15"

2
artist: **Adam Rex**
art director: Adam Rex
client: Harcourt Children's Books
title: Frankenwaiter
medium: Oil on paper
size: 17^1/2"x25"

3
artist: **Peter de Sève**
art director: Daniel Gray
client: Cougar Papers
title: Cougar
medium: Watercolor, pencil, ink
size: 11"x17"

4
artist: **Glen Orbik**
art director: Peter Bickford
designer: Glen Orbik & Laurel Blechman
client: Human Computing
title: Comicbase #11
medium: Oil
size: 17^1/2"x25"

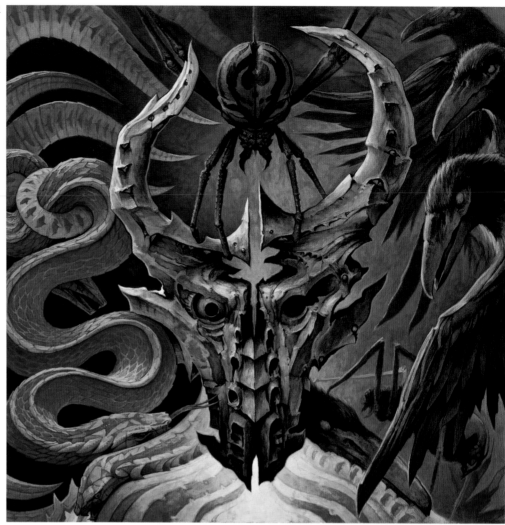

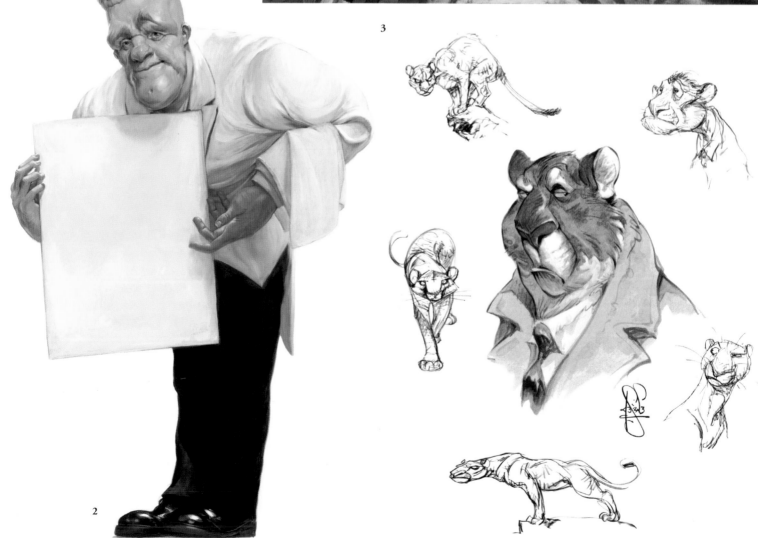

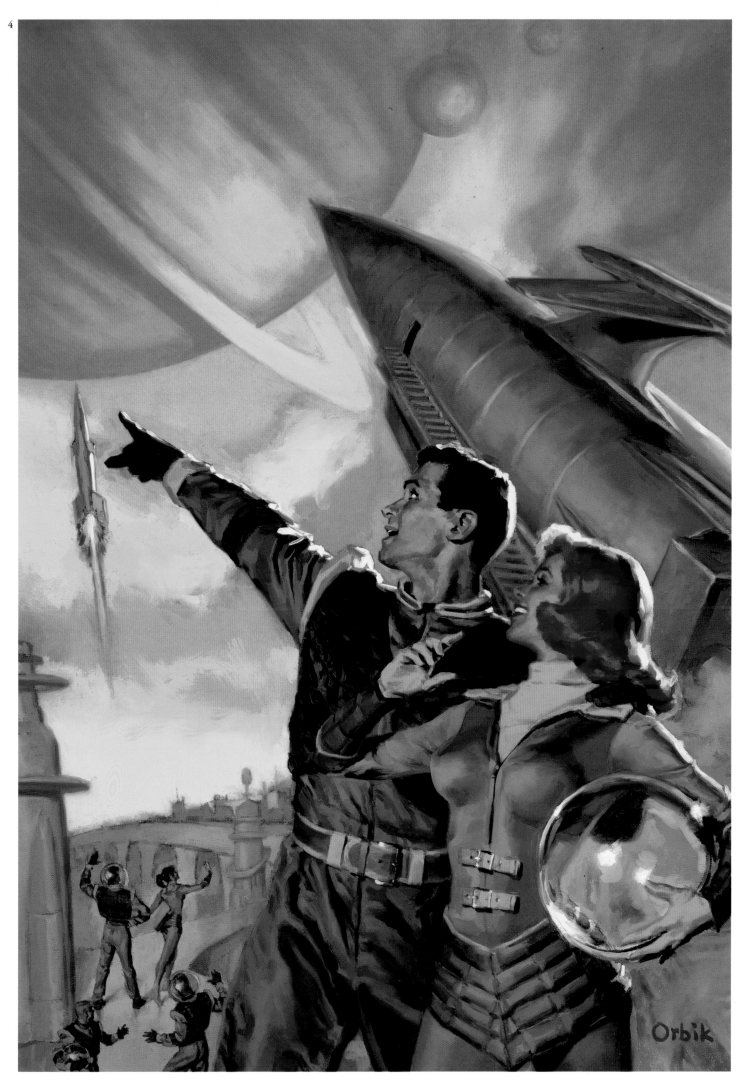

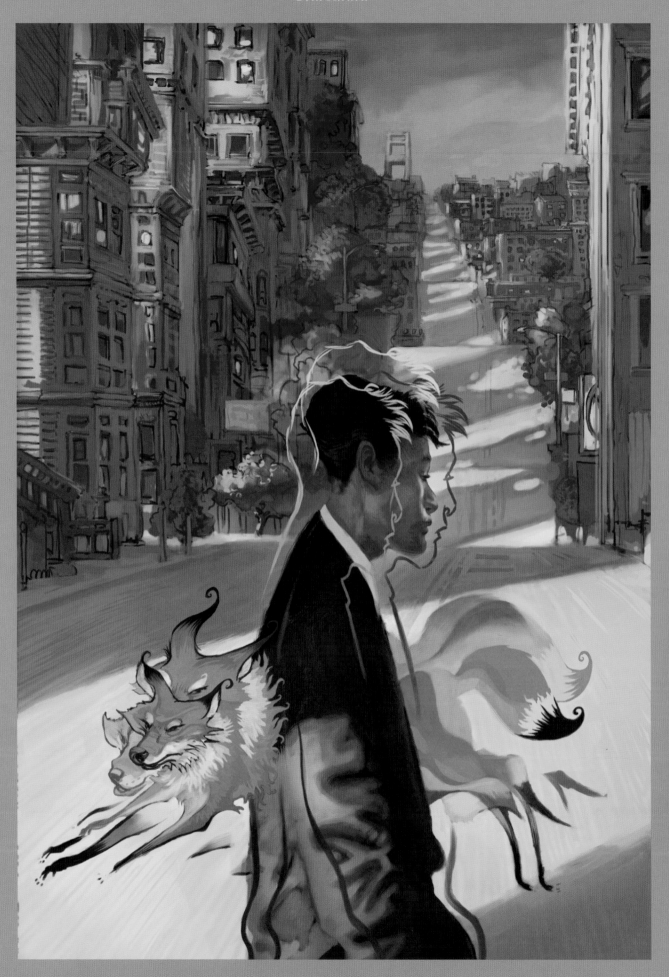

artist: **Jon Foster**

art director: Jeremy Lassen *client:* Night Shade Books *title:* Nine Tailed Fox *medium:* Digital

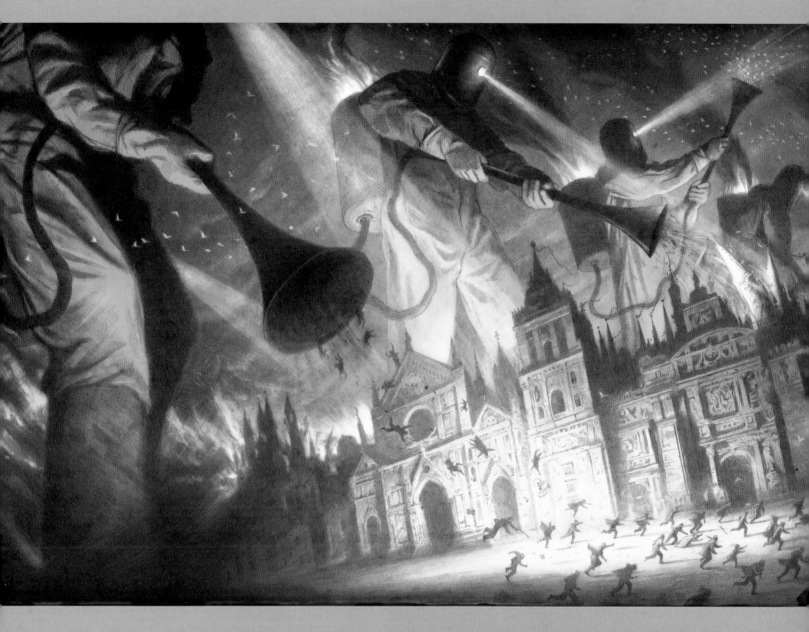

artist: Shaun Tan

art director: Shaun Tan *client:* Lothian Books, Melbourne *title:* The Arrival: The Giants
medium: Graphite pencil/digital color *size:* 23^1/2"x15^1/2"

1
artist: **Aleksi Briclot**
art director: Matt Adelsperger
client: Wizards of the Coast
title: Magic: Future Sight
medium: Digital
size: $12^1/2$"x$12^1/2$"

2
artist: **Rick Berry**
art director: Deborah Kaplan
designer: Lori Thorn
client: Penguin Group/Firebird
title: The Game
medium: Mixed/digital
size: 5"x7"

3
artist: **Rick Berry**
art director: Irene Gallo
client: Tor Books
title: Wolf Skin
medium: Oil on board
size: 36"x48"

4
artist: **Kinuko Y. Craft**
art director: Irene Gallo
client: Tor Books
title: Firebird
medium: Oil
size: 11"x17"

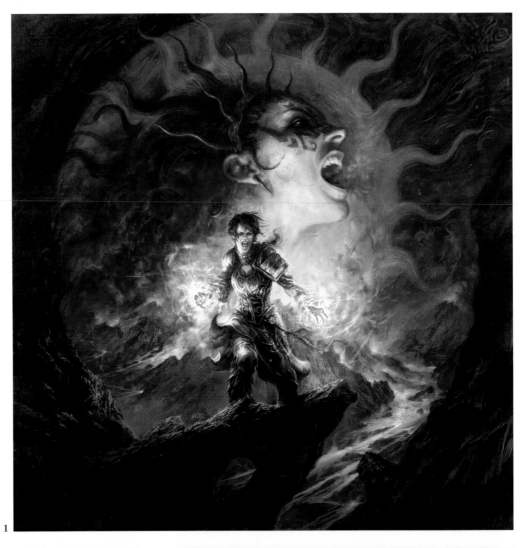

1

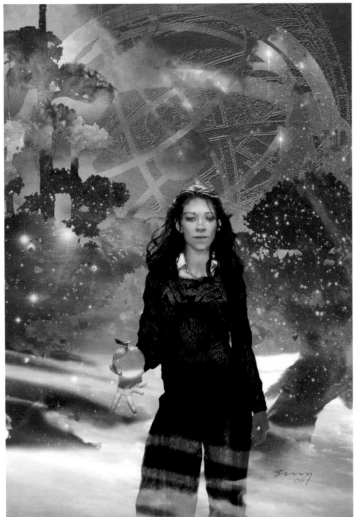

2

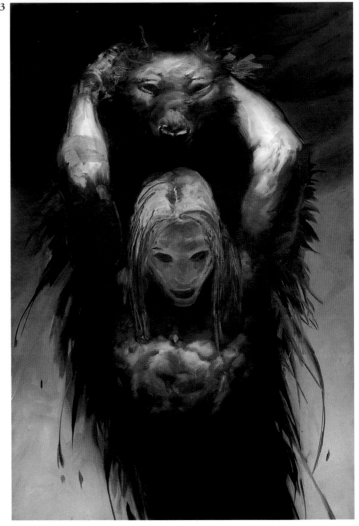

3

4

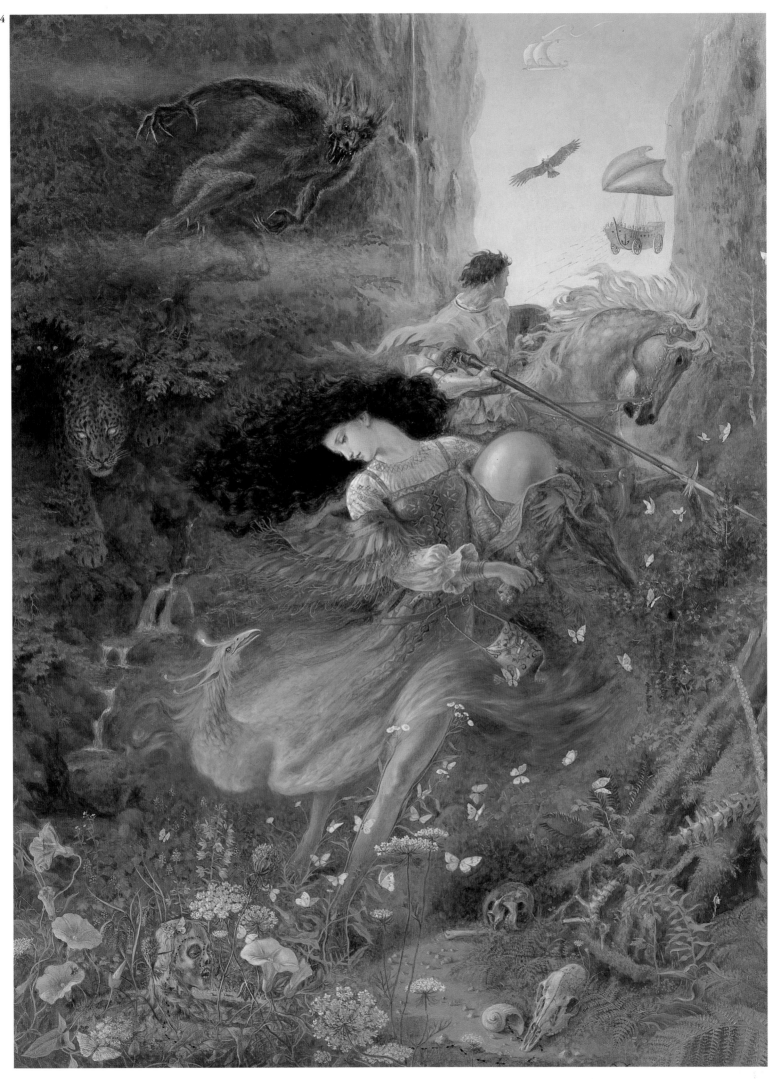

1
artist: **Dave McKean**
art director: Dave McKean
client: Allen Spiegel Fine Arts/Hourglass
title: Two of Staffs/Particle Tarot Minor
medium: Mixed
size: 8¹/₂"x8¹/₂"

2
artist: **Stephan Martiniere**
art director: Lou Anders
client: Pyr
title: Bright of Star
medium: Digital

3
artist: **Stephan Martiniere**
art director: Irene Gallo
client: Tor Books
title: Mainspring
medium: Digital

4
artist: **Stephan Martiniere**
art director: Irene Gallo
client: Tor Books
title: Variable Star
medium: Digital

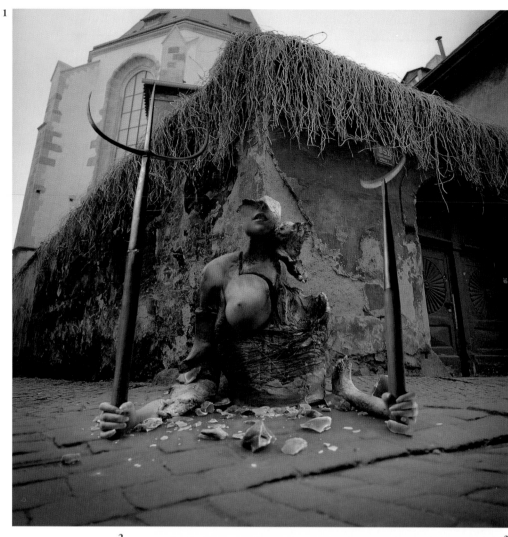

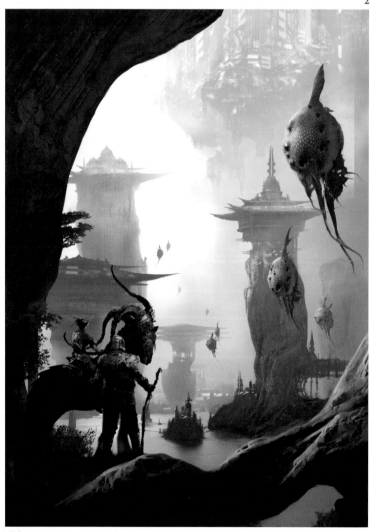

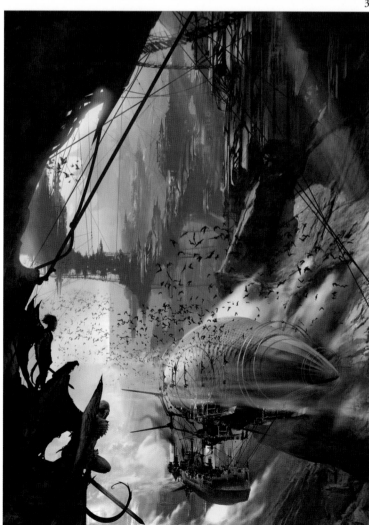

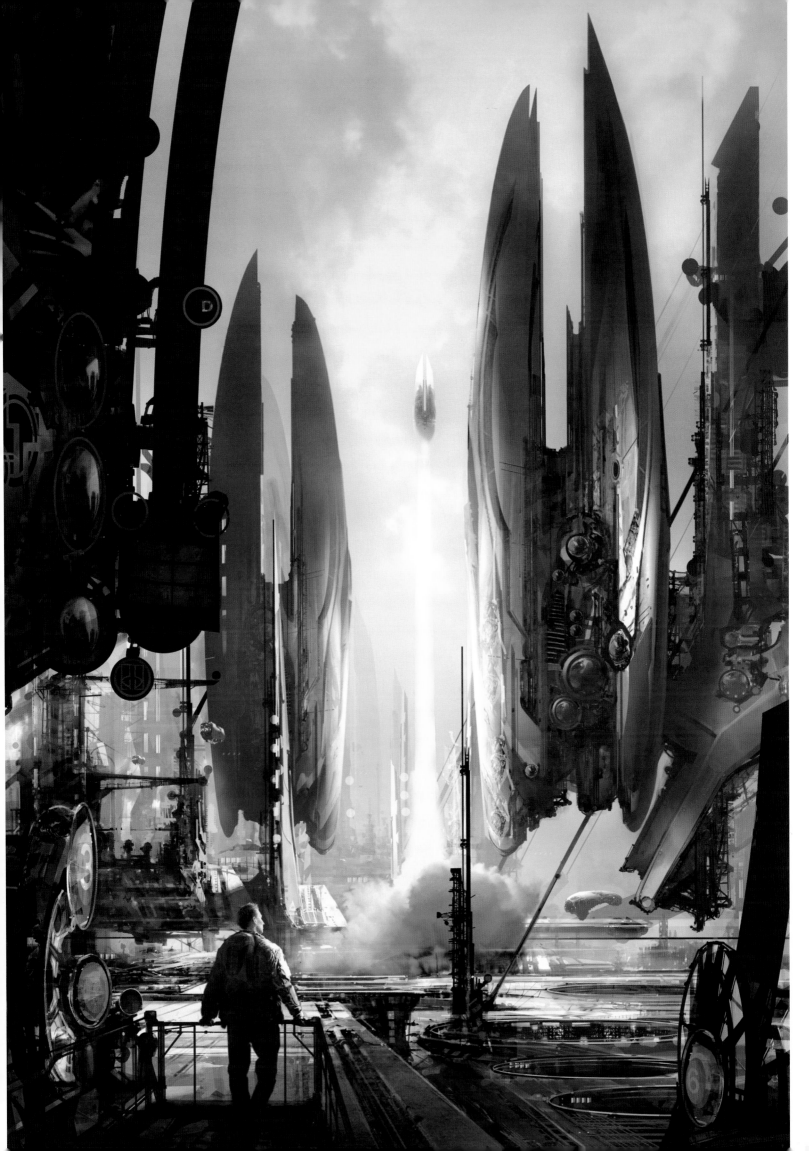

1
artist: **Steve Prescott**
art director: Mari Kolkowsky
client: Wizards of the Coast
title: Barrow of the
 Forgotten King
medium: Oil
size: 8¹/2"x11"

2
artist: **Raymond Swanland**
art director: Irene Gallo
client: Tor Books
title: Soarer's Choice
medium: Digital

3
artist: **J.P. Targete**
art director: Sue Cook
client: Malhavoc Press
title: Arcana Evolved
medium: Digital
size: 17"x8"

4
artist: **Tim Jessel**
art director: Matt Adelsperger
client: Wizards of the Coast
title: Dragon of Doom
medium: Digital

5
artist: **Ralph Horsley**
art director: Mari Kolkowsky
client: Wizards of the Coast
title: City of Shadows
medium: Acrylic
size: 11"x14"

1

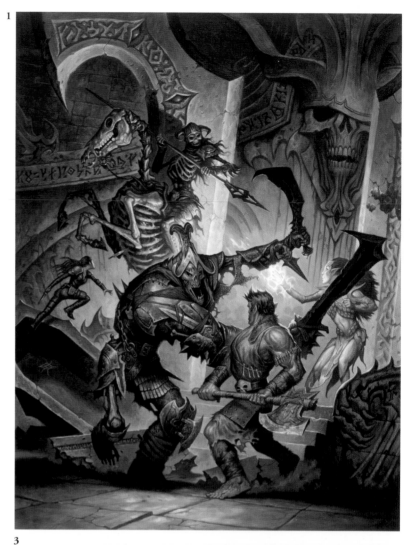

2

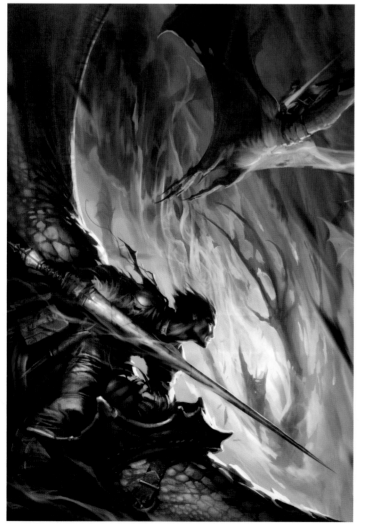

3

4

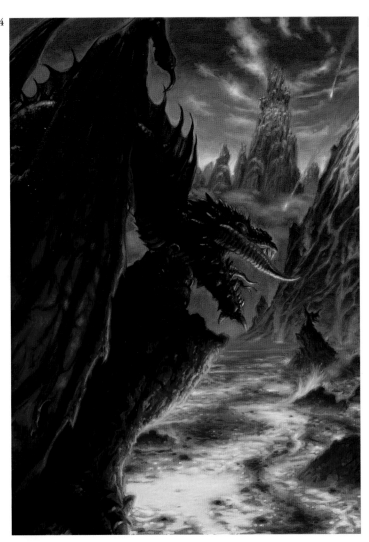

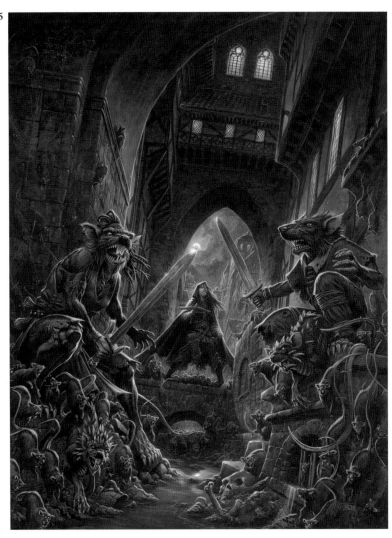

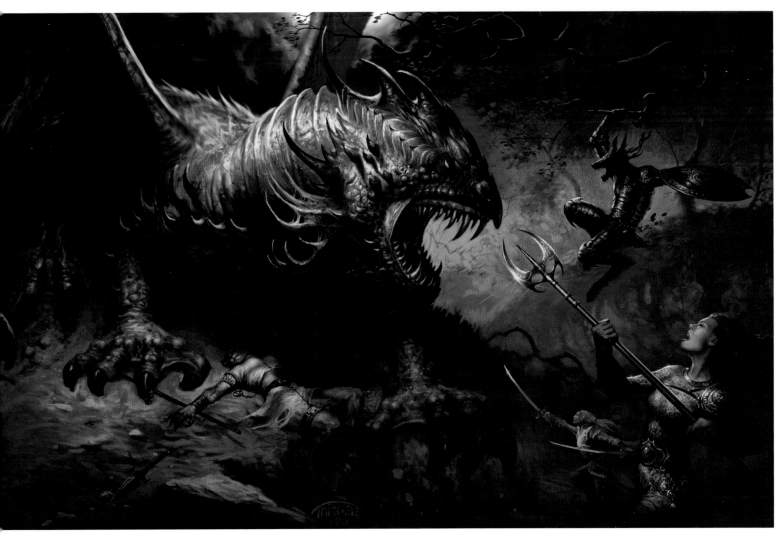

1
artist: **Jan Patrick Krasny**
client: Weltbild Verlag
title: Night Watch
medium: Digital

2
artist: **John Van Fleet**
art director: Dave Stevenson
client: Random House
title: Batman: Inferno
medium: Mixed
size: 8^1/2"x11"

3
artist: **Greg Ruth**
art director: Dawn Murin
client: Wizards of the Coast
title: Unclean
medium: Mixed
size: 8"x10"

4
artist: **Luis Royo**
client: Norma Editorial/NBM
title: Dark Labyrinth
medium: Acrylics
size: 9"x13"

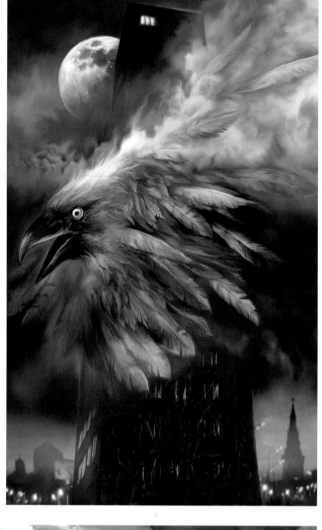

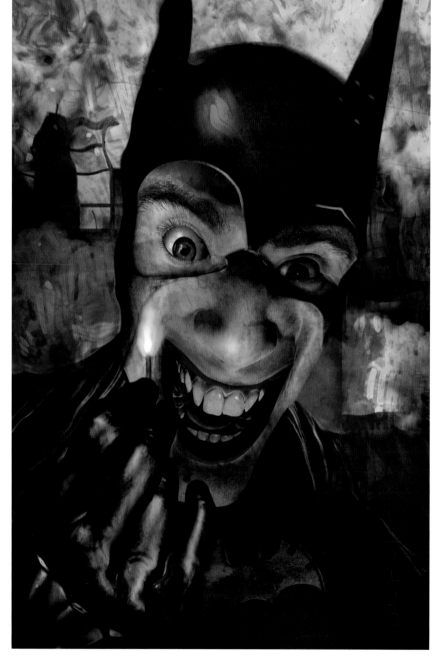

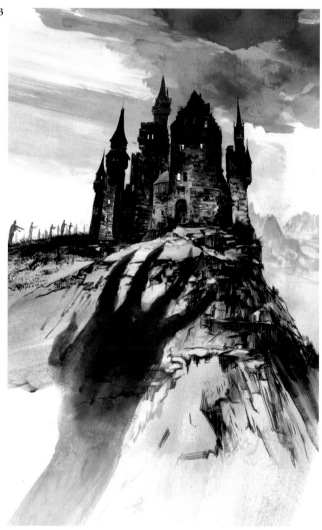

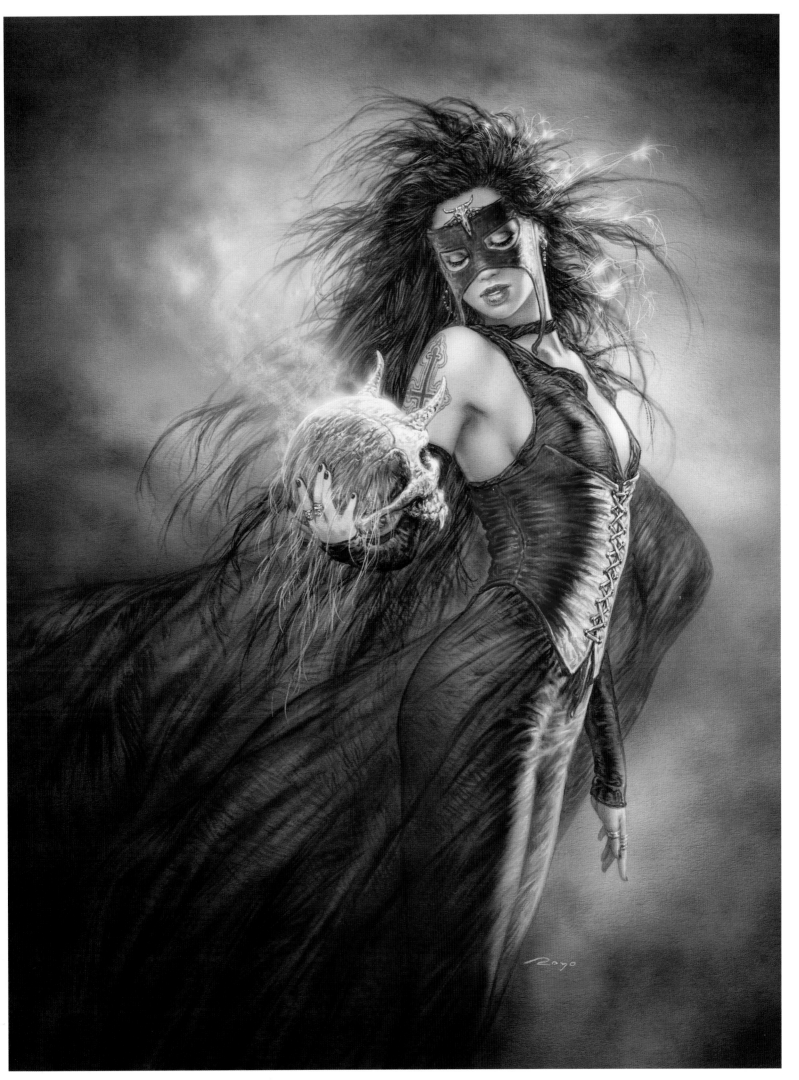

1
artist: **Jon Sullivan**
art director: Christian Dunn
client: Solaris Books
title: Solaris Fantasy Anthology
medium: Digital

2
artist: **Daarken**
art director: Karen Jaques
client: Wizards of the Coast
title: Urban Swarm
medium: Digital
size: 7³/4"x8"

3
artist: **Gregory Manchess**
art director: Marcelo Anciano
client: Wandering Star
title: Conqueroring Sword of Conan
medium: Oil
size: 30"x40"

4
artist: **Justin Sweet**
art director: Marcelo Anciano
client: Wandering Star
title: Kull
medium: Oil on canvas
size: 32"x48"

5
artist: **Cliff Nielsen**
art director: Maria Mercado
client: Little, Brown
title: Cirque du Freak 10
medium: Digital
size: 6"x9"

6
artist: **Jennifer Reagles**
client: Ballistic Publishing
title: Mera
medium: Digital
size: 24"x36"

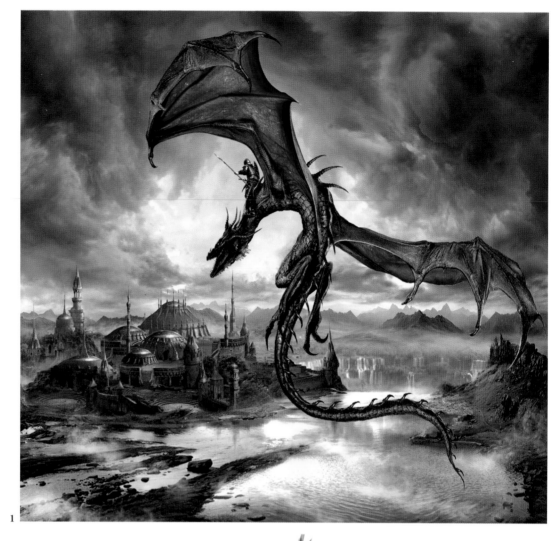

1

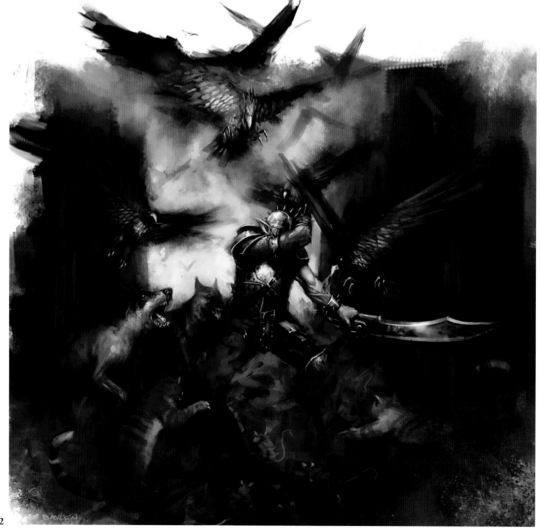

2

1
artist: **Peter Ferguson**
art director: Deborah Kaplan
designer: Jeanine Henderson
client: Penguin/Putnam
title: Samuel Bling and the
 Forbidden Forest
size: 5¹/2"x8¹/4 "

2
artist: **Peter Ferguson**
art director: Deborah Kaplan
designer: Jay Cooper
client: Penguin/
 Sleuth Philomel
title: The Case of the
 Missing Marquess
size: 5¹/16"x7³/4"

3
artist: **Scott M. Fischer**
art director: Deborah Kaplan
client: Penguin/Putnam
title: Little Grrl Lost
medium: Digital

4
artist: **Ciruelo**
client: DAC Editions
title: Fairies and Dragons
medium: Oil
size: 27"x20"

5
artist: **Greg Swearingen**
art director: Lisa Vega
client: Simon & Schuster
title: Aliens Ate My
 Homework
medium: Mixed
size: 6"x9"

6
artist: **Adam Rex**
client: Hyperion Books
 for Children
title: The True Meaning of
 Smekday
medium: Oil
size: 11"x16"

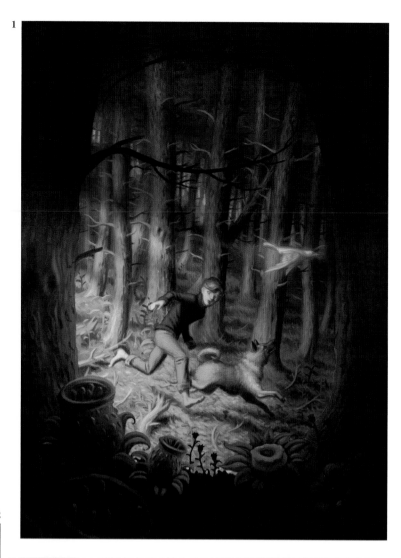

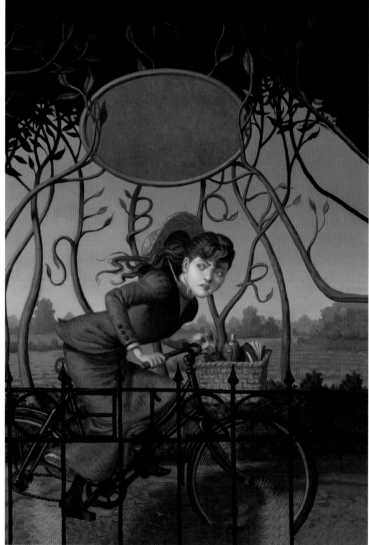

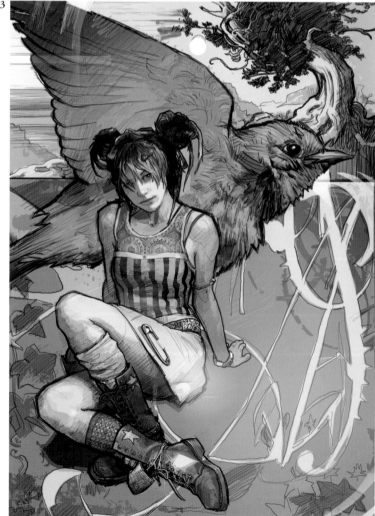

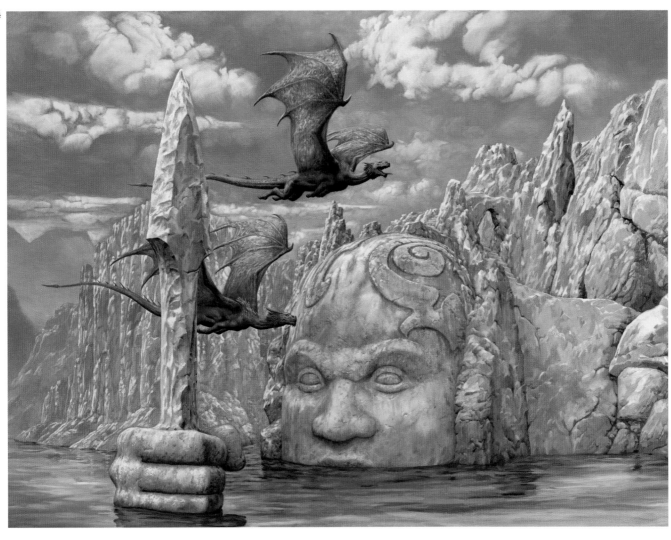

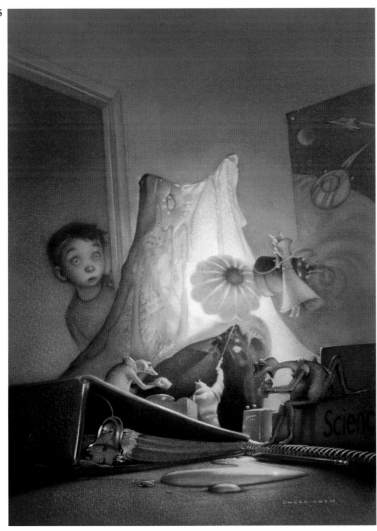

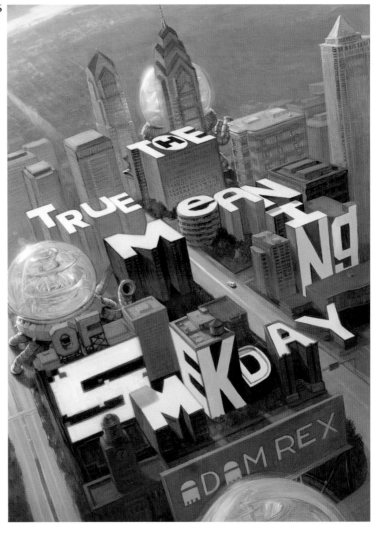

1
artist: **Michael Kaluta**
art director: Irene Gallo
client: Tor Books
title: Spirit Gate
medium: Watercolor

2
artist: **Mark A. Nelson**
art director: Bill Schafer
client: Subterranean Press
title: Rite
medium: Pencil/digital
size: 10"x13"

3
artist: **Greg Staples**
art director: Jeremy Cranford
client: Wizards of the Coast
title: The New Master
medium: Oil
size: 41cm x 56cm

4
artist: **Greg Staples**
art director: Rhyan Scorpio-Ryhs
client: Bulls Eye
title: Lady Death
medium: Digital

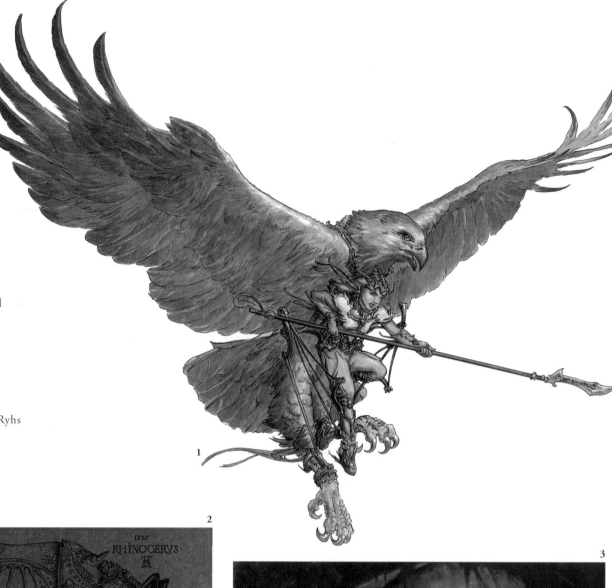

1

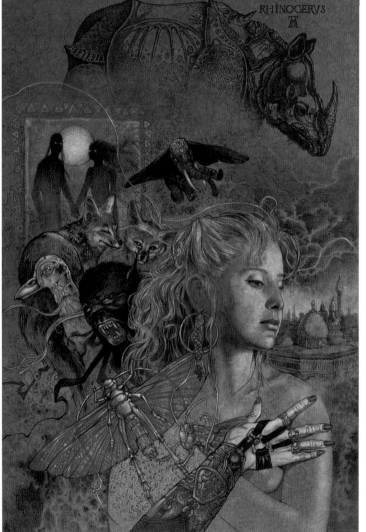

2

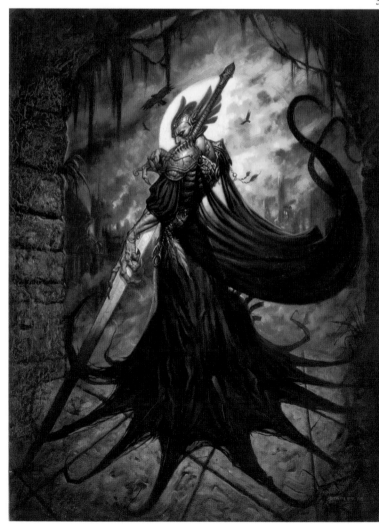

3

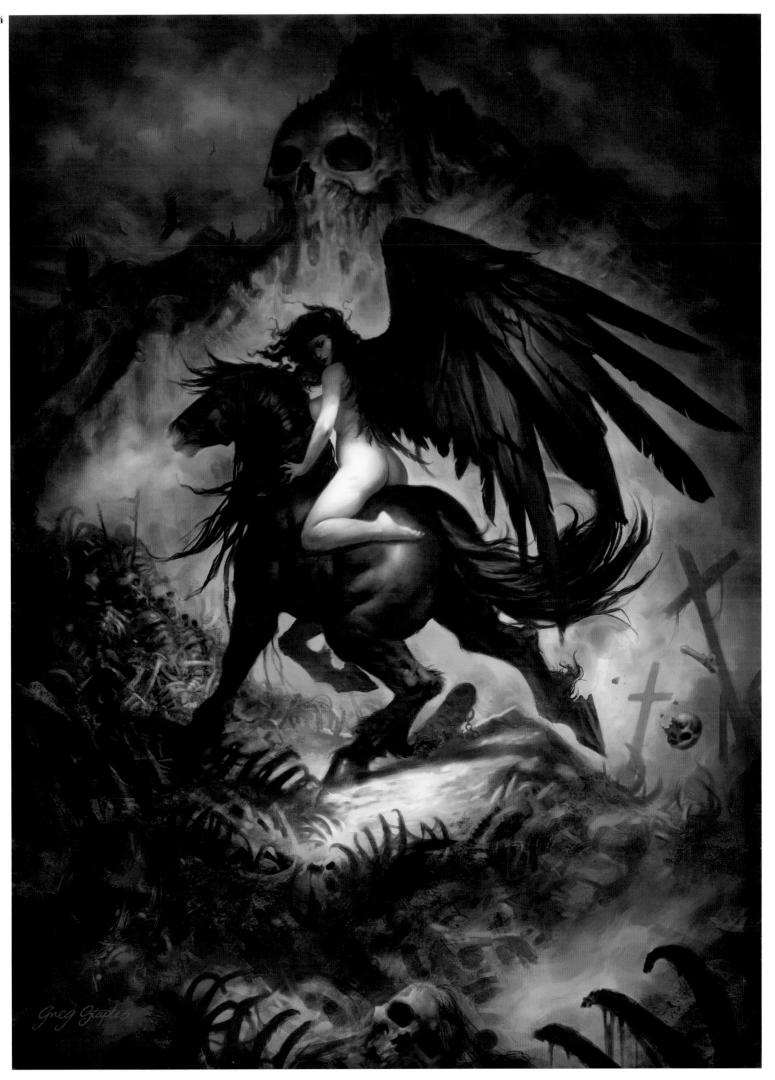

greg staples

1
artist: **Jody A. Lee**
art director: Sheila Gilbert
client: DAW Books
title: The Four Forges
medium: Acrylics
size: 17"x18"

2
artist: **Dave McKean**
art director: Dave McKean
client: Allen Spiegel Fine Arts/Hourglass
title: King of Staffs/Particle Tarot Minor
medium: Mixed
size: 8$\frac{1}{2}$"x8$\frac{1}{2}$"

3
artist: **Todd Lockwood**
art director: Irene Gallo
client: Tor Books
title: Midnight Tides
medium: Digital
size: 22"x15"

4
artist: **Stephan Martiniere**
art director: Nicholas Sica
client: Bookspan
title: Snow Crash
medium: Digital

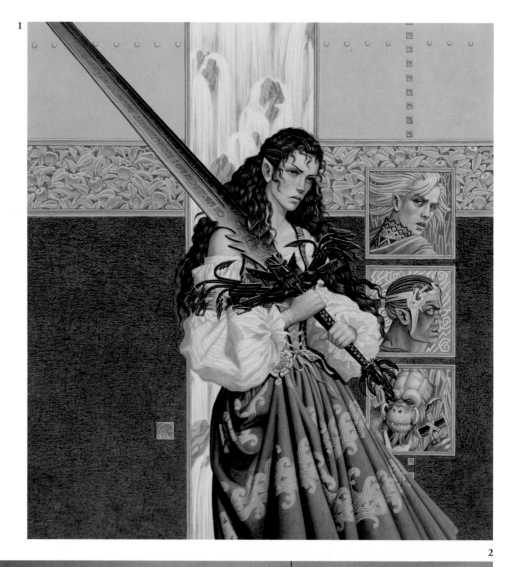

3

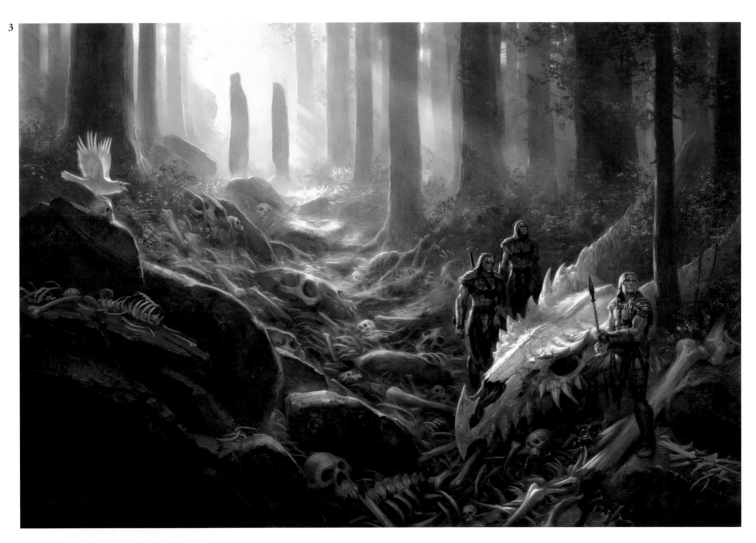

4

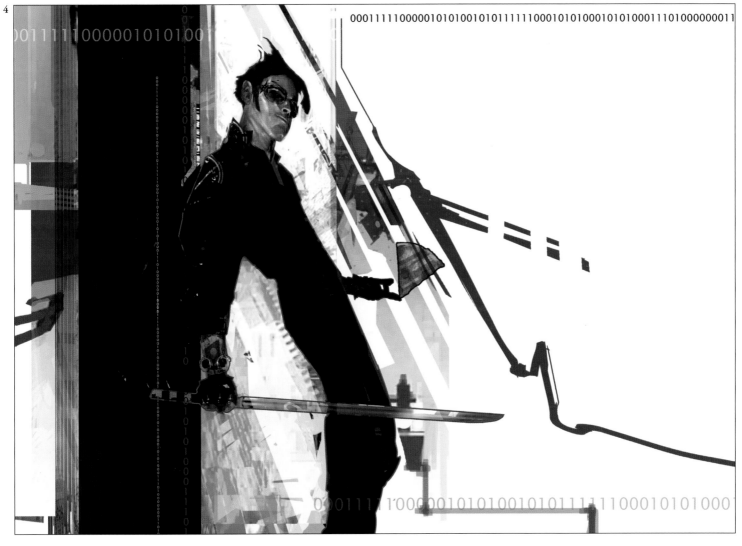

1
artist: **James Gurney**
art director: Dorothy O'Brien
client: Andrews McMeel Publishing
title: Desert Crossing
medium: Oil
size: 28"x14"

2
artist: **Gregory Manchess**
art director: Irene Gallo
client: Tor Books
title: The Sky People
medium: Oil
size: 24"x12"

3
artist: **Andrea Blasich**
designer: Andrea Blasich
client: Paquet/Out of Picture
title: Yes, I Can
medium: Ink/Photoshop
size: 11"x17"

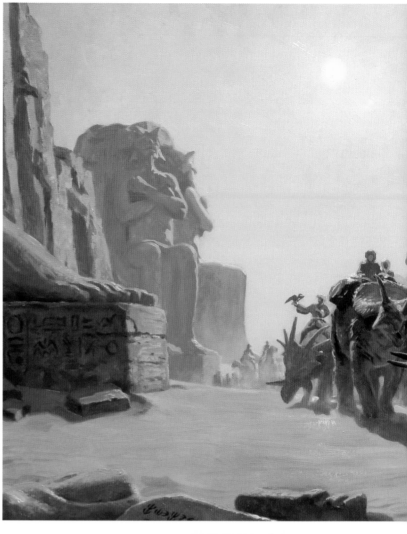

1

2

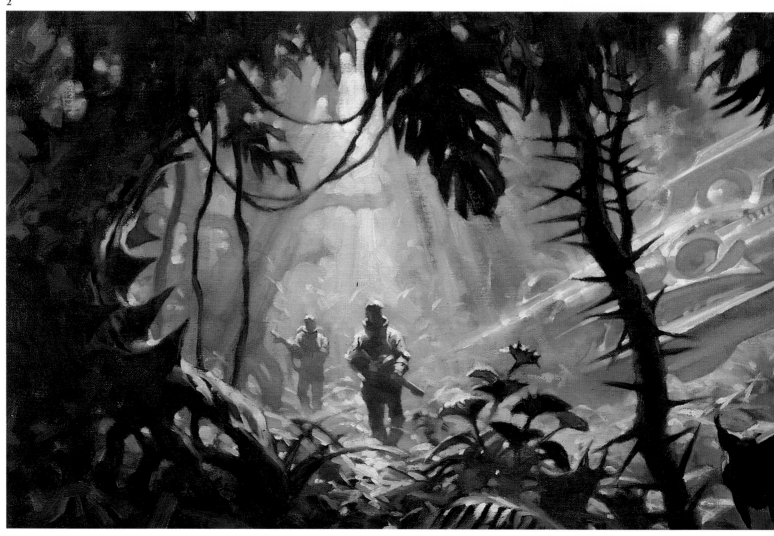

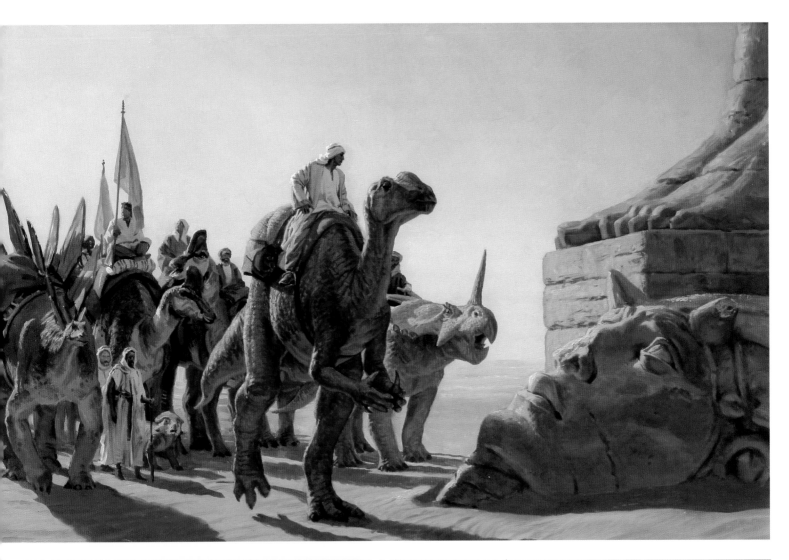

3

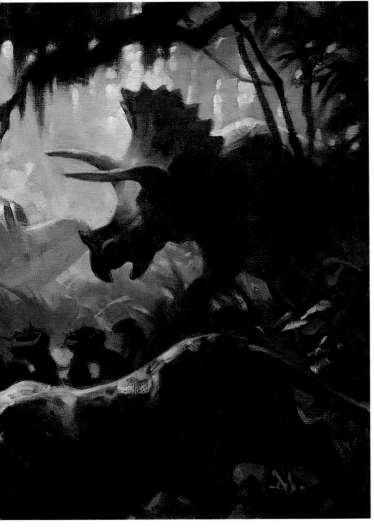

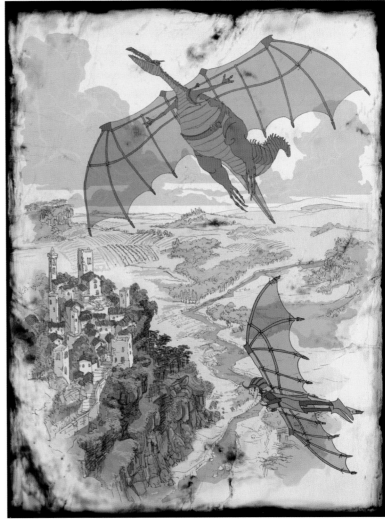

1
artist: **Michael Komarck**
art director: Randall Bills
client: FanPro/WizKids
title: Mercenaries Supplemental Update
medium: Digital

2
artist: **Stephen Youll**
art director: Irene Gallo
client: Tor Books
title: Hunters of Dune
medium: Digital *size:* 20"x9"

3
artist: **Donato Giancola**
art director: Betsy Wollheim
client: DAW Books
title: Pretender
medium: Oil on paper *size:* 18"x29"

4
artist: **Dan dos Santos**
art director: Irene Gallo
client: Tor Books
title: Farseed
medium: Oil on board

5
artist: **Scott M. Fischer**
art director: Irene Gallo
client: Tor Books
title: Gugitives of Chaos
medium: Oil *size:* 17"x262"

6
artist: **Craig Phillips**
art director: Deborah Kaplan
designer: Jeanine Henderson
client: Penguin/Putnam
title: Journey Between Worlds *size:* 5¹/₂"x8¹/₄"

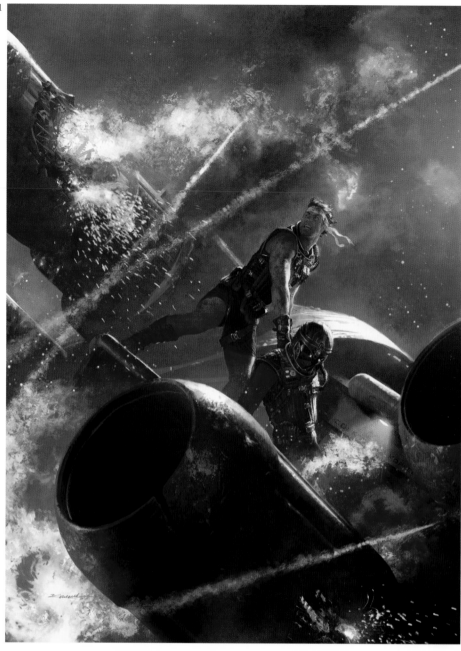

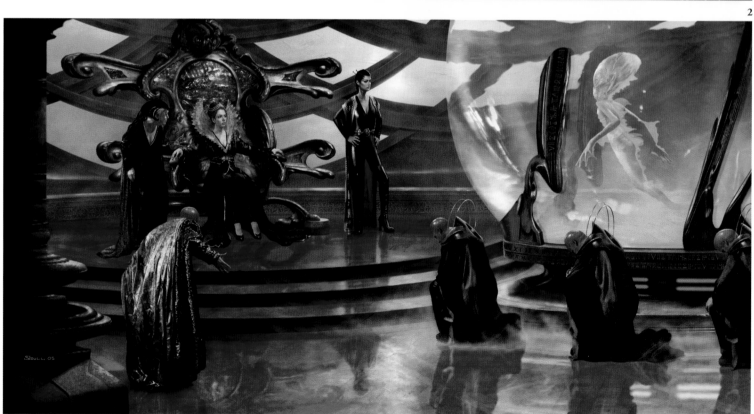

3

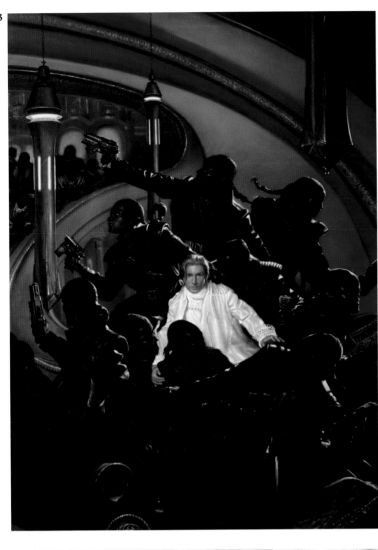

4

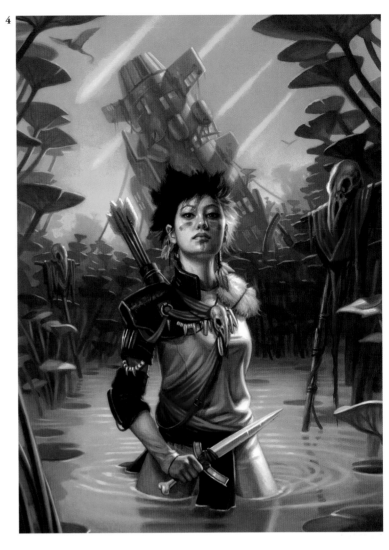

5

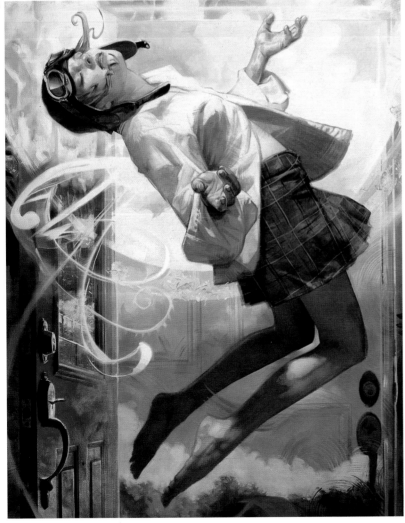

6

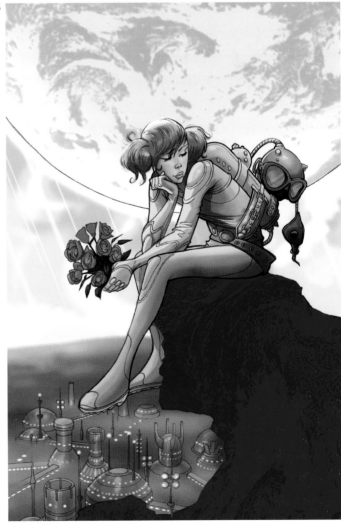

1
artist: **William Stout**
client: Terra Nova Press
title: Robert Johnson
medium: Ink & watercolor on board
size: 4³/4"x6³/4"

2
artist: **Cliff Nielsen**
art director: Deborah Kaplan
client: Penguin/Firebird
title: Firebirds Rising
medium: Digital
size: 8"x11"

3
artist: **Marc Sasso**
art director: Ray Lundgren
client: Penguin/Putnam
title: Knights of the Blood
medium: Digital

4
artist: **Cliff Nielsen**
art director: Hilary Zarycky
client: Harper Collins
title: Devil's Tango
medium: Digital
size: 6"x9"

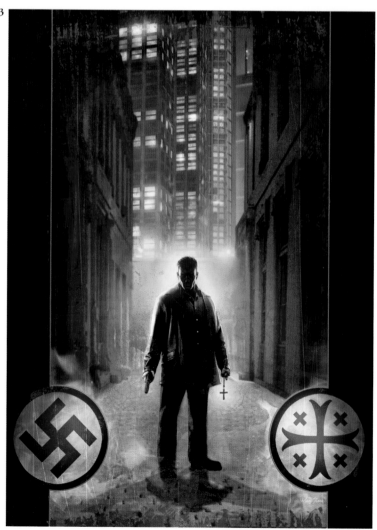

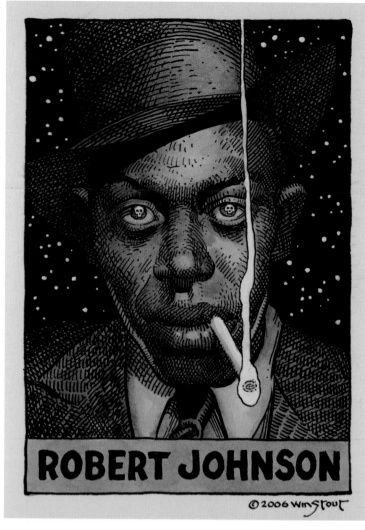

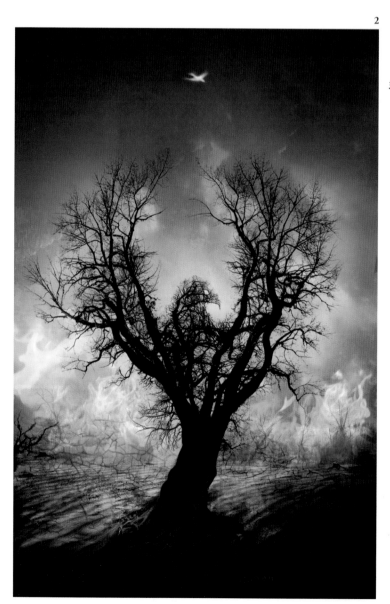

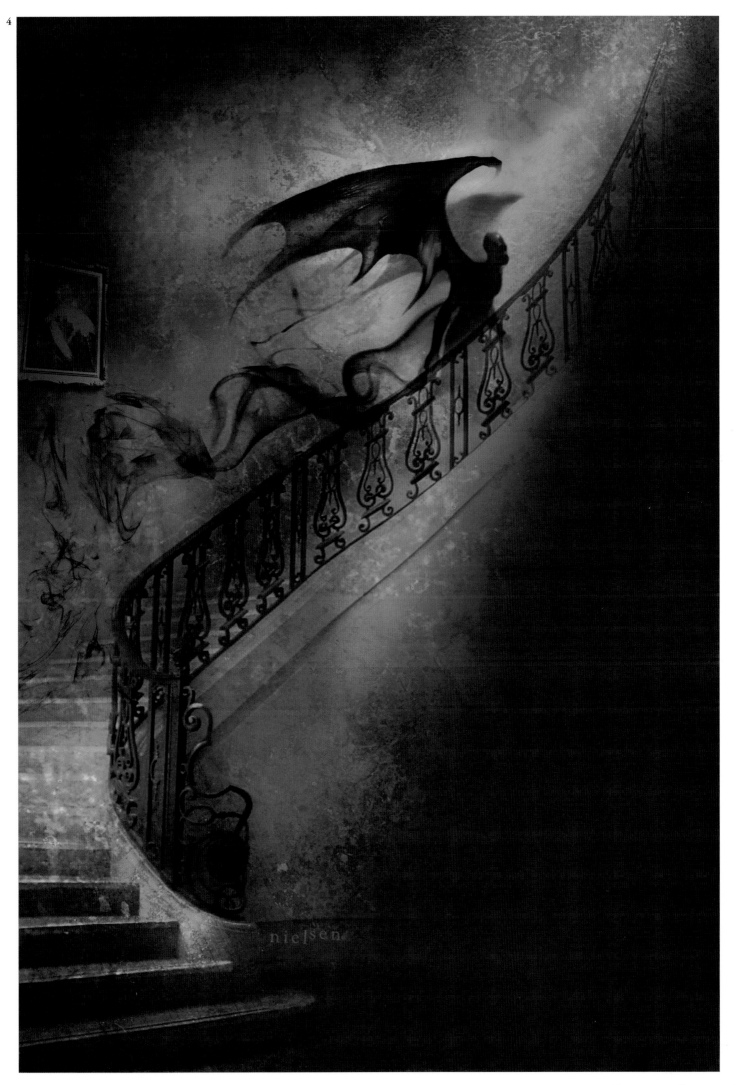

nielsen

1
artist: **John Jude Palencar**
art director: Kristen Pettit
client: Razorbill/Penguin
title: The Black Tattoo
medium: Acrylics
size: 38"x29"

2
artist: **Paul Bonner**
art director: Jean Bey
client: Rackham
title: Behemoth Orks
medium: Watercolor
size: 23 1/2"x15 1/2"

3
artist: **Paul Bonner**
art director: Theodore Bergquist
client: Riotminds
title: Likstorm
medium: Watercolor
size: 12"x19"

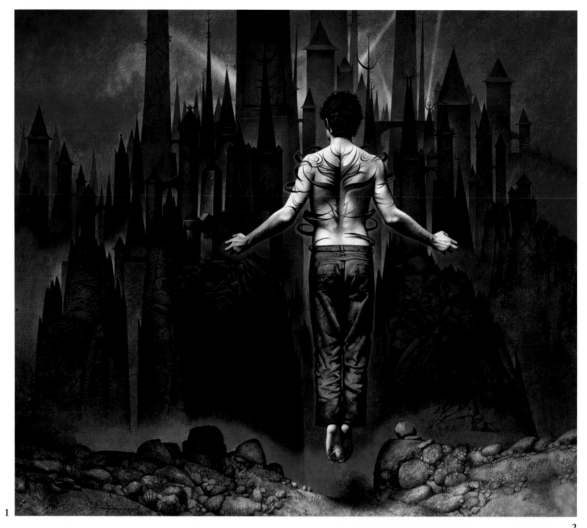

1

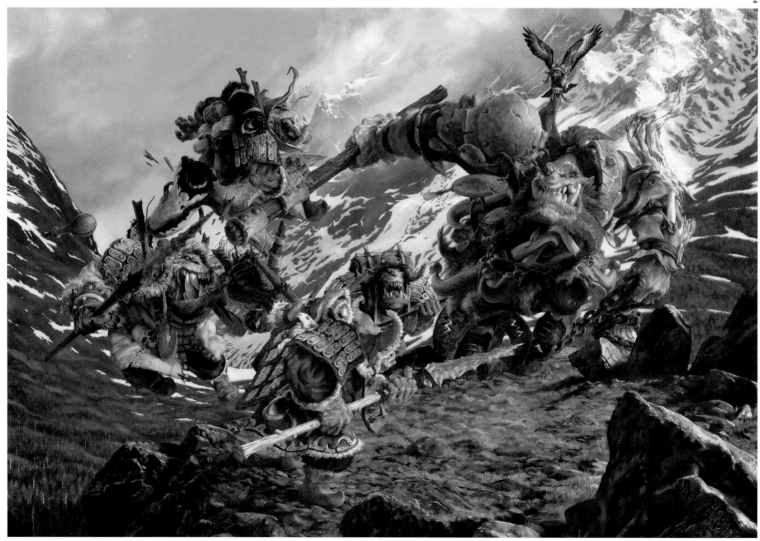

2

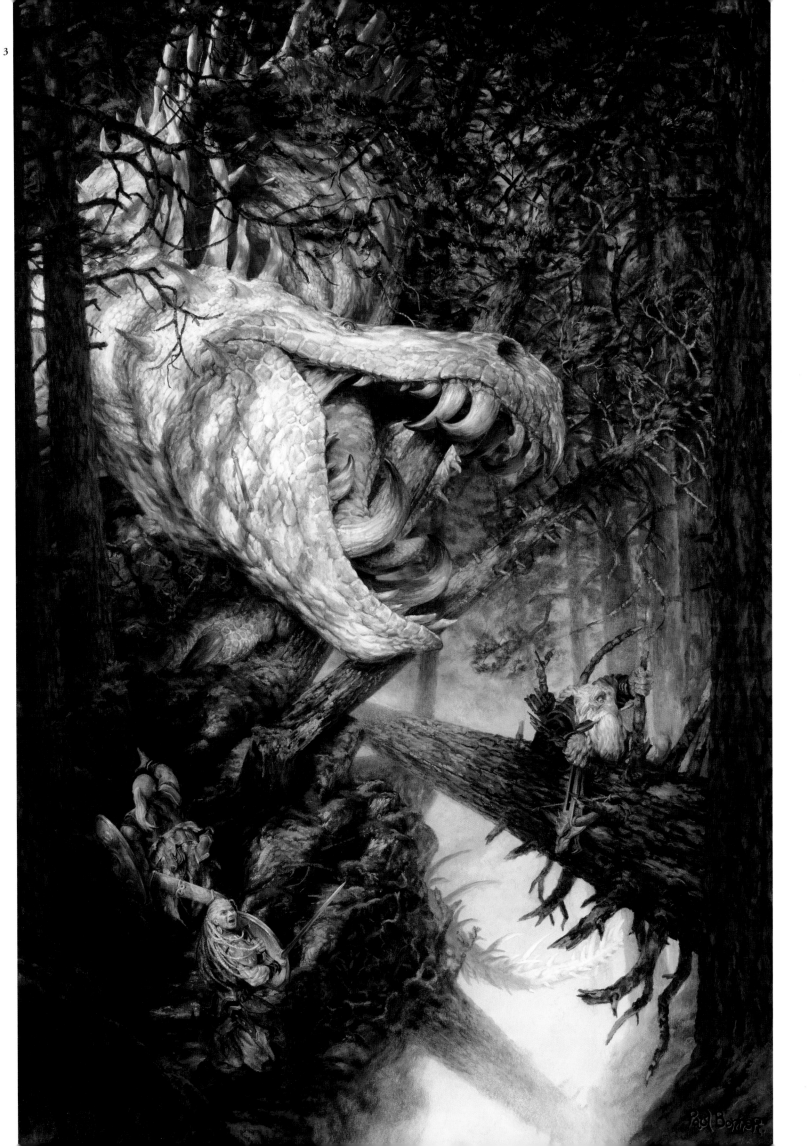

1
artist: **Chuck Richards**
art director: Donna Mark
designer: Nicole Gastonguay
client: Walker Books
title: Jungle Gym Jitters
medium: Colored pencil
size: 11"x14"

2
artist: **Chuck Richards**
art director: Donna Mark
designer: Nicole Gastonguay
client: Walker Books
title: Jungle Gym Jitters
medium: Colored pencil
size: 36"x18"

3
artist: **Dennis Brown**
client: Klaimco
title: Thelonious and the Children of Ego
medium: Oil/acrylics
size: 12"x16"

4
artist: **Chris Gall**
client: Little, Brown
title: Octopus
medium: Scratchboard/digital
size: 8^1/$_2$"x11"

5
artist: **Chris Gall**
client: Little, Brown
title: Blastoff
medium: Scratchboard/digital
size: 11"x8^1/$_2$"

1

2

3

4

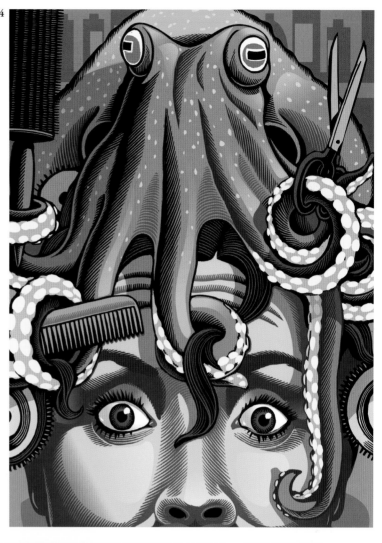

5

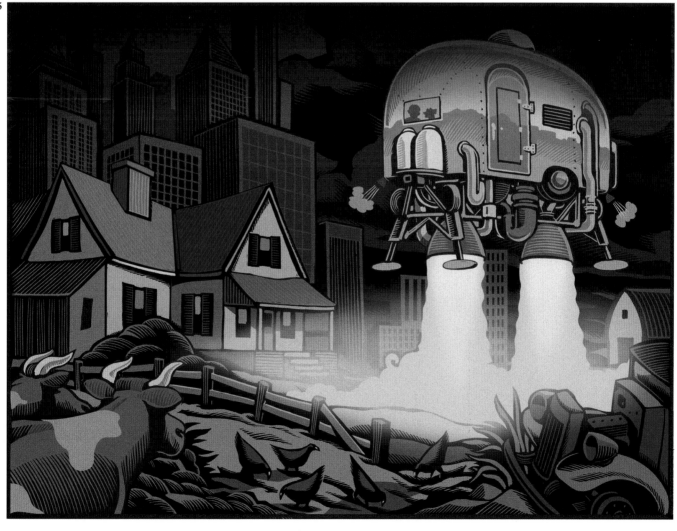

1
artist: **Daren Bader**
art director: Pauline Benney
client: White Wolf Publishing
title: Origins
medium: Digital
size: 8¹/₂"x6³/₄"

2
artist: **John Van Fleet**
art director: Dave Stevenson
client: Random House
title: Star Wars: Alliances
medium: Mixed
size: 11"x8¹/₂"

3
artist: **Mark Zug**
art director: Cam Lay
client: Easton Press
title: Gift of the Stars
medium: Oil

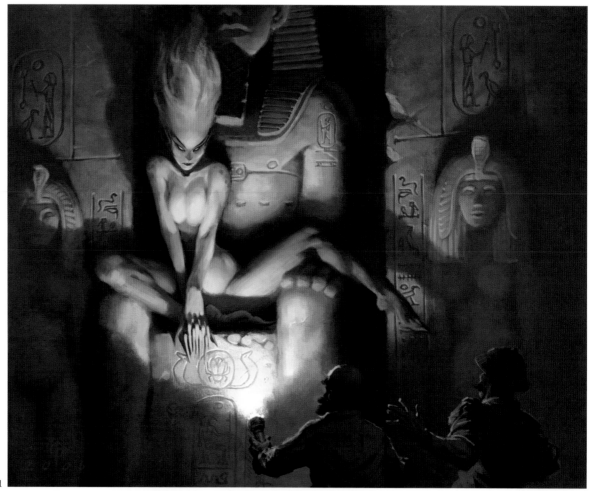

1

2

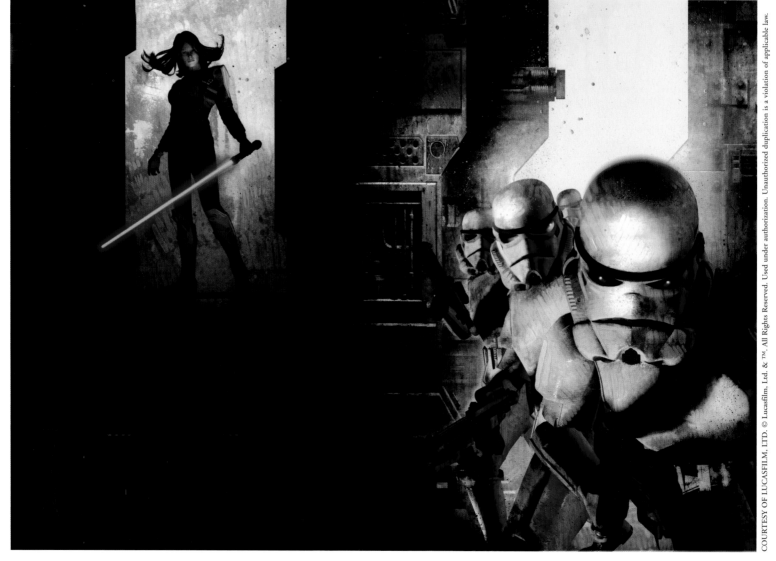

3

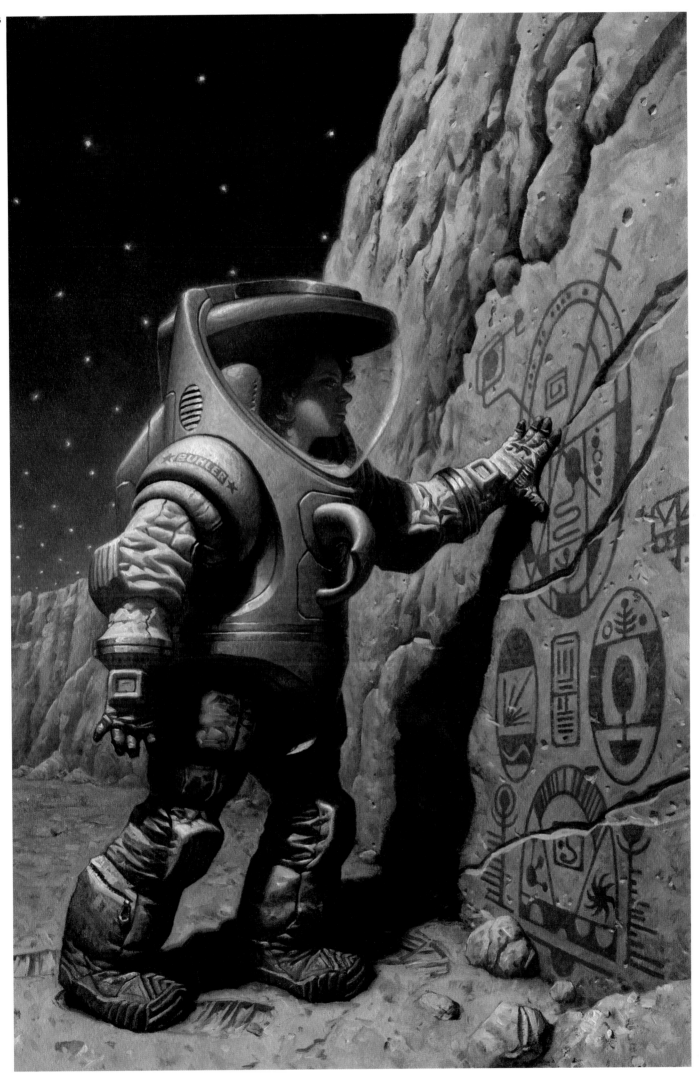

1
artist: **Matt Hughes**
title: Becoming...
medium: Watercolor/colored pencil
size: 16"x20"

2
artist: **Wes Benscoter**
art director: Matt Adelsperger
client: Wizards of the Coast
title: Sacrifice of the Widow
medium: Acrylics/digital
size: 10"x15"

3
artist: **E.M. Gist**
art director: Matt Adelsperger
client: Wizards of the Coast
title: Sleep With Evil
medium: Oil/digital
size: 20"x30"

4
artist: **Patrick Arrasmith**
art director: Irene Gallo
client: Tor Books
title: Brother to Dragons
medium: Scratchboard/Photoshop
size: 10"x14"

1

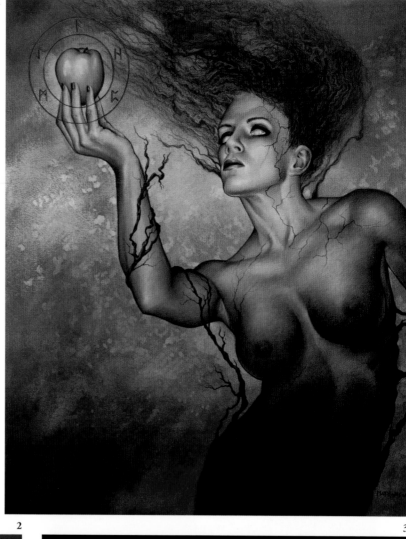

2

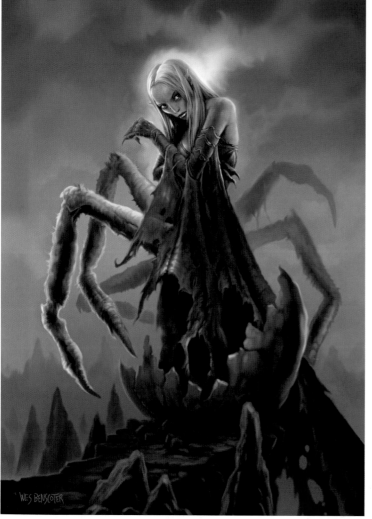

3

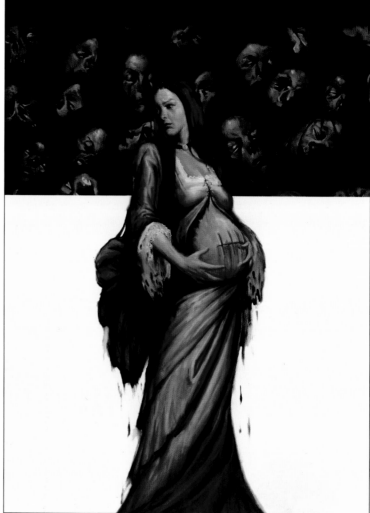

4

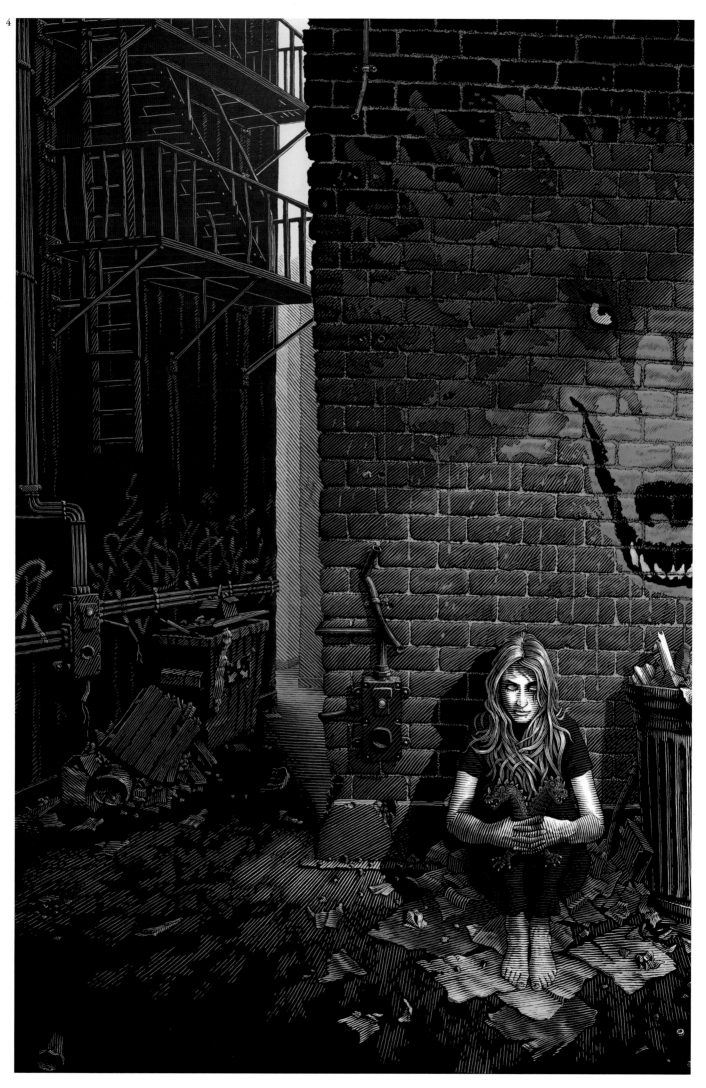

1
artist: **Raymond Swanland**
art director: Jeremy Lassen
client: Night Shade Books
title: A Cruel Wind
medium: Digital

2
artist: **Matt Stawicki**
art director: Matt Adelsperger
client: Wizards of the Coast
title: Amber & Iron
medium: Digital

3
artist: **Omar Rayyan**
art director: Karin Paprocki
client: Simon & Schuster
title: Danger At Snow Hill
medium: Watercolor
size: 10"x15"

4
artist: **Tristan Elwell**
art director: Dreu Pennington
client: Del Rey Books
title: Every Inch a King
medium: Oil on board
size: 10"x16"

5
artist: **David Hollenbach**
art director: Judith Murello Lagerman
client: Berkley Publishing Group
title: Grave Surprise
medium: Mixed
size: 10"x15"

6
artist: **Scott Gustafson**
art director: Scott Usher
client: The Greenwich Worskshop
title: Bat, Bat
medium: Oil on masonite
size: 14"x12"

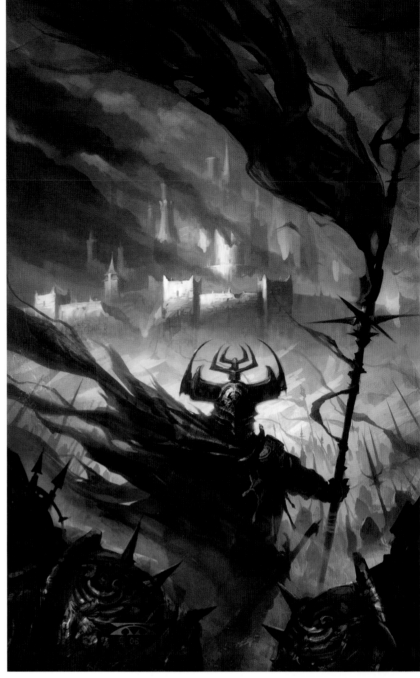

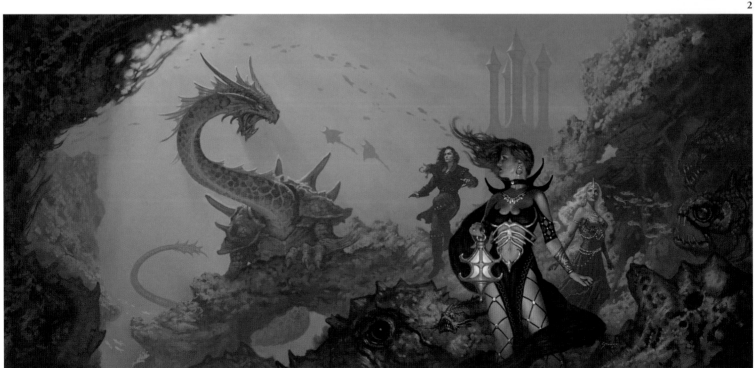

3

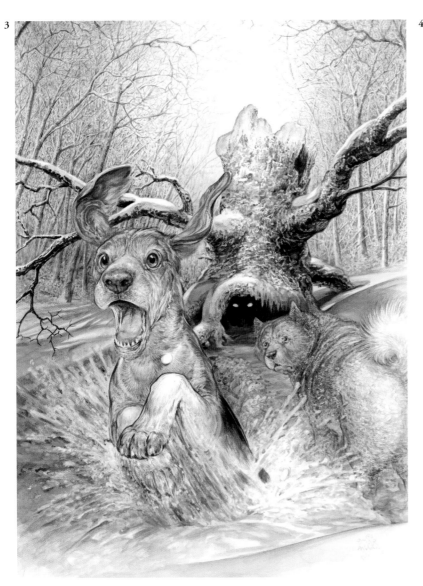

4

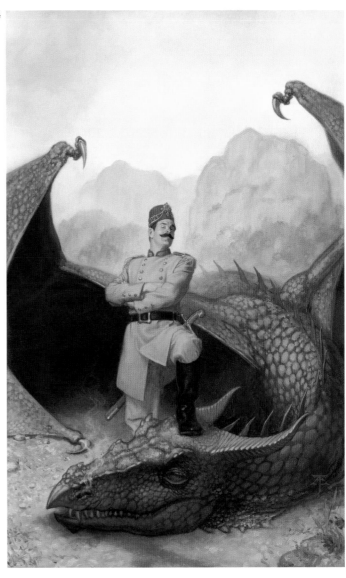

5

6

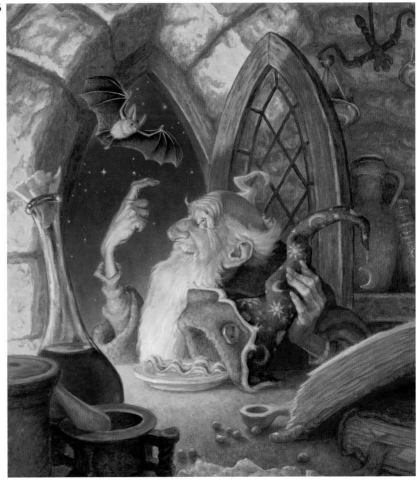

1
artist: **Franz Vohwinkel**
art director: Sascha Mamczak
client: Heyne Publishing
title: Undead Bones
medium: Digital
size: 7"x9^1/$_2$"

3
artist: **Chris McGrath**
art director: Tom Egner
client: Harper Collins
title: Scent of Shadows
medium: Digital
size: 4^1/$_2$"x7"

2
artist: **Vince Natale**
art director: Larry Reynolds
client: Bloodletting Press
title: Love Lies Dying
medium: Oil
size: 20"x30"

4
artist: **John Jude Palencar**
art director: Jamie Warren-Youll
client: Bantam Books
title: Chasing Fire
medium: Acrylics
size: 17"x22"

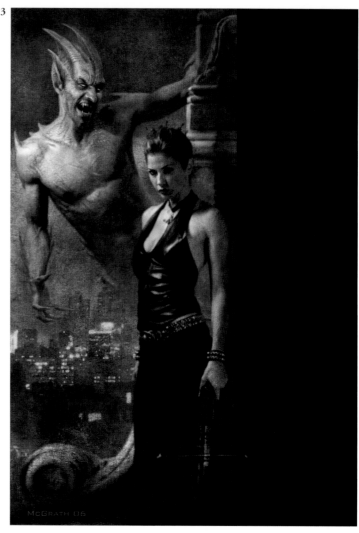

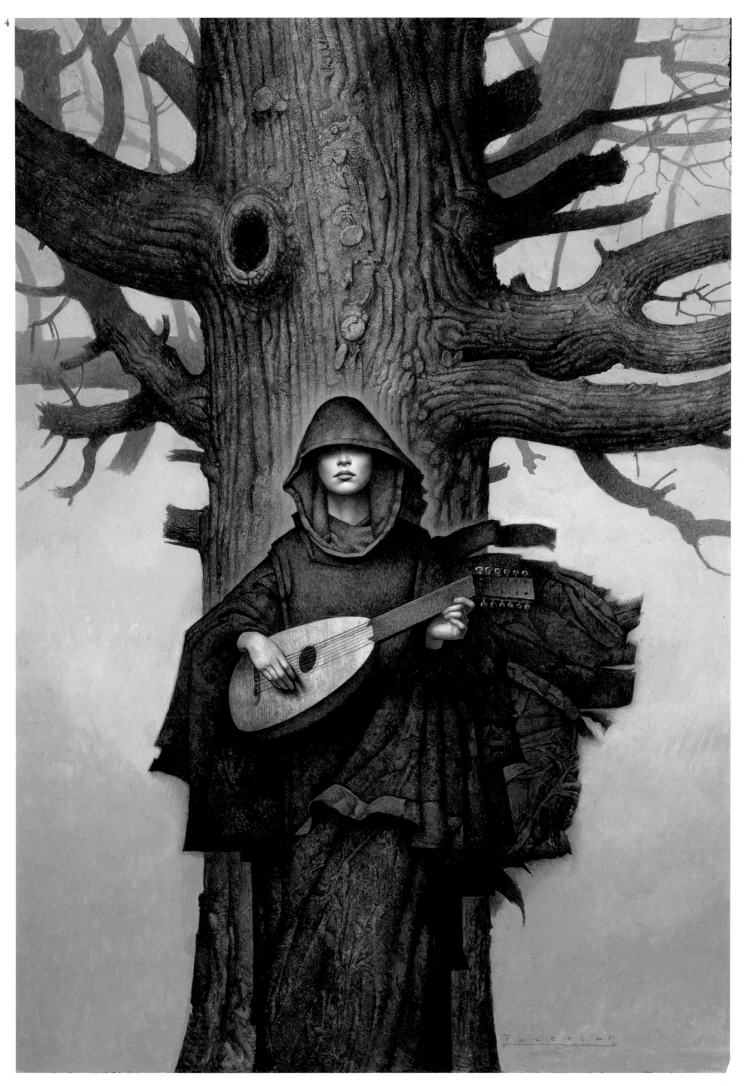

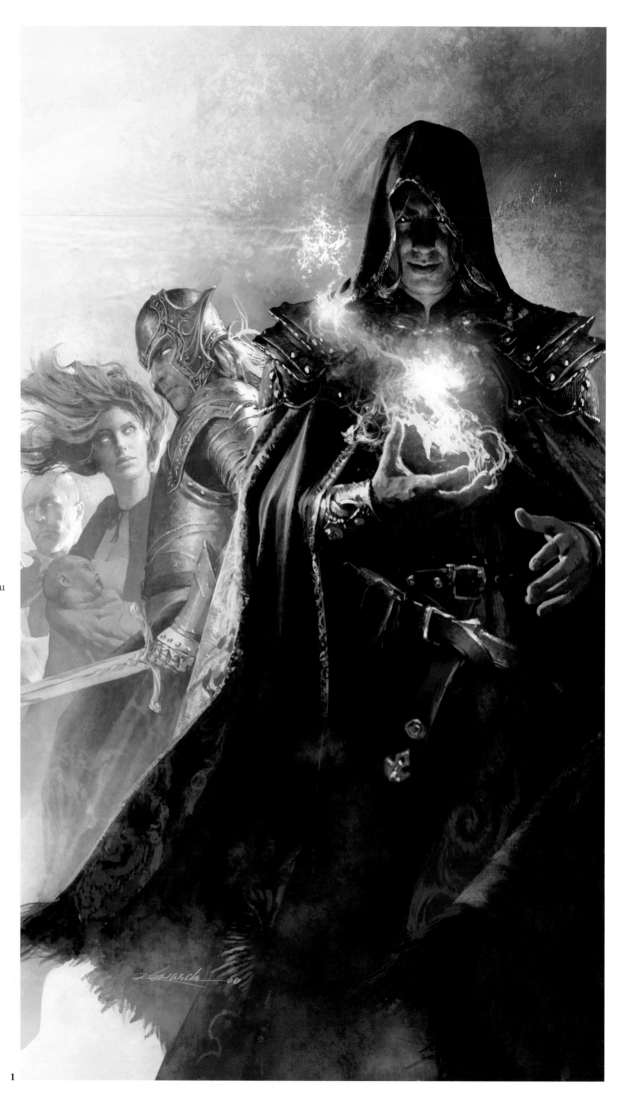

1

2

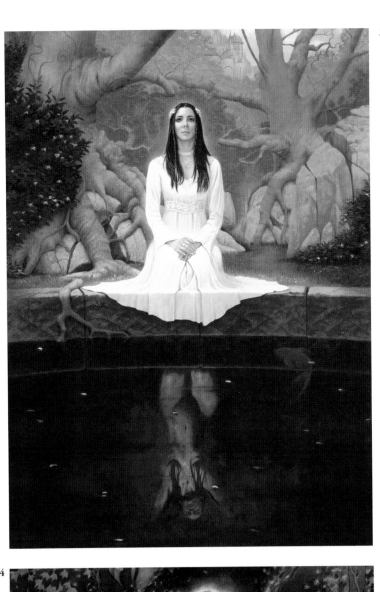

3

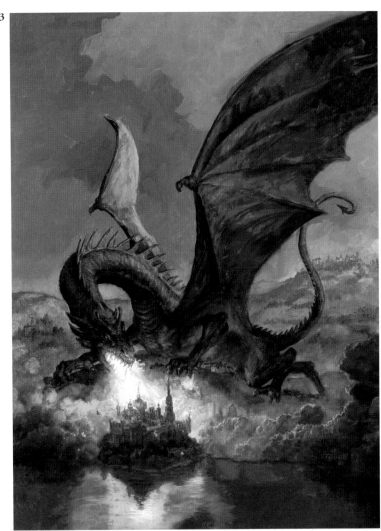

4

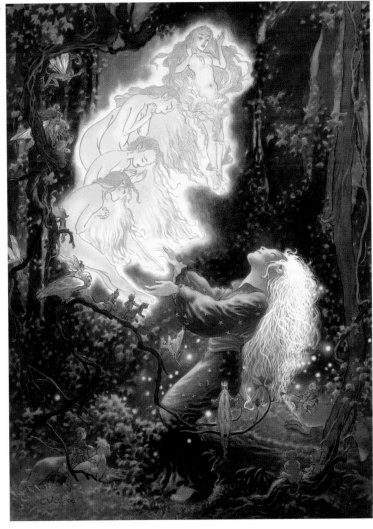

5

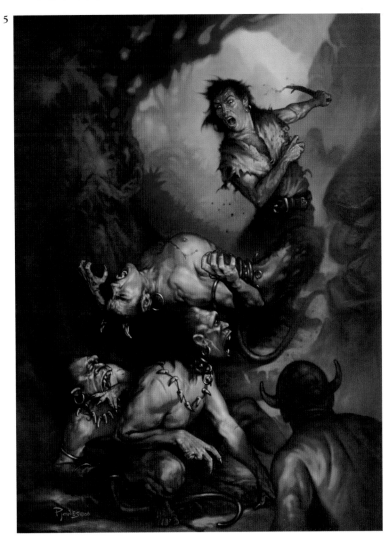

1
artist: **Stanley Martucci/**
 Cheryl Griesbach
art director: Kate Gardner
client: Random House
title: Star-Crossed
medium: Oil
size: 12"x16"

2
artist: **August Hall**
art director: Dave Stevenson
client: Random House
title: Un-lun-dun
medium: Mixed
size: 8"x10"

3
artist: **Jeremy Geddes**
art director: Jeremy Lassen
client: Night Shade Books
title: Grey—Version 1
medium: Oil
size: 79cm x 121cm

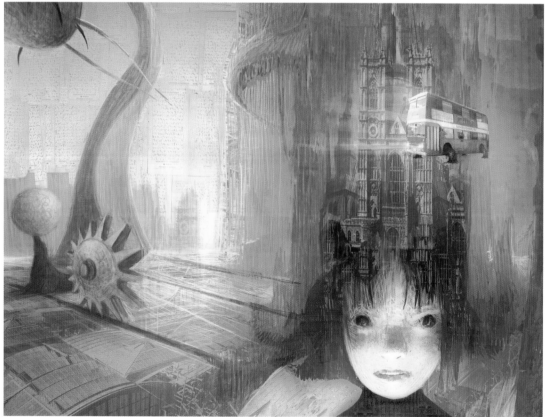

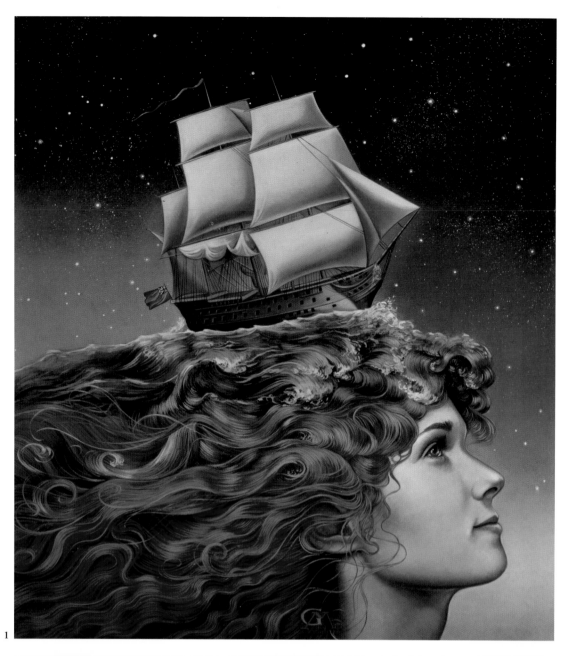

3

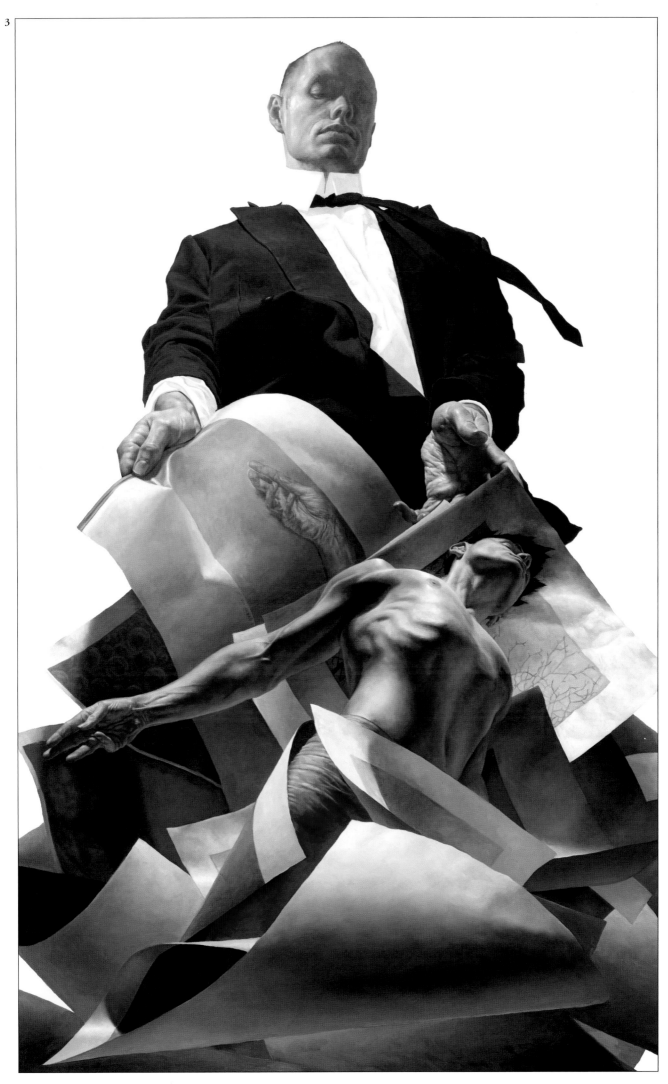

1
artist: **Shaun Tan**
art director: Shaun Tan
client: Lothian Books, Melbourne
title: The Arrival: An Encounter
medium: Graphite pencil/digital
size: 12"x15"

2
artist: **Shaun Tan**
art director: Shaun Tan
client: Lothian Books, Melbourne
title: The Arrival: The Flight
 Over the City
medium: Graphite pencil/digital
size: 23¹/2"x15¹/2"

3
artist: **Ragnar**
client: Baby Tattoo Books
title: Burt
medium: Digital
size: 10"x7"

4
artist: **Scott Gustafson**
art director: Scott Usher/
 Wendy Wentworth
client: The Greenwich Workshop
title: Polly, Put the Kettle On
medium: Oil on masonite
size: 12"x14"

5
artist: **Christian Alzmann**
art director: Deborah Kaplan
client: Penguin Young Readers
title: Ratha's Creature
medium: Mixed/digital
size: 8¹/3"x12²/3"

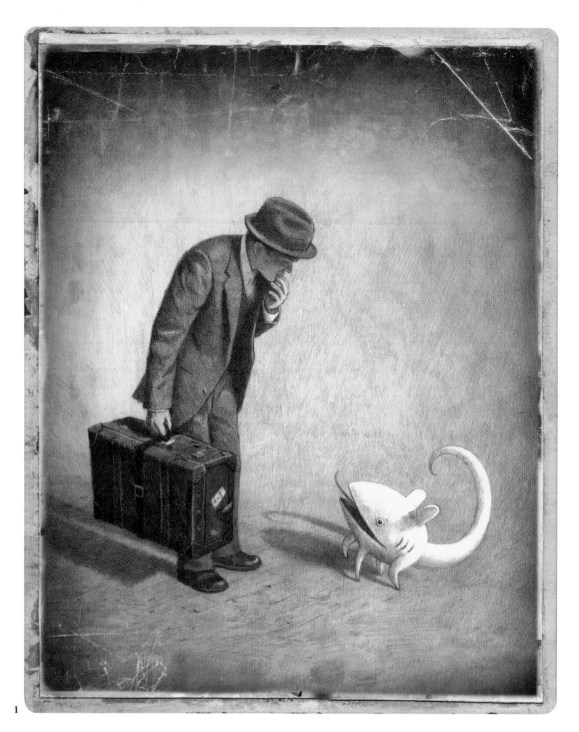

1

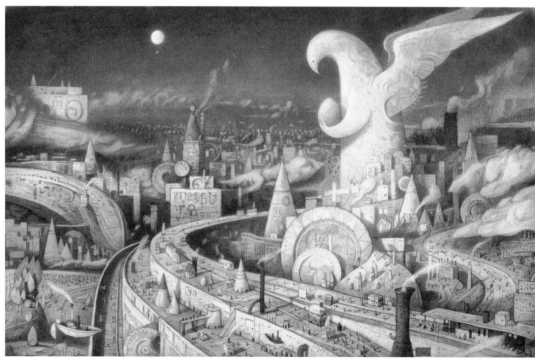

2

3

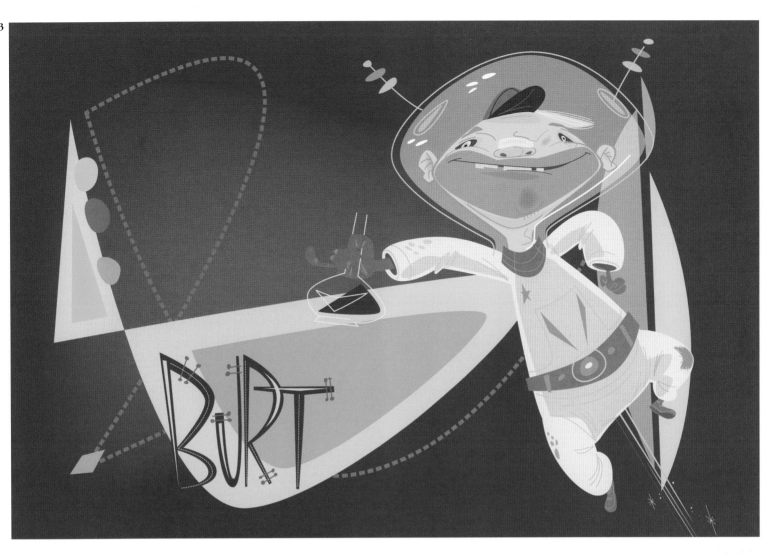

4

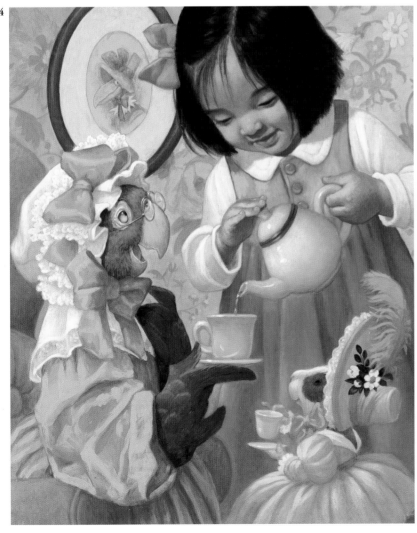

5

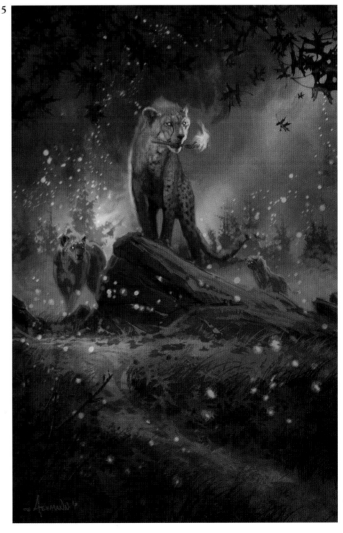

1
artist: **Dave Seeley**
art director: Dave Stevenson
designer: Dreu Pennington-McNeil
client: Del Rey Books
title: Command Decision
medium: Oil/mixed
size: 23"x35"

2
artist: **Raven Mimura**
client: Eos Press
title: Daphne's Undertaking
medium: Digital
size: 5¹/2"x13¹/8"

3
artist: **John Harris**
art director: Irene Gallo
client: Tor Books
title: Horizons
medium: Oil on canvas
size: 16"x25"

4
artist: **Donato Giancola**
art director: Irene Gallo
client: Tor Books
title: Outback Stars
medium: Oil on paper
size: 19"x29"

4

1
artist: **Beet**
art director: Pierre Laichaut
client: L'Atalante
title: Syfron [cover]
medium: Digital
size: 35^1/$_2$"x24^1/$_4$"

2
artist: **Larry MacDougall**
art director: Neil Christopher
client: Arctic Myths
title: Arctic Giantess
medium: Gouache
size: 13"x10"

3
artist: **Bryn Barnard**
art director: Tony Jacobson
client: Kidesign
title: Sir Henry, The Polite Knight: Meeting
medium: Oil
size: 20"x15"

4
artist: **Dan dos Santos**
art director: Irene Gallo
client: Tor Books
title: Yanti
medium: Oil on board

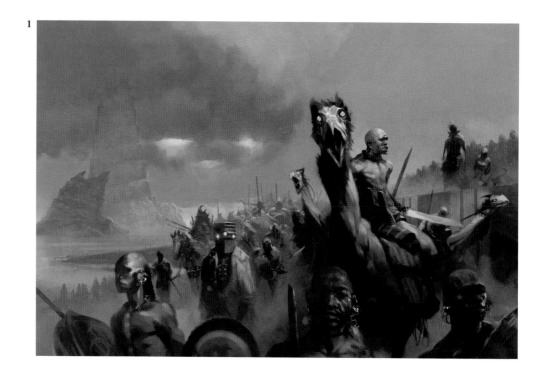

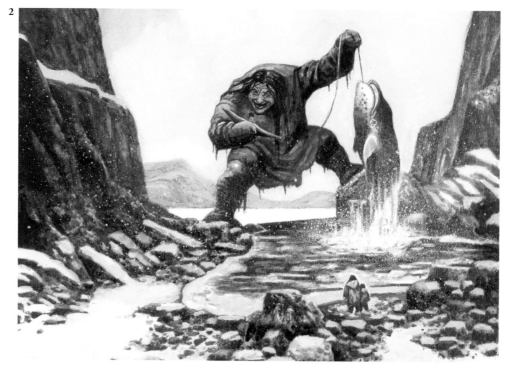

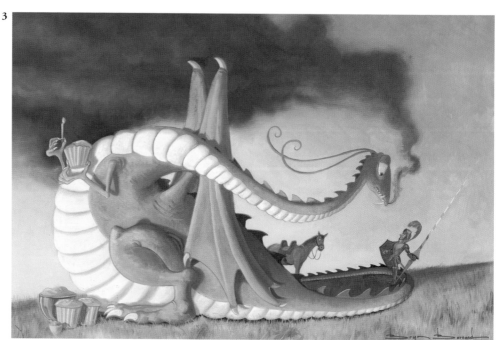

4

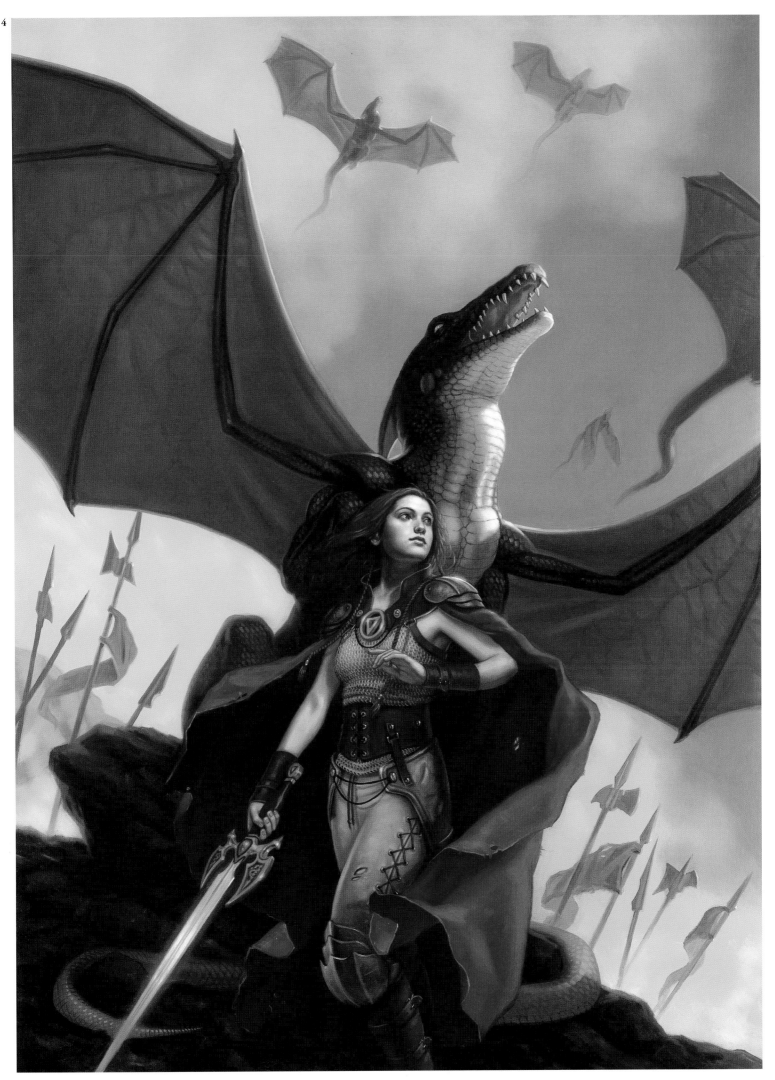

1
artist: **David Grove**
art director: Irene Gallo
client: Tor Books
title: Soldier of Sidon
medium: Acrylic

2
artist: **Gary A. Lippincott**
art director: Liz Pasfield
client: Quarto Publishing
title: The Sorceress

3
artist: **Jean-Sebastien Rossbach**
art director: Bénédiete Lombardo
client: Pocket
title: The Jackal of Nar
medium: Digital
size: 7"x11"

4
artist: **Christophe Vacher**
client: Harper Collins
title: Forest Mage
medium: Photoshop

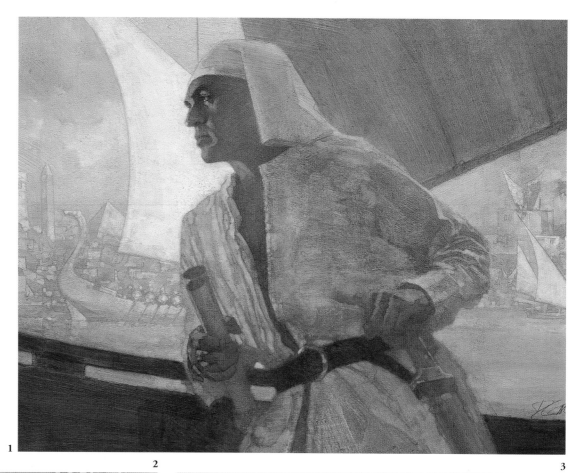

1

2

3

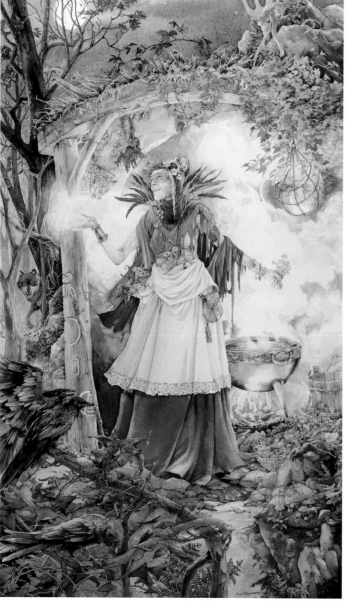

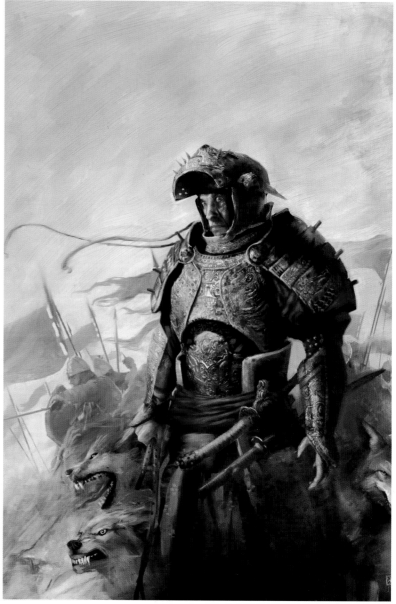

4

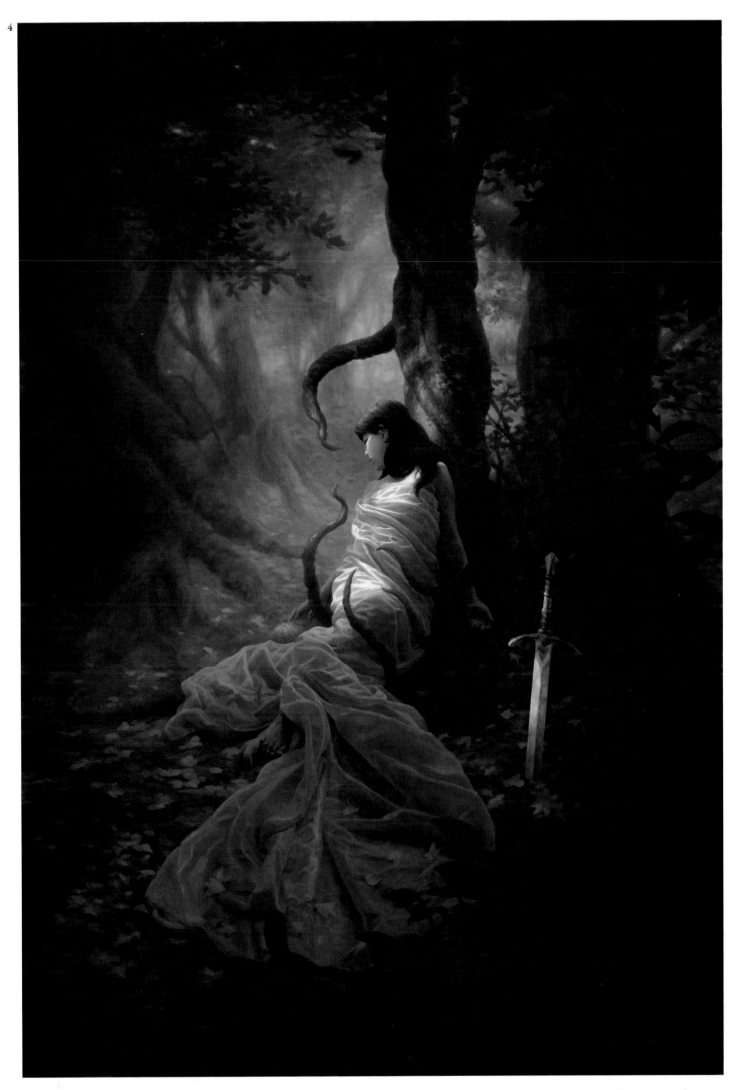

1
artist: **Jon Foster**
art director: Jeremy Lassen
client: Night Shade Books
title: Precious Dragon
medium: Digital

2
artist: **Paul Bonner**
art director: Theodore Bergquist
client: Riotminds
title: Vastermark
medium: Watercolor
size: 37cm x 55cm

3
artist: **Jon Foster**
art director: Debra Sfetsios
client: Simon & Schuster
title: Questors
medium: Digital

4
artist: **Jon Foster**
art director: Alison Impey
client: Little, Brown/Hachette
title: Tide of Terror
medium: Digital

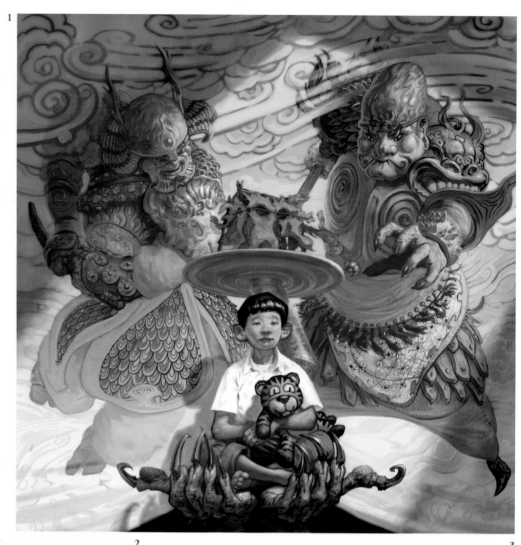

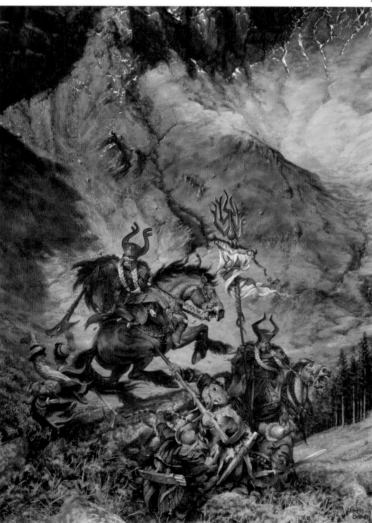

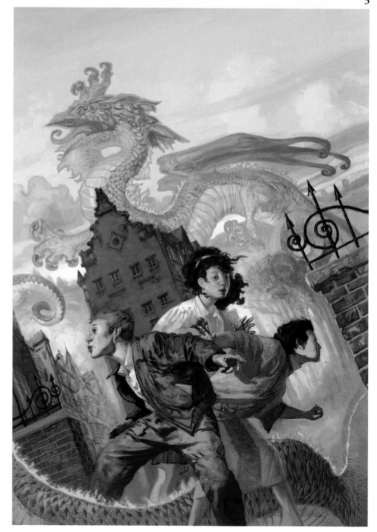

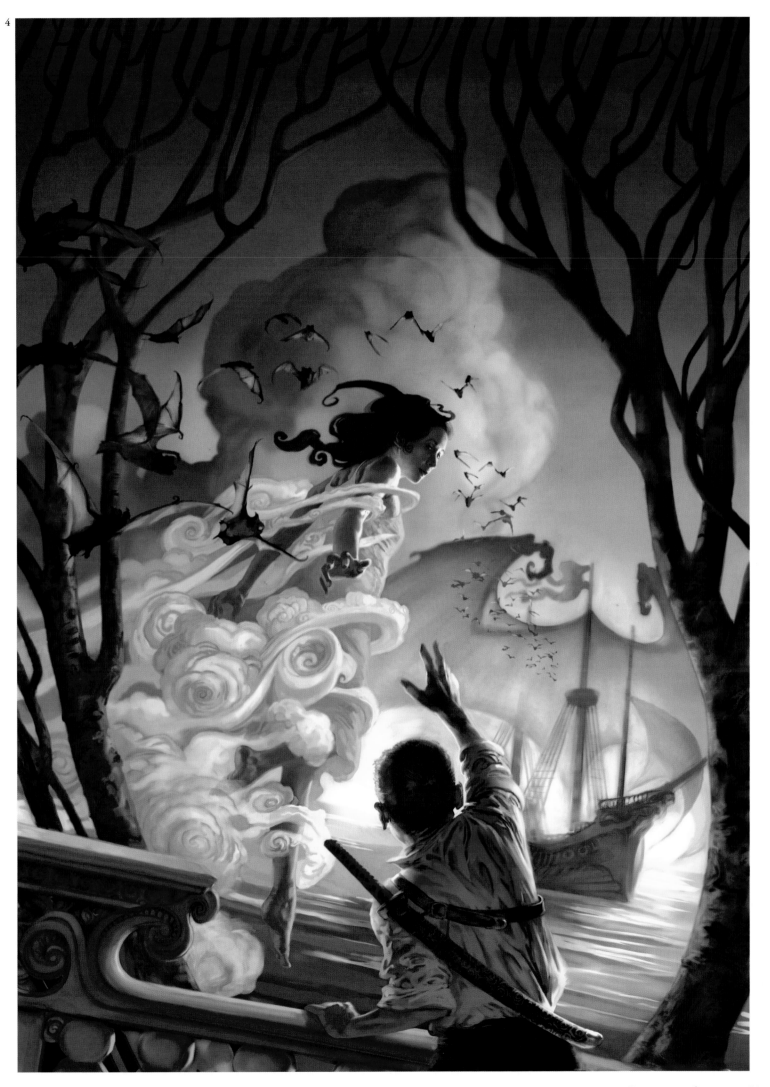

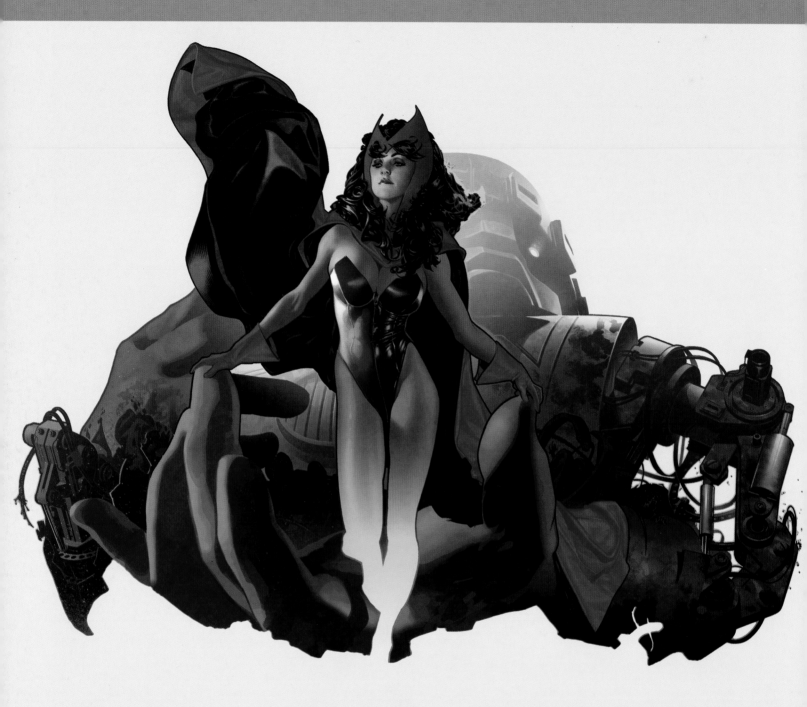

artist: Adam Hughes

art director: Mark Irwin *designer:* Adam Hughes *client:* Upper Deck Entertainment *title:* Wanda-Lust *medium:* Pen & ink/digital

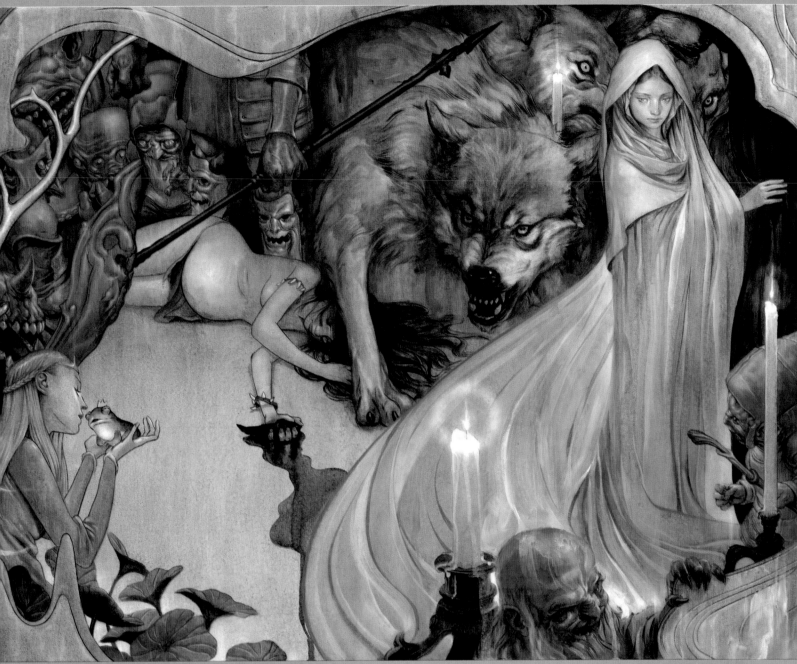

artist: **James Jean**

art director: Shelly Bond *client:* DC Comics/Vertigo *title:* Fables: 1001 Nights of Snowfall *medium:* Acrylics/digital *size:* 30"x22"

1
artist: **Arthur Adams**
title: Sampler V Back Cover
medium: Pen & ink
size: 13"x16¹/2"

2
artist: **Sonny Liew**
art director: Dan Vado
client: Slave Labor Graphics
title: Malinky Robot: Bicycle
medium: Pencil/digital
size: 8"x10¹/2"

3
artist: **Daisuke "Dice" Tsutsumi**
client: Out of Picture Comics
title: Noche y Dia
medium: Oil/digital
size: 9"x12"

4
artist: **Sonny Liew**
art director: Dan Vado
client: Slave Labor Graphics
title: Malinky Robot: Bicycle
 [cover]
medium: Pencil/digital
size: 8"x10¹/2"

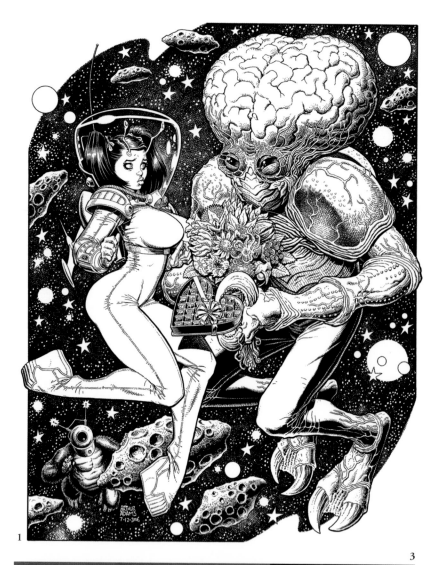

1

2

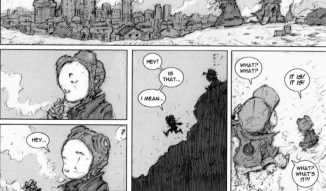

3

1
artist: **Frank Cho**
client: Dynamite Entertainment
title: Red Sonja #13
medium: Ink/digital
colorist: Jason Keith
size: 22"x17"

2
artist: **Christopher Moeller**
art director: Dan Raspler/
Mike Carlin
client: DC Comics
title: Cold Steel #1
medium: Acrylics
size: 30"x20"

3
artist: **Frank Cho**
client: Dynamite Entertainment
title: Savage Red Sonja #1
medium: Ink/digital
colorist: Jason Keith
size: 14"x21"

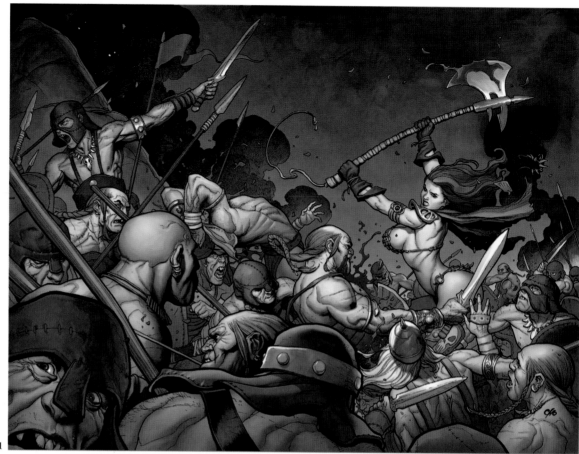

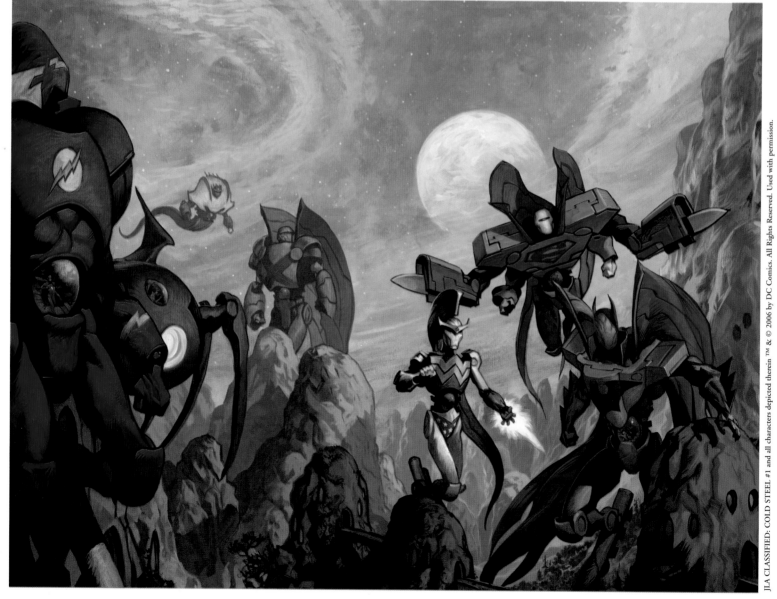

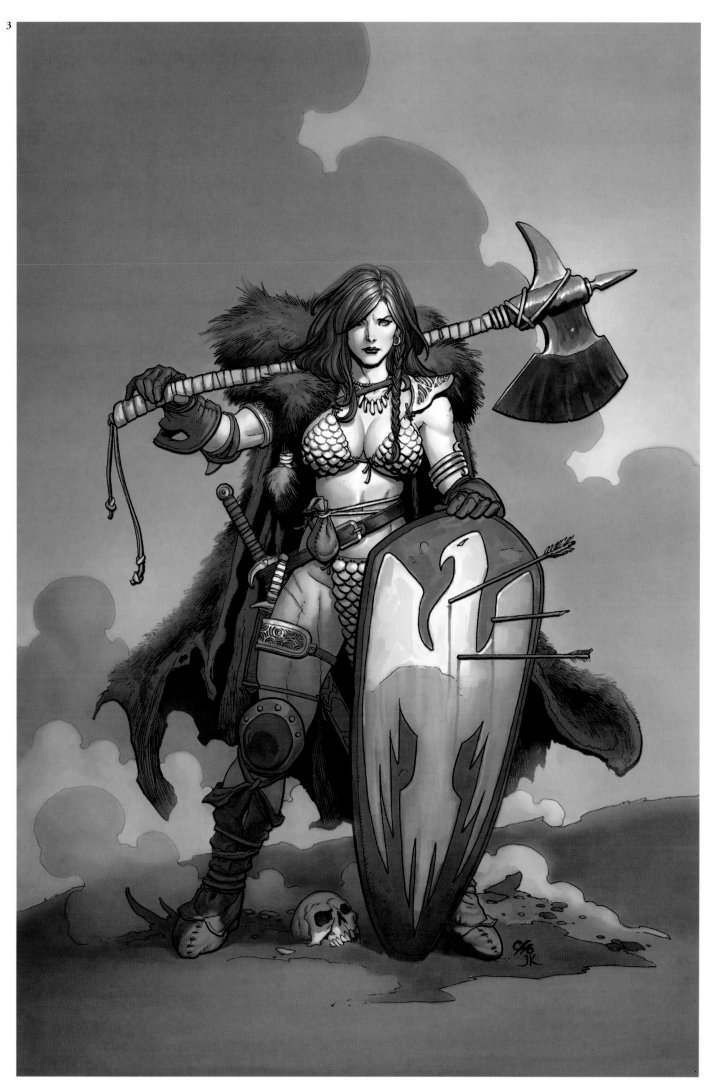

1
artist: **Arthur Suydam**
art director: Axel Alonso
client: Marvel Comics
title: Wolverine Origins
medium: Oil/mixed
size: 24"x30"

2
artist: **Ben Templesmith**
client: IDW Publishing
title: Medusa 01
medium: Mixed
size: 13^1/2"x5^1/3"

3
artist: **Michael Golden**
art director: Scott Dunbier
client: Wildstorm Productions
title: Vigilante Memories
medium: Mixed
size: 182"x24"

4
artist: **Frank Cho**
client: Marvel Comics
title: Ms Marvel #2
medium: Ink/digital
colorist: Jason Keith
size: 14"x21"

5
artist: **Tony Shasteen**
client: Image Comics
title: O.C.T. #2
medium: Pencil/Photoshop
size: 6^3/4"x10^3/8"

5
artist: **Aleksi Briclot**
art director: David Land
client: Dark Horse Comics/Flagship Studio
title: Hellgate: London #1
medium: Digital
size: 8"x12^1/2"

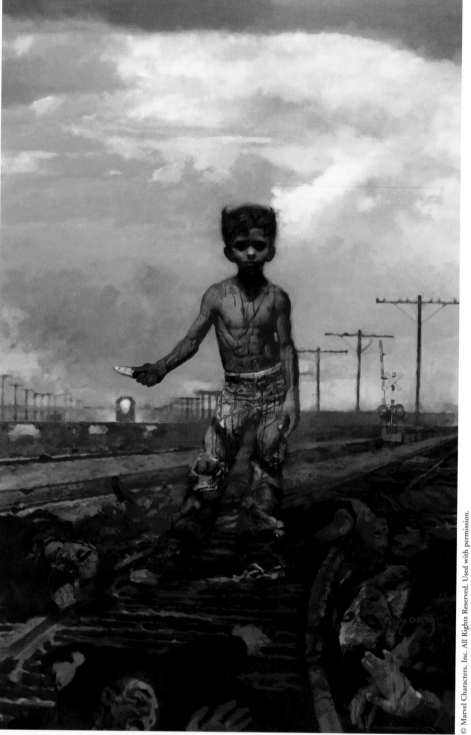

1

2

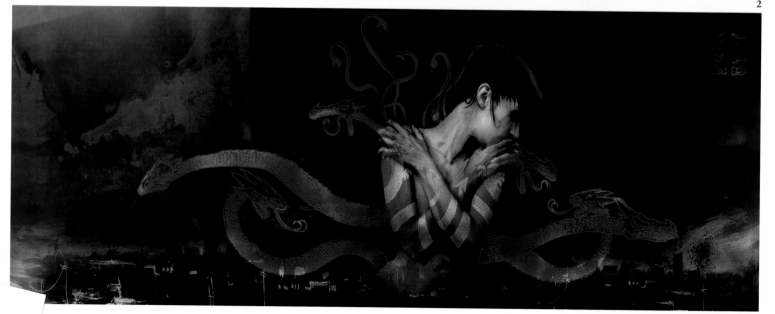

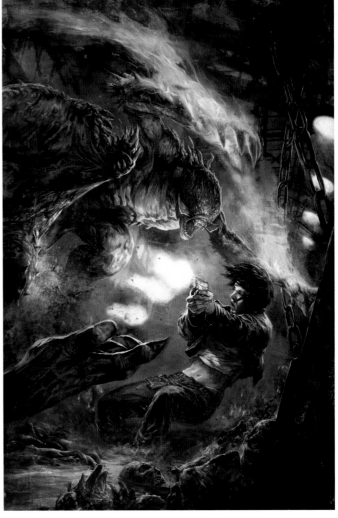

1
artist: **Mike Huddleston**
art director: Matt Idelson
designer: Mark Chiarello
client: DC Comics
title: Manbat #1
medium: Mixed *size:* 6⅝"x10¼"

2
artist: **Arcadia Studio**
art director: Marco Bianchini
designer: Patrizio Evangelisti
client: Vittorio Pavesio Editore
title: Termite Bianca
medium: Gouache *size:* 10"x14"

3
artist: **Caleb Prochnow**
art director: Rafael Nieves
client: Transfuzion Studio
title: Poe
medium: Pencil/digital *size:* 11"x16"

4
artist: **Ben Templesmith**
client: IDW Publishing
title: Discordia 01
medium: Mixed *size:* 6⅞"x10⅜"

1

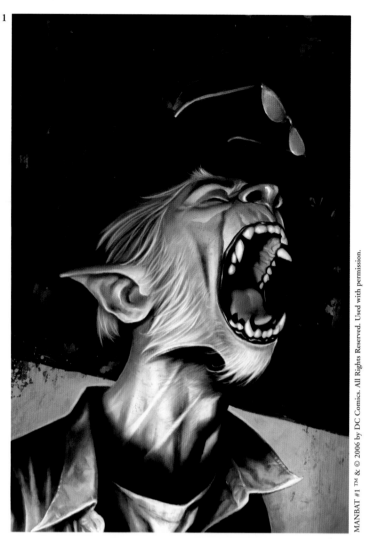

2

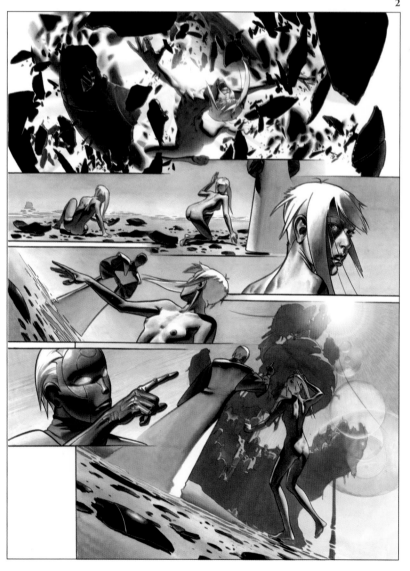

3

4

在

1
artist: **Vincent Proce**
art director: Michael Reidy
client: Silver Phoenix Entertainment
title: Mystery Manor Haunted Theater
medium: Digital *size:* 44¹/8"x57³/8"

2
artist: **Jeremy Geddes**
art director: Chris Ryall
client: IDW Publishing
title: Zombies #2
medium: Oil *size:* 25¹/2"x33³/8"

3
artist: **Jason Felix**
art director: Aaron Blecha
client: A&J Books
title: The Field Guide to the Midwest Monsters
medium: Pen & ink *size:* 8¹/2"x11"

4
artist: **Vincent Proce**
art director: Michael Reidy
client: Silver Phoenix Entertainment
title: Mystery Manor Haunted Theater
medium: Digital *size:* 32¹/4"x40¹/8"

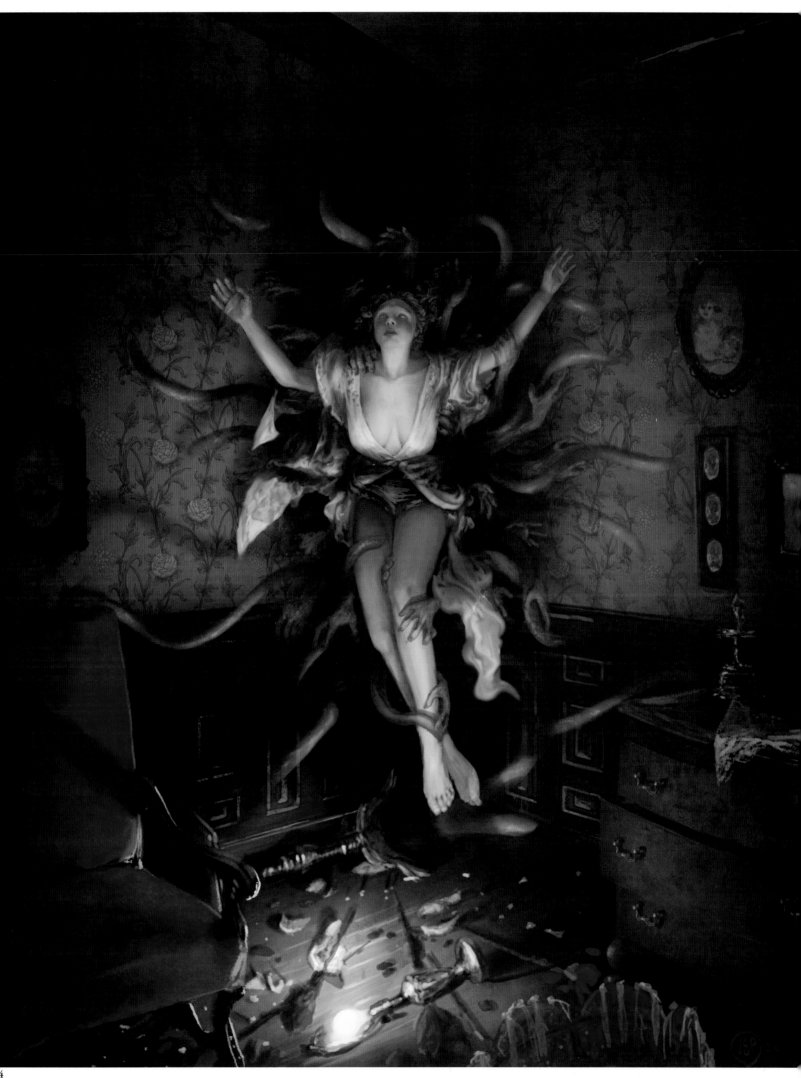

1
artist: **Wei Ming**
title: Dark Lord
medium: Digital
size: 46¹/₃"x57³/₄"

2
artist: **Nilson**
title: Quampa & Mopox
medium: Mixed
size: 11⁷/₈"x15³/₄" @

3
artist: **Steve Rude**
client: Dark Horse Comics
title: Nexus Archives V5
medium: Watercolor
size: 20"x30"

4
artist: **Philip Tan &
 Brian Jon Haberlin**
client: Todd McFarlane Prod.
title: Spawn #161
medium: Pencil/digital
size: 11"x17"

5
artist: **Paolo Rivera**
client: Marvel Comics
title: Mythos: X-Men p3
medium: Oil
size: 16"x24"

6
artist: **Paolo Rivera**
client: Marvel Comics
title: Mythos: X-Men p8
medium: Oil
size: 16"x24"

1

2

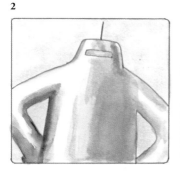
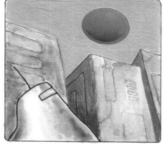
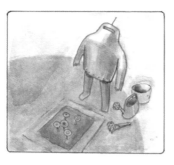
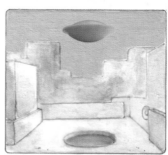

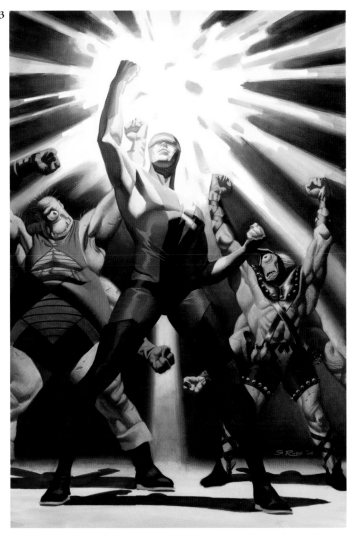

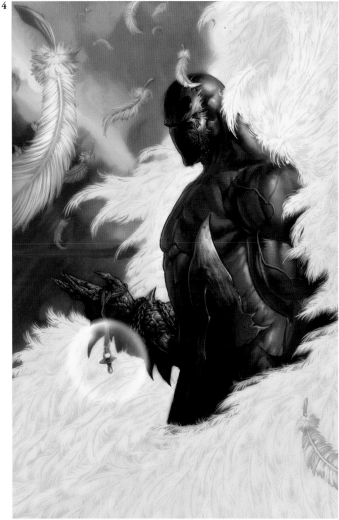

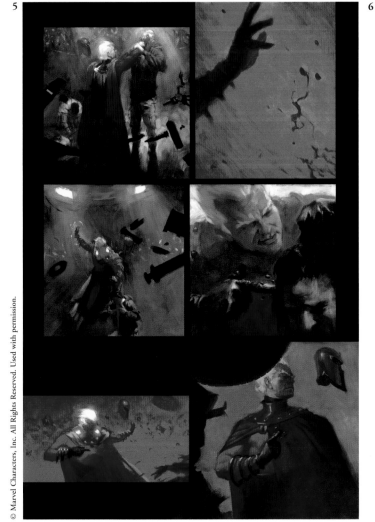

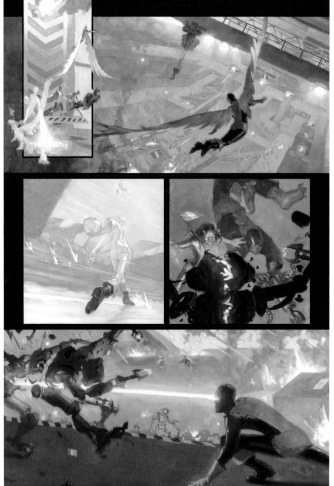

1
artist: **James Jean**
art director: Shelly Bond
client: DC Comics/Vertigo
title: Fables #54
medium: Acrylics
size: 22"x30"

2
artist: **Rick Berry**
art director: Nick Lowe/
Neil Gaiman
client: Marvel Comics
title: The Eternals
medium: Oil/digital
size: 6³/4"x10¹/4"

3
artist: **Nic Klein**
art director: Andreas Keiser
client: Edition-Panel
title: Chapter Onw
medium: Digital

4
artist: **Ben Olson**
art director: Frank Forte
client: Asylum Press
title: Warlash: Zombie
Mutant Genesis
medium: Digital
size: 7"x10¹/2"

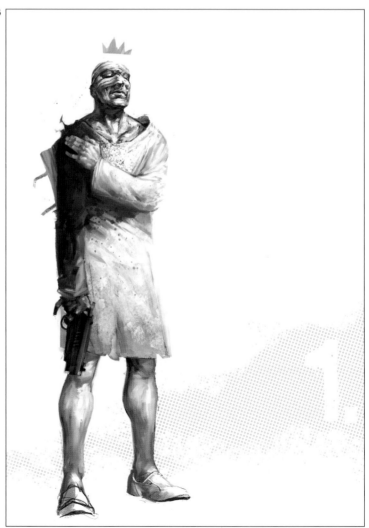

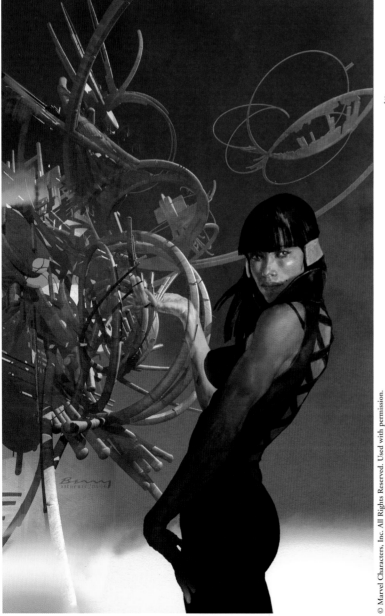

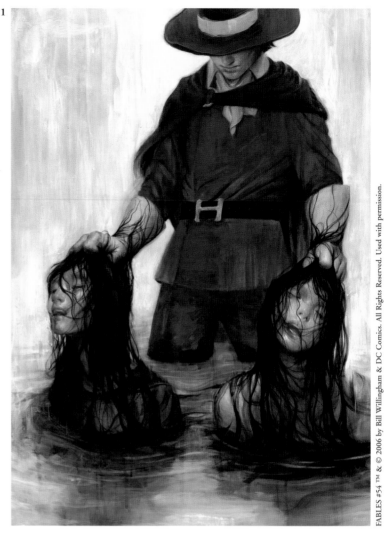

4

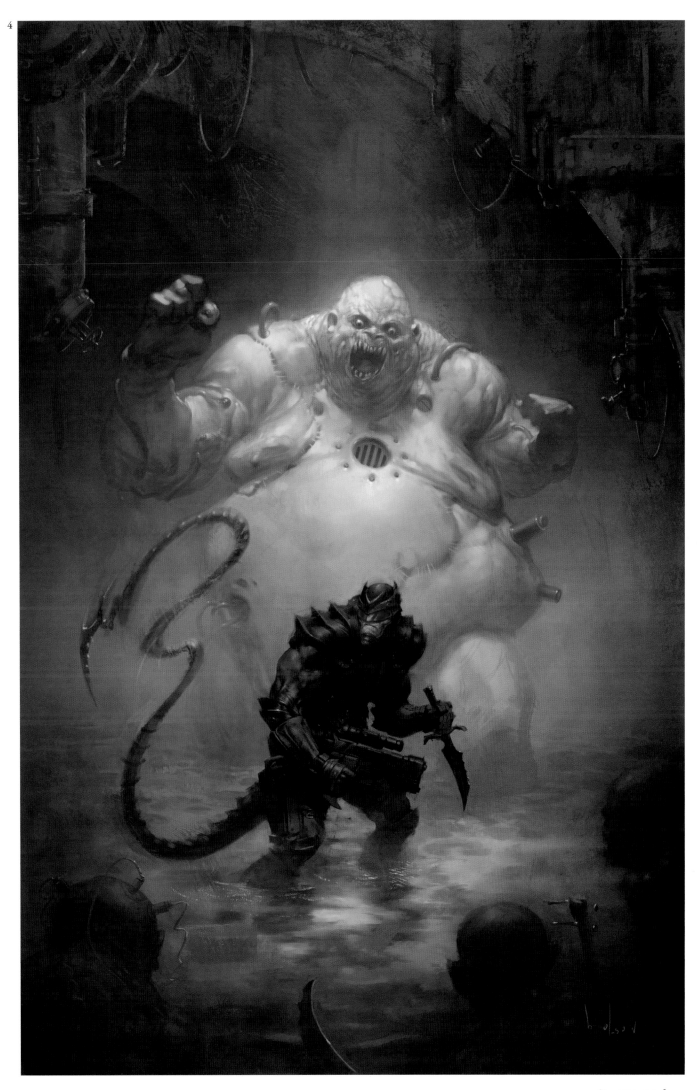

1
artist: **Brandon Peterson**
client: Marvel Comics
title: Ultimate Vision 2
medium: Pen & ink/digital
size: 7"x10½"

2
artist: **Arthur Adams**
title: Sampler V Title Page
medium: Pen & ink
size: 6"x10½"

3
artist: **Christian Gossett**
designer: Emil Petrinic
client: The Red Star
title: Knight at the Crossroads
medium: Pencil/Photoshop
size: 11"x16"

4
artist: **Gary Gianni**
client: King Features Syndicate, Inc.
title: Prince Valiant
medium: Pen & ink
colorist: Scott Roberts
size: 13"x19"

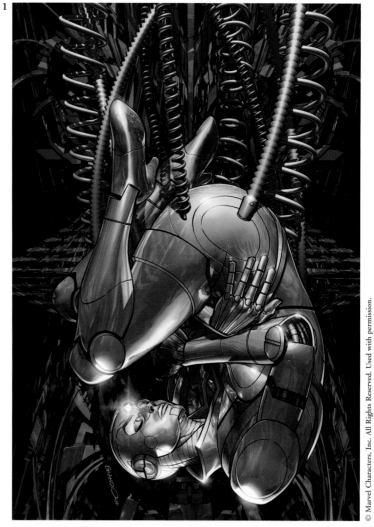

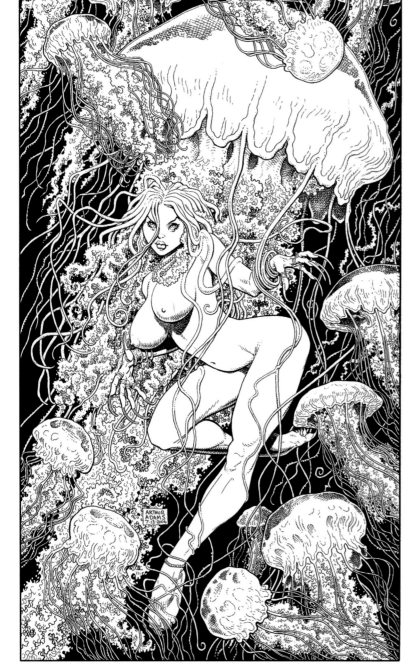

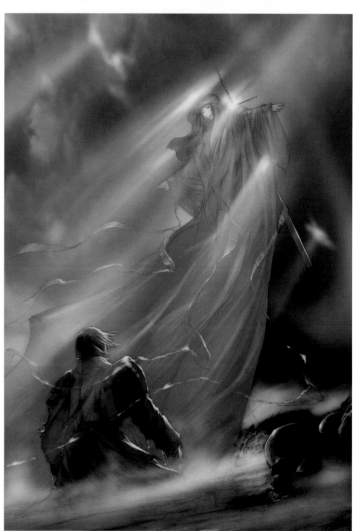

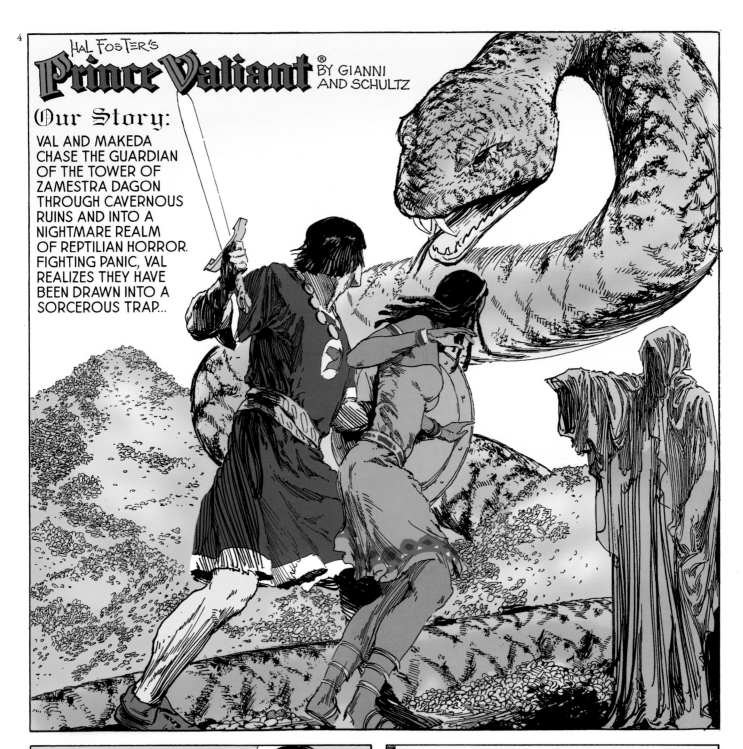

Hal Foster's Prince Valiant

BY GIANNI AND SCHULTZ

Our Story: VAL AND MAKEDA CHASE THE GUARDIAN OF THE TOWER OF ZAMESTRA DAGON THROUGH CAVERNOUS RUINS AND INTO A NIGHTMARE REALM OF REPTILIAN HORROR. FIGHTING PANIC, VAL REALIZES THEY HAVE BEEN DRAWN INTO A SORCEROUS TRAP...

...BUT THE GIRL HE SEEKS TO PROTECT SEEMS OBLIVIOUS TO THE DANGER. SHE STRUGGLES FREE OF HER DUMBSTRUCK PROTECTOR...

3653

...AND MOUTHING TERRIBLE INCANTATIONS, RUSHES TO MEET THE SCALED MOSTROSITY CRAWLING TOWARD HER!

NEXT WEEK:
Cat and Mouse

1
artist: **Charles Vess/Michael Kaluta**
art director: Shelly Bond
client: DC Comics/Vertigo
title: 1001 Nights of Snowfall
medium: Colored inks
size: 11"x16"

2
artist: **Jay Anacleto**
art director: Brian Jon Haberin
client: Todd McFarlane Prod.
title: Llyra
medium: Pencil/digital
colorist: Brian Jon Haberin
size: 11"x17"

3
artist: **Todd Lockwood**
art director: Mark Powers
client: Devil's Due Publishing, Inc.
title: Drizzt & Guenhwyvar
medium: Digital
size: 15"x22"

4
artist: **Charles Vess/Michael Kaluta**
art director: Shelly Bond
client: DC Comics/Vertigo
title: 1001 Nights of Snowfall
medium: Colored inks
size: 11"x16"

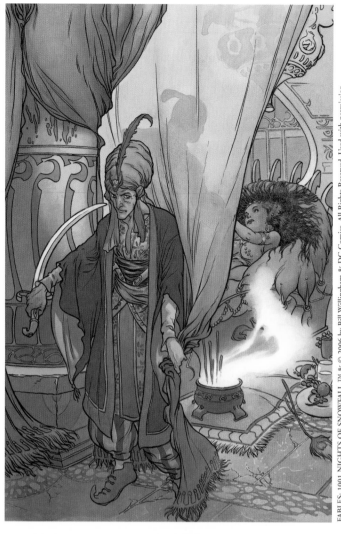

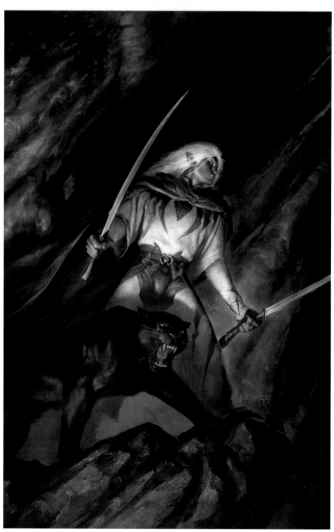

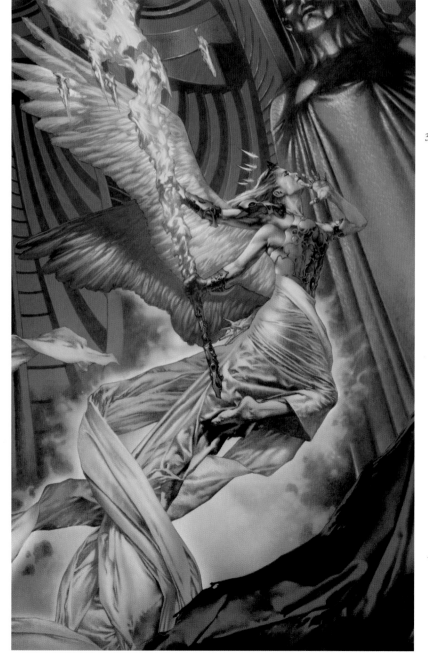

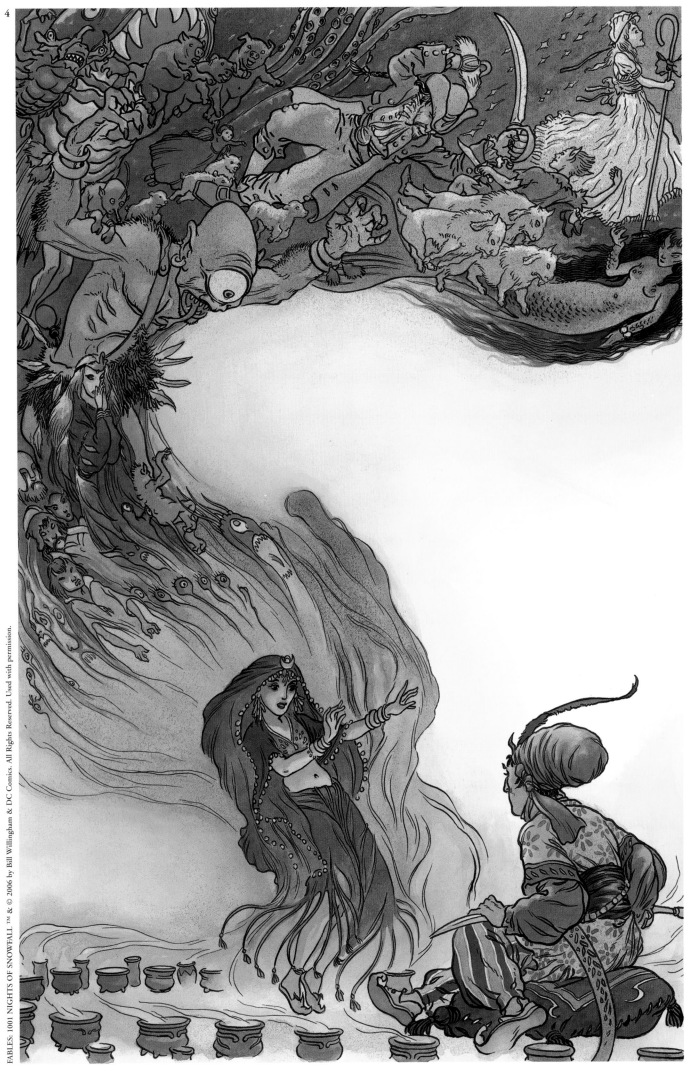

1
artist: **Adam Hughes**
art director: Mark Chiarello
designer: Adam Hughes
client: DC Comics
title: Catwoman #64
medium: Pen & ink/digital

2
artist: **Adam Hughes**
art director: Mark Chiarello
designer: Adam Hughes
client: DC Comics
title: Supergirl & The Legion
of Superheroes #23
medium: Pen & ink/digital

3
artist: **Adam Hughes**
art director: Mark Chiarello
designer: Adam Hughes
client: DC Comics
title: Catwoman #56
medium: Pen & ink/digital

4
artist: **Adam Hughes**
art director: Mark Chiarello
designer: Adam Hughes
client: DC Comics
title: Catwoman #57
medium: Pen & ink/digital

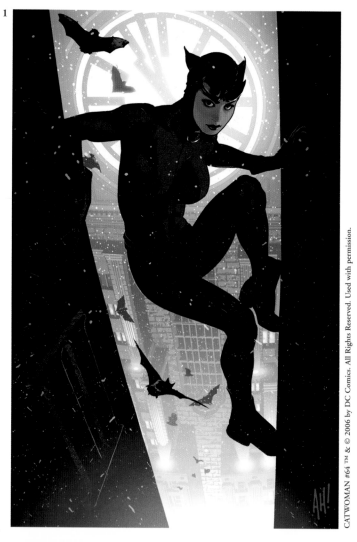

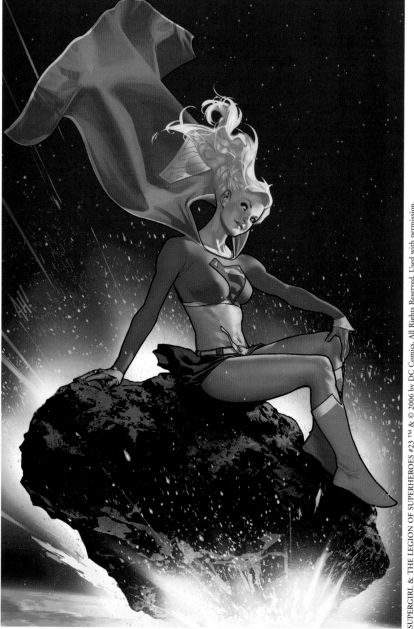

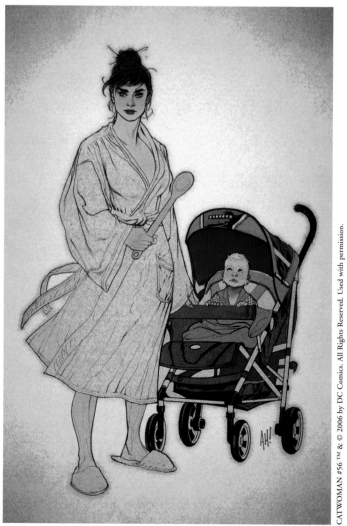

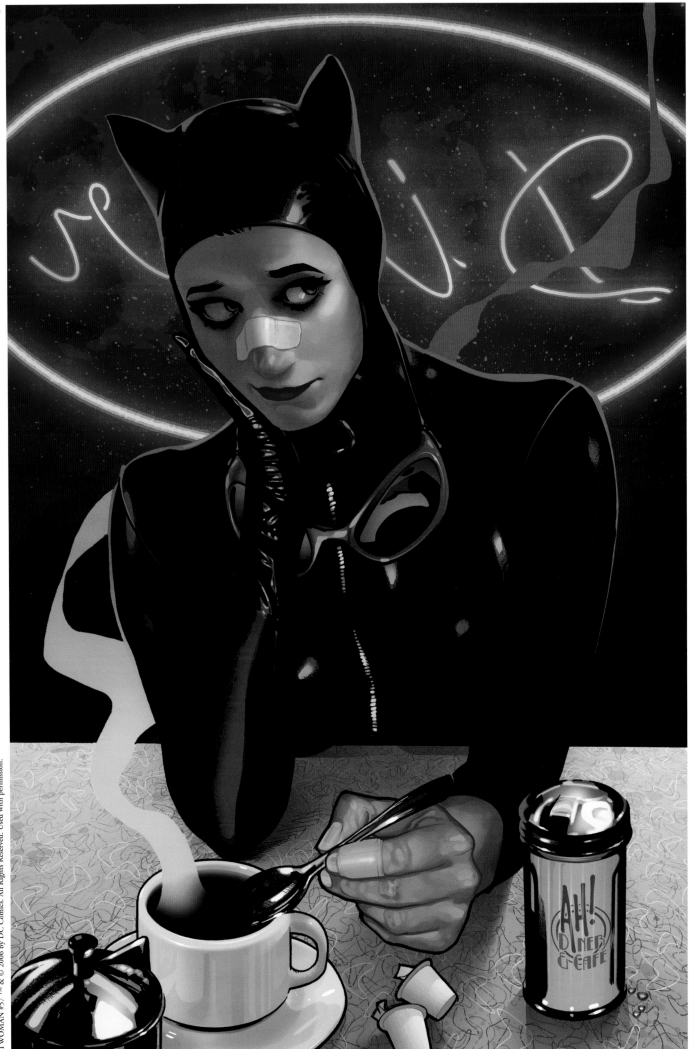

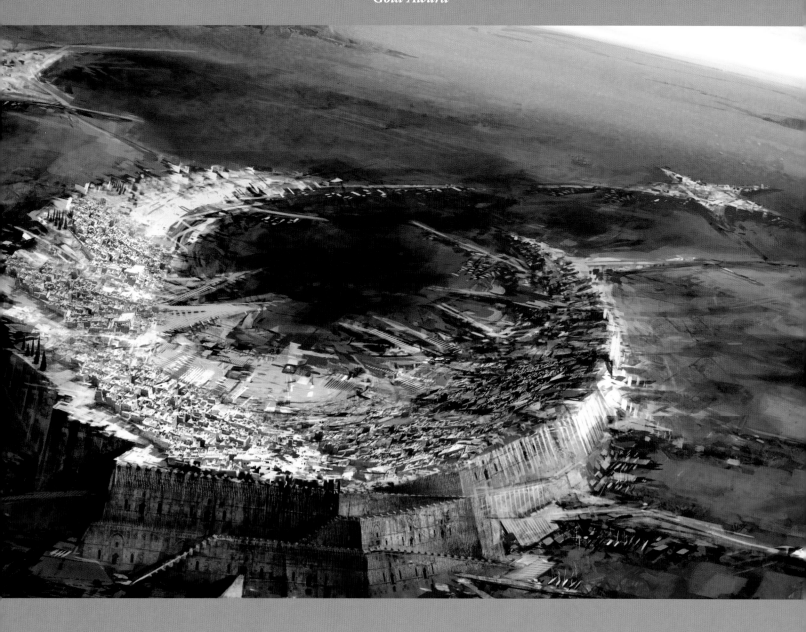

artist: Daniel Dociu

art director: Daniel Dociu *client:* Arenanet/GuildWars *title:* Crescent City *medium:* Digital

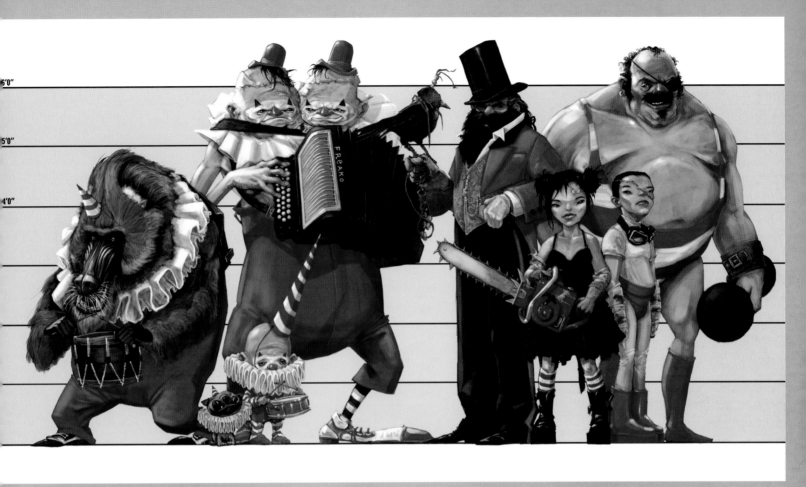

6'0"

5'0"

4'0"

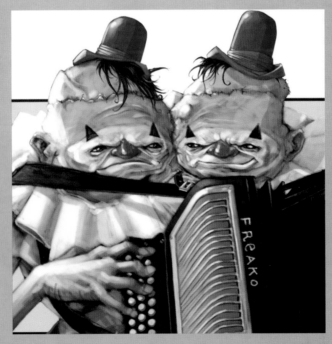

artist: Jonny Duddle

client: Future Publishing *title:* The Circus Freako *medium:* Digital *size:* 19"x11¹/2"

1
artist: **Andrew Jones aka "Android"**
client: Massive Black
title: Speaker Fist
medium: Digital
size: 40^{1}/$_{16}$"x40^{1}/$_{16}$"

2
artist: **Andrew Jones aka "Android"**
client: Massive Black
title: The Purge
medium: Digital
size: 40^{1}/$_{16}$"x26^{5}/$_{8}$"

3
artist: **Brian Despain**
art director: Brian Sostrom
client: Snowblind Studios
title: Lost Gods
medium: Digital
size: 6"x8"

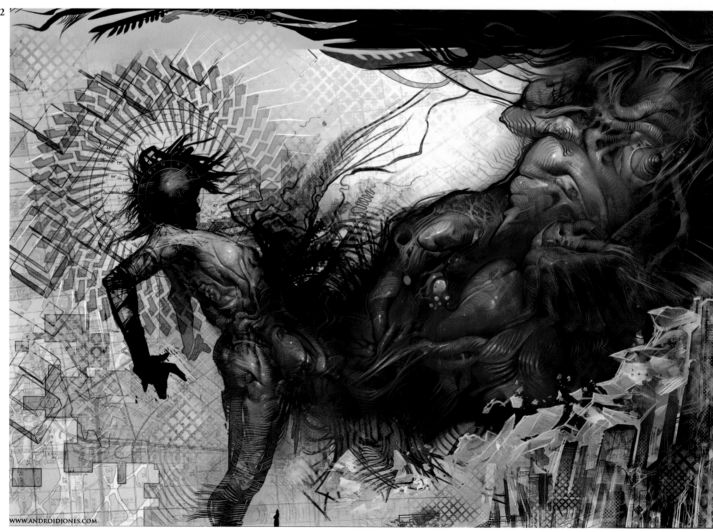

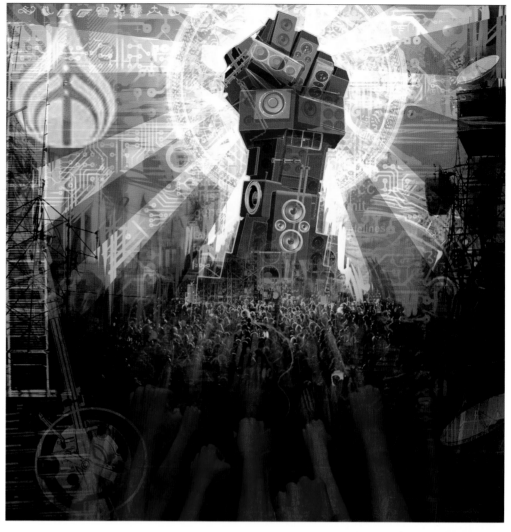

WWW.ANDROIDJONES.COM

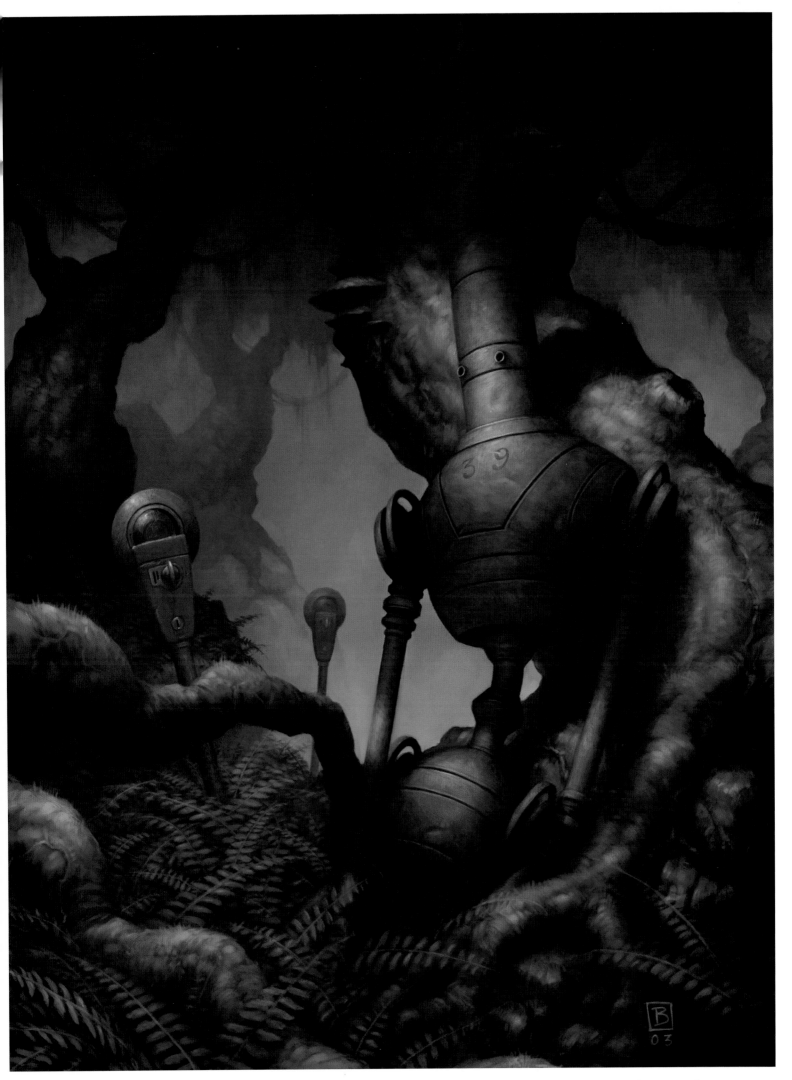

1
artist: **Coro**
art director: Coro
client: Massive Black
title: Bird Man
medium: Mixed
size: 8"x11"

2
artist: **Jeff Haynie**
art director: Jeff Haynie
client: THQ/Cranky Pants Games
title: The Graveyard/Evil Dead Regneration
 PS2 & Xbox Game
medium: Digital
size: 15³/4"x6³/4"

3
artist: **Xiao Chen Fu**
art director: Xiao Chen Fu
client: Suzhou Digigon Group
title: The Demon Gate
medium: Photoshop
size: 16⁵/8"x12"

4
artist: **William Stout**
art director: Guillermo del Toro
designer: William Stout
client: Guillermo del Toro/Pan's Labyrinth
title: Ancient Goat Creature (*El Fauno*)
medium: Ink & watercolor on board
size: 17"x11"

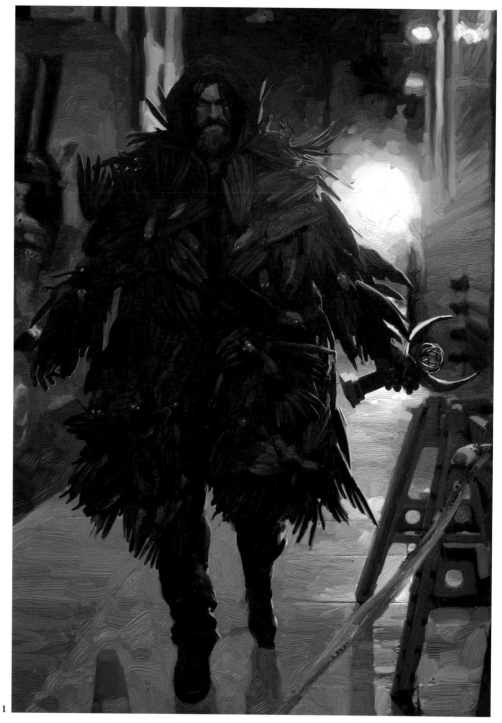

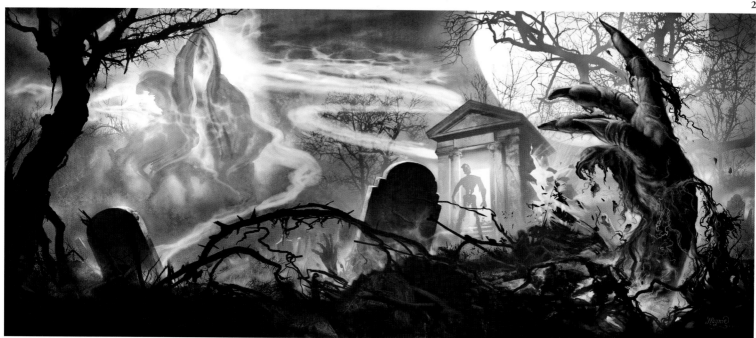

3

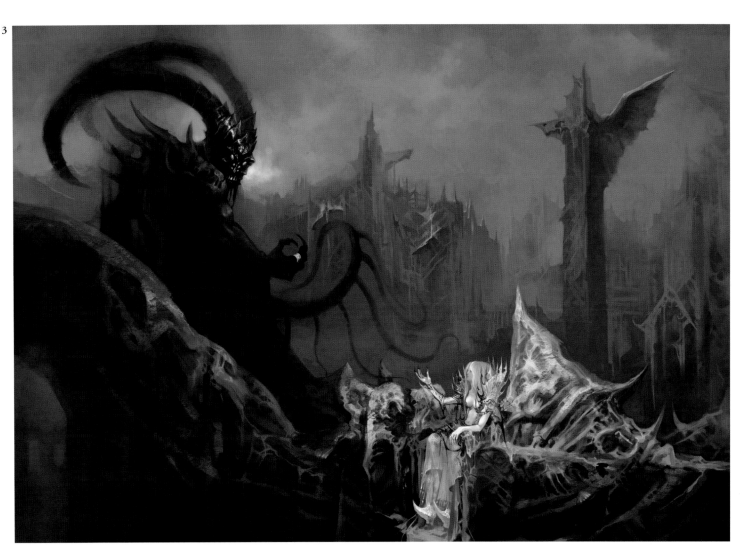

4

ANCIENT GOAT CREATURE
MONSTRUO CABRION (Muy Viejo)

PAN'S LABYRINTH WS-002

1
artist: **Francis Tsai**
title: Royal Operator

2
artist: **Wayne Lo/Jason Courtney/**
James Zhang
art director: Wayne Lo
client: Factor 5—"Lair"
title: Storm Dragon
medium: Mixed/digital

3
artist: **Nox**
art director: Massive Black
client: Secret Level
title: The Chase
medium: Digital

4
artist: **Anthony Ermio/Wayne Lo/**
Jason Courtney
art director: Wayne Lo
client: Factor 5—"Lair"
medium: Mixed/digital

5
artist: **Bruno Werneck**
title: Nightingale: Departure
medium: Digital
size: 17"x9"

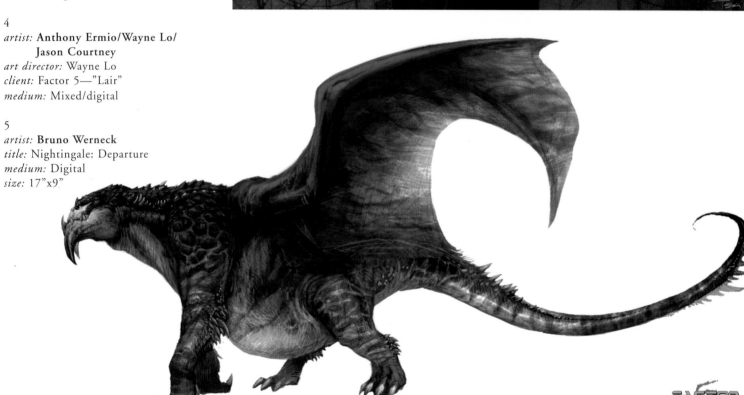

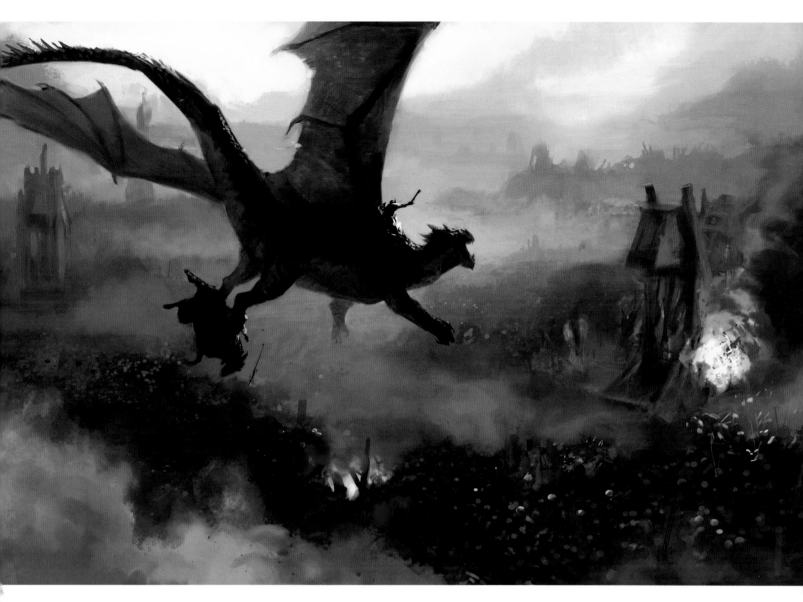

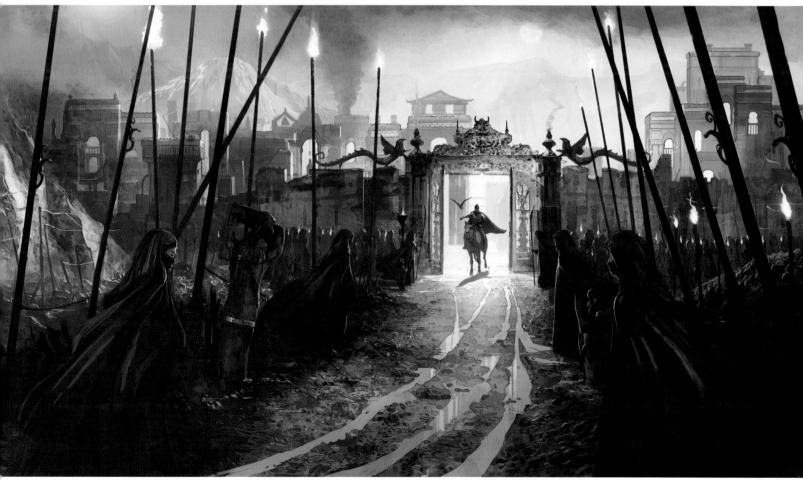

1
artist: **Nurö**
art director: Canon Thierry
client: Specimen
title: B4 Spirit Bomber
medium: Digital

2
artist: **Francis Tsai**
title: Translight Jump
medium: Digital
size: 10"x6"

3
artist: **Fred Gambino**
art director: John Davis
client: DNA Productions
title: The Ant Bully: Zoc's Lab
medium: Digital

4
artist: **Jeffrey Dean Murchie**
art director: Yaming Di
client: Turbine Entertainment
 Software
title: The Lord of the Rings Online:
 Witch King
medium: Digital

5
artist: **Ryan Woodward/**
 Sandman Studios
creative director: Trainor Houghton
art director: Stephen Sobisky/
 Ryan Woodward
client: Penny-Farthing Press
title: The Loch Trilogy
medium: Mixed/digital

6
artist: **Mike Bruinsma**
client: Mike Bruinsma Art & Design
title: Spiny Cranimus
medium: Digital
size: 17"x11"

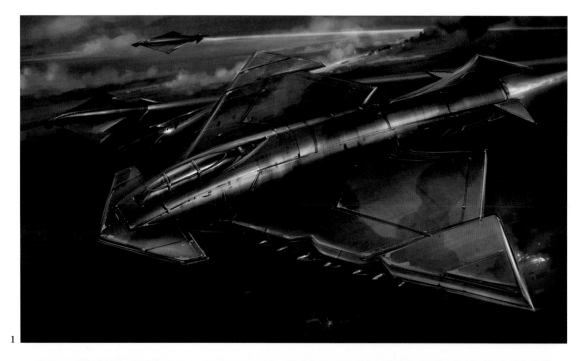

1

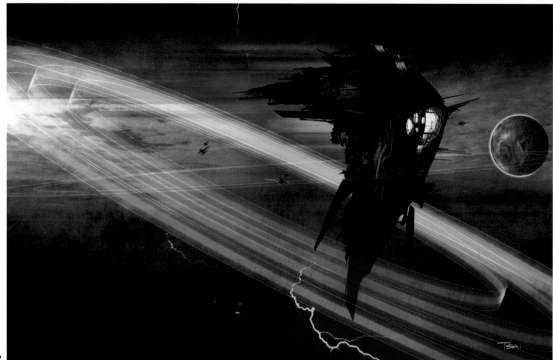

2

3

4

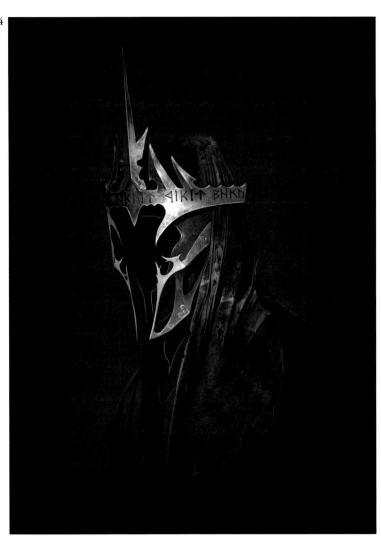

5

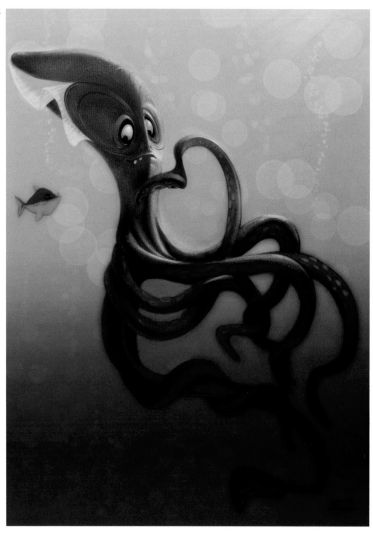

6

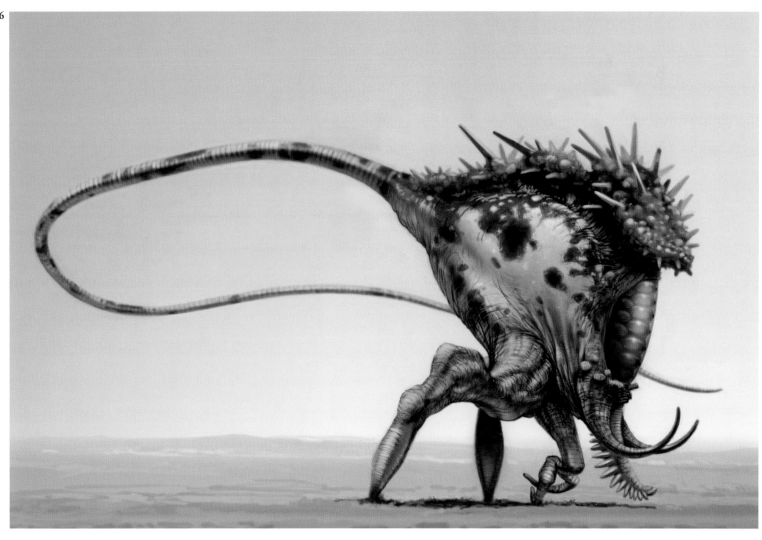

1
artist: **Daniel Dociu**
art director: Daniel Dociu
client: Arenanet/GuildWars
title: Floating Mosque
medium: Digital

2
artist: **Jerome Opena**
art director: Wayne Lo
client: Factor 5—"Lair"
title: Rohn
medium: Pencil

3
artist: **Vincent Proce**
art director: Stephan Martiniere/
 Jason Kaehler
client: Midway Games
title: Twins (Thing 1 & Thing 2)
medium: Digital

4
artist: **Vincent Proce**
art director: Murphy Michaels
client: Midway Games
title: Royal City
medium: Digital
size: 44"x34"

5
artist: **Daniel Dociu**
art director: Daniel Dociu
client: Arenanet/GuildWars
title: Temple
medium: Digital

1

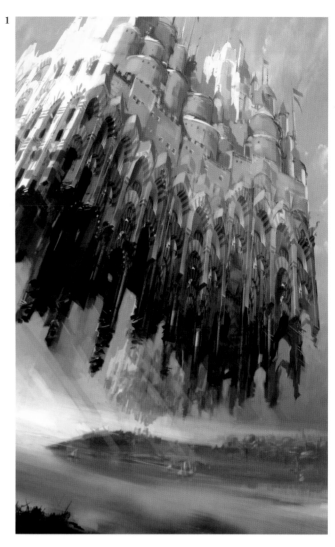

2

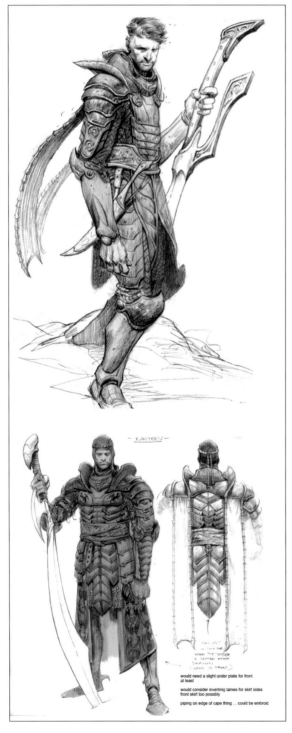

3

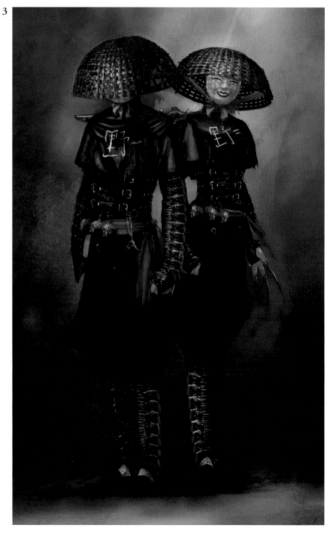

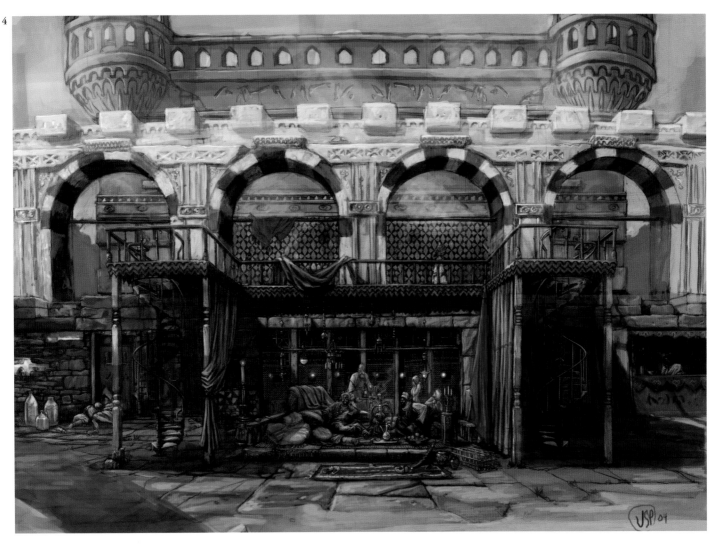

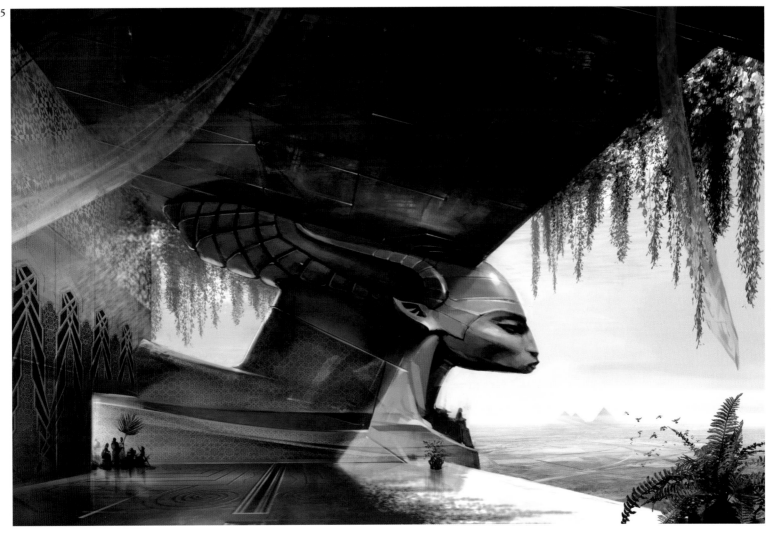

1
artist: **Mark Hendrickson**
title: Charred Ancient
medium: Digital
size: 8"x10"

2
artist: **Emmanuel Malin**
title: Mekanics/3
medium: Digital
size: 9"x12"

3
artist: **Michael Phillippi**
art director: Greg Grimsby
client: EA Mythic
title: Empire War Altar
medium: Digital

4
artist: **Robh Ruppel**
client: Bar Libres
title: Mega City
medium: CS2
size: 11"x17"

5
artist: **Robh Ruppel**
client: Bar Libres
title: Docking
medium: CS2
size: 11"x17"

1

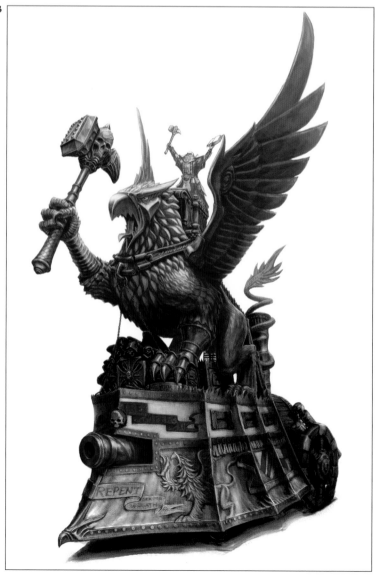

2

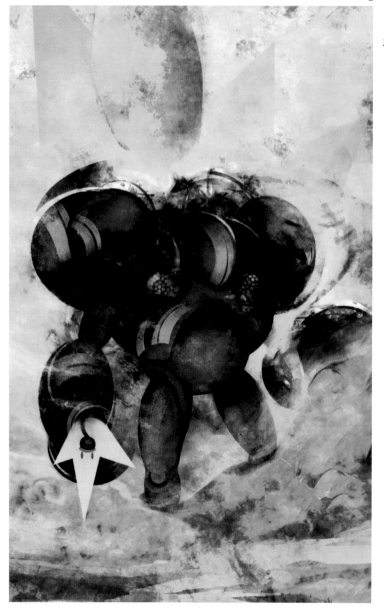

3

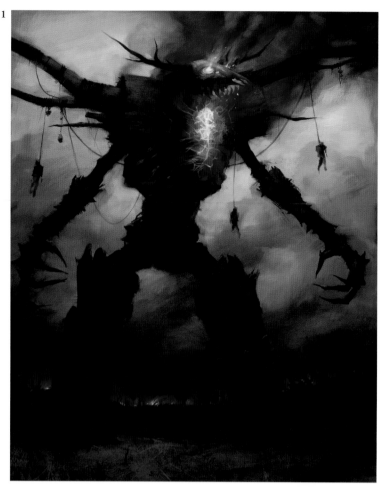

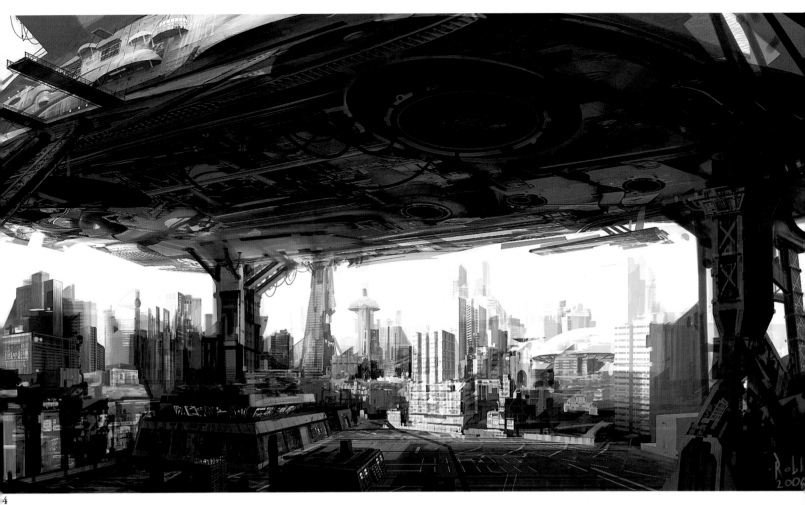

4

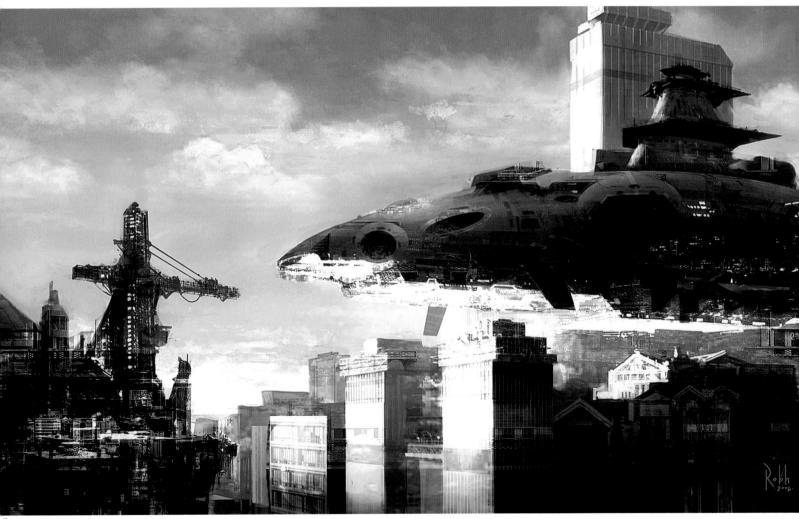

5

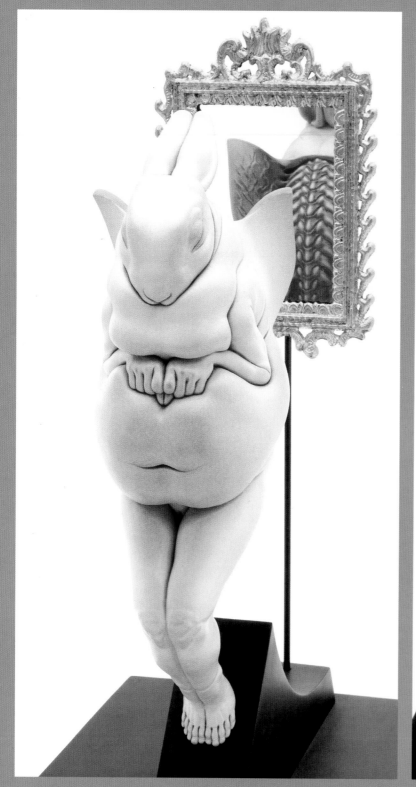 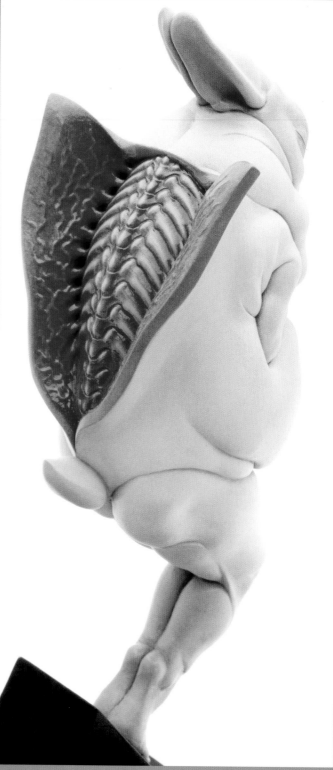

artist: Cam De Leon

art director: Cam De Leon *photographer:* Ben Zhu/Gallery Nucleus *client:* Happy Pencil *title:* Not Tested On
size: 14"x10"x12" *medium:* Polymer clay, wood, mirror

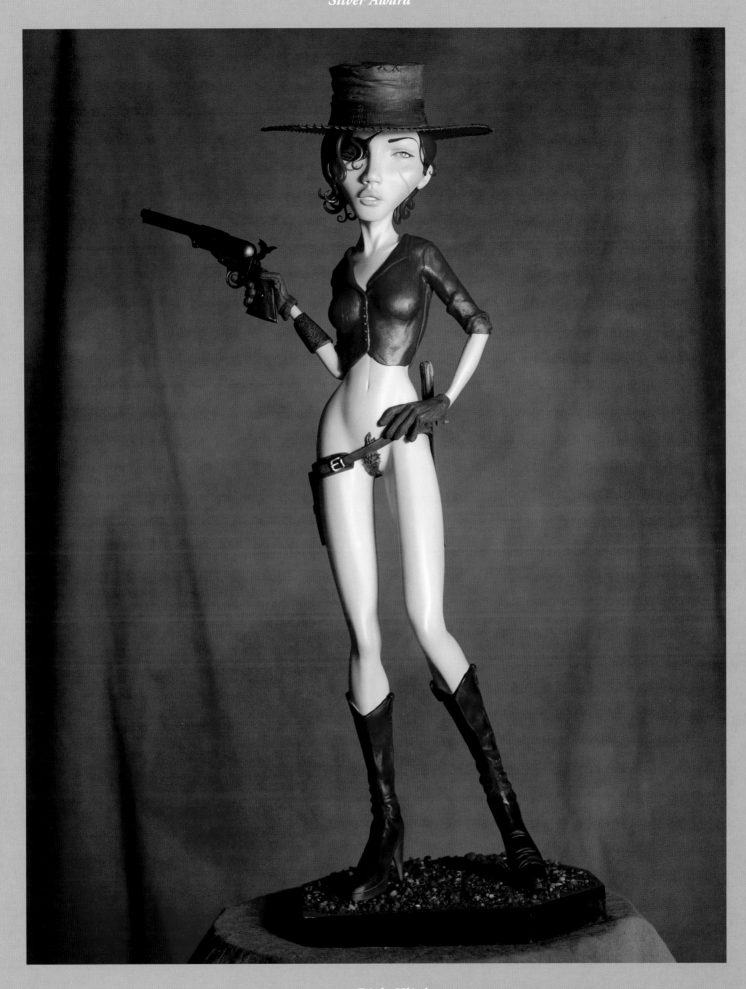

artist: Rich Klink

title: Cinnamon *medium:* Mixed *size:* 23" tall

1
artist: **Michael Defeo/Shaun Cusick**
designer: Peter de Sève
client: 20th Century Fox
title: Villains: Ice Age 2
medium: Resin
size: 11"

2
artist: **The Shiflett Bros.**
photographer: Chad Michael Ward
title: Ol' Scratch
medium: Polymer clay
size: 11^1/$_2$" tall

3
artist: **Mark Newman**
client: Mark Newman Sculpture, Inc.
title: Frankenstein's Monster
medium: Painted resin
size: 15^1/$_2$" tall

4
artist: **Thomas S. Kuebler**
title: Dr. Nighty Night
medium: Silicone/mixed
size: Life-size

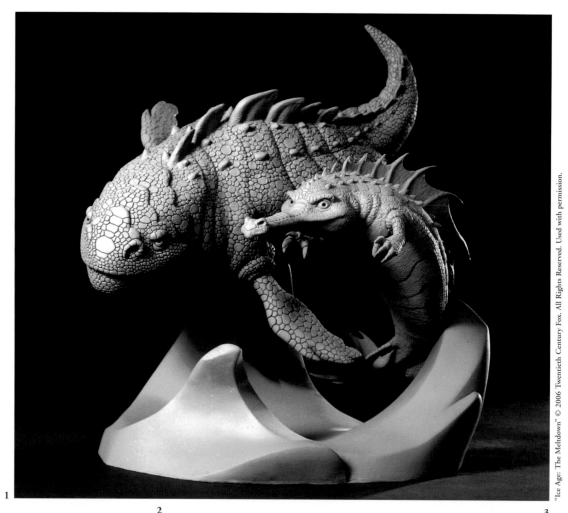

1

2

3

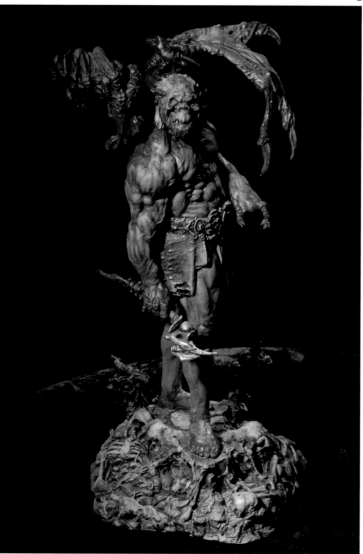

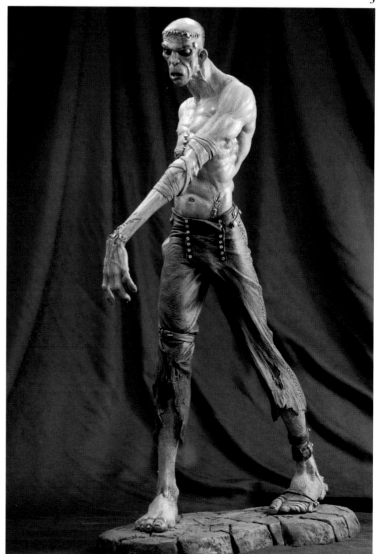

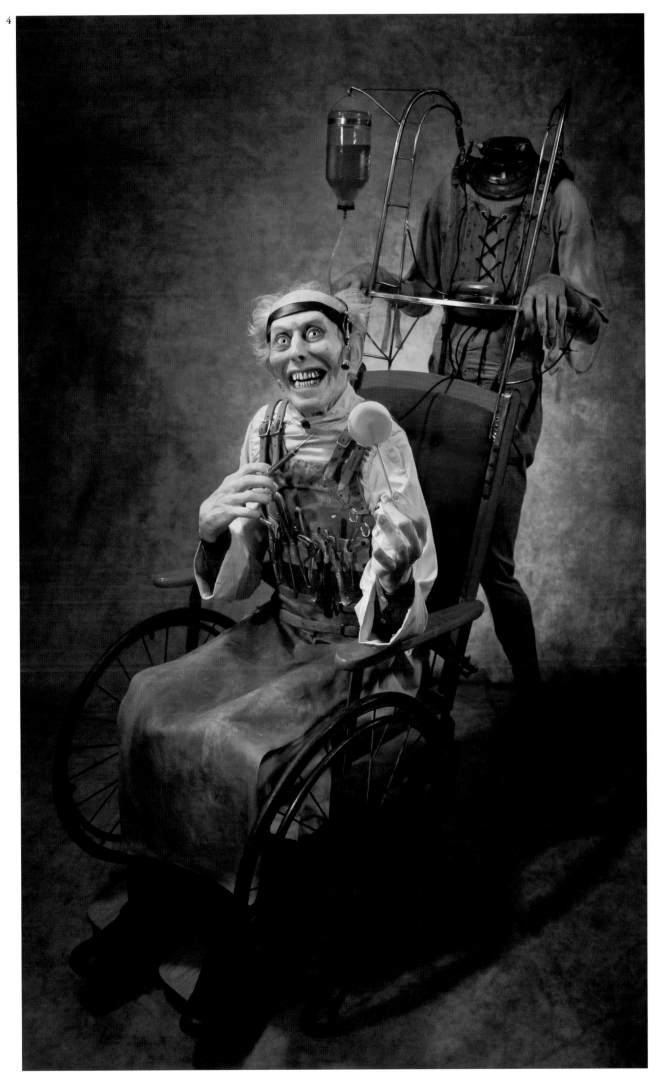

1
artist: **A. Brent Armstrong**
title: King Kong
medium: Fiberglass
size: 54"tall x 28"wide

2
artist: **Dave Cortés**
client: Inv Art
title: Pugsly
medium: Clay
painter: Brandy Anderson
size: 2"tall

3
artist: **Bill Toma**
photographer: David Kern
title: Re-Booty
medium: Stainless steel & bronze
size: 33"x19"x9"

4
artist: **Michelle Scrimpsher**
title: Tsuki, No Kage
medium: Polymer/mixed
size: 9"

5
artist: **Mike Petryszak**
art director: Frank Cho/Michael Hudson
designer: Frank Cho
client: ReelArt Studios
title: Babe & Ape
medium: Resin
painter: Rick Cantu
size: 1/8 scale

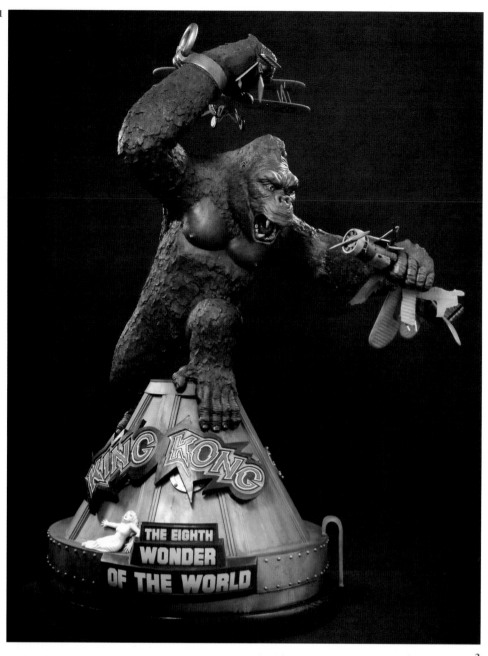

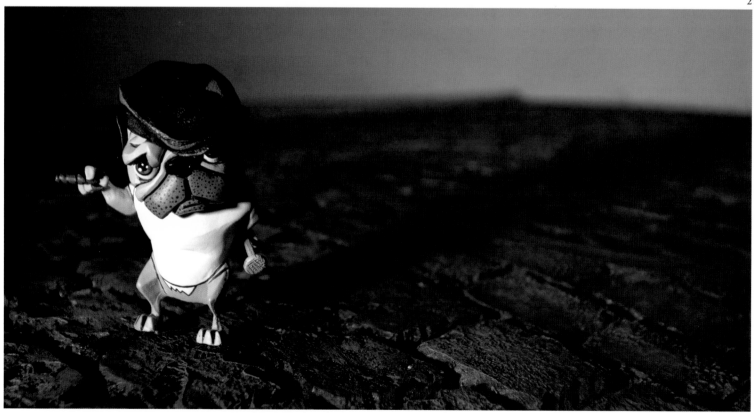

3

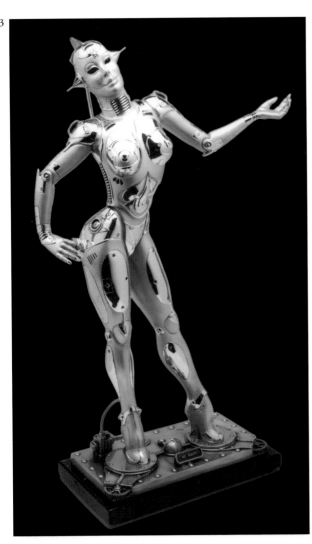

4

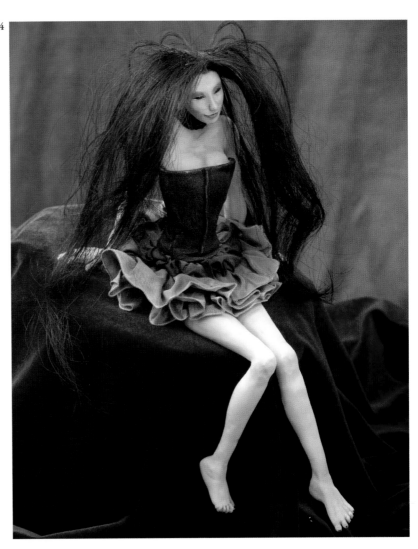

5

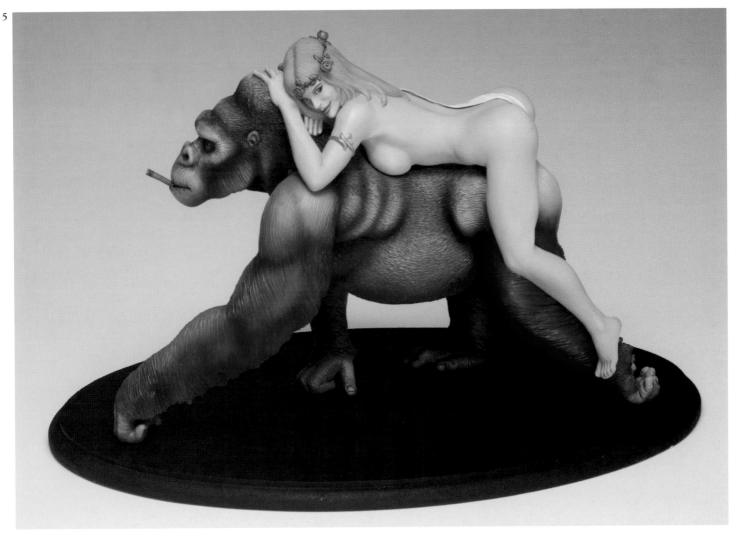

1
artist: **Mark Newman**
client: Mark Newman Sculpture, Inc.
title: Devil Dude
medium: Painted Resin
size: 18"tall

2
artist: **Clayburn Moore**
art director: David Mack/Clayburn Moore
photographer: Chris Clark
client: David Mack
title: Kabuki
medium: Bronze
size: 14^1/4"tall

3
artist: **Brian Matyas**
art director: Ben Mahan/MarkHazelrig
title: NSF Soldier
medium: Sculpey
size: 12"tall

4
artist: **Rich Klink**
title: Blotho and Squidge...Waiting
medium: Mixed
size: 23"tall

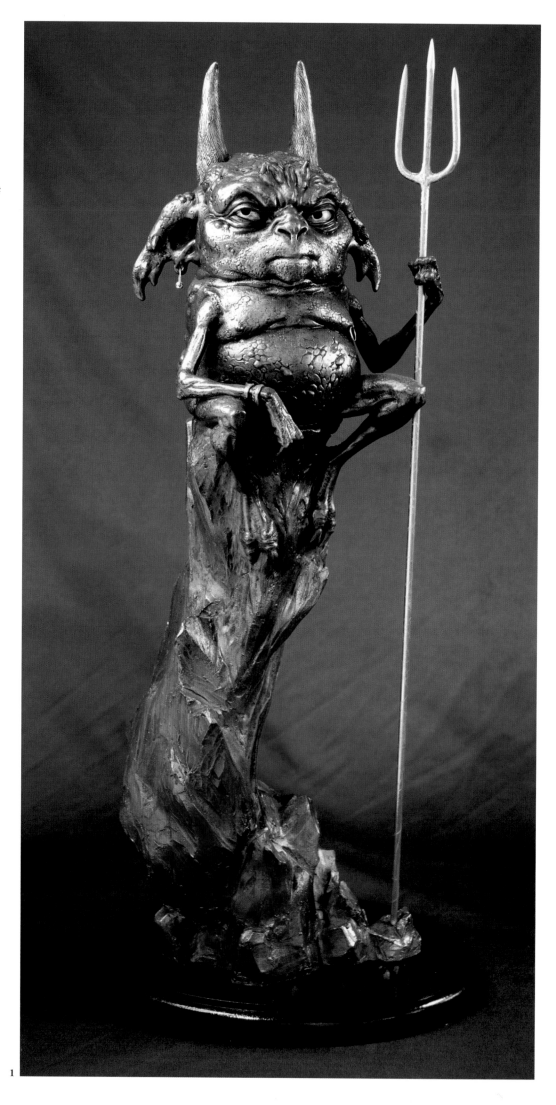

1

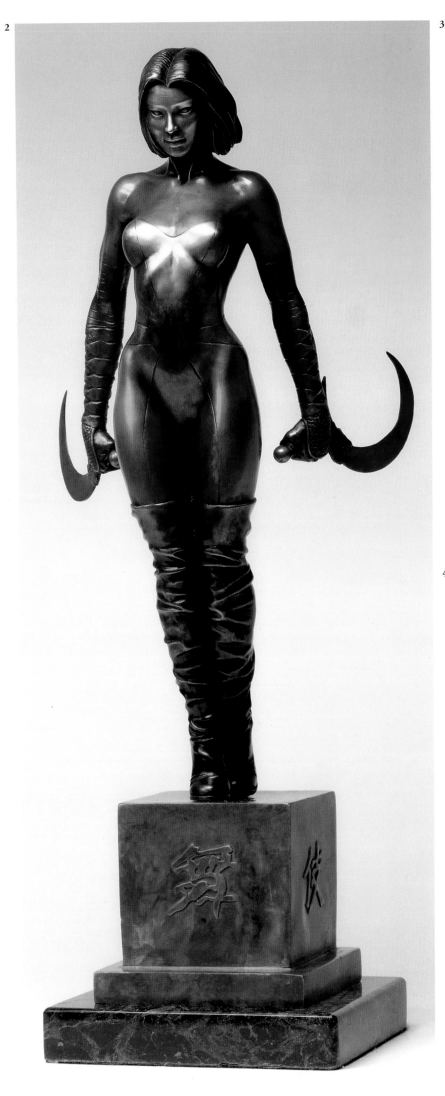

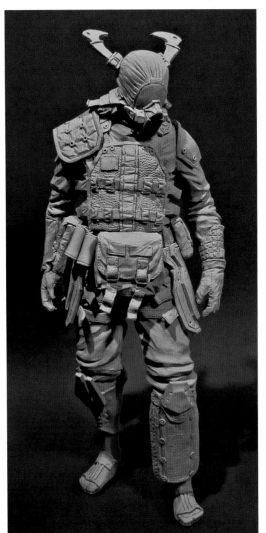

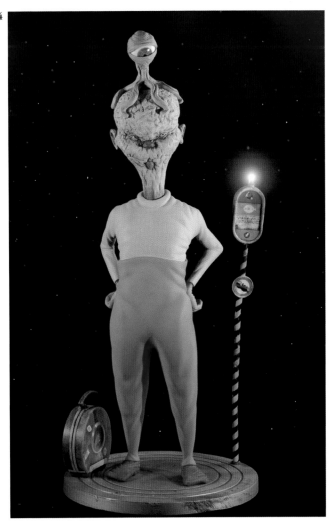

1
artist: **Mario Torres Jr.**
photographer: Matt Ullman
title: Spout
medium: Mixed
size: 18"tall x 28"wide

2
artist: **Jack Mathews**
art director: Jim Fletcher
designer: Adam Hughes
client: DC Comics/DC Direct
title: Powergirl Mini Bust
medium: Painted resin

3
artist: **Andrea Blaisich**
art director: Wayne Lo
designer: Brian Kalin O'Connell
painter: Danny Wagner/Melanie Walas
client: Factor 5—"Lair"
title: Spider Fly Maquette
medium: Plastilina/painted resin
size: 35"x26"x20"

4
artist: **Alena Wooten**
art director: Dice Tsutsumi
designer: Heinrich Kley
title: After Heinrich Kley's Sketch
medium: Super sculpey
size: 9"x8"x11"

5
artist: **Christopher Conte**
photographer: Amanda Dutton
title: Carbon Fiber Insect
medium: Found/recycled parts
size: 8"x6"x4"

6
artist: **Rubén Procopio**
art director: Tracy Mark Lee
designer: Mike Mignola
client: Electric Tiki
title: Lobster Johnson
medium: Polyform
size: 13"tall

7
artist: **Karen Palinko**
art director: Jim Fletcher
designer: Alex Ross
client: DC Comics/DC Direct
title: Elseworlds Series 3:
	Kingdom Come/Aquaman
size: 7"tall

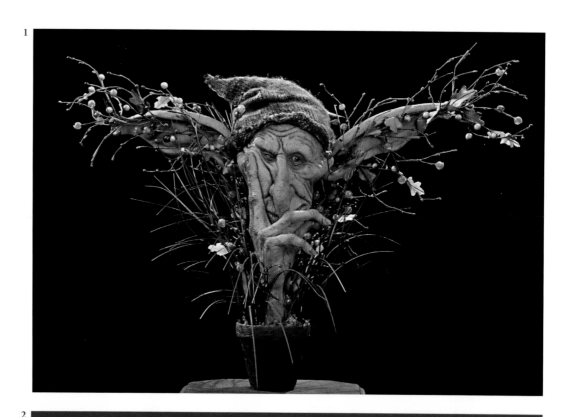

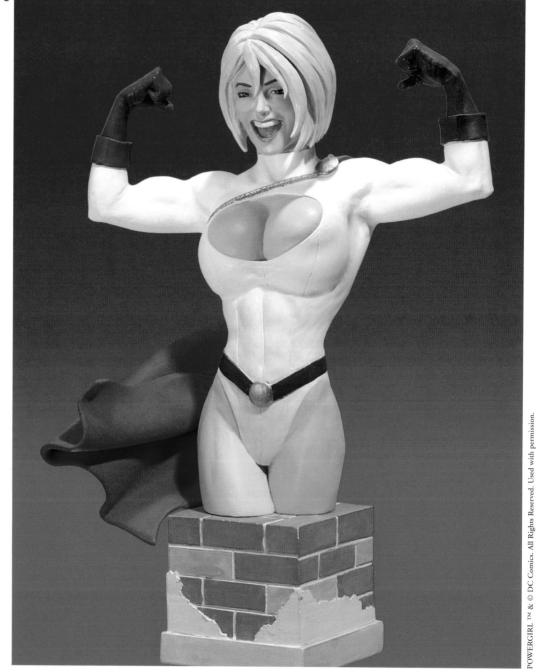

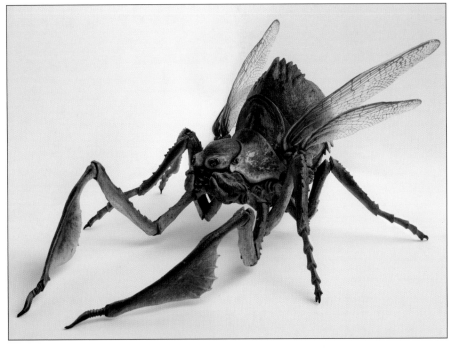

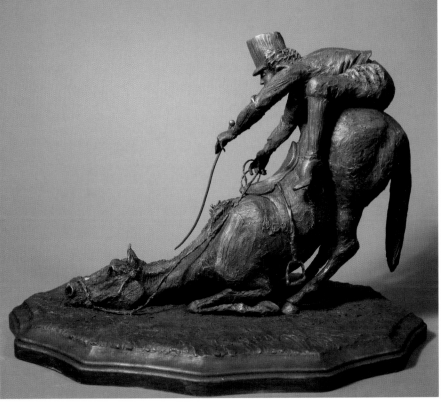

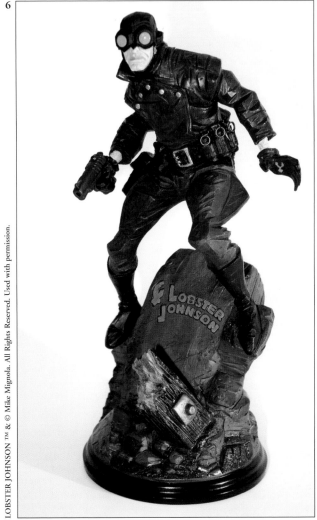

6

7

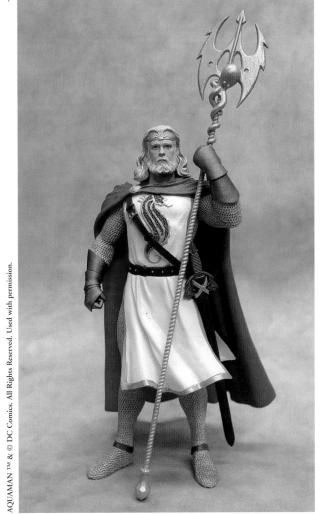

DIMENSIONAL

1
artist: **Melissa Ferreira**
title: Rendezvous
medium: Mixed
size: 13"x13"

2
artist: **Catherine Burris**
title: Step Right Up
medium: Assemblage
size: 6³/4"x15"x4"

3
artist: **Mark Newman**
client: Mark Newman
 Sculpture, Inc.
title: Conscience
medium: Painted resin
size: 16¹/2"x20¹/2"

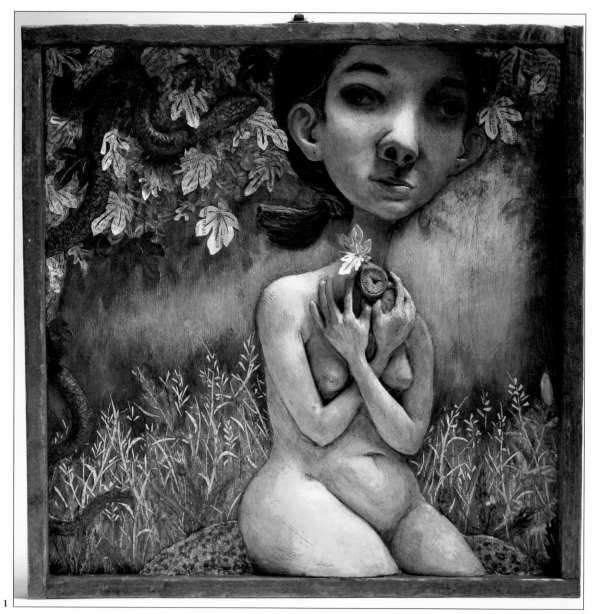

1

2

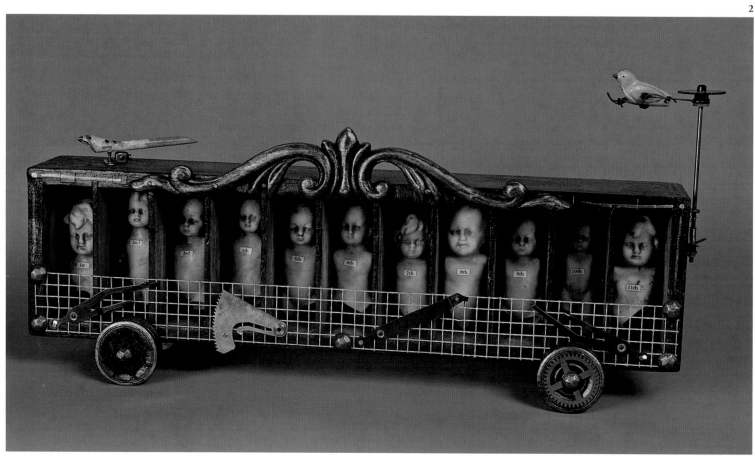

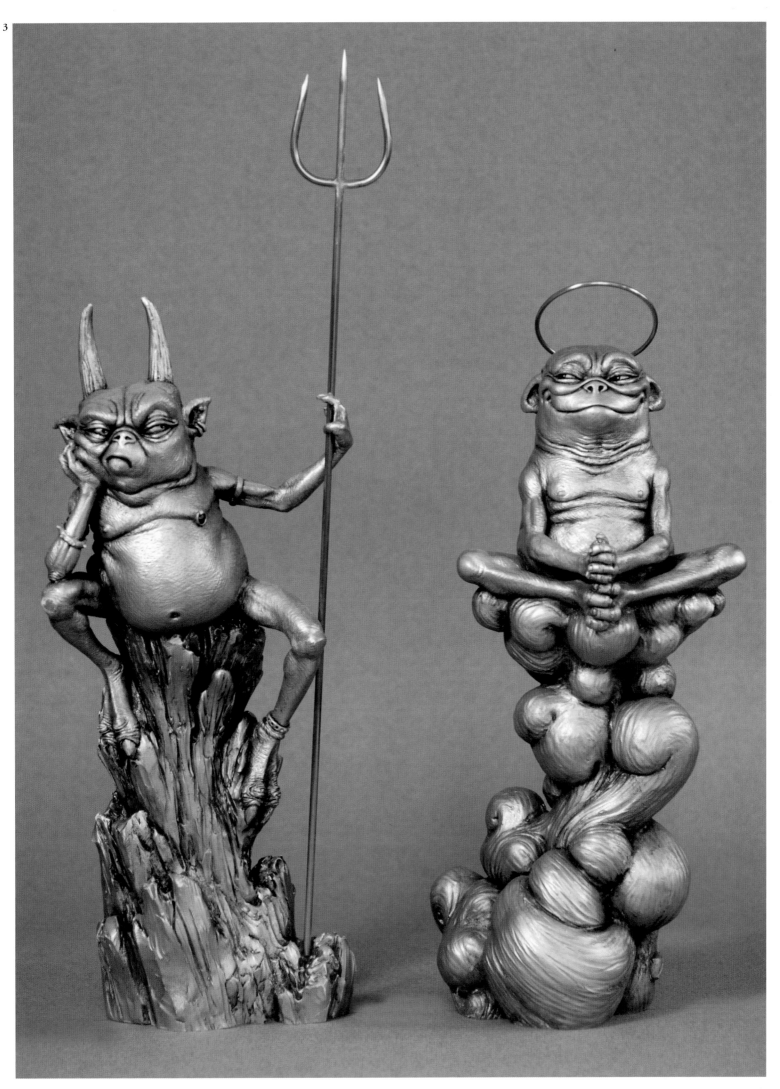

1
artist: **Vincent Villafranca**
client: Private Collection
title: The Technical Ascetic
medium: Cast bronze
size: 24"tall

2
artist: **Julie Mansergh**
client: Fairies in the Attic [FITA]
title: Rock Mermaid
medium: Polymer clay
size: 7"x10"

3
artist: **Red Nose Studio**
art director: Jennifer McGuire
client: Books and Culture
title: Spiritualism
medium: Mixed

4
artist: **Daniel Hawkins**
title: Oracle Mask
medium: Mixed
size: 38"x30"x6"

5
artist: **Kenshiro Suzuki**
title: Neko Ryu
medium: Super sculpey
size: 29"tall x 26"long

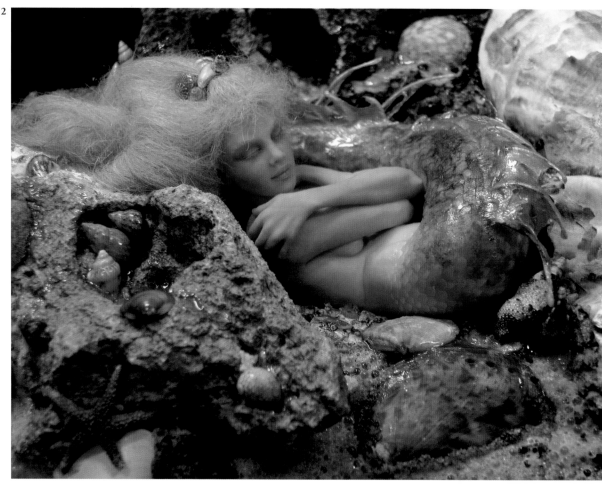

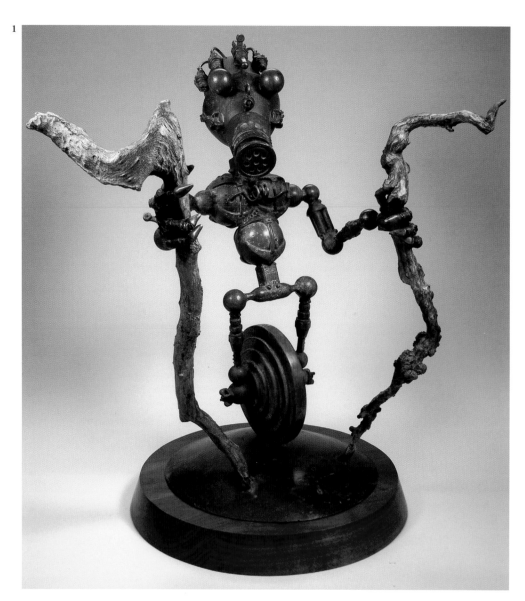

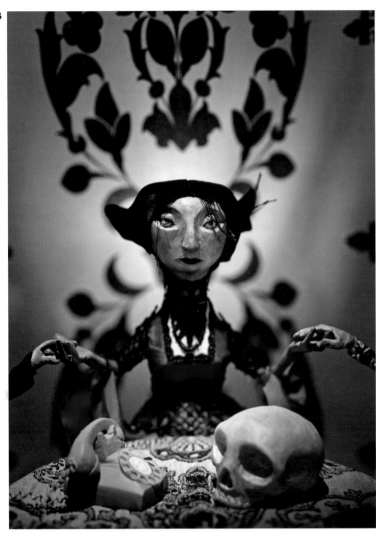

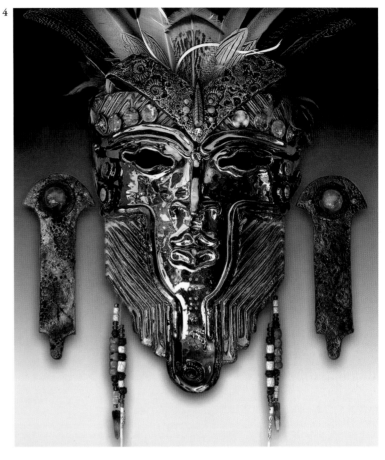

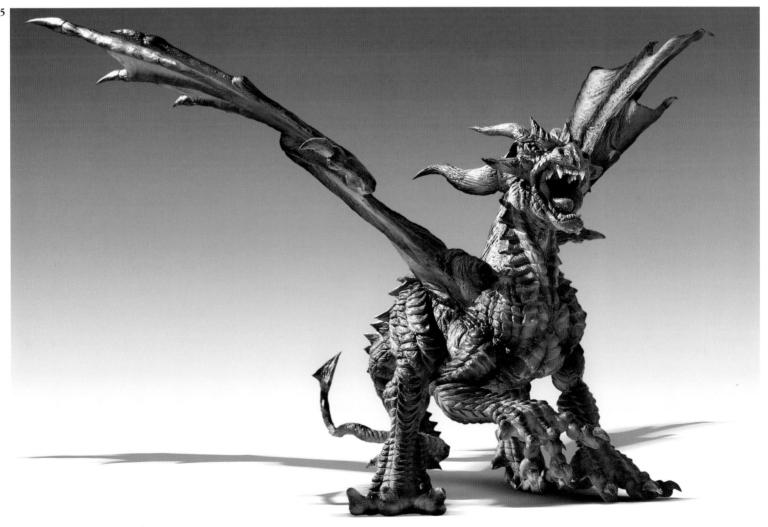

1
artist: **Shawn Nagle**
art director: Michael Hudson
designer: J. Allen St. John
client: ReelArt Studios
title: Tarzan and the Golden Lion
medium: Painted resin
painter: Joy Snyder
size: ⅛ scale

2
artist: **Mark Rehkopf**
designer: Mark Rehkopf/Research
 Casting International
client: San Diego Museum
 of Natural History
title: Albertosaur
medium: Polyester resin
size: Life-size (22')

3
artist: **Andrew Sinclair**
client: Ridgeway Sculpture Design
title: Pre-Hysteric
medium: Bronze
size: 72"tall

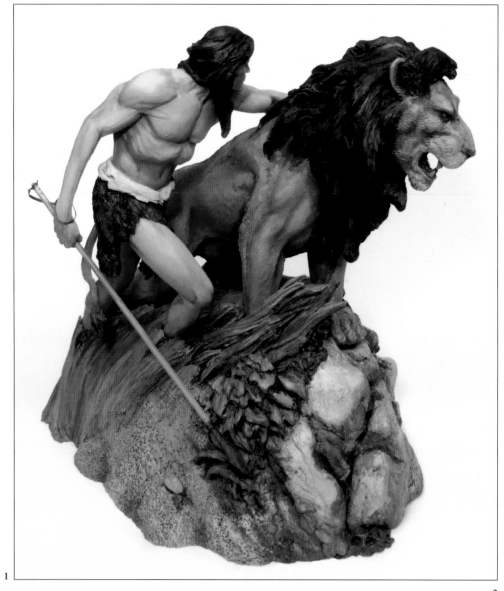

1

2

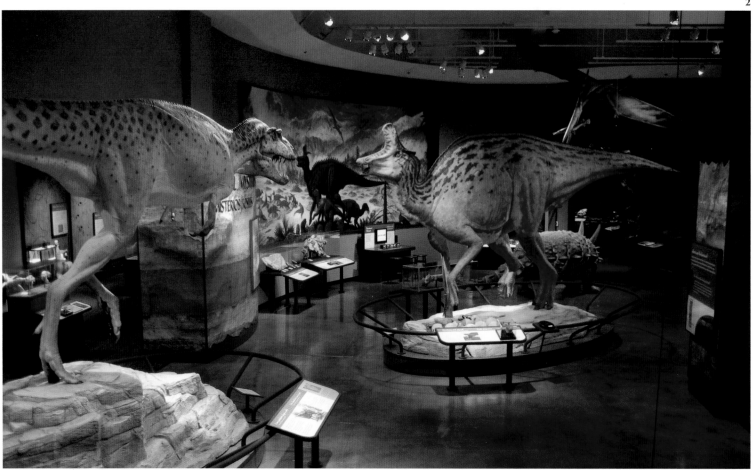

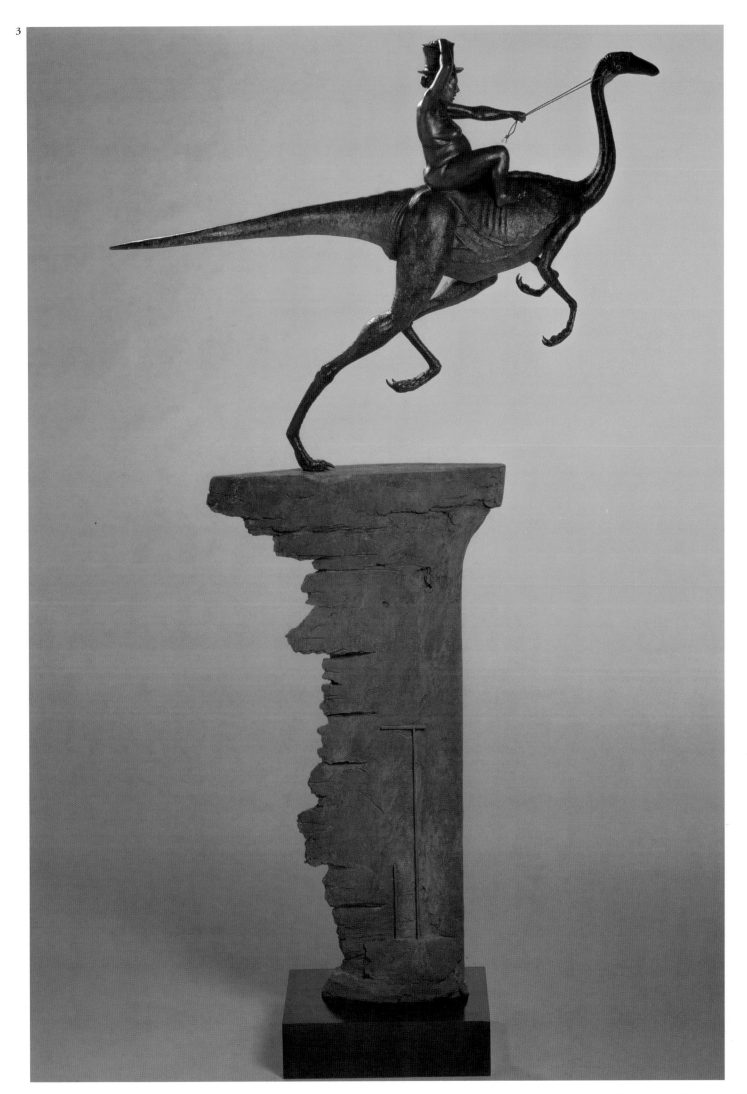

1
artist: **Ray Villafane**
art director: Georg Brewer
designer: Terry Dodson
client: DC Comics/DC Direct
title: Superman Vs Wonder Woman
medium: Painted resin

2
artist: **Karen Palinko**
art director: Jim Fletcher
designer: Alex Ross
client: DC Comics/DC Direct
title: Superman Forever
medium: Painted resin

3
artist: **Jonathan Matthews**
art director: Shawn Knapp
designer: Andy Kubert
client: DC Comics/DC Direct
title: Joker
medium: Painted resin
size: 6¹/2"tall

4
artist: **Jean St. Jean**
art director: Shawn Knapp
designer: Paul Pope
client: DC Comics/DC Direct
title: Batman Black & White
medium: Painted resin

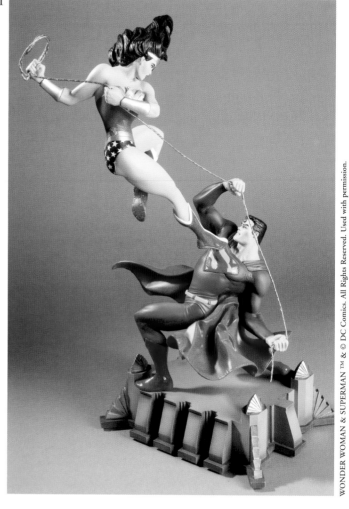

WONDER WOMAN & SUPERMAN ™ & © DC Comics. All Rights Reserved. Used with permission.

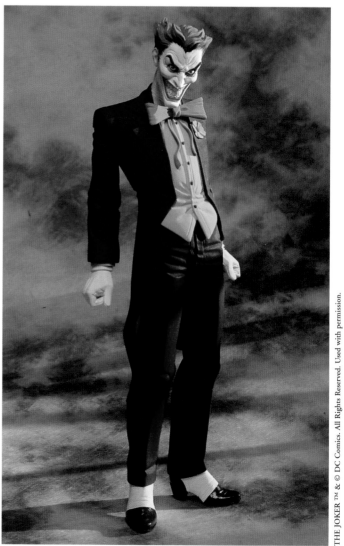

THE JOKER ™ & © DC Comics. All Rights Reserved. Used with permission.

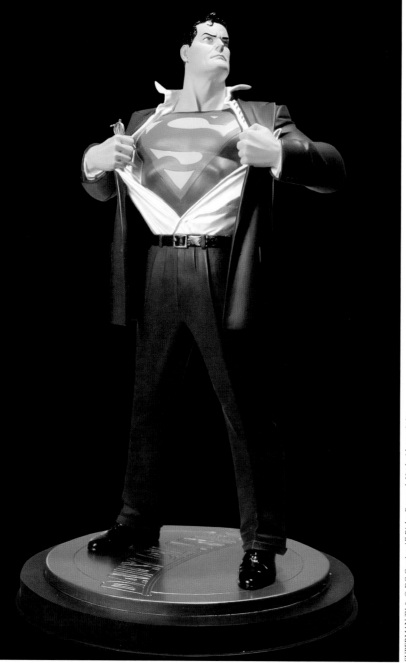

SUPERMAN ™ & © DC Comics. All Rights Reserved. Used with permission.

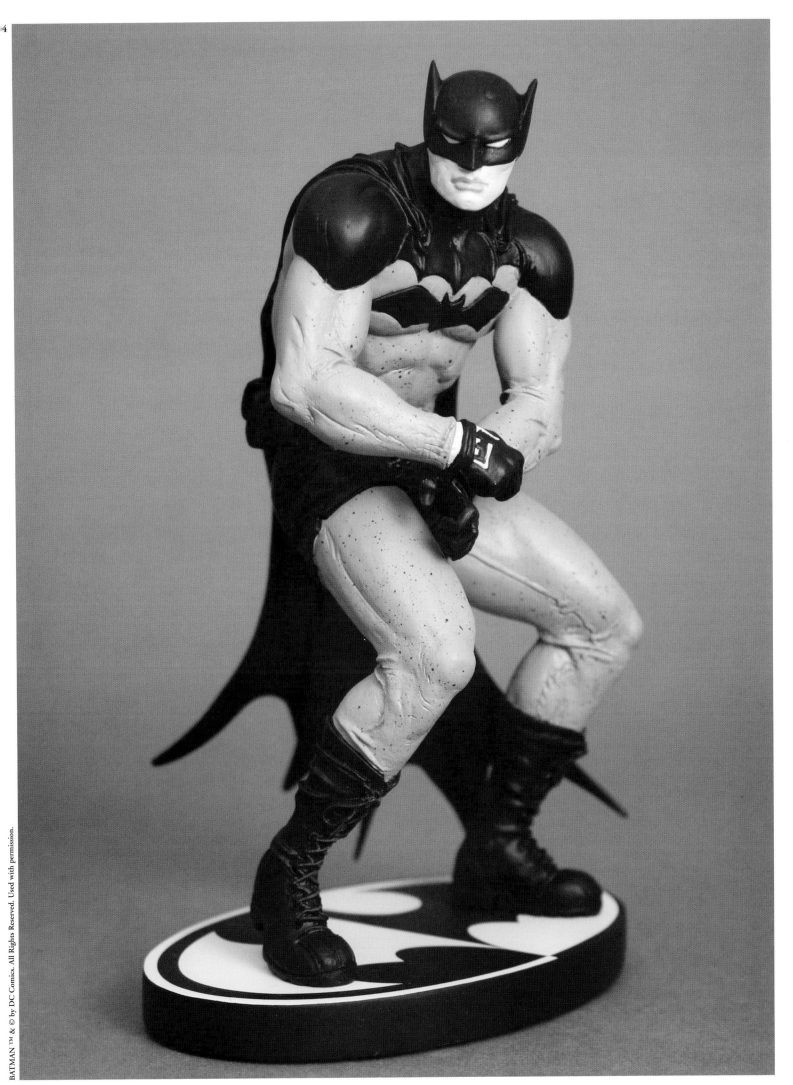

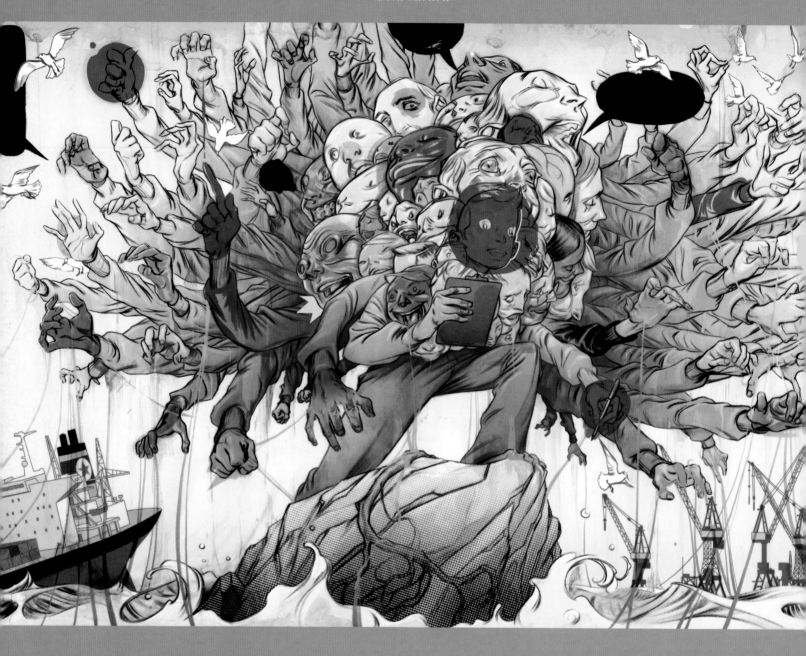

artist: **James Jean**

art director: Jeremy LaCroix *client:* Wired Magazine *title:* Crowdsourcing *medium:* Digital *size:* 16"x11"

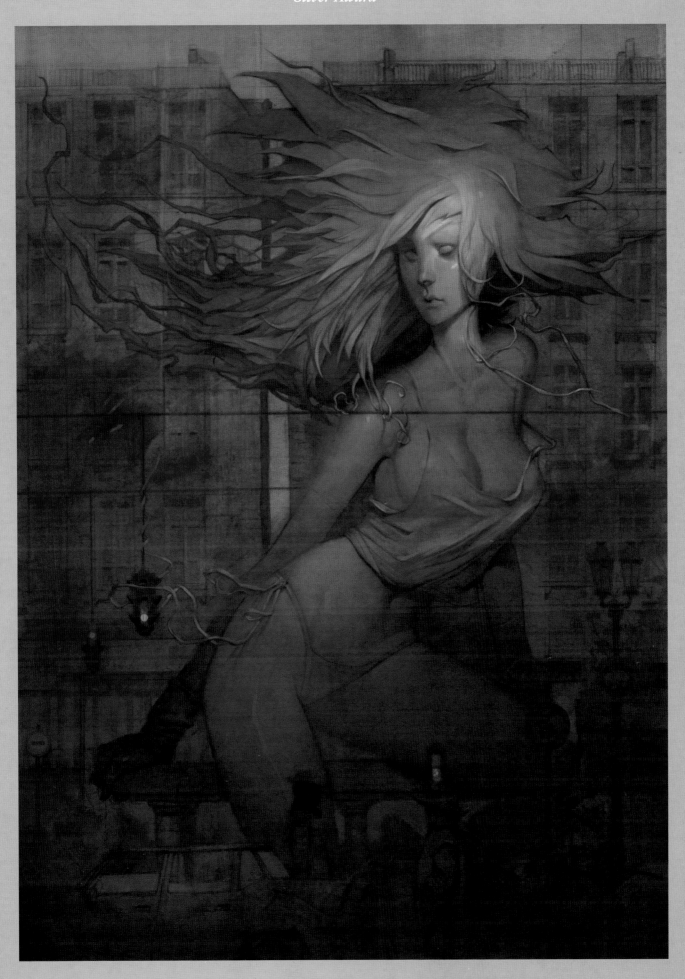

artist: **Joao Ruas**

art director: Rob Carney *client:* Future Publishing, Ltd. *title:* Downtown*medium:* Mixed *size:* 9^1/2"x12^7/8"

1
artist: **Ray-Mel Cornelius**
art director: Michael Hogue
client: Dallas Morning News
title: The Decorator
medium: Acrylics
size: 9"x9"

2
artist: **Erik Siador**
client: Cannibal Flower
title: Mideast Fashion Victim
medium: Ink & acrylic on paper
size: 11"x17"

3
artist: **Andrea Wicklund**
art director: Laura Cleveland
client: Realms of Fantasy
title: Number of the Bus
medium: Mixed
size: 11"x15"

4
artist: **Eric Fortune**
art director: Laura Cleveland
client: Realms of Fantasy
title: Stephanie Shrugs
medium: Acrylics
size: 12"x18"

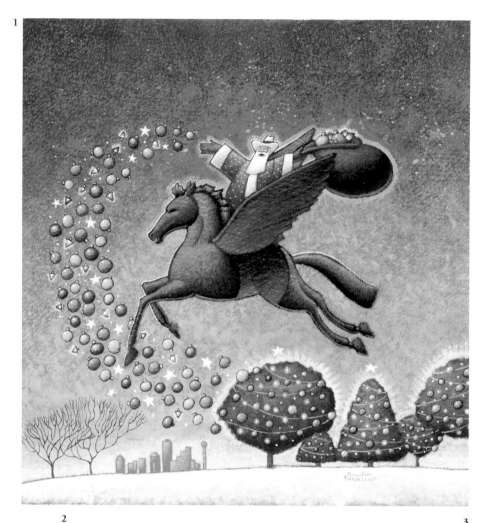

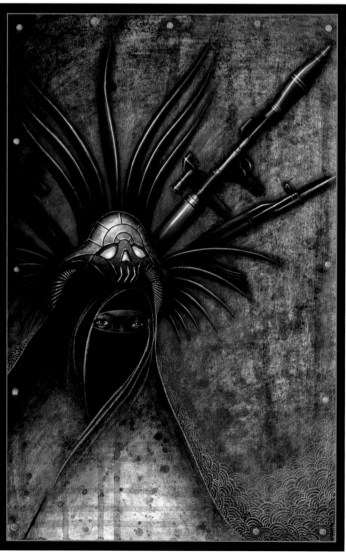

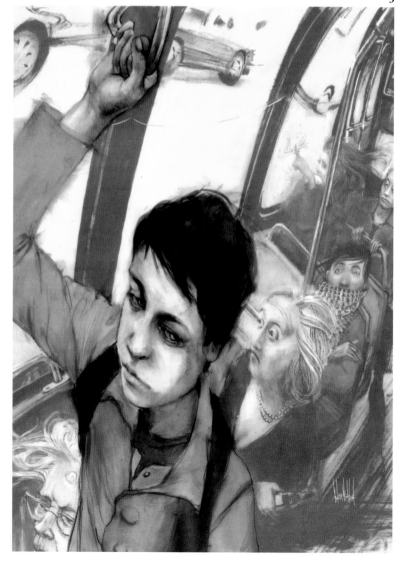

4

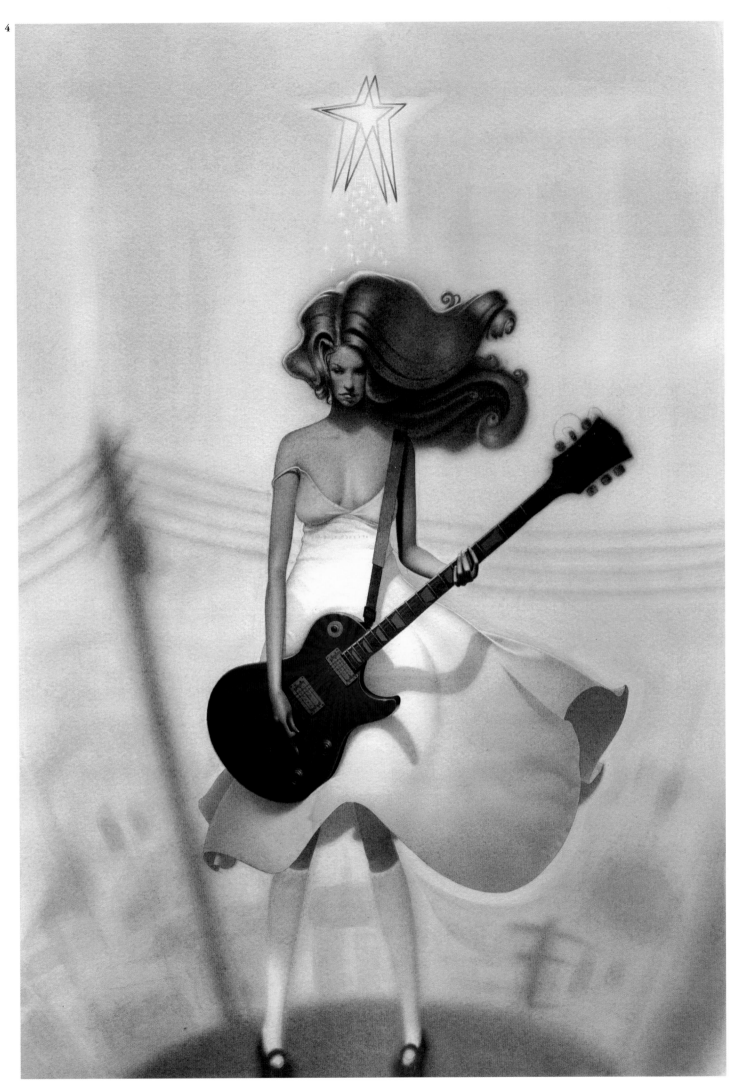

1
artist: **Cyril Van der Haegen**
art director: Rob Carney
client: ImagineFX Magazine
title: Insane Asylum Surgeon II
medium: Digital

2
artist: **Bobby Chiu**
art director: Rob Carney
client: ImagineFX Magazine
title: Big Bad Bunny Eater
medium: Digital
size: 10"x13"

3
artist: **Woodrow J. Hinton III**
art director: Andrew Jennings
client: wjh3illustration.com
title: Dr. Van Helsing
medium: Mixed
size: 11"x17"

4
artist: **Jeff Haynie**
client: Play Magazine
title: Evil Dead Regeneration
medium: Digital
size: 13"x15^{1}/$_{2}$"

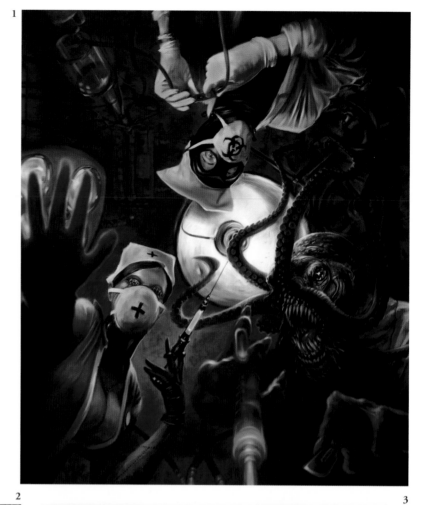

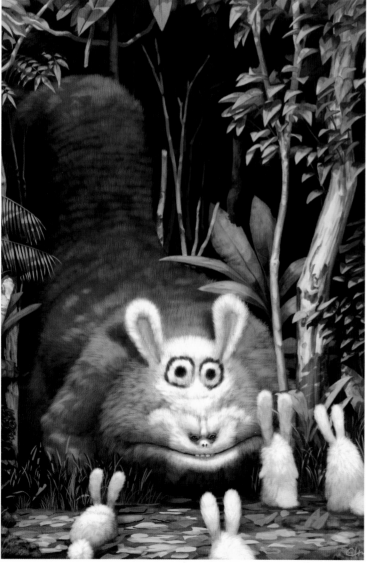

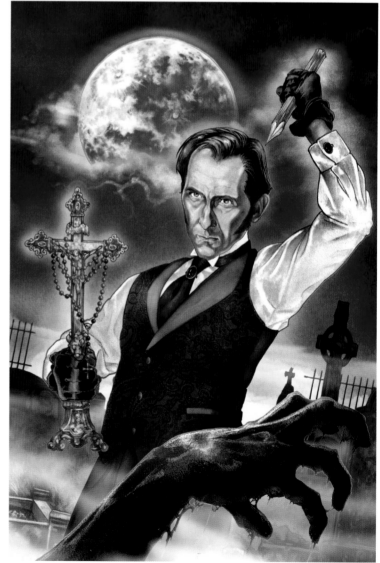

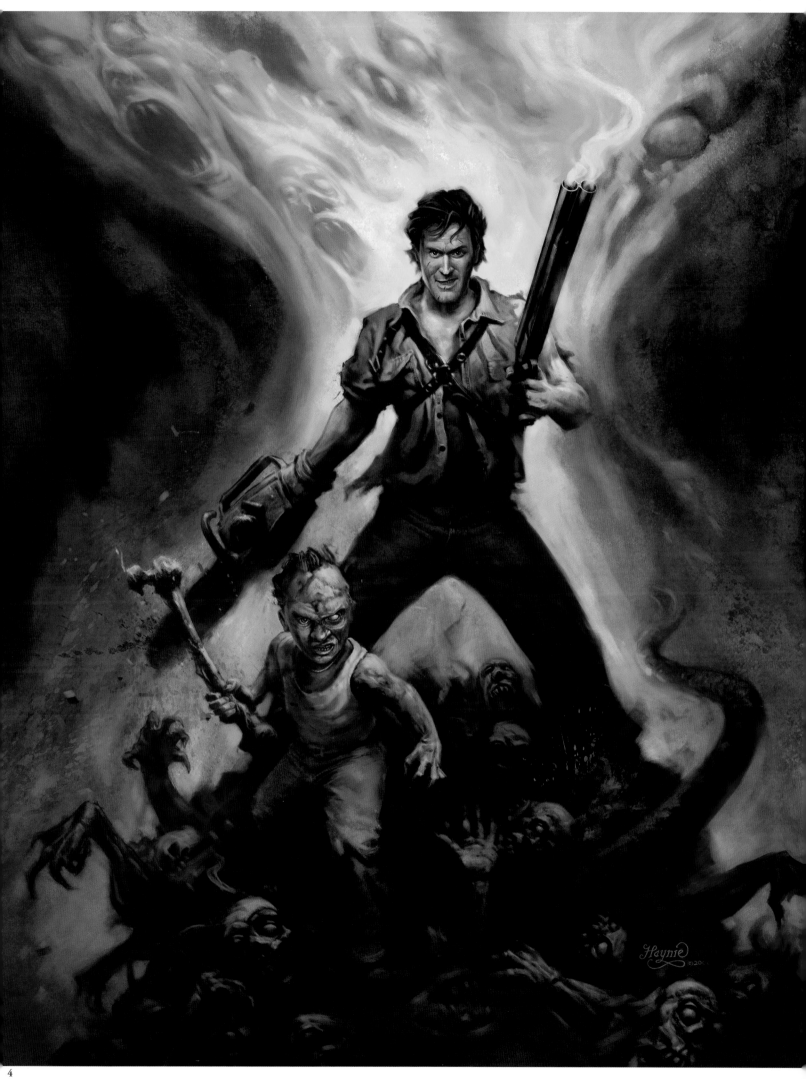

4

1
artist: **Nate Van Dyke**
art director: Ryan Vulk
client: Official Playstation Magazine
title: Corporate Game Companies
medium: Ink/digital
size: 17"x11"

2
artist: **Christopher Gibbs**
designer: Lorna Wood
client: Woman's Weekly
title: Unfinished Business
medium: Digital

3
artist: **Jonny Duddle**
art director: Rob Carney
client: Future Publishing
title: Chimpski: Alone?
medium: Digital
size: 11 1/2"x19"

4
artist: **Skan Srisuwan**
client: S Magazine
title: Oiran
medium: Photoshop
size: 53 3/8"x35 1/4"

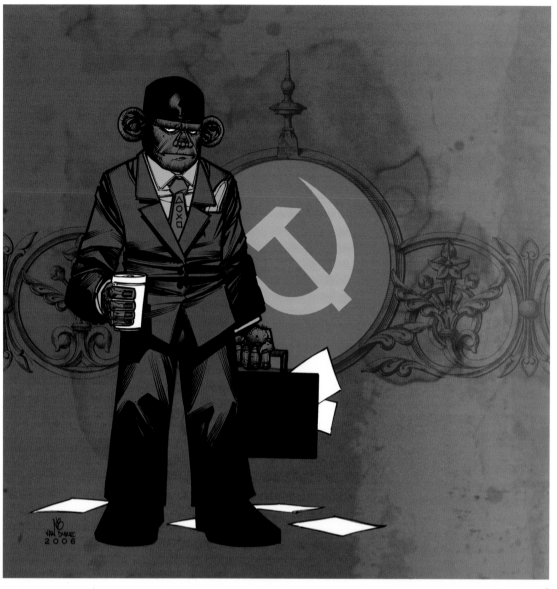

1

2

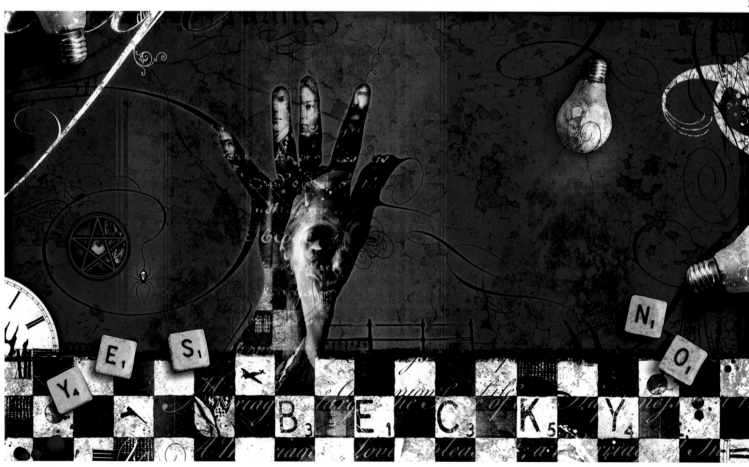

3

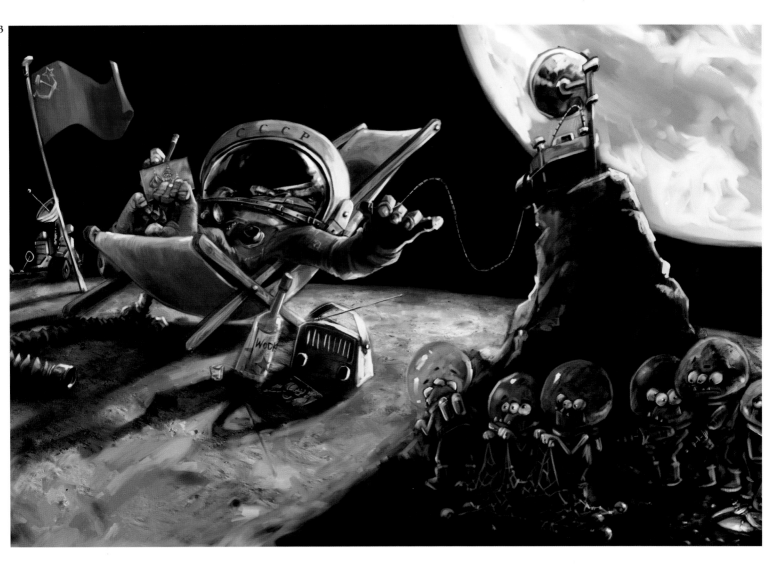

4

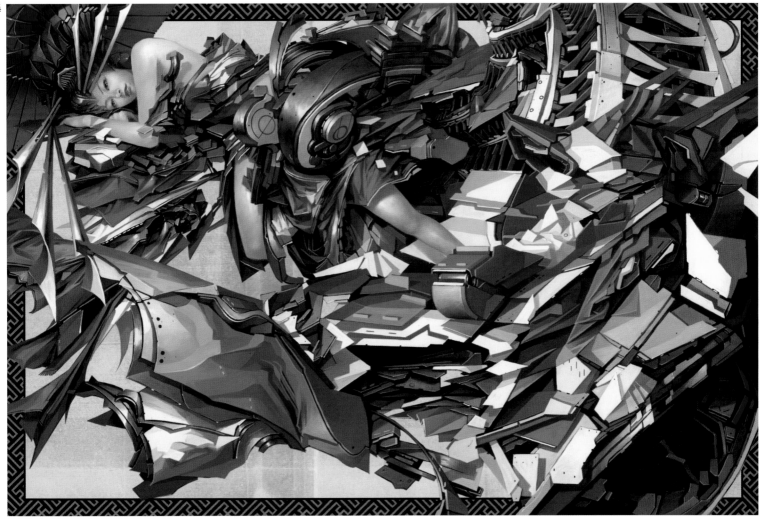

1
artist: **Kent Williams**
art director: Tom Staebler
client: Playboy Magazine
title: Proactive Keller

2
artist: **Rob Johnson**
art director: Laura Cleveland
client: Realms of Fantasy
title: Tao of Crocodiles
medium: Digital
size: 9"x12"

3
artist: **Tae Young Choi**
title: Rat Man
medium: Digital

4
artist: **Peter de Sève**
art director: François Mouly
client: The New Yorker
title: Stay!
medium: Ink/watercolor
size: 11"x15"

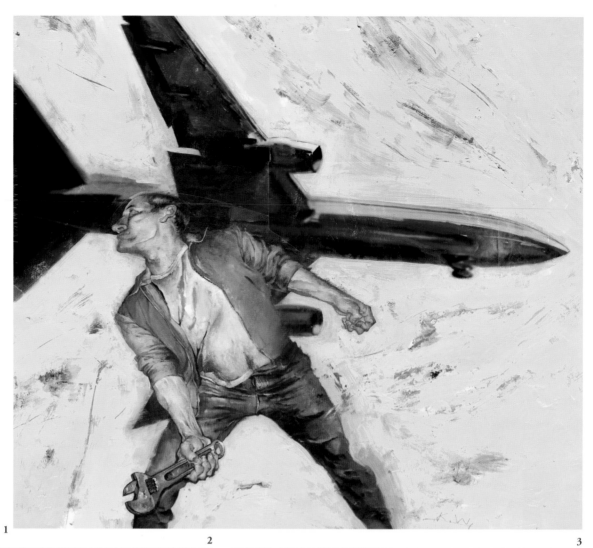

1

2

3

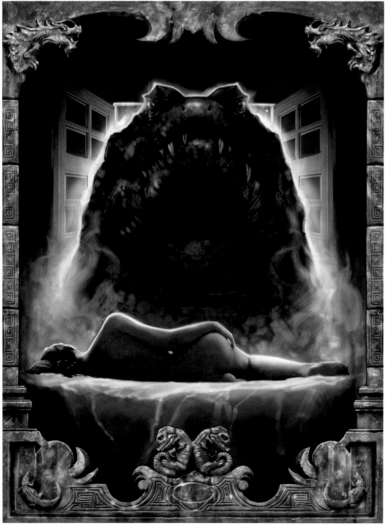

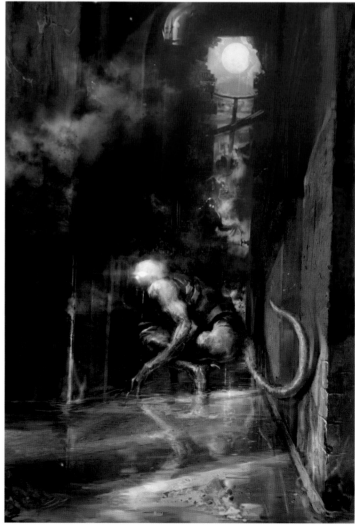

4

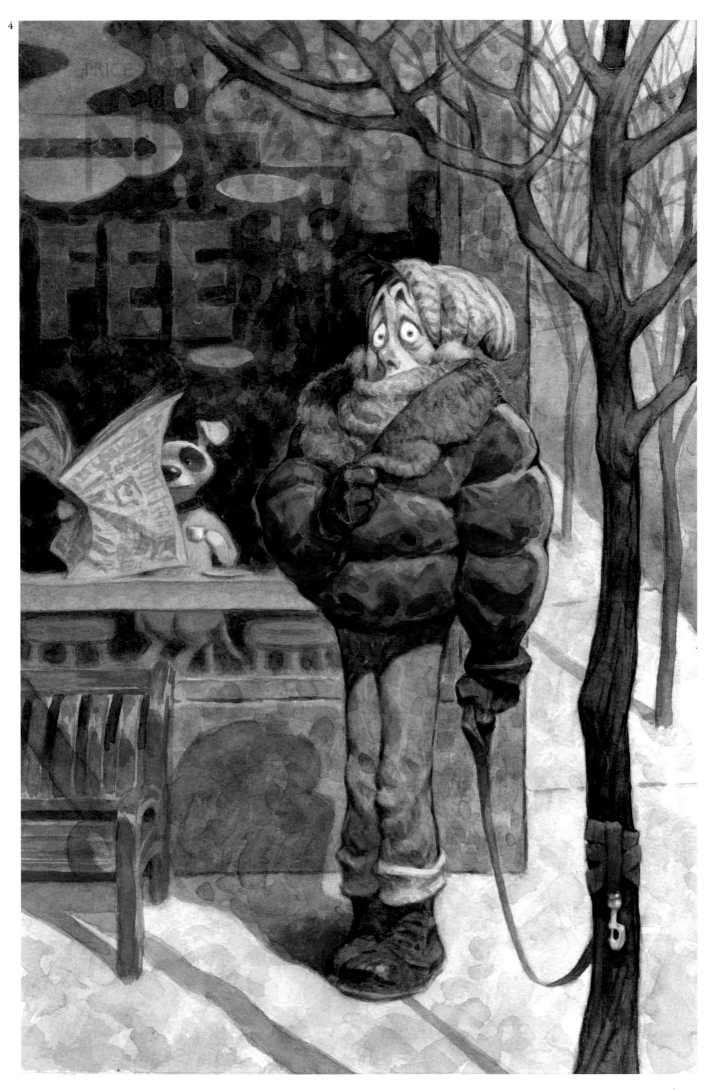

1
artist: **Owen Richardson**
art director: Jeremy Nelson
client: Greenspring Media
title: Demotivator!
medium: Digital
size: 8"x11"

2
artist: **Jesse Lefkowitz**
art director: Soo Jin Buzelli
client: Plansponsor Magazine
title: A New World
medium: Ink/digital
size: 8$\frac{1}{4}$"x10$\frac{3}{4}$"

3
artist: **Peter de Sève**
art director: François Mouly
client: The New Yorker
title: Rush Hour
medium: Ink/watercolor
size: 11"x15"

4
artist: **Owen Richardson**
art director: Scott Bentley
client: Men's Health UK
title: The Girl Never Eats!
medium: Digital
size: 8"x11"

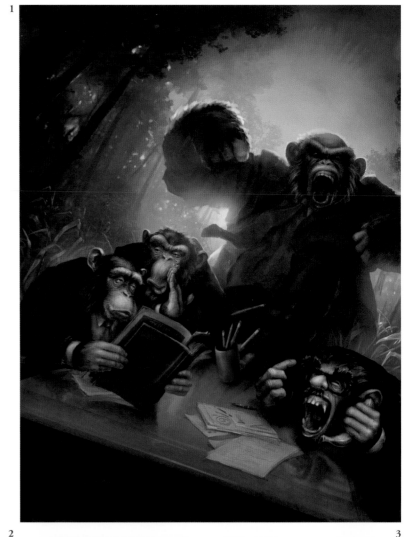

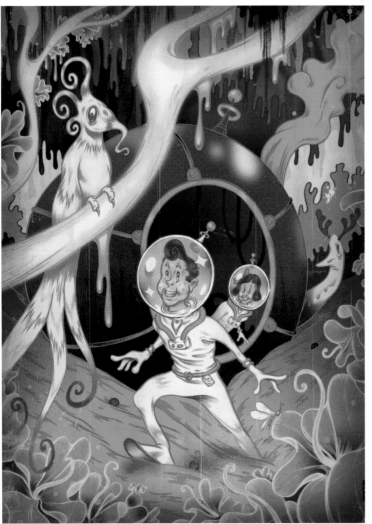

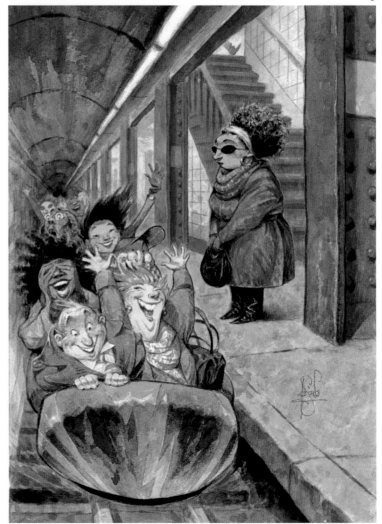

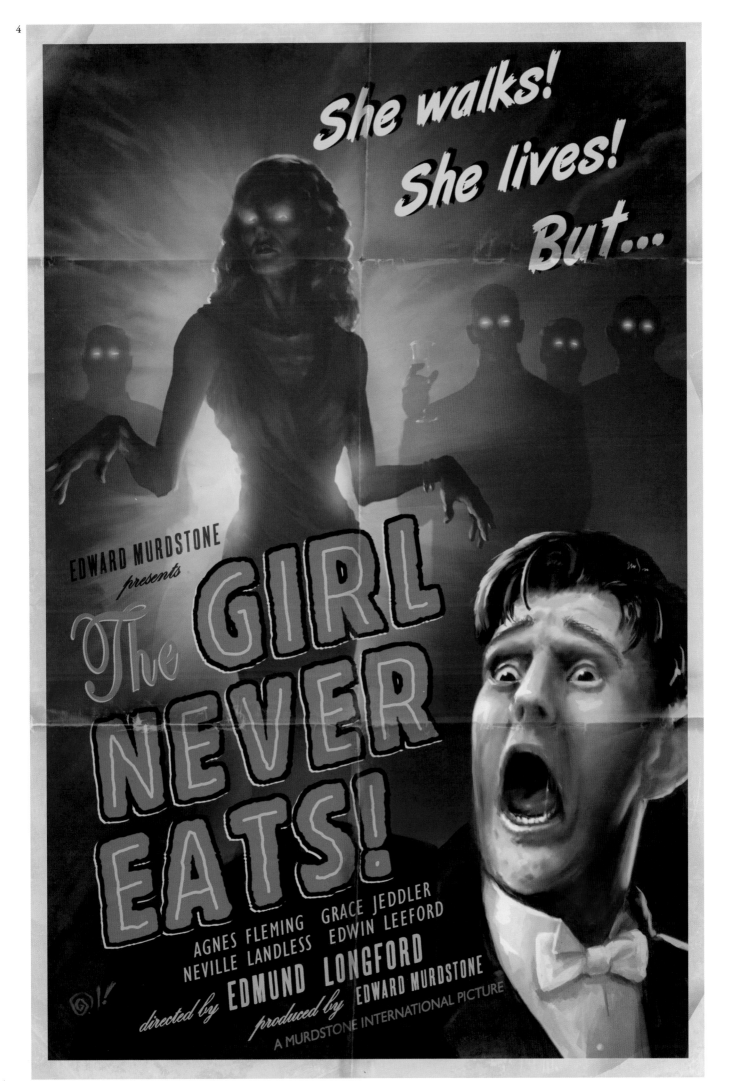

1
artist: **Jerry Lofaro**
client: Advanced Photoshop Magazine
title: Rapt Patrol
medium: Digital
size: 10"x12"

2
artist: **Philip Straub**
art director: Philip Straub
client: ImagineFX Magazine
title: Reckoning Day
medium: Digital
size: 15⁵/₈"x9¹/₂"

3
artist: **Tae Young Choi**
title: Taekwon V
medium: Digital

4
artist: **Jean-Sebastion Rossbach**
art director: Shane Hartley
client: Wizkids
title: Razorblade Vixen
medium: Digital
size: 10¹/₄"x14"

5
artist: **Tom Kidd**
art director: Carl Gnam
client: Realms of Fantasy
title: Robin of the Green
medium: Oil
size: 26"x16"

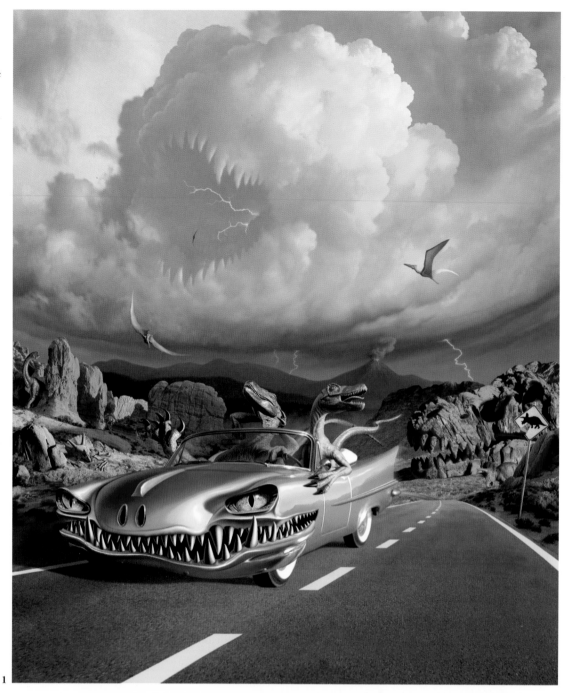

1

2

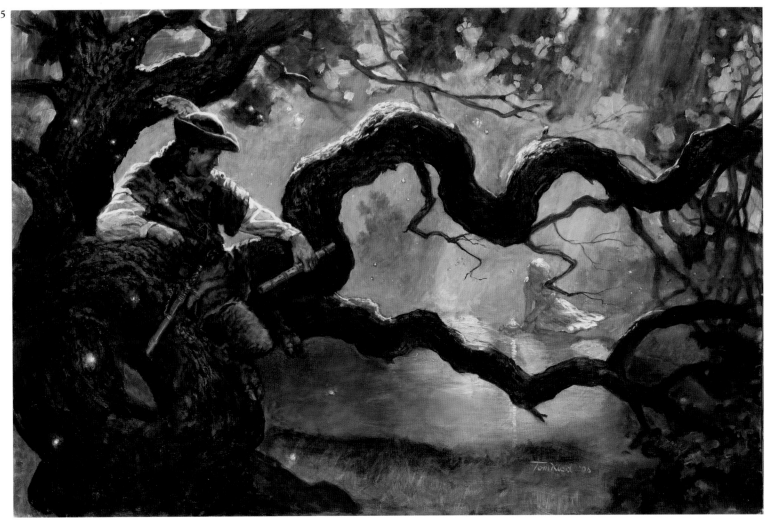

1
artist: **Michael Ryan**
client: Strange Horizons
title: Forgiveness
medium: Oil on masonite
size: 16"x20"

2
artist: **Patrick Arrasmith**
art director: David Lai
client: Bookspan
title: The Historian
medium: Scratchboard/digital
size: 6"x13"

3
artist: **Andrea Wicklund**
art director: Carl Gnam
client: Realms of Fantasy
title: The Grand Mal Reaper
medium: Mixed
size: 11"x15"

4
artist: **Scott M Fischer**
art director: Sean Glen
client: Dragon Magazine
title: Medusa
medium: Oil/digital

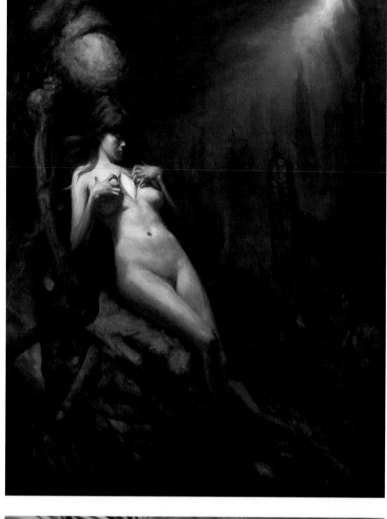

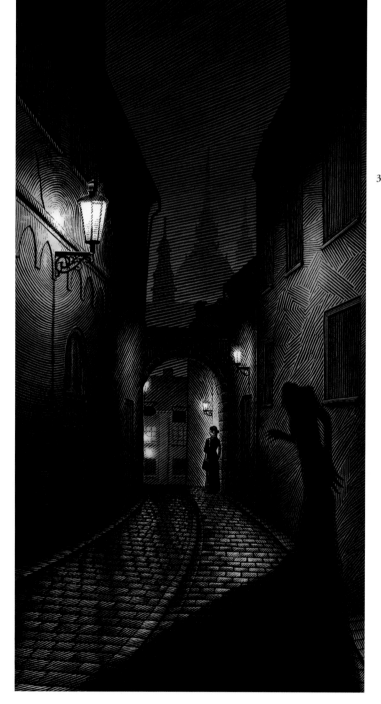

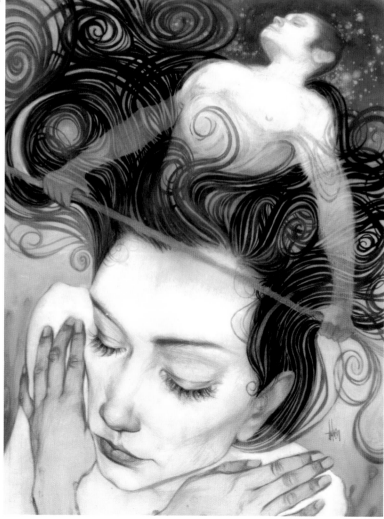

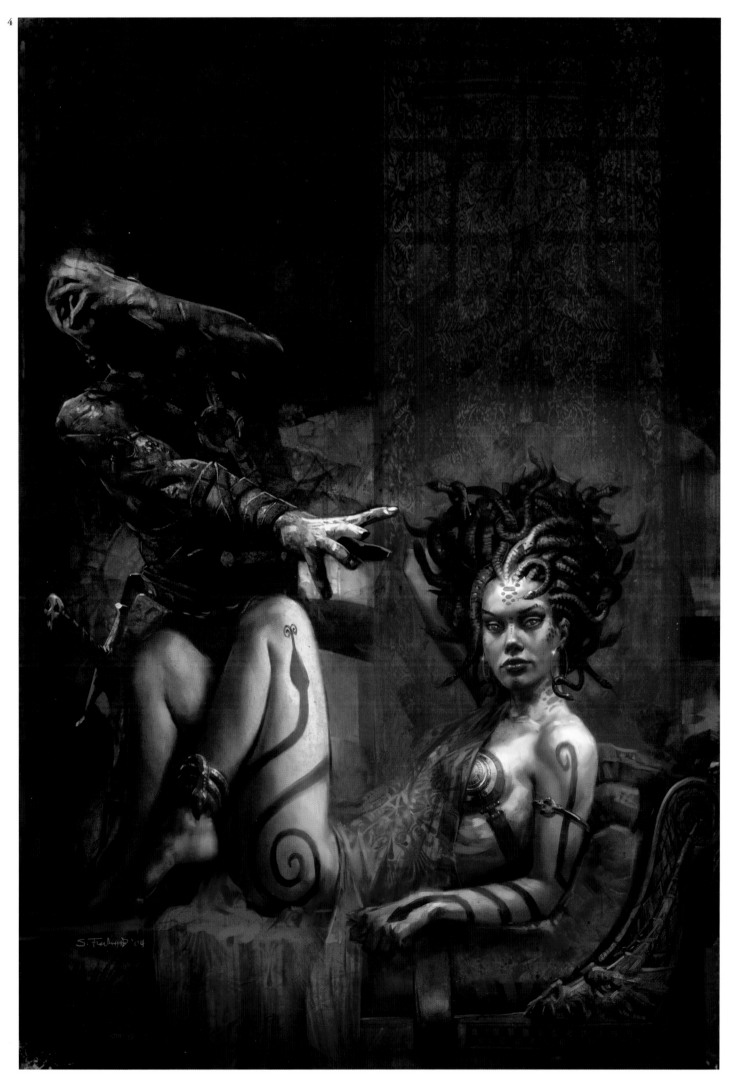

1
artist: **Allen Douglas**
art director: Carl Gnam
client: Realms of Fantasy
title: Metal Men and Scarlet Thread
medium: Digital

2
artist: **Cory & Catska Ench**
art director: Gordon Van Gelder
client: Magazine of Fantasy & Science Fiction
title: Two Hearts
medium: Digital
size: 2'x3'

3
artist: **Tony Shasteen**
art director: Laura Cleveland
client: Realms of Fantasy
title: Bottles
medium: Pencil/digital
size: 8"x11"

4
artist: **Tiffany Prothero**
art director: Laura Cleveland
client: Realms of Fantasy
title: A Touch of Hell
medium: Oil
size: 26"x35^1/$_2$"'

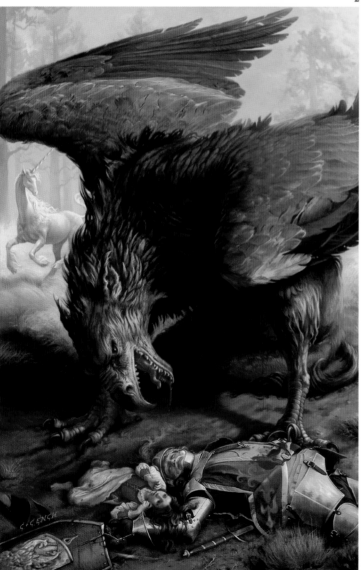

4

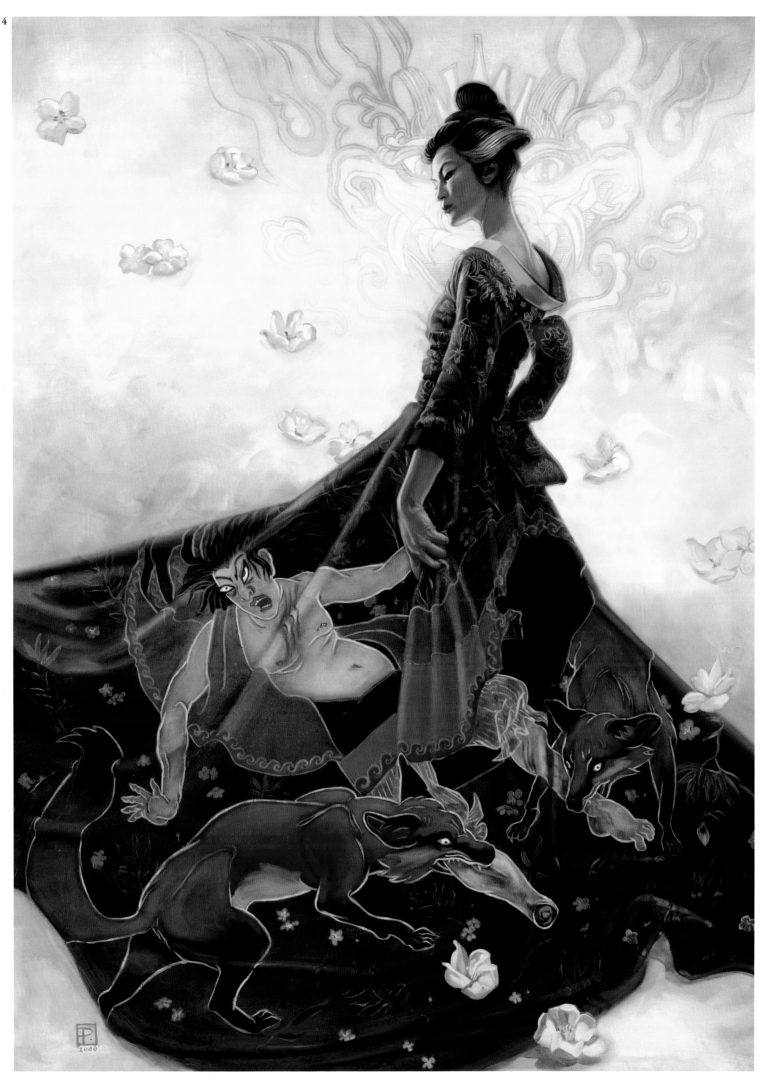

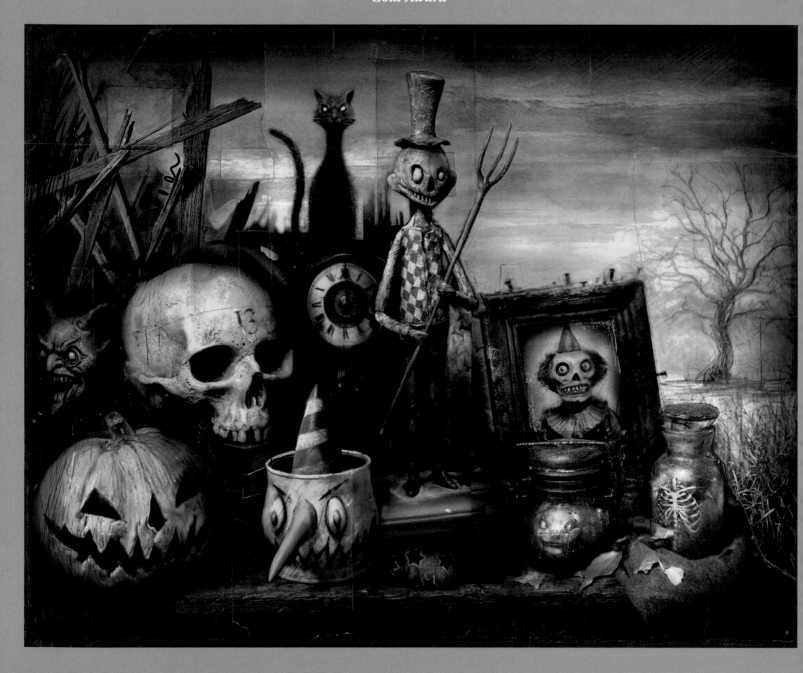

artist: William Basso

art director: William Basso *client:* Creature Features *title:* October Shadows *medium:* Collage/acrylics on canvas *size:* 14"x11"

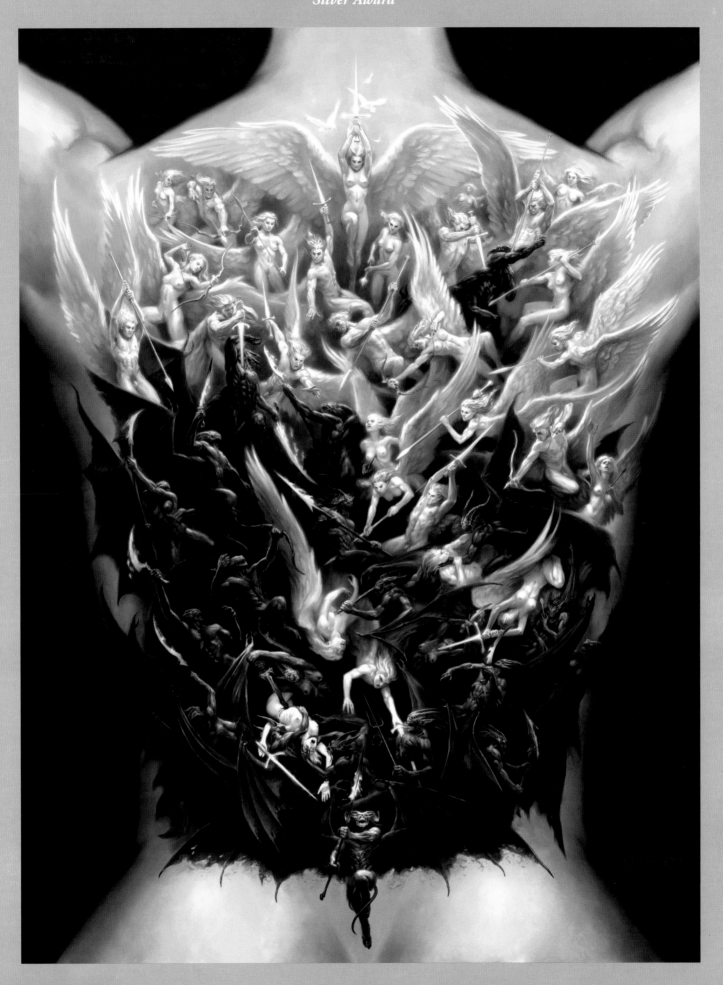

artist: **Todd Lockwood**

art director: Rhyan Scorpio-Rhys *client:* Bullseye Tattoo *title:* War of Angels *medium:* Digital *size:* 15"x22"

1
artist: **Matt Cavotta**
art director: Jeremy Jarvis
client: Wizards of the Coast
title: Scourge of Legacies
medium: Digital
size: 8¹/2"x8¹/2"

2
artist: **Jason Chan**
title: Junk Angel
medium: Digital
size: 6"x11"

3
artist: **Jason Chan**
art director: Coro
client: Massive Black
title: Twins
medium: Digital
size: 10"x13"

4
artist: **Jason Chan**
title: Iron Angel
medium: Digital
size: 8"x11"

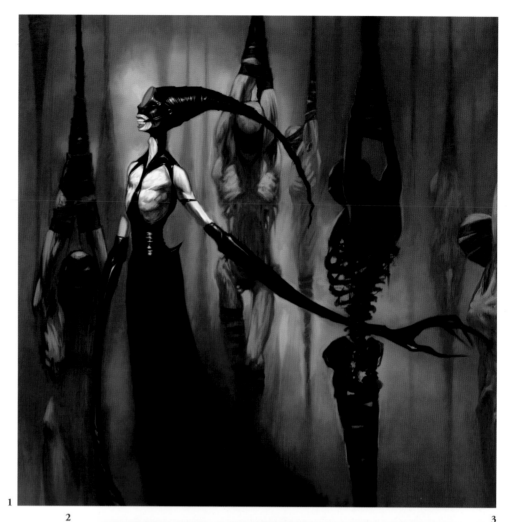

1

2

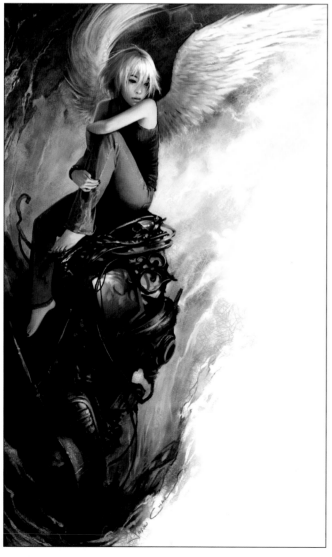

3

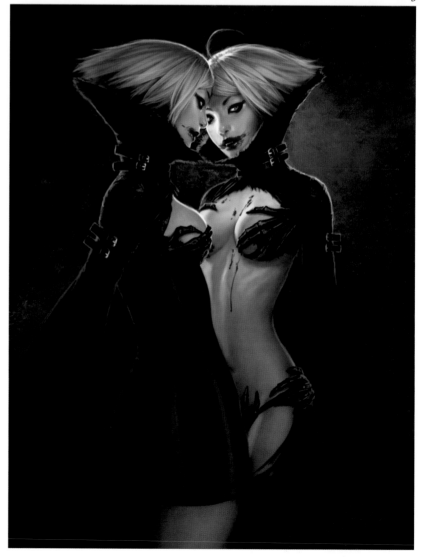

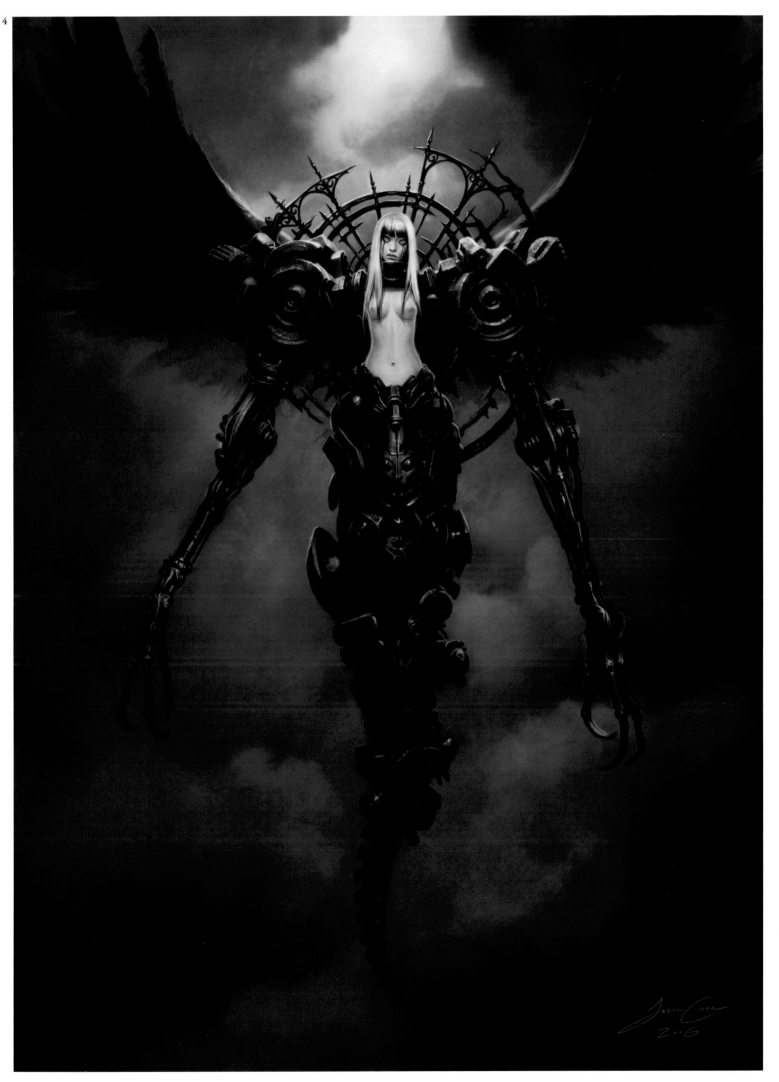

1
artist: **Raoul Vitale**
client: HOW Design Conference
title: Did You See That?
medium: Color Pencil
size: 8$\frac{1}{2}$"x9$\frac{1}{2}$"

2
artist: **Tomislav Torjanac**
client: ULUPUH
title: Hop!
medium: Digital
size: 12"x17"

3
artist: **Tom Fowler**
title: Mean Streets
medium: Watercolor
size: 10$\frac{1}{2}$"x14$\frac{1}{2}$"

4
artist: **Dan L. Henderson**
client: DLH Printworks
title: Arctic Clown Force
medium: Charcoal
size: 20"x26"

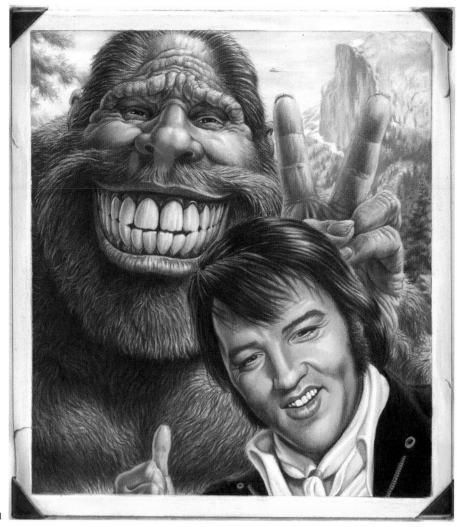

1

2

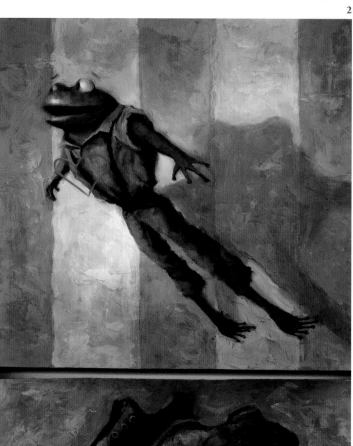

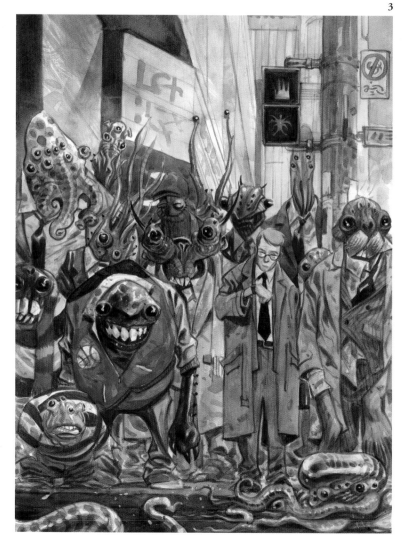

3

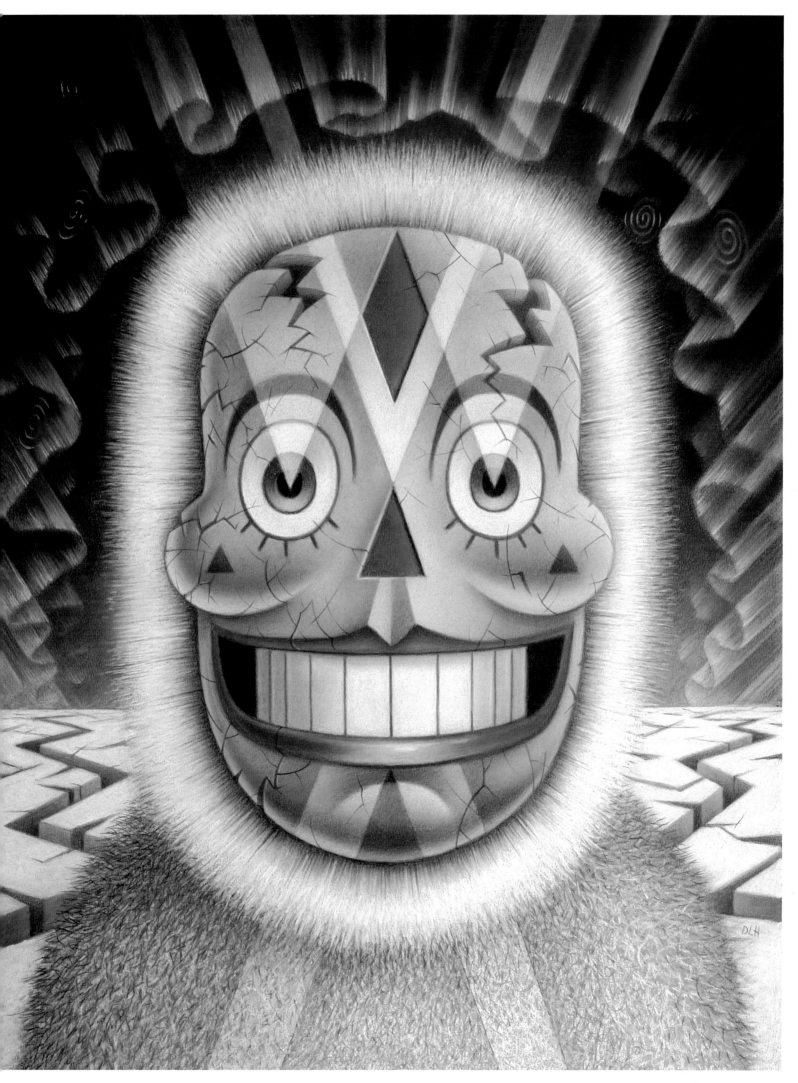

1
artist: **Hoang Nguyen**
client: Liquidbrush Productions
title: Eternal Sorrow
medium: Photoshop
size: 13"x13"

2
artist: **Chippy**
art director: Jeremy Cranford
client: Wizards of the Coast
title: Voidmage Husher
medium: Digital

3
artist: **Jeff Lee Johnson**
art director: Christian Stroble
client: www.santharia.com
title: Light Elf
medium: Digital

4
artist: **Jeff Lee Johnson**
art director: Christian Stroble
client: www.santharia.com
title: King Thar
medium: Digital

5
artist: **Tiffany Prothero**
title: The Escape
medium: Digital
size: 15$\frac{1}{2}$"x10$\frac{1}{4}$"

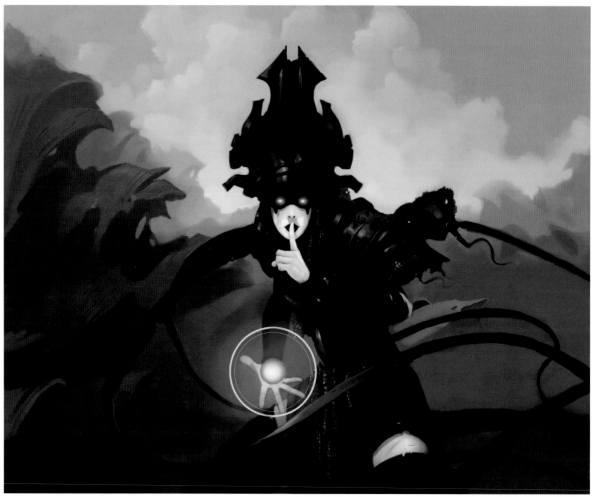

1

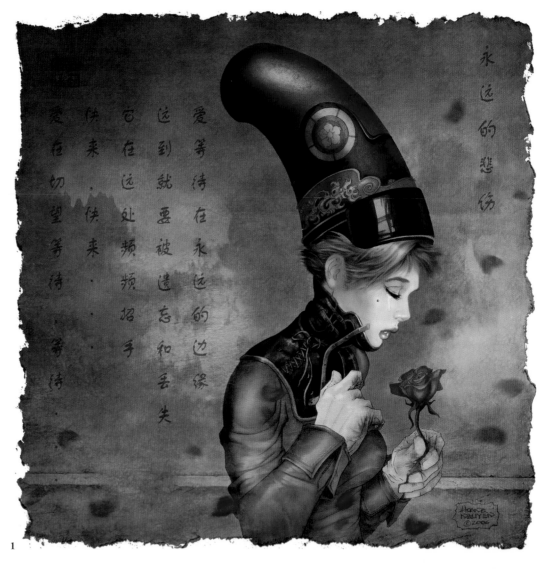

2

3

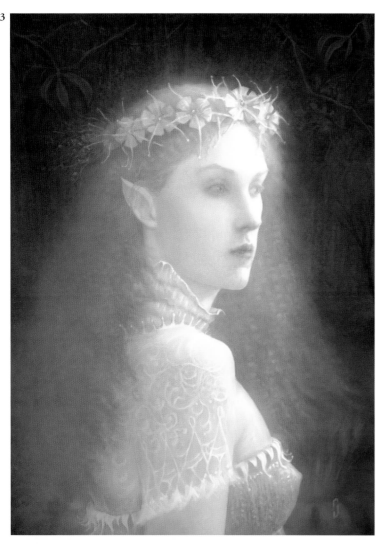

4

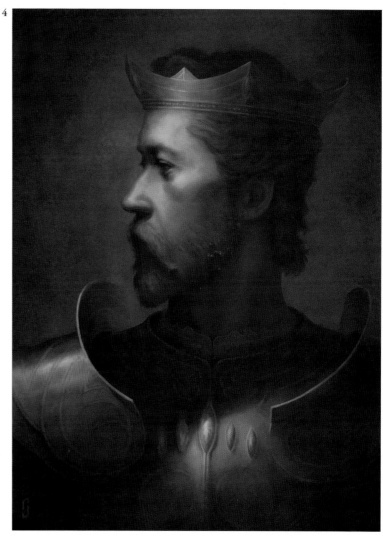

5

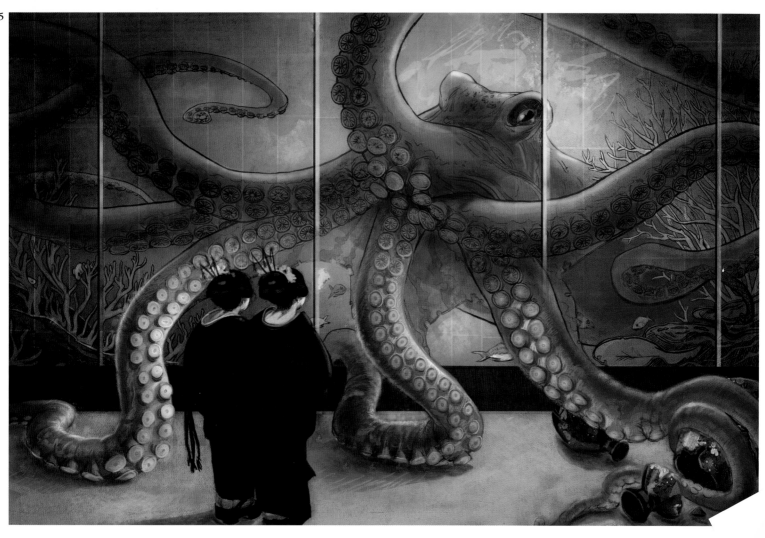

1
artist: **Victor Powell**
client: victorpowell.com
title: Everybodies Beautiful
medium: Oil
size: 48"x48"

2
artist: **Roxana Villa**
art director: Diana Duren
client: Vanderbilt Nurse
title: Centering Pregnancy
medium: Acrylics on board
size: 9"x12"

3
artist: **Dominick Cabalo**
client: Domnx.com
title: Revolution
medium: Digital
size: 10"x18"

4
artist: **Adam Rex**
client: MicroVisions/
 Society of Illustrators
medium: Oil/mixed
size: 5"x7"

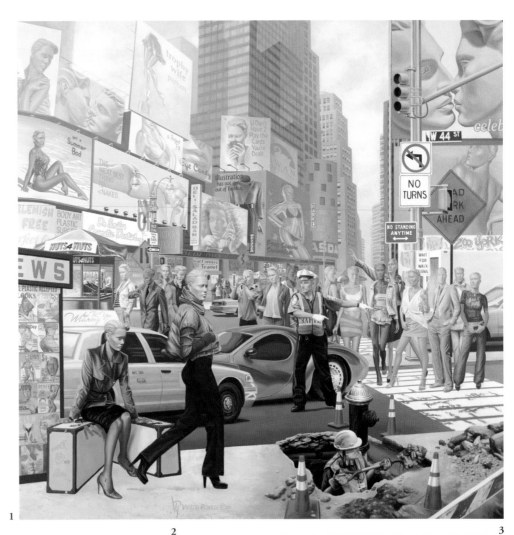

1

2

3

4

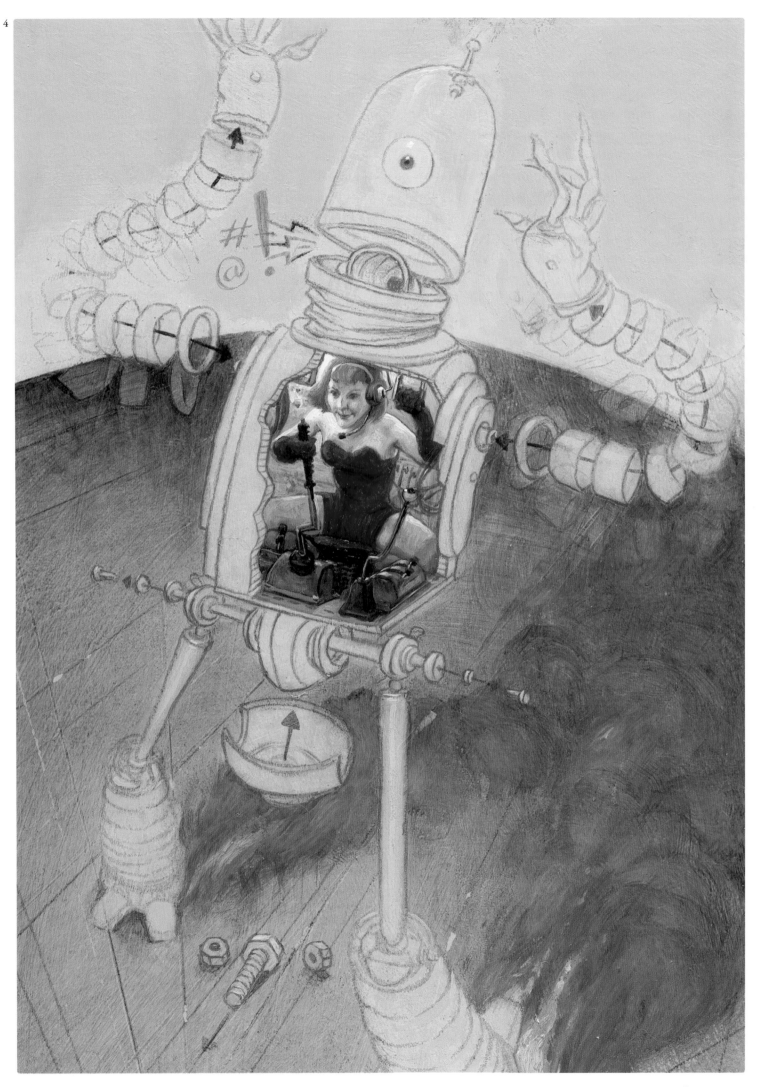

1
artist: **Benjamin Foster**
art director: Cody Tilson
client: Last Man Standing
title: Wings (Welcome to the
 Beginning of the end
medium: Oil
size: 32"x32"

2
artist: **Jim Murray**
art director: Jeremy Jarvis
client: Wizards of the Coast
title: Elvish Jaguar Rider
medium: Acrylics

3
artist: **Adam Rex**
client: Jeremy Jarvis
client: Wizards of the Coast
title: Eternal Dragon
medium: Oil/digital
size: $15^1/4$"x$11^1/2$"

4
artist: **Jim Murray**
art director: Jeremy Jarvis
client: Wizards of the Coast
title: Gaea's Herald
medium: Acrylics

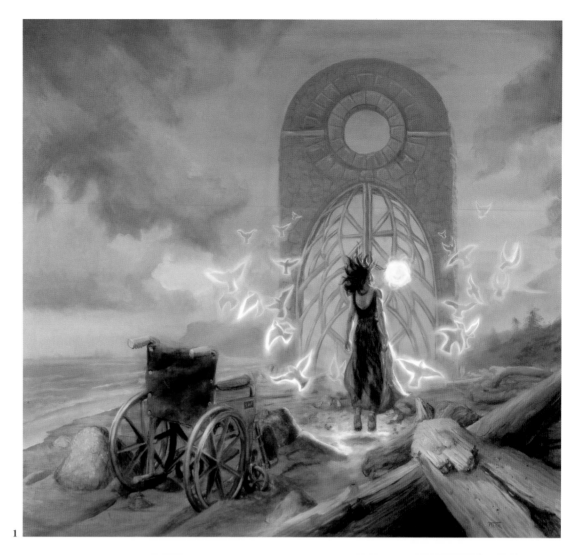

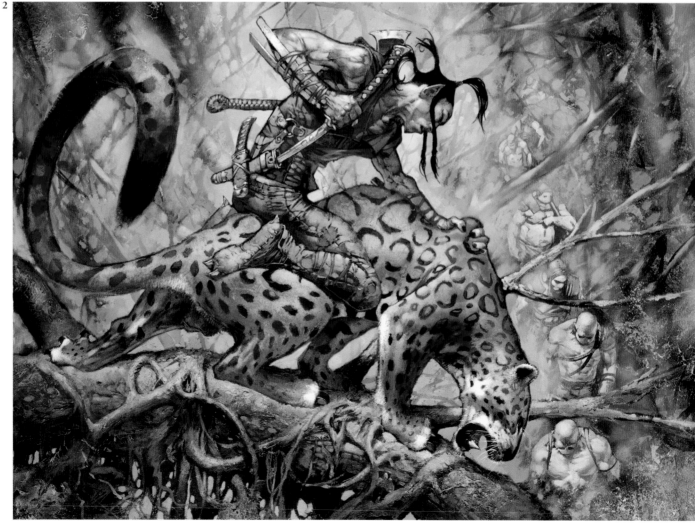

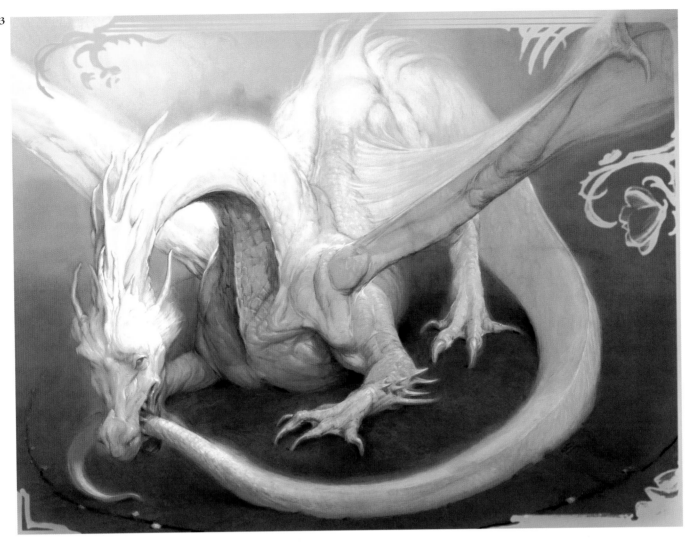

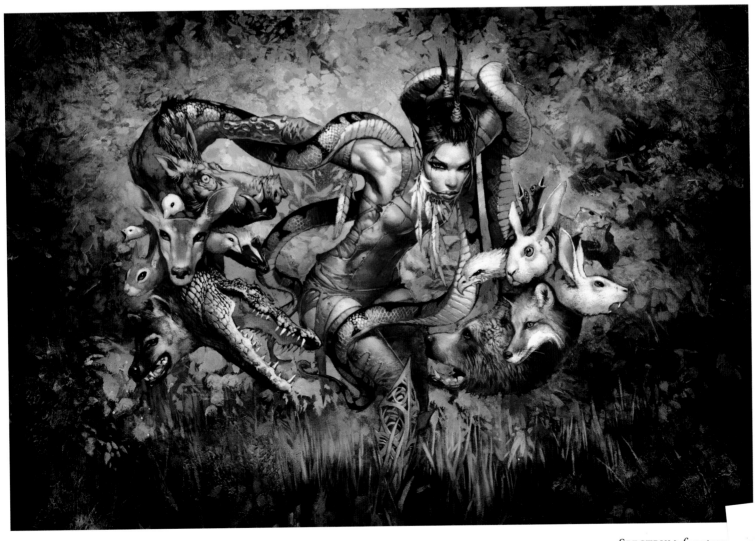

1
artist: **Justin Sweet**
art director: Jeremy Jarvis
client: Wizards of the Coast
title: Blade of the Sixth Pride
medium: Digital

2
artist: **Dermot Power**
art director: Jeremy Cranford
client: Upper Deck Entertainment
title: Draeni Survival Hunter
medium: Digital

3
artist: **Boris Vallejo**
client: MicroVisions/
 Society of Illustrators
medium: Oil
size: 5"x7"

4
artist: **Daren Bader**
art director: Jeremy Cranford
client: Wizards of the Coast
title: Oros
medium: Oil
size: 16"x21"

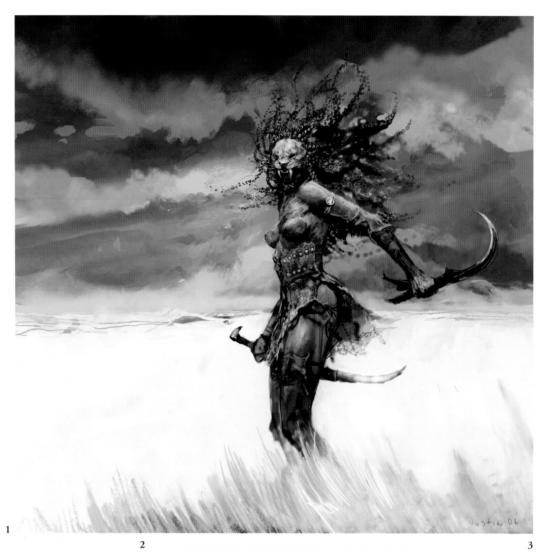

1

2

3

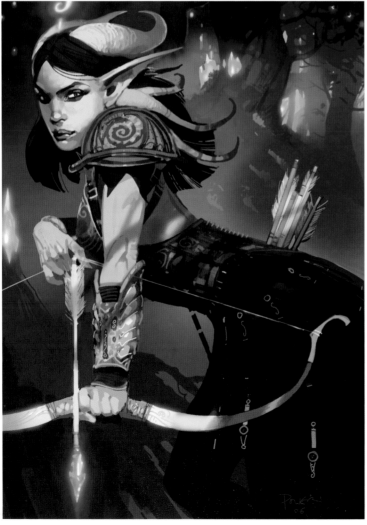

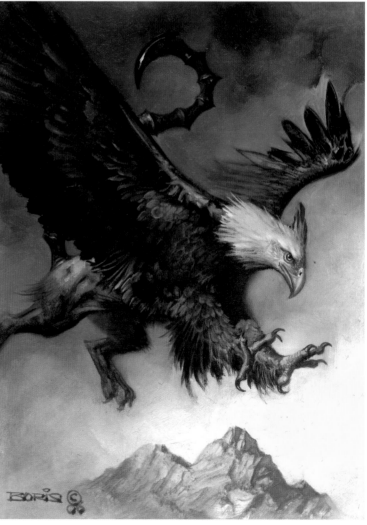

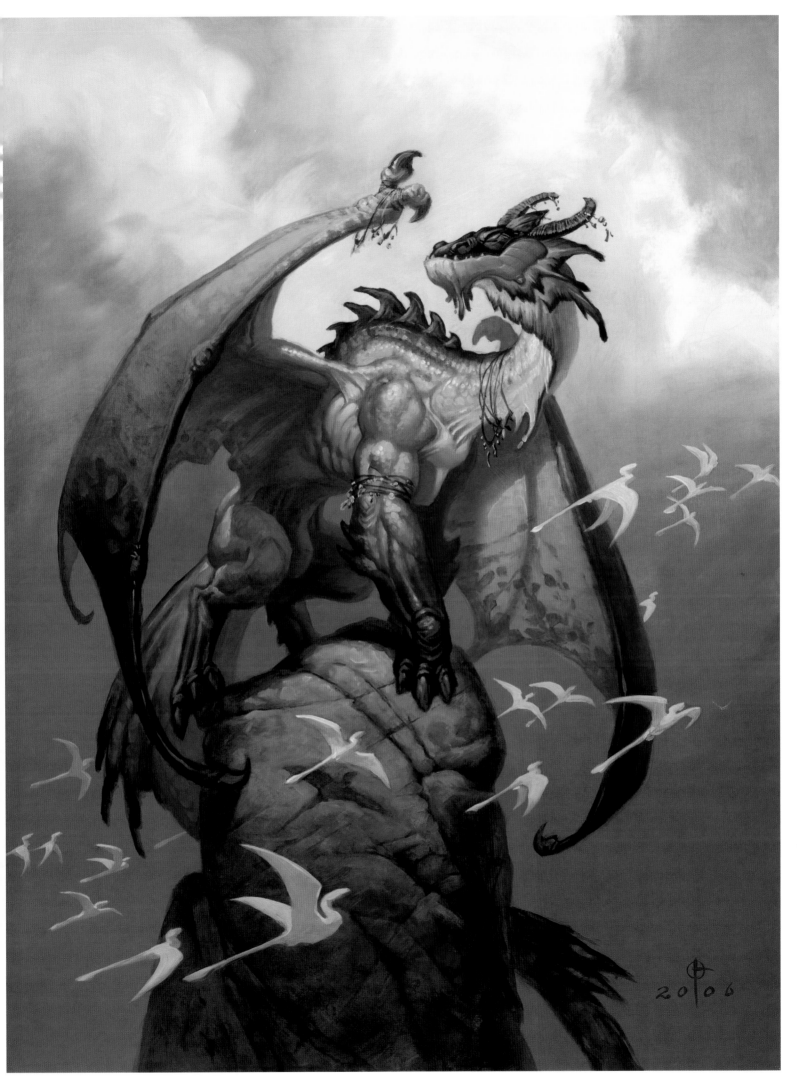

1
artist: **R.K. Post**
art director: Jeremy Jarvis
client: Wizards of the Coaqst
title: Knight of Dusk
medium: Digital

2
artist: **William Stout**
art director: Lynett Gillette
designer: William Stout
client: Science Museum of Minnesota/
 San Diego Natural History Museum
title: Before God: Cretaceous San Diego
 (mural preliminary study)
medium: Acrylics on board
size: 28"x10"

3
artist: **Volkan Baga**
art director: Jeremy Cranford
client: Wizards of the Coast
title: Angel of Mercy
medium: Oil

4
artist: **Aleksi Briclot**
art director: Stacy Longstreet
 and Shauna Narciso
client: Wizards of the Coast
title: Dreamblade
medium: Digital
size: 7"x8"

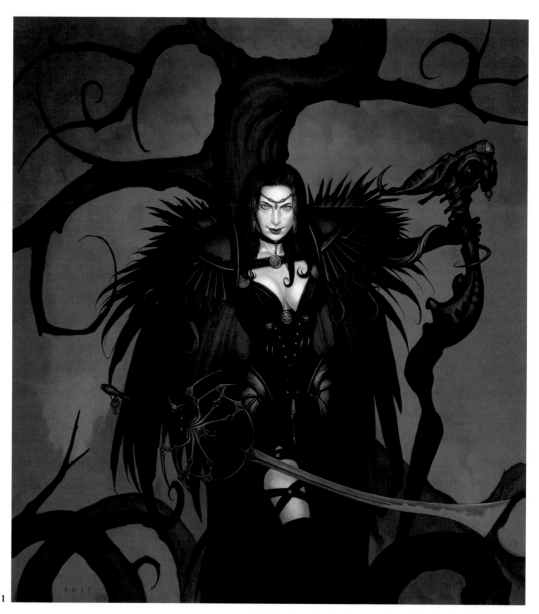

1

2

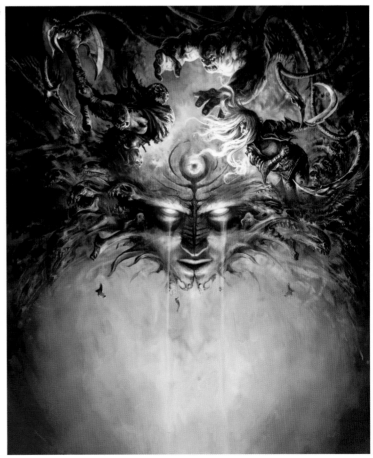

1
artist: **Karl Kopinski**
art director: Paolo Parente
client: Rackham
title: U.N.A. On the Move
medium: Oil
size: 23¹/2”x15³/4”

2
artist: **Joerg Warda**
title: Passenger
medium: Digital
size: 12”x8¹/4”

3
artist: **Greg Lunzer**
client: Robot Island
title: Apollo Roboteer
medium: Mixed
size: 16”x5”

4
artist: **Jason Newhouse**
title: Catch of the Day
medium: Digital
size: 12”x7”

5
artist: **Matt Cavotta**
art director: Jeremy Cranford
client: Wizards of the Coast
title: Jaya Ballard
medium: Digital
size: 8¹/2”x6”

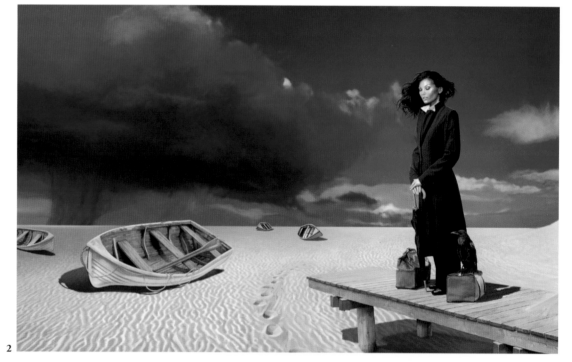

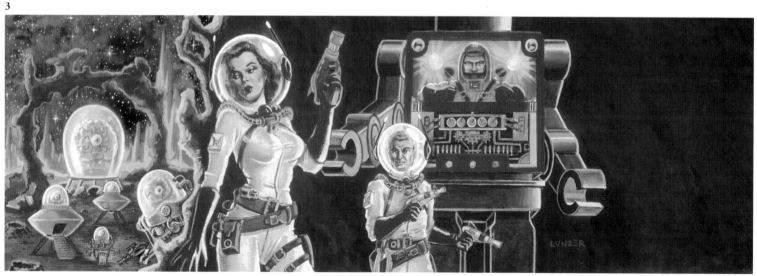

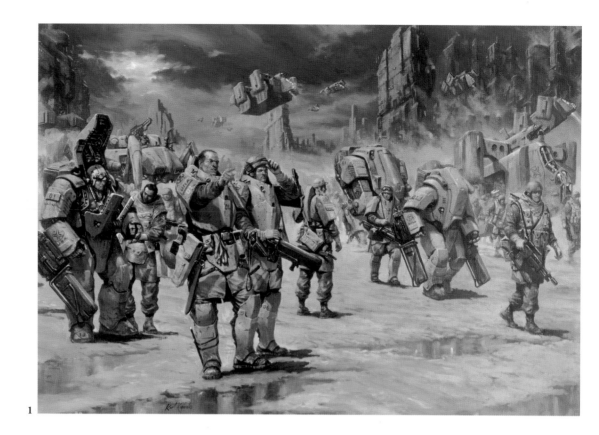

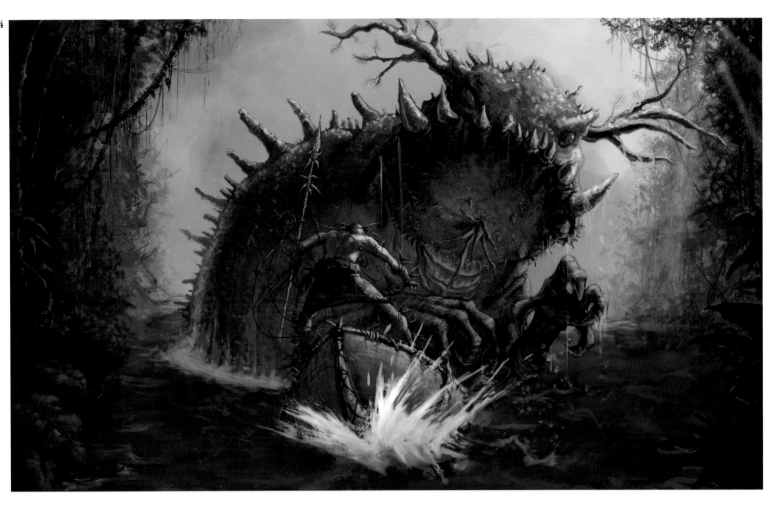

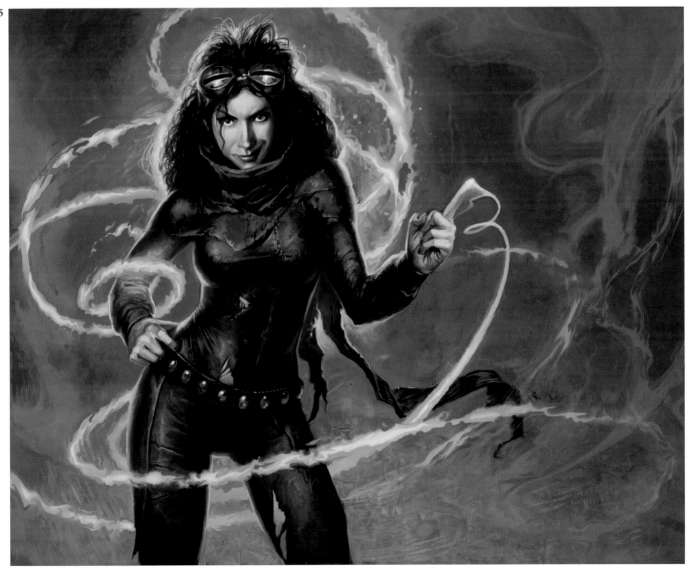

1
artist: **Echo Chernik**
art director: Michael Feeley
client: Art-N-Body
title: The Spirit of Navigation
medium: Digital
size: 12"x12"

2
artist: **Christopher Moeller**
art director: Terese Nielsen
client: Angel Quest
title: Angel of Freedom
medium: Acrylics
size: 9"x14"

3
artist: **Pascal Blanché**
title: Valkyrie
medium: Digital/3D

4
artist: **Shelly Wan**
title: Self-Portrait with Goblins
medium: Gouache/digital
size: 8"x10⁷/8"

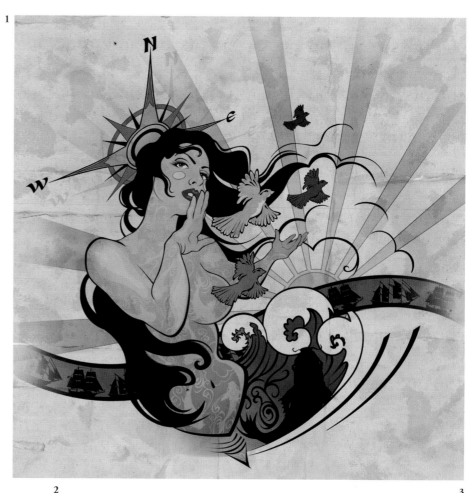

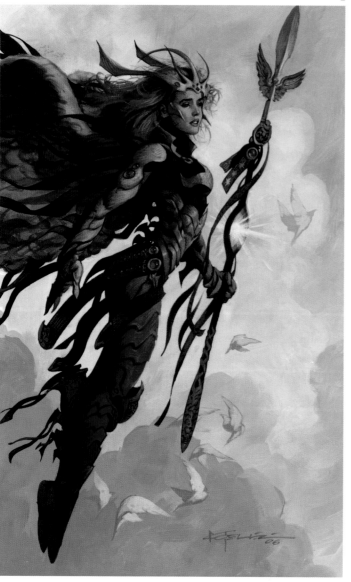

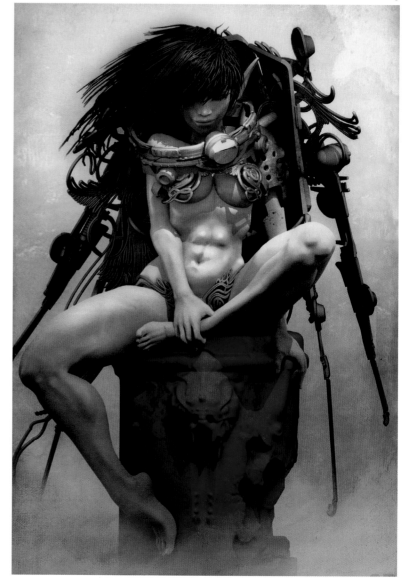

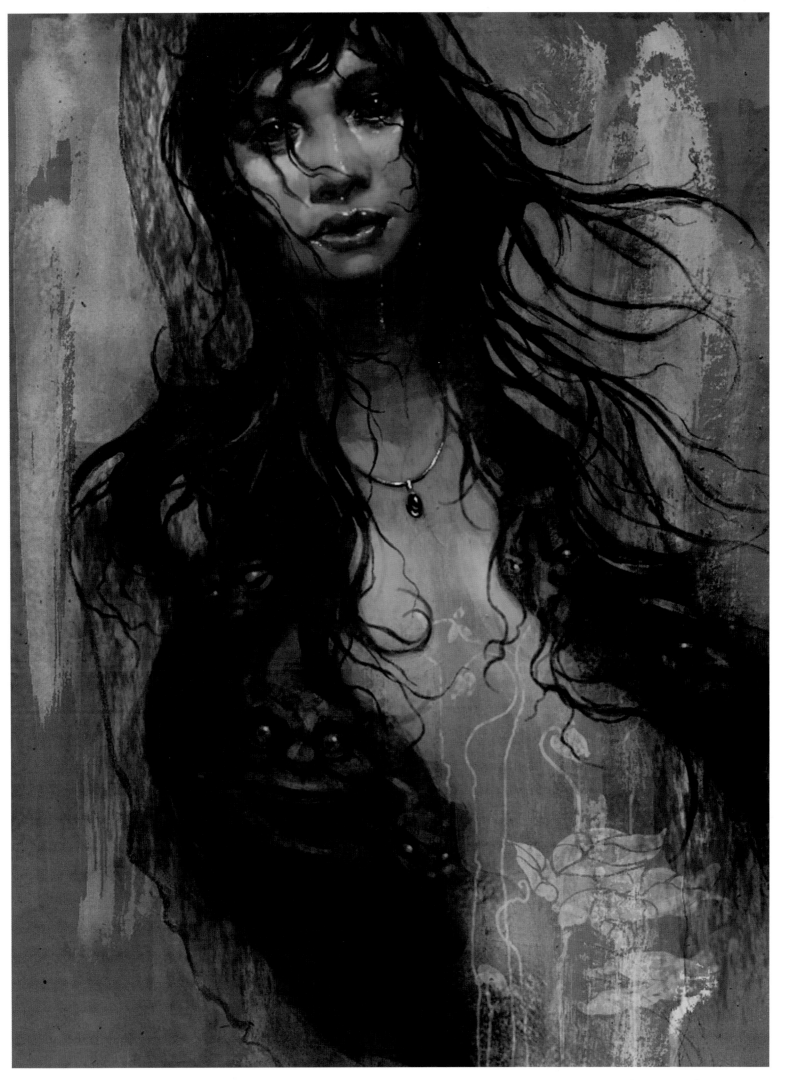

1
artist: **Coro**
client: Massive Black
title: Take *This*, Robots!
medium: Digital
size: 8"x11"

2
artist: **Blur**
art director: Dave Inscore
client: Big Huge Games
title: Vinci Hero
medium: Digital
size: 8"x10"

3
artist: **Jason Engle**
art director: Christine Brucker
client: Game Manufacturers Assoc.
title: Late Arrival
medium: Digital
size: 8¹/₂"x11"

4
artist: **Bob Eggleton**
client: Baby Tattoo Books
title: One of Our Robots is Missing
medium: Acrylics
size: 18"x14"

1

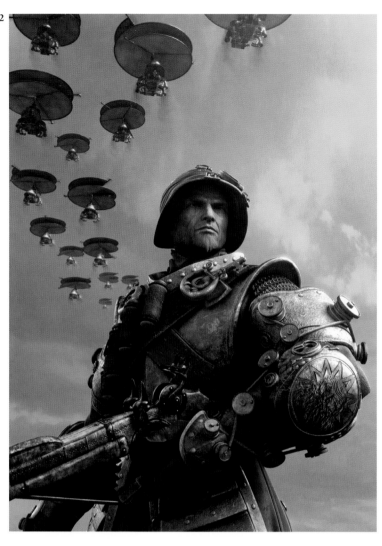

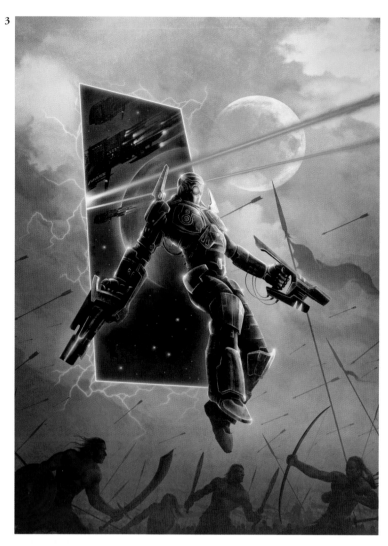

1
artist: **Vincent DiFate**
client: MicroVisions/Society of Illustrators
medium: Acrylics
size: 7"x5"

2
artist: **Craig Mullins**
art director: Jeremy Cranford
client: Wizards of the Coast
title: Island
medium: Digital

3
artist: **Steven Belledin**
art director: Jeremy Cranford
client: Wizards of the Coast
title: Treacherous Urge
medium: Oil

4
artist: **Donato Giancola**
art director: Irene Gallo/Donato Giancola
client: Scot Tubbs
title: The Battle of Agincourt
medium: Oil on paper on panel
size: 84"x48"

5
artist: **Vance Kovacs**
art director: Jeremy Jarvis
client: Wizards of the Coast
title: Certain Death
medium: Digital

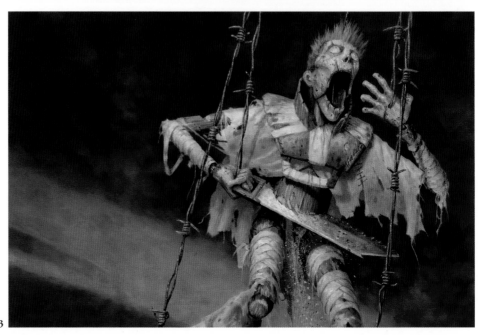

4

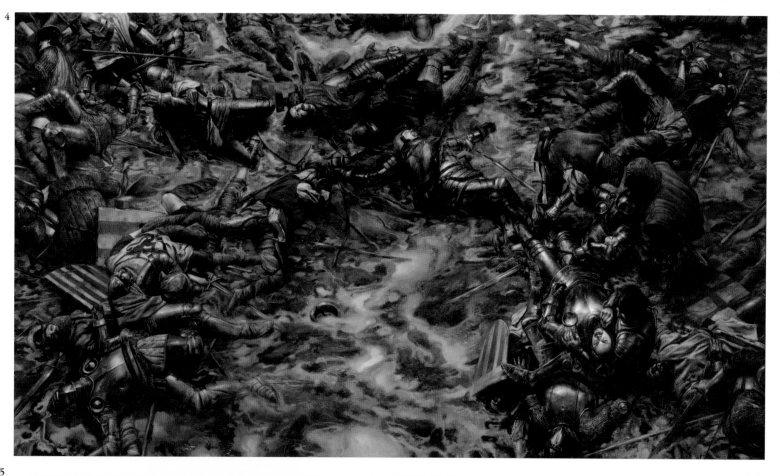

5

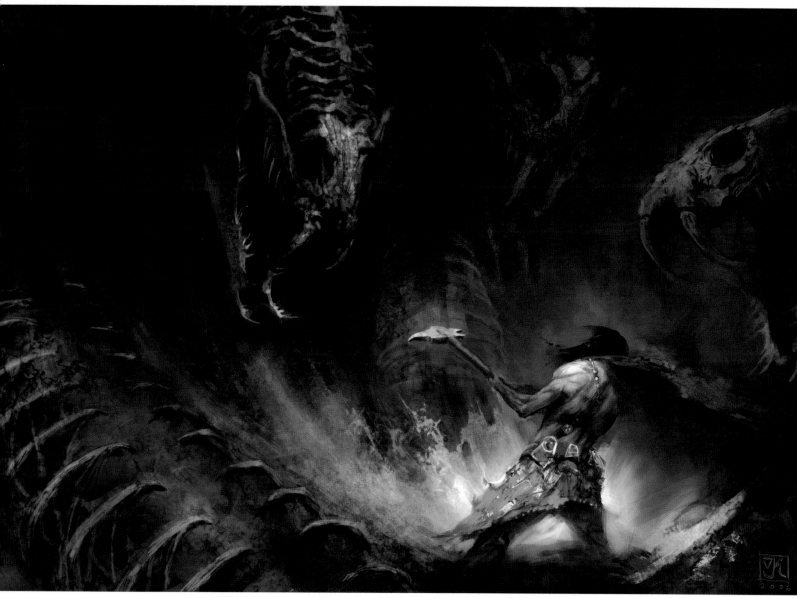

1
artist: **Mike Dutton**
art director: Cody Tilson
client: www.conceptart.org
title: The Great Discovery
medium: Digital
size: 19"x13"

2
artist: **Matt Dixon**
title: Firestarter
medium: Digital

3
artist: **Tom Fowler**
title: Bad Panda
medium: Ink/watercolor
size: 10"x7¹/4"

4
artist: **Bobby Chiu**
client: Imaginism Studios
title: Kangamole Bunny
medium: Digital
size: 10"x13"

5
artist: **Dan L. Henderson**
client: DLH Printworks
title: Marbles
medium: Charcoal
size: 20"x26"

6
artist: **Edward Binkley**
client: Stark-Raving Studios
title: Picnic
medium: Digital
size: 12"x16"

7
artist: **Cam De Leon**
client: Happy Pencil
title: Dusk
medium: Digital
size: 18"x24"

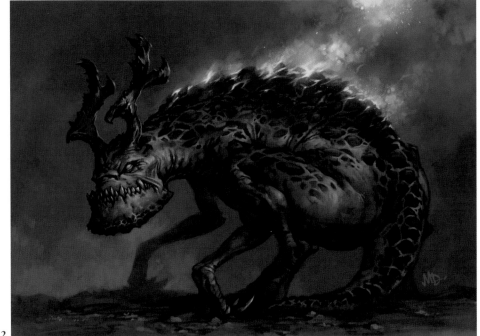

1

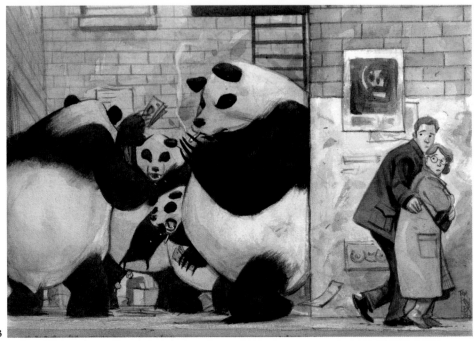

2

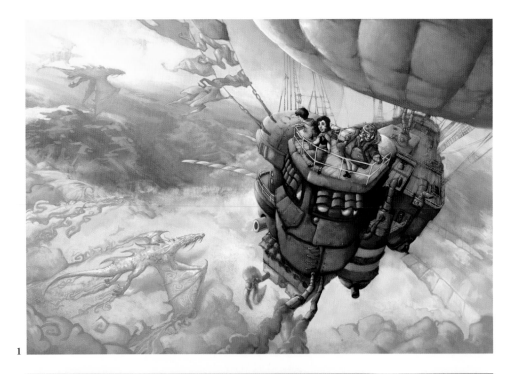

3

4

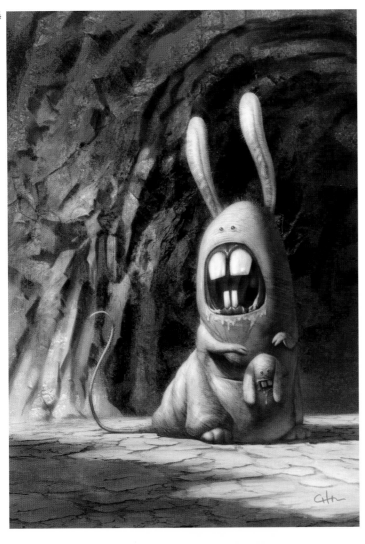

5

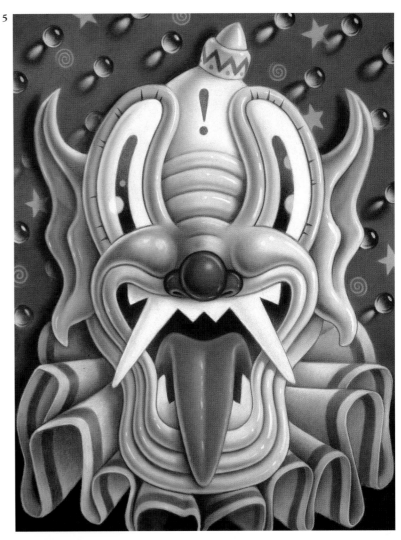

6

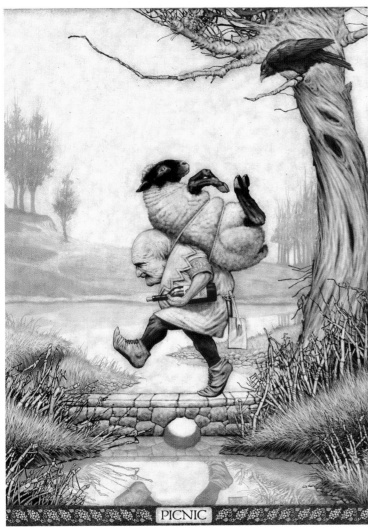

PICNIC

7

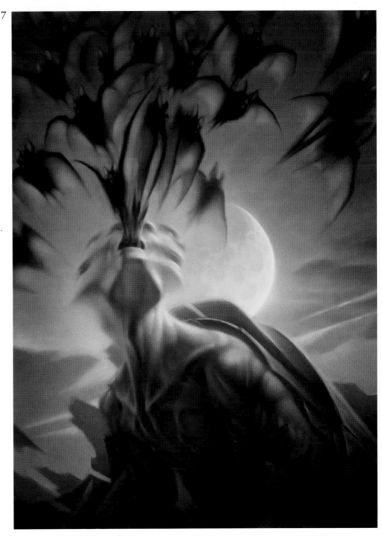

1
artist: **Brom**
client: Abrams
title: Hell Bent
medium: Oil

2
artist: **Edward Binkley**
title: Dragon Takes the Morning Air
medium: Digital

3
artist: **Volkan Baga**
art director: André Maack
client: Amigo Spiele + Freizeit
title: Alchemist
medium: Oil on paper
size: 16⁵/8"x25¹/4"

4
artist: **Chris Beatrice**
title: Donkeyskin
medium: Digital/Painter

5
artist: **Jeff Faerber**
art director: Bill Hanjorgiris
title: Boogey Mouse
medium: Mixed
size: 14"x20"

6
artist: **Terese Nielsen**
client: Angel Quest
title: Angel of Comfort
medium: Acrylics/colored pencil
size: 8"x12"

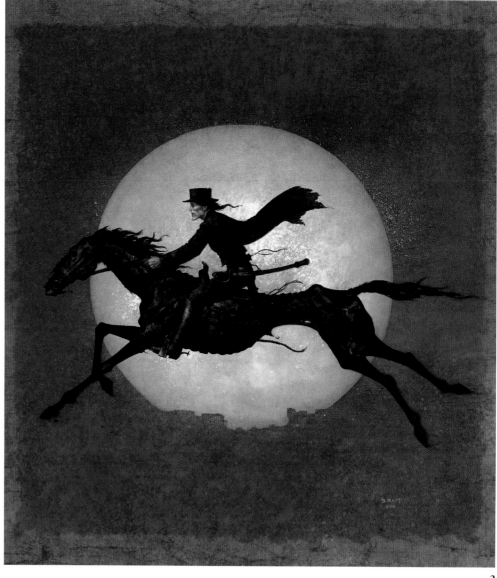

1

2

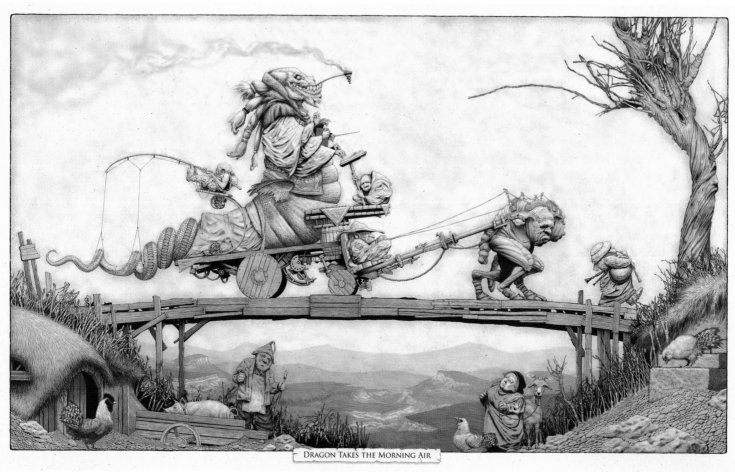

DRAGON TAKES THE MORNING AIR

3

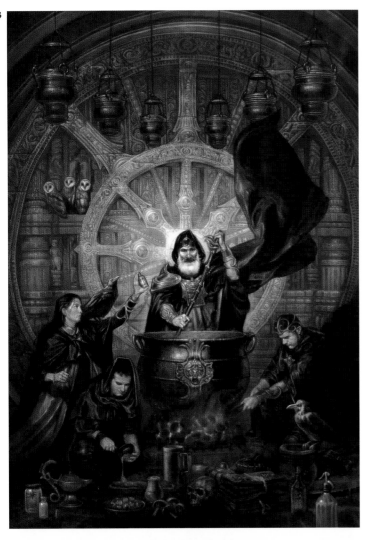

4

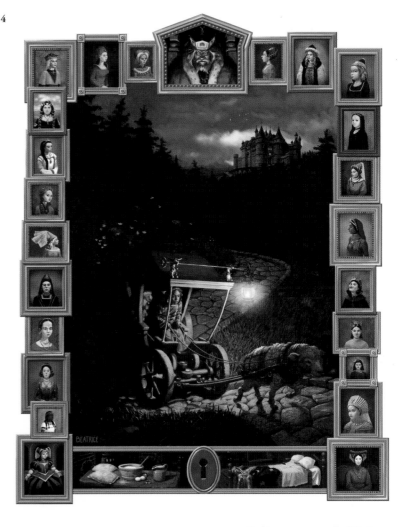

5

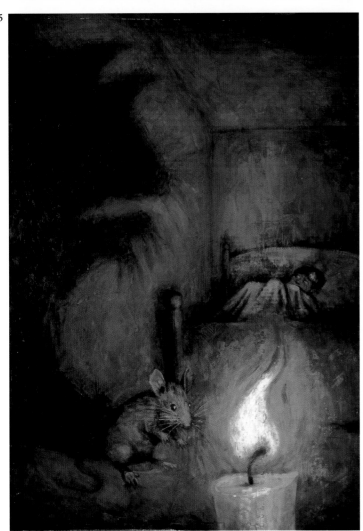

6

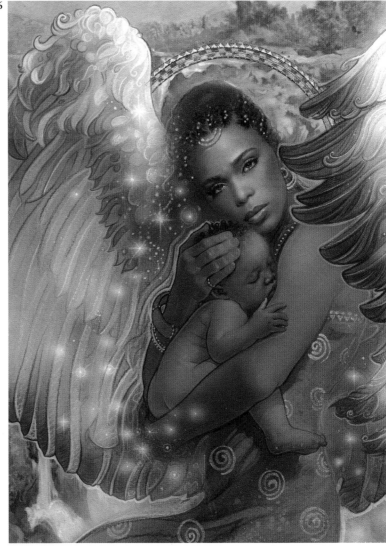

1
artist: **Erin Kelso**
client: www.conceptart.org
title: Life Cycle
medium: Ink/digital
size: 8"x10"

2
artist: **Shelly Wan**
client: www.conceptart.org/LMS2 contest
title: Charge
medium: Mixed
size: 13"x7"

3
artist: **Rob Alenxander**
art director: Jeremy Cranford
client: Wizards of the Coast
title: Out of the Mist
medium: Digital
size: 18"x12"

4
artist: **Greg Staples**
art director: Jeremy Cranford
client: Wizards of the Coast
title: Stormcloud Djinn
medium: Oil

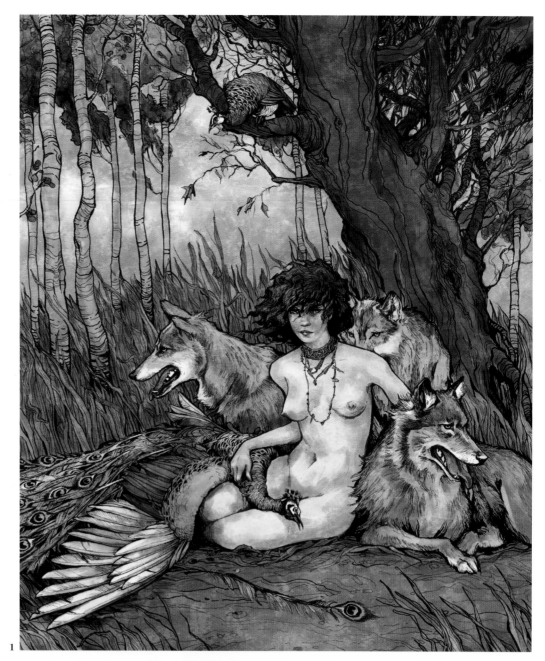

1

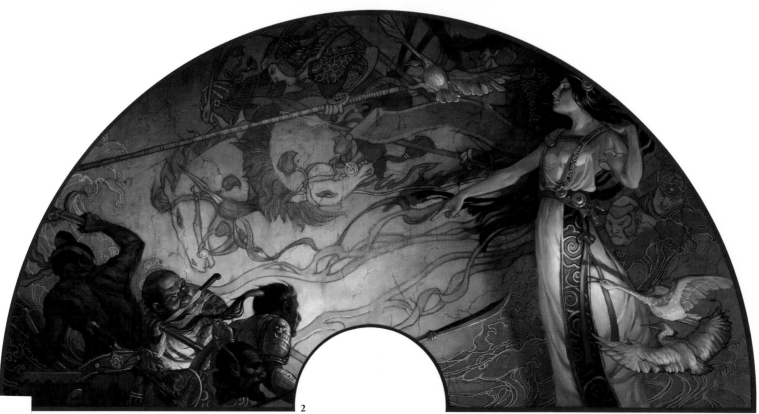

2

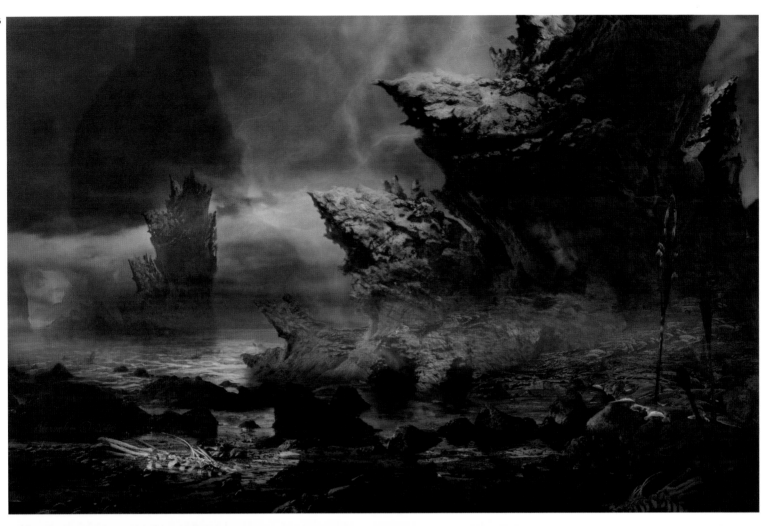

3

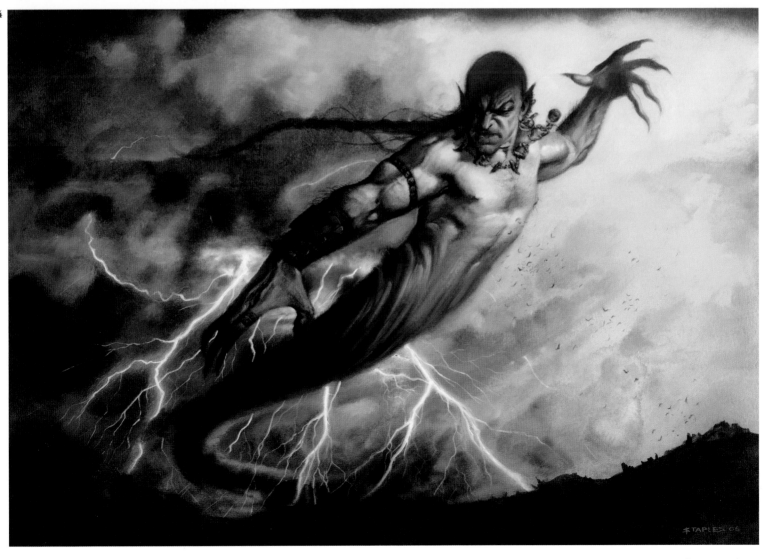

4

1
artist: **Greg Staples**
art director: Jeremy Jarvis
client: Wizards of the Coast
title: Squee, Goblin Nabob
medium: Blow

2
artist: **Travis Louie**
title: Uncle Six Eyes
medium: Acrylics on board
size: 11"x14"

3
artist: **Francis Tsai**
title: Ganesh
medium: Digital
size: 11"x17"

4
artist: **Michael Golden**
art director: Mark Irwin
client: Upper Deck
title: Rush Hour
medium: Mixed
size: 20"x20"

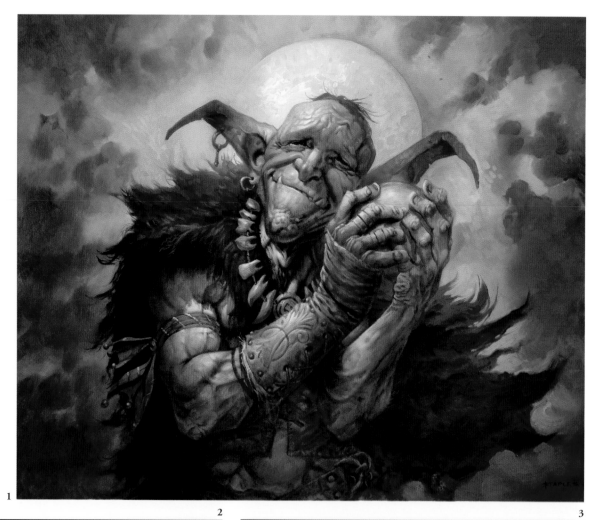

1

2
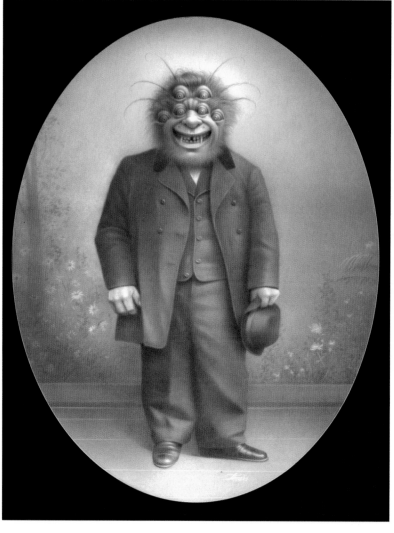

3
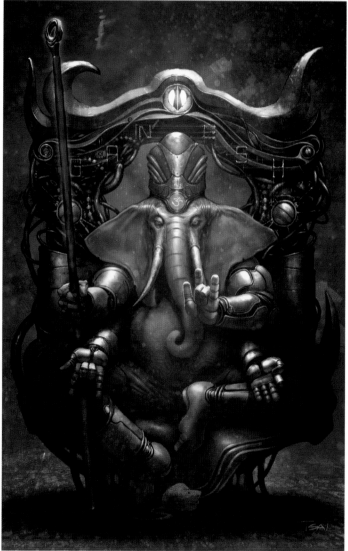

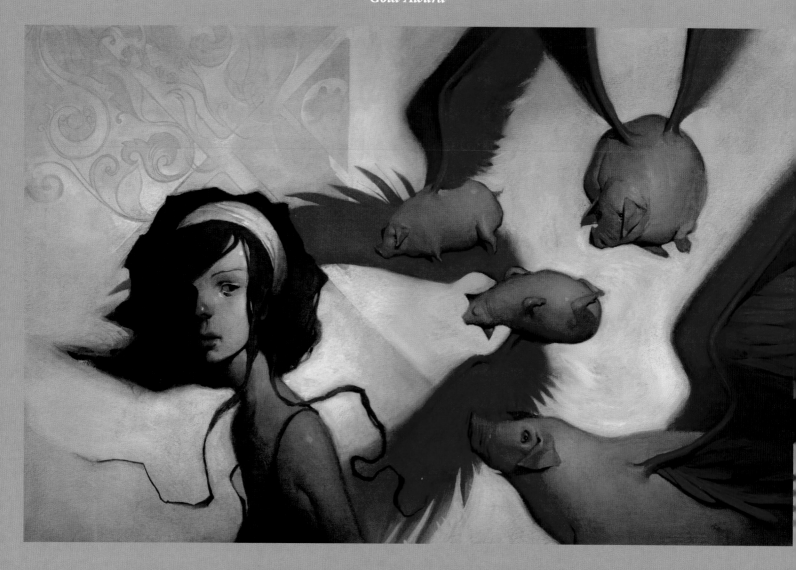

U N P U B L I S H E D

artist: Joao Ruas
title: Haunted #3 *medium:* Gouache *size:* 15$\frac{1}{2}$"x10"

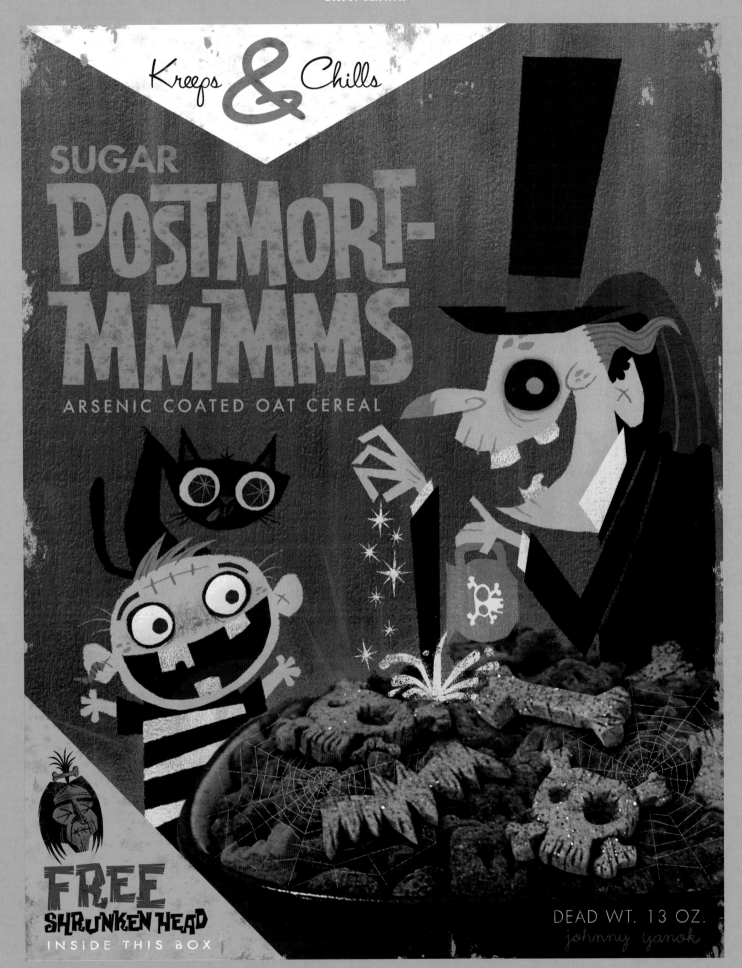

Kreeps **&** *Chills*

SUGAR
POSTMORT-
MMMMS
ARSENIC COATED OAT CEREAL

FREE
SHRUNKEN HEAD
INSIDE THIS BOX

DEAD WT. 13 OZ.
johnny yanok

artist: **Johnny Yanok**
title: Postmort-mmmms *medium:* Digital *size:* 8¹/₂"x11"

1
artist: **David Bowers**
title: The Pig Walker
medium: Oil on wood
size: 12"x18"

2
artist: **David Bowers**
title: Alter Ego
medium: Oil on wood
size: 11"x14"

3
artist: **David Bowers**
client: Halcyon Gallery
title: Waiting For Spring
medium: Oil on linen
size: 12"x18"

4
artist: **David Bowers**
title: Fragile Egos
medium: Oil on linen
size: 12"x17"

1

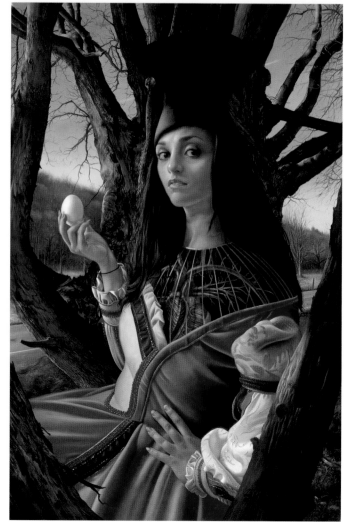

2

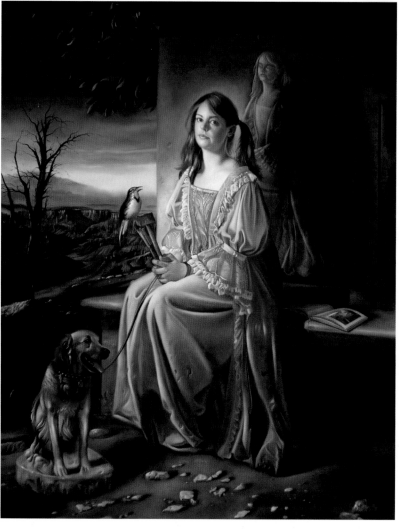

3

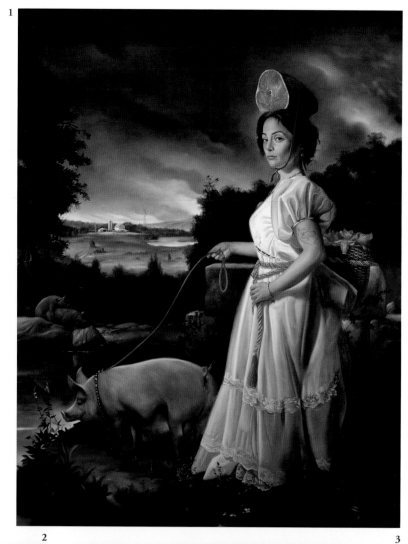

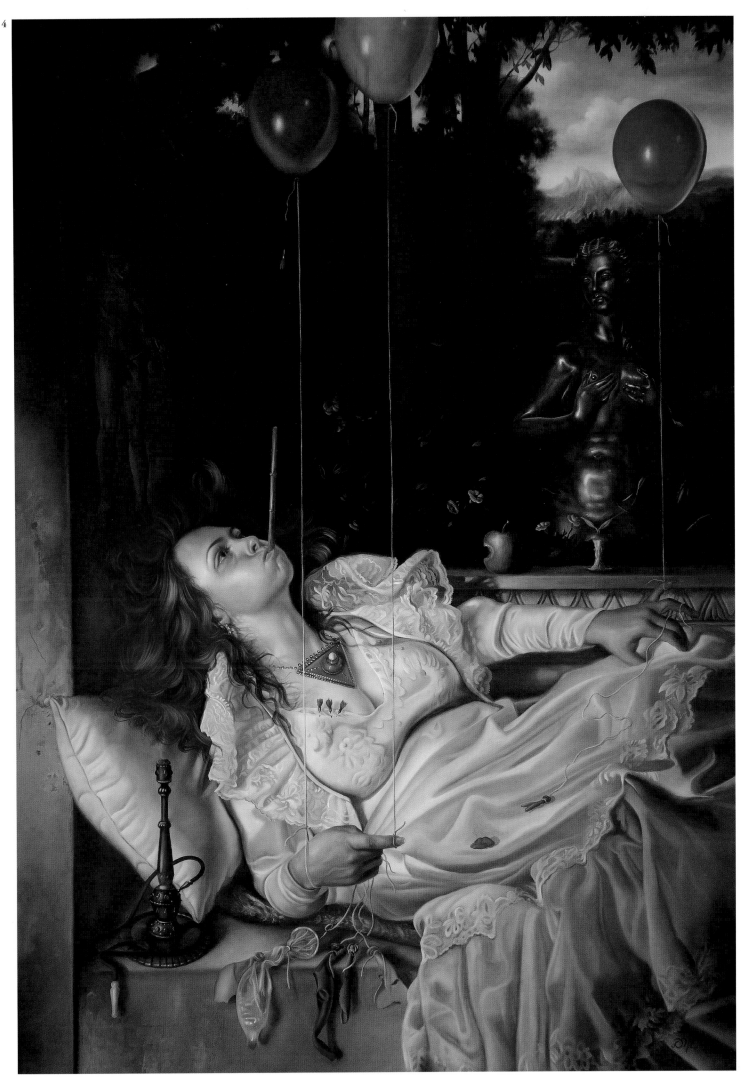

1
artist: **John Jude Palencar**
title: Prophet #2: Virgin with Ovum
medium: Oil on wood
size: 14³/4"x16¹/4"

2
artist: **Kimberly Kincaid**
title: Prelude to a Kiss
medium: Colored pencil
size: 20"x16"

3
artist: **Esao Andrews**
title: Happiness and Wisdom
medium: Oil on board
size: 13"x21"

4
artist: **John Blumen**
title: Lady
medium: Digital

5
artist: **Richard Hescox**
title: Twilight Summoning
medium: Oil
size: 24"x18"

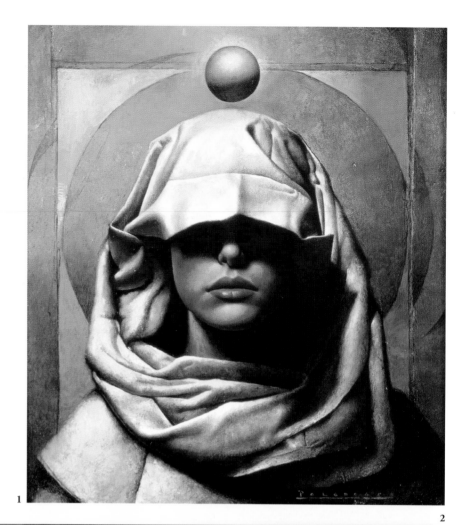

1

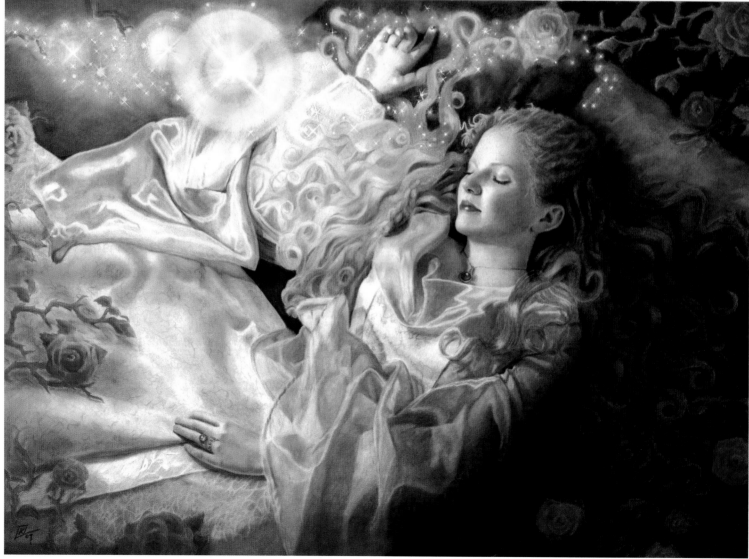

2

3

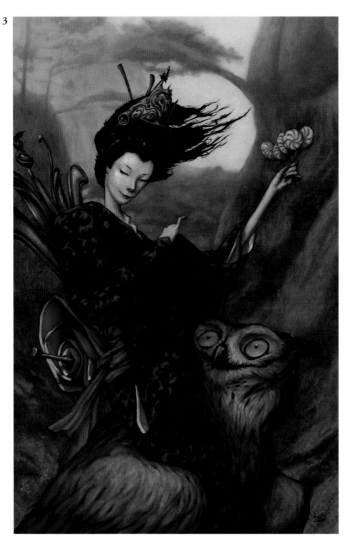

4

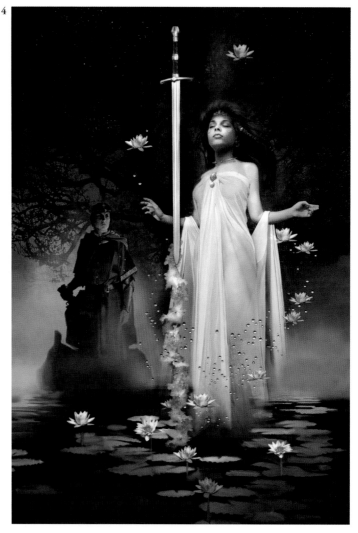

5

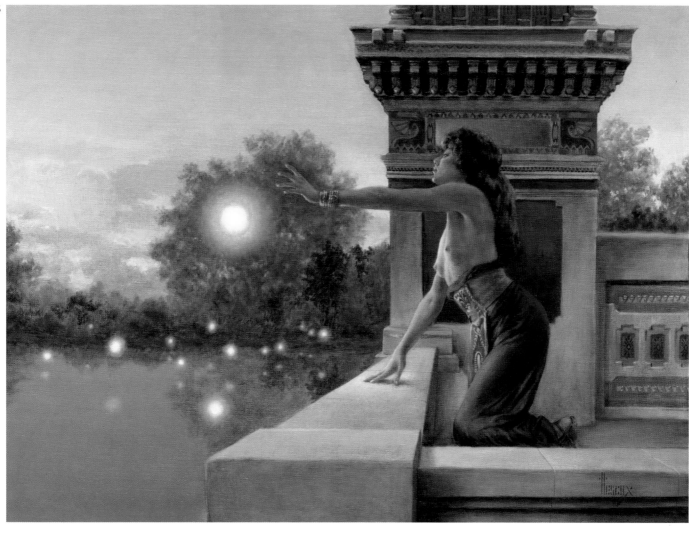

1
artist: **Guy Francis**
title: Surprise
medium: Pen and ink
size: 10"x8"

2
artist: **Matt Dangler**
title: Goblin King
medium: Watercolor
size: 9"x12"

3
artist: **Augie Pagan**
title: Scarecrow (Knowledge of Self)
medium: Acrylics on canvas
size: 3'x5'

4
artist: **Bobby Chiu**
client: www.imaginismstudios.com
title: The First Line of Defence
medium: Digital
size: 10"x13"

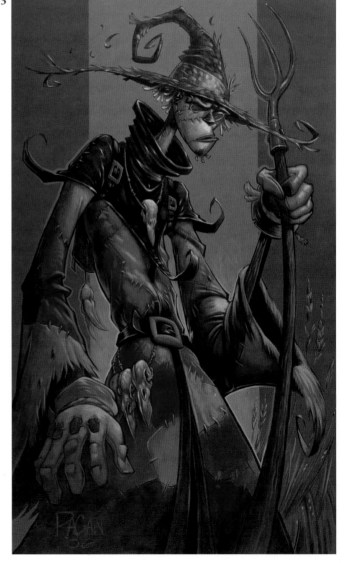

1

2

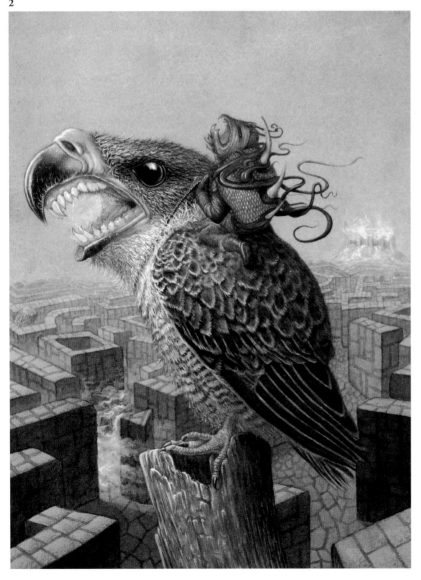

3

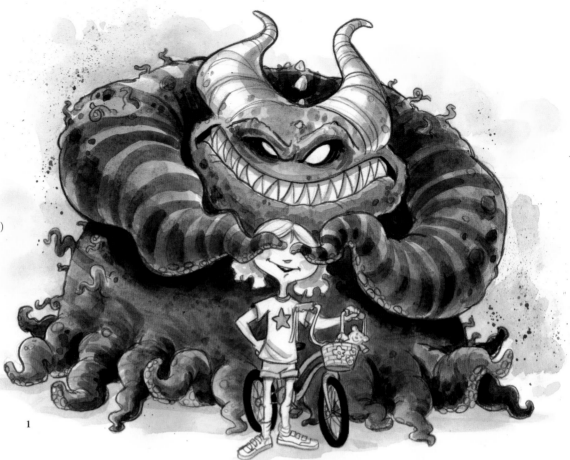

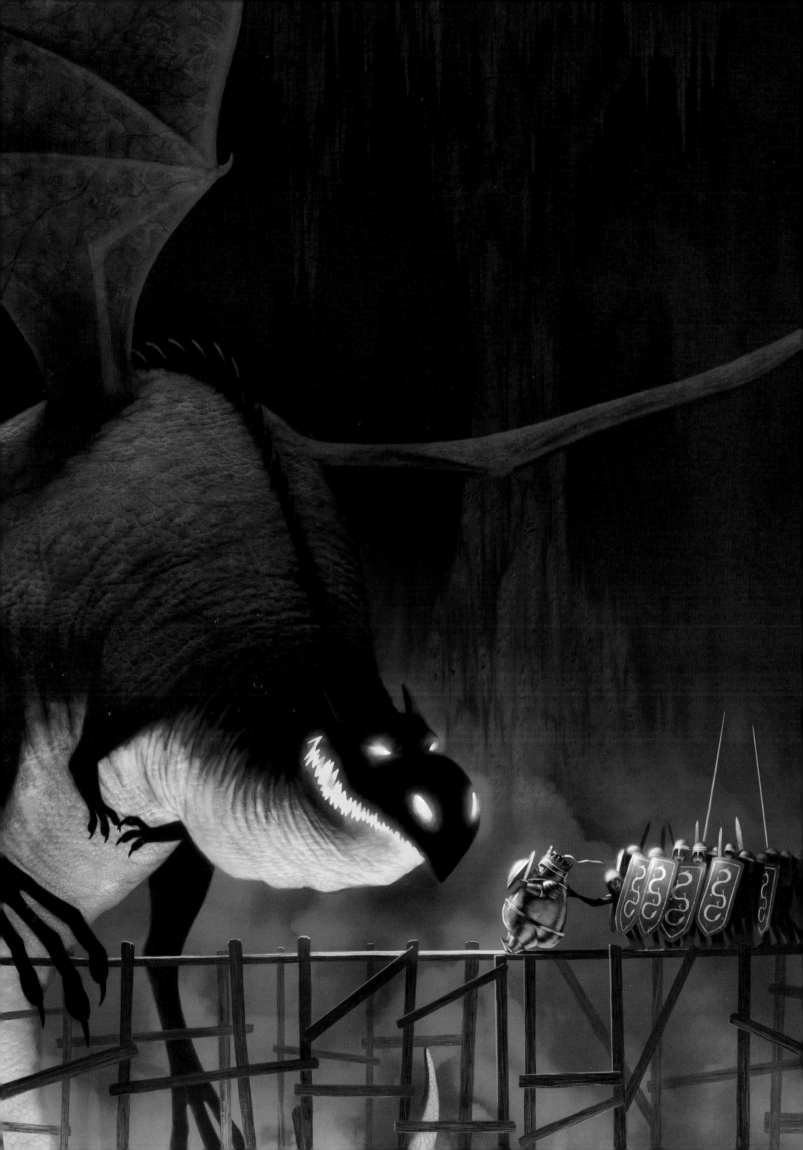

1
artist: **Sean Chapman**
art director: Octavio Perez
title: Macabre
medium: Mixed

2
artist: **Greg Spalenka**
title: Beacon
medium: Digital
size: 17"x11"

3
artist: **Colin Fix**
title: The Harvest
medium: Digital
size: 21"x10"

4
artist: **Kei Acedera**
client: imaninismstudios.com
title: An Unexpected Visitor
medium: Digital
size: 10"x13"

5
artist: **Greg Capullo**
title: Heat Seeker
medium: Digital
size: 8"x10"

6
artist: **Christian Alzmann**
title: Team Shortbus
medium: Mixed/digital
size: 8"x12"

7
artist: **Scott Altmann**
client: Strychnin Gallery
title: Auto Human
medium: Oil on linen on panel
size: 16"x20"

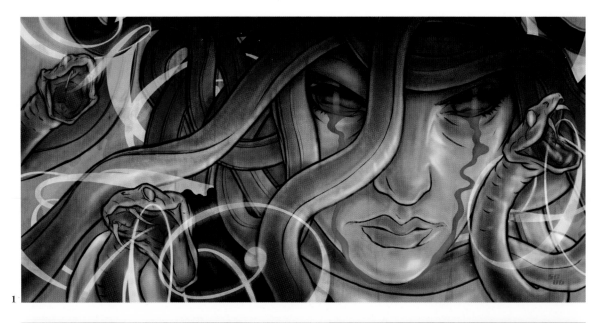

1

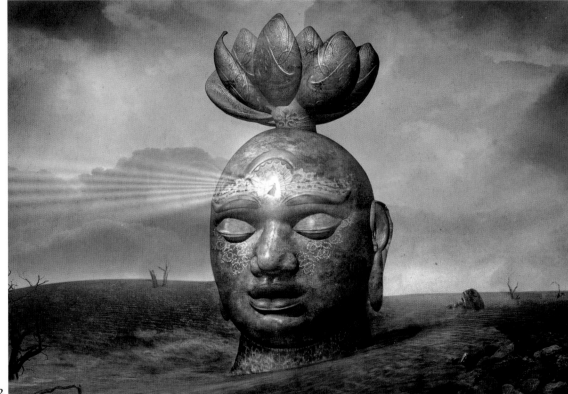

2

3

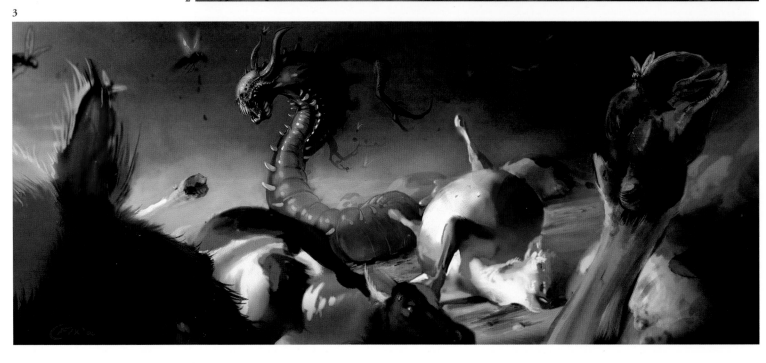

4

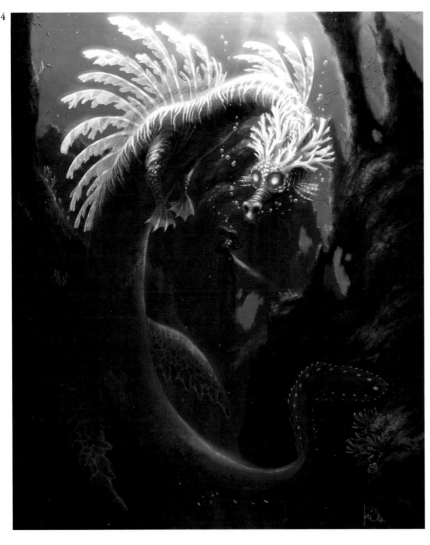

5

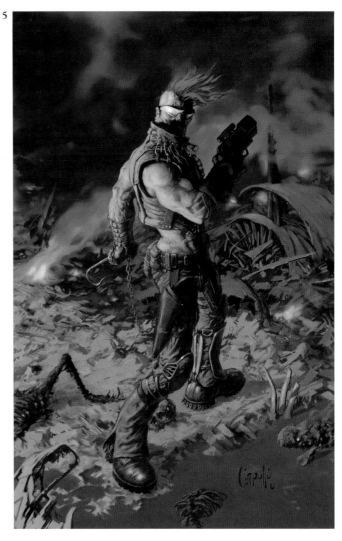

6

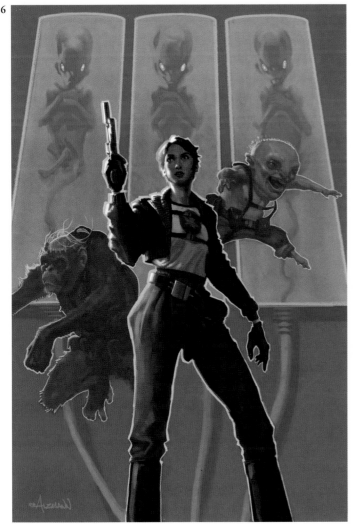

7

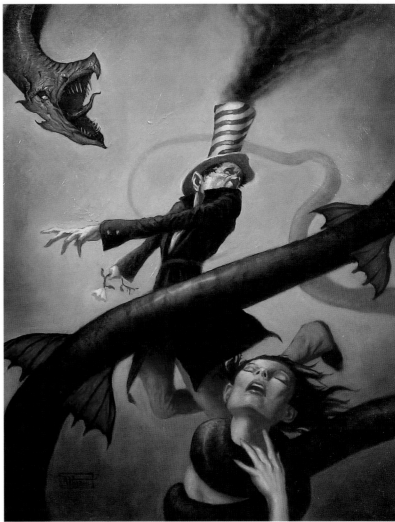

1
artist: **Erin Kelso**
title: Alice and the Gryphon
medium: Ink/digital
size: 8"x10"

2
artist: **Jim Burns**
title: Dryad of the Oaks
medium: Acrylics & inks on gessoed MDF
size: 40"x27"

3
artist: **Jason Merck**
title: Angel of Death
medium: Digital
size: 8¹/2"x11"

4
artist: **Glen Angus**
title: Victory Gal P-40
medium: Digital
size: 14"x20"

5
artist: **Petar Meseldzija**
client: Zmaj, Novi Sad
title: The Legend of Steel-Bashaw 10
medium: Oil
size: 30¹/4"x27¹/2"

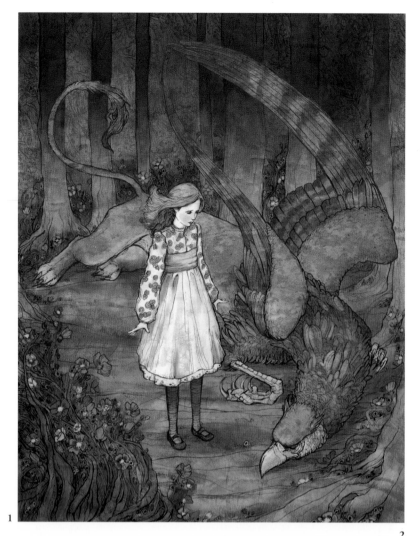

1

2

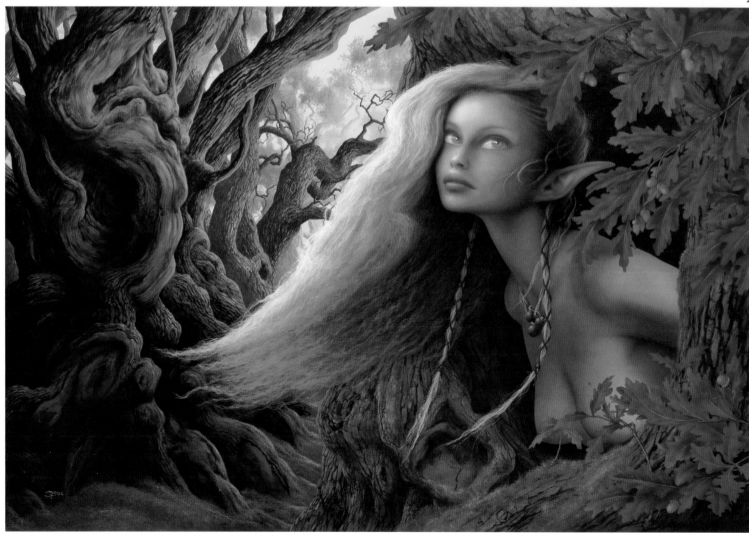

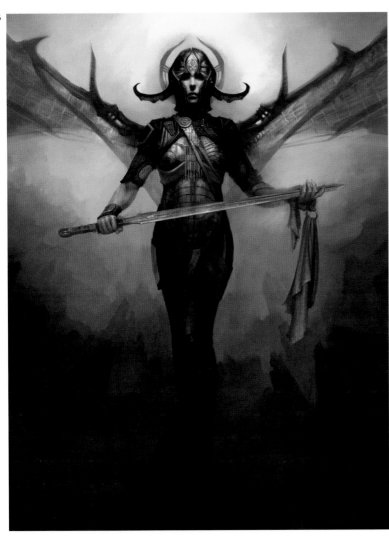

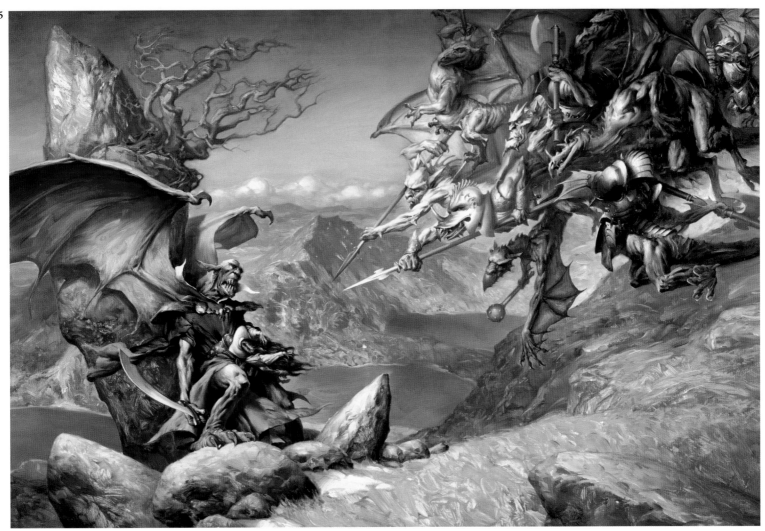

1
artist: **Jeremy Geddes**
client: Ashley Wood
title: Lady Sham Inspects the Damage
medium: Oil
size: 43³/8"x43³/8"

2
artist: **Arkady Roytman**
title: The Beginning of the End
medium: Mixed
size: 9¹/2"x13¹/2"

3
artist: **Matt Dixon**
title: Happy Halloween
medium: Digital

4
artist: **Aleksi Briclot**
art director: Aleksi Briclot/
 Jean-Sébastien Rossbach
client: Soleil Editions
title: Merlin: La Genèse
medium: Digital
size: 10"x11¹/2"

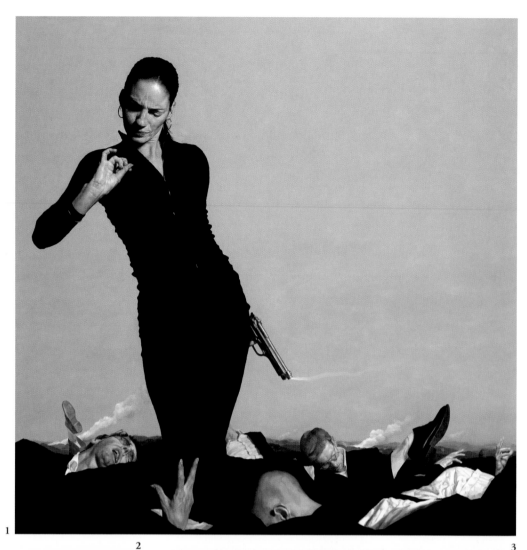

1

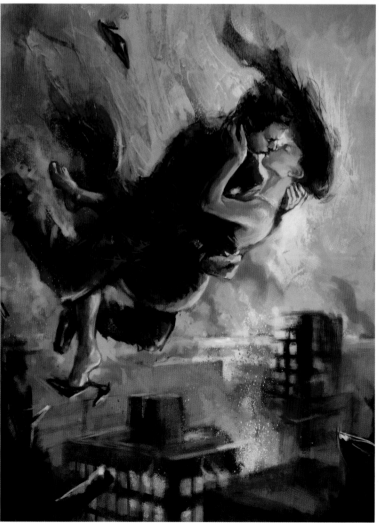

2

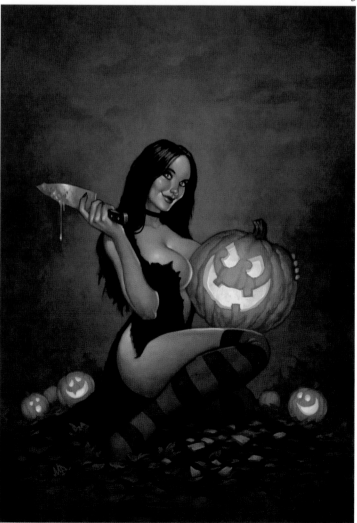

3

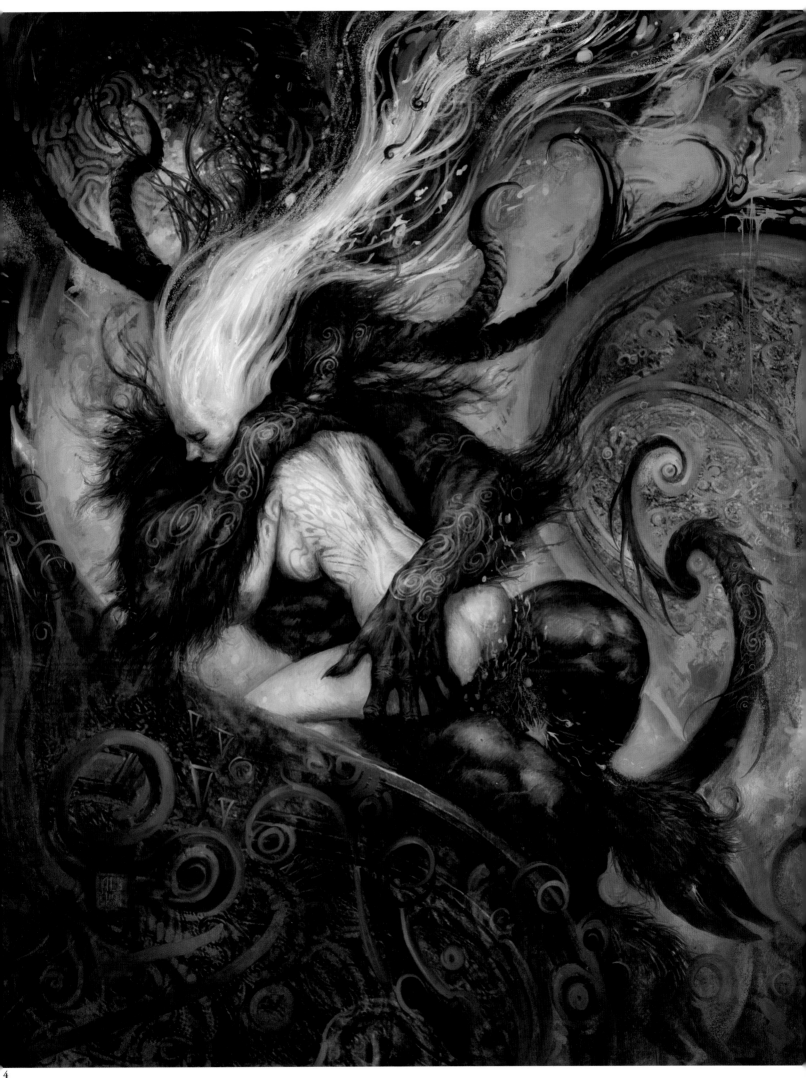

4

1
artist: **Chris Rahn**
client: www.rahnart.com
title: Vote for Satan
medium: Oil over collage
size: 12"x16"

2
artist: **David Palumbo**
title: Sword of Legends
medium: Oil
size: 18"x27"

3
artist: **David Ho**
title: Candice Controls Her Desires
medium: Digital
size: 8"x10"

4
artist: **Brom**
client: Abrams
title: The Horned God
medium: Oil

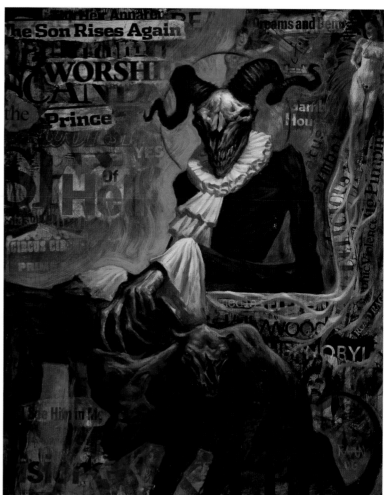

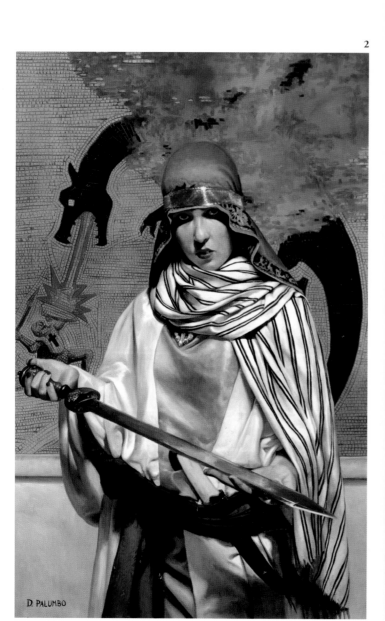

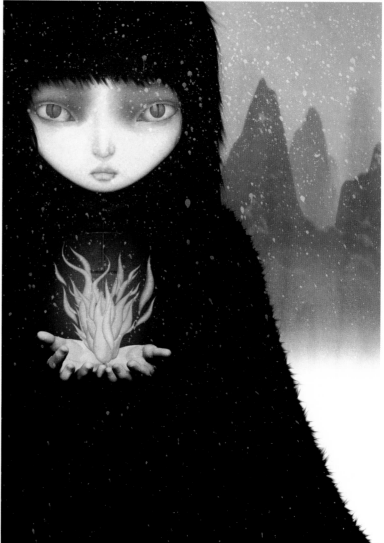

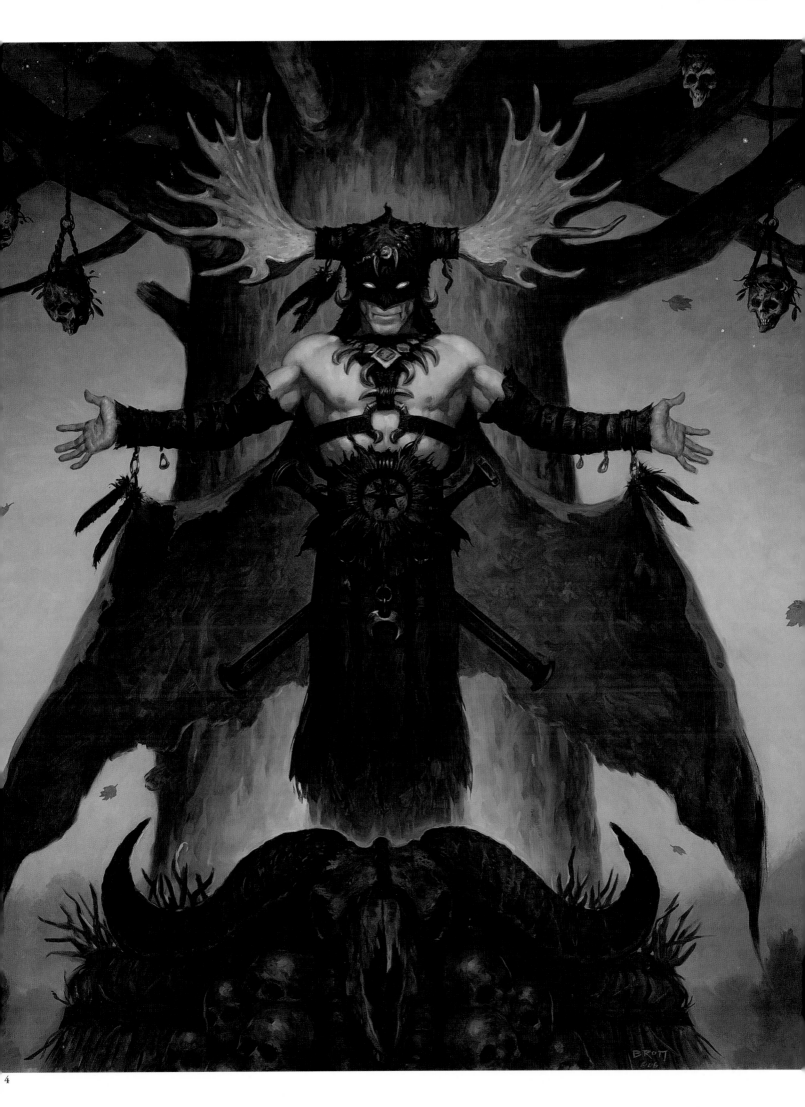

4

1
artist: **Mike Sosnowski**
title: Fear of Shadows
medium: Oil on canvas
size: 30"x40"

2
artist: **Joshua Viers**
title: Tentaculus Gigantus
medium: Digital
size: 19"x5¹/4"

3
artist: **Joseph Daniel Fiedler**
art director: C. Falcionoi
client: Magnet Reps
title: Roe V. Godzilla
medium: Mixed
size: 11"x14"

4
artist: **Steve Ellis**
art director: Yamila Fournier
title: Smash!
medium: Acrylics on masonite
size: 24"x36"

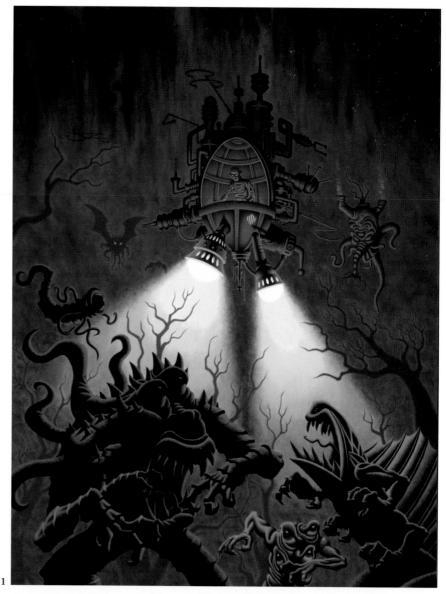

1

2

1
artist: **Mathias Verhasselt**
title: Welcome to the
 Beginning of the End
medium: Photoshop

2
artist: **Kip Omolade**
title: An Amphibious
 Sonnet
medium: Oil
size: 18"x24"

3
artist: **Greg Couch**
title: Witch
medium: Acrylics/
 colored pencil
size: 10"x14"

4
artist: **Ben Neuhart**
title: Lady in the Water
medium: Adobe Illustrator
size: 7¼"x9¼"

5
artist: **AG Ford**
title: Peppermint Kids
medium: Acrylics/oil
size: 30"x48"

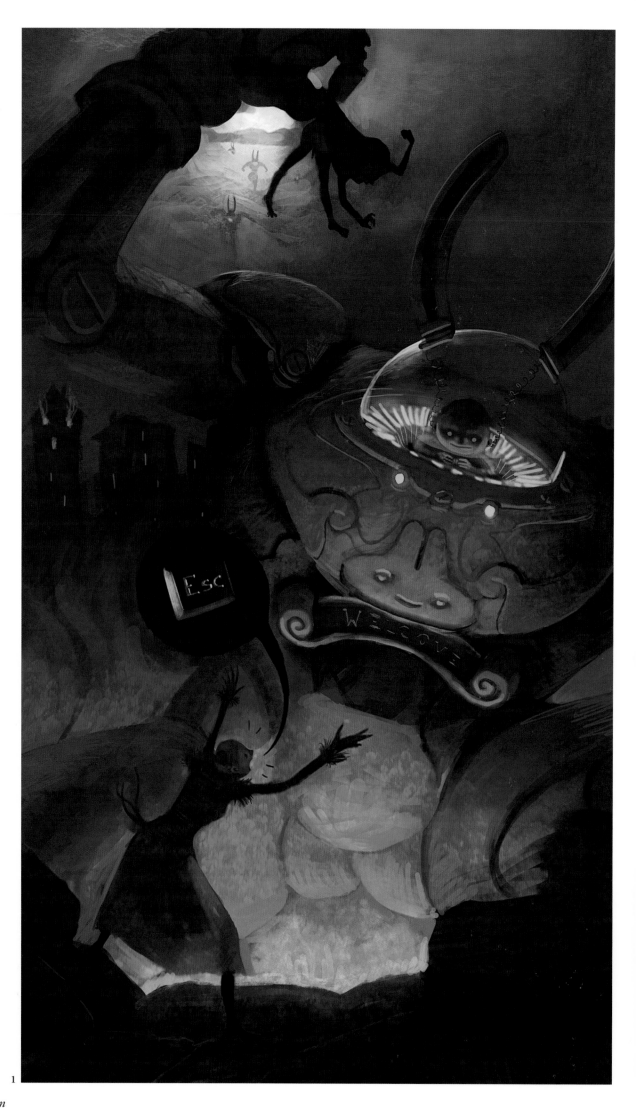

1

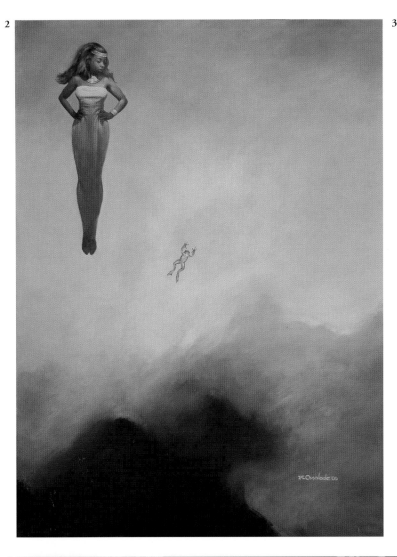

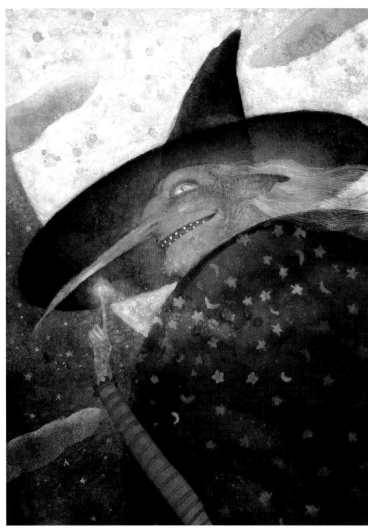

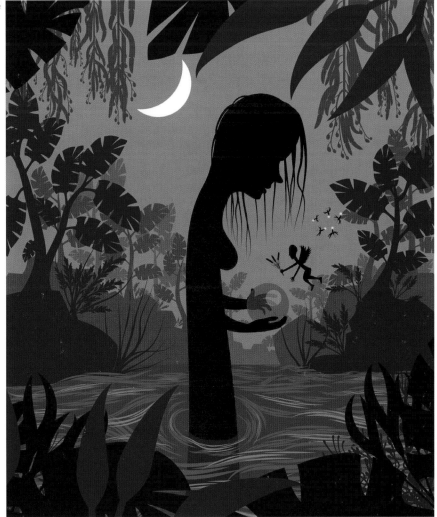

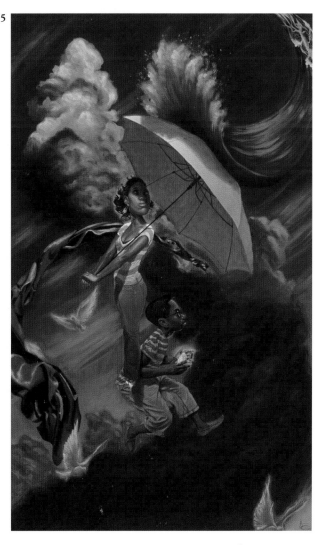

1
artist: **Michael Morris**
title: Bait
medium: Photography/digital
size: 12"x12"

2
artist: **Cris Ortega**
client: Norma Editorial
title: The Forgotten: Harp
medium: Mixed
size: 12"x8"

3
artist: **Gordon Crabb**
title: Big Fish
medium: Digital

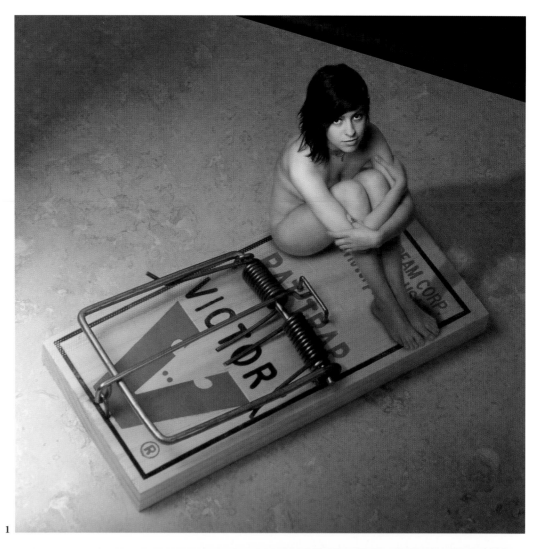

1

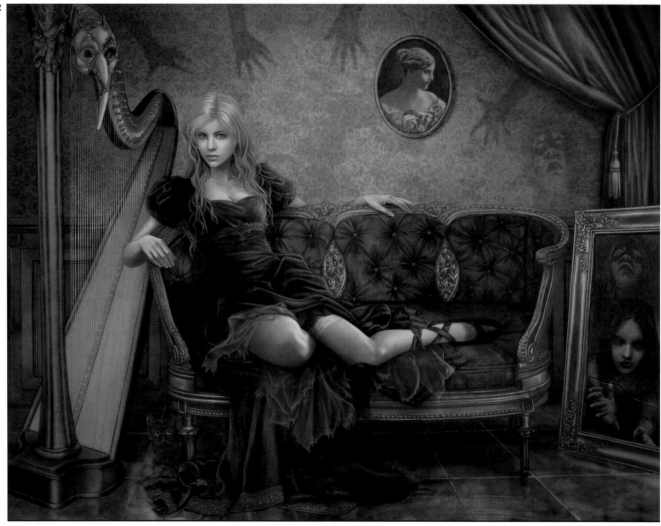

2

3

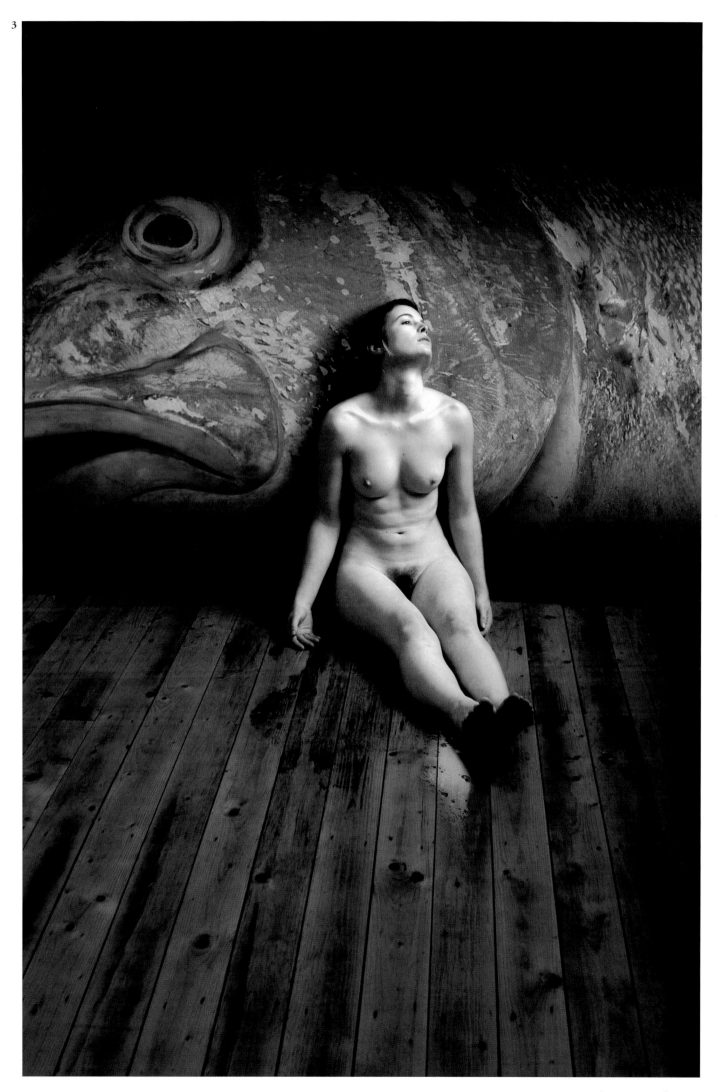

1
artist: **Colin Fix**
title: Pop
medium: Mixed/digital
size: 17"x7¹/₂"

2
artist: **Raphael Lacoste**
title: Path to the Gothic Choir
medium: Photoshop/3DS
size: 11"x8¹/₂"

3
artist: **Hyejeong Park**
title: Hunting
medium: Acrylics on board
size: 24"x18"

4
artist: **Chris Rahn**
client: www.rahnart.com
title: Gretel
medium: Oil on masonite
size: 16"x20"

5
artist: **Ben Neuhart**
title: The Fight
medium: Adobe Illustrator
size: 7¹/₄"x9¹/₄"

6
artist: **Jeremy Forson**
title: Tentacles
medium: Mixed
size: 15"x12"

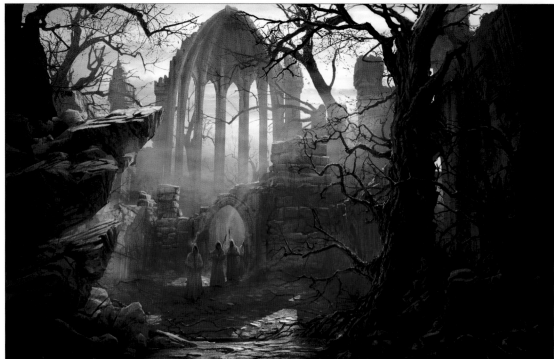

1

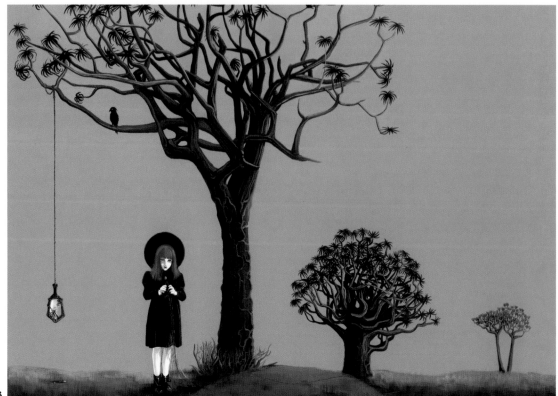

2

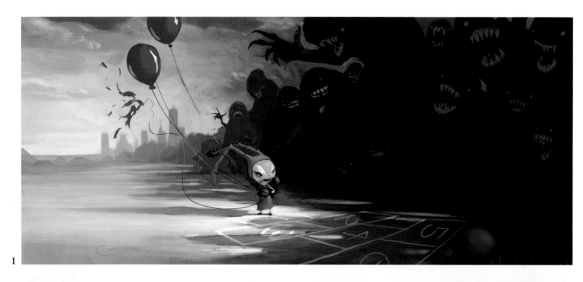

3

4

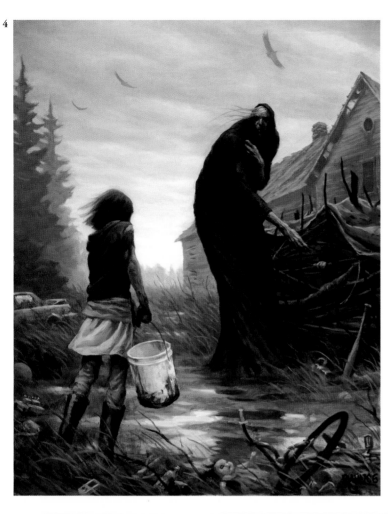

5

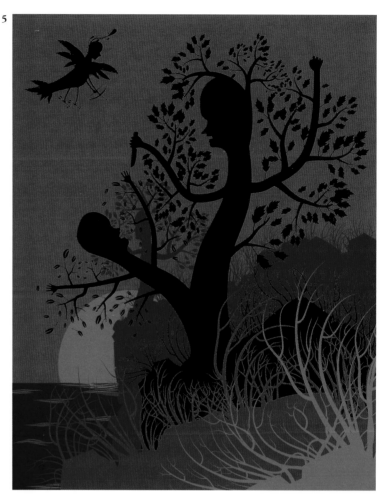

6

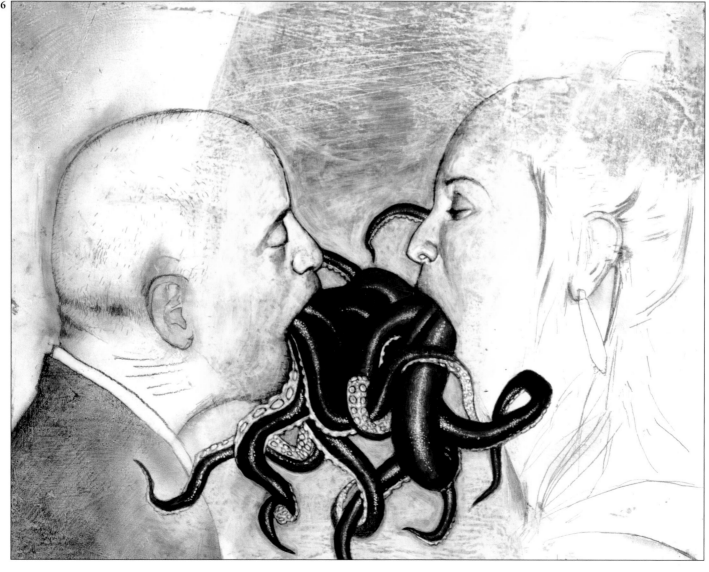

1
artist: **Aleksi Briclot**
art director: Aleksi Briclot/Jean-Sébastien Rossbach
client: Soleil Editions
title: Merlin: Le Roi-Dragon
medium: Digital
size: 11^1/2"x10"

2
artist: **Dustin Papow**
instructor: Gil Ashly
client: College for Creative Studies
title: Bolero
medium: Digital
size: 11^5/8"x16^1/2"

3
artist: **Hong Kuang**
art director: Joe Blow
title: The Dying Dream
medium: Digital
size: 11^3/4"x16^5/8"

4
artist: **Deseo**
title: Samurai Girl 2
medium: Pencil/Photoshop

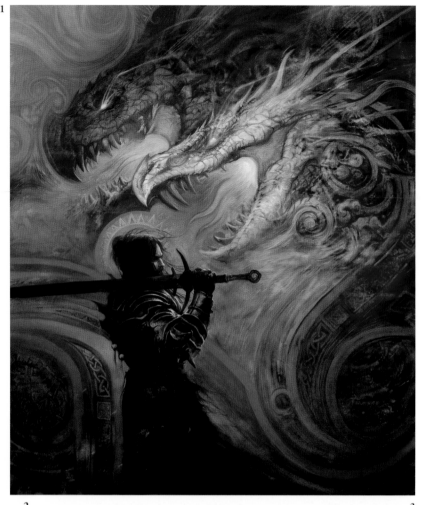

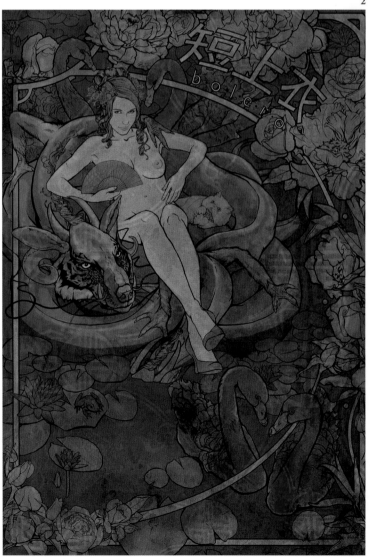

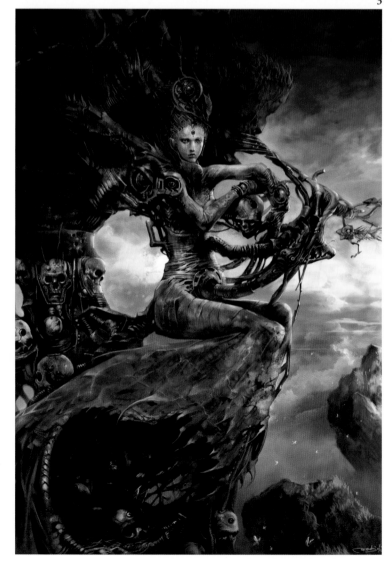

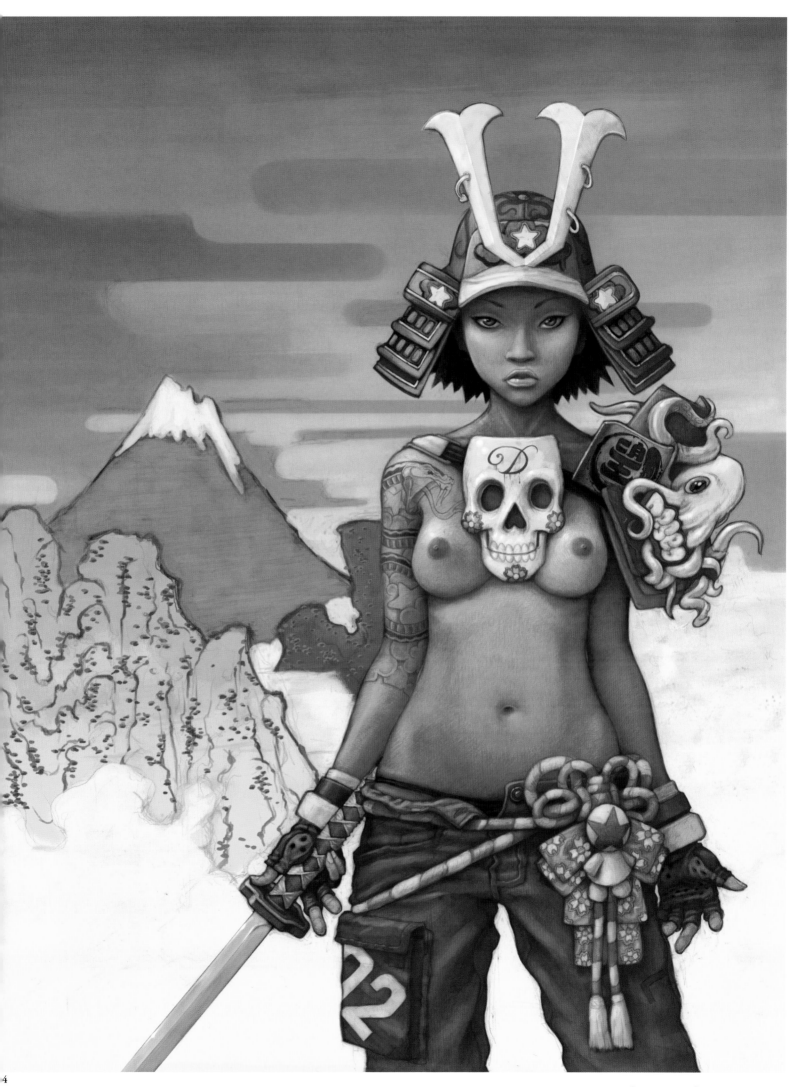

1
artist: **Melissa Ferreira**
title: Heat
medium: Mixed
size: 13"x19"

2
artist: **David Ho**
title: Candice Unleashes Her Demons
medium: Digital
size: 10"x5"

3
artist: **John Mueller**
title: Das Butcher
medium: Digital

4
artist: **Jaime Zollars**
client: Copro-Nason Gallery
title: Red Bird Battalion
medium: Acrylics/collage
size: 8"x10"

5
artist: **Esao Andrews**
medium: Oil on wood
size: 18"x31"

6
artist: **Edward J. Bateman**
title: Holiday Card
medium: Digital
size: 4^1/$_2$"x5^1/$_4$"

1
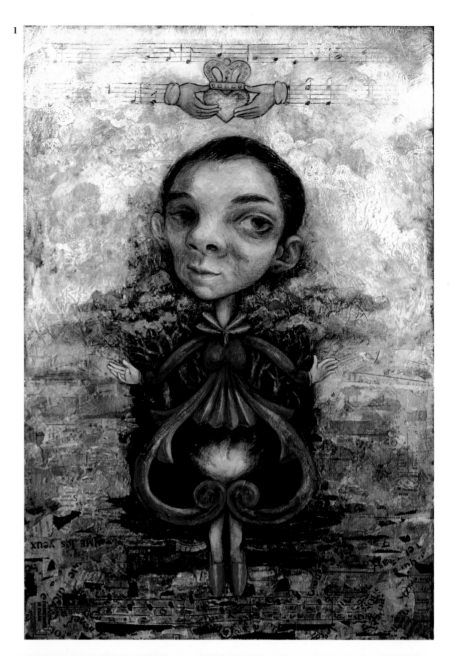

2
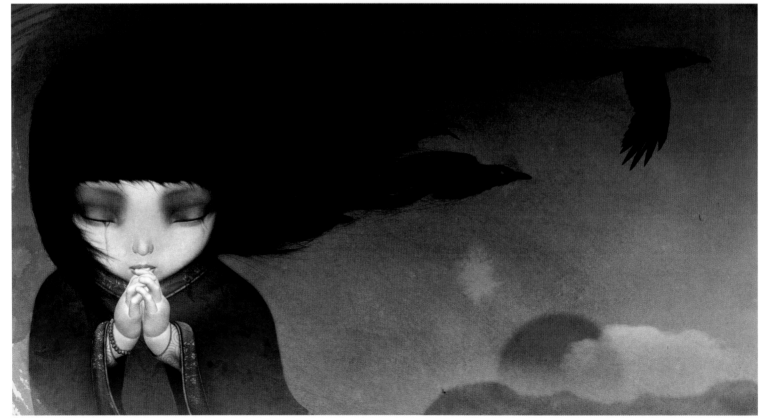

3

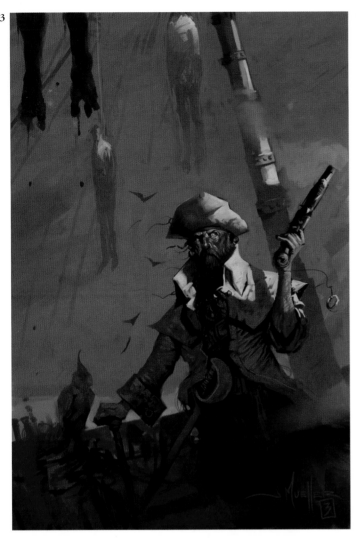

4

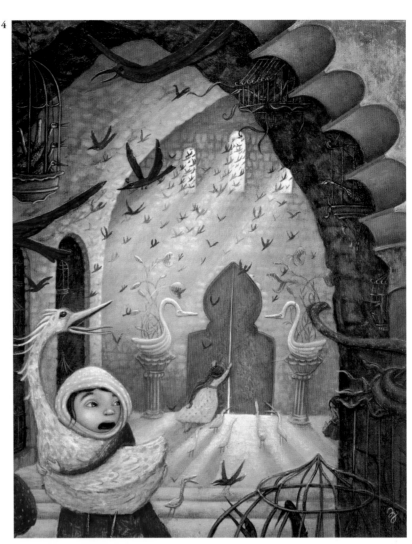

5

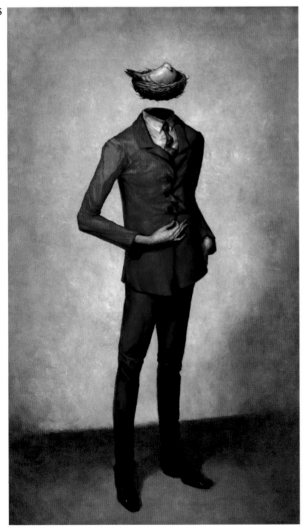

6

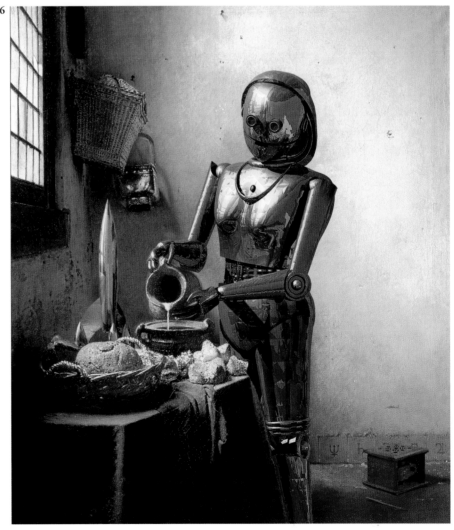

1
artist: **Steven Tabbutt**
title: The Three Muses
medium: Mixed
size: 12$^{1}/_{2}$"x14"

2
artist: **Stephen Hickman**
title: Galadriel's Harp
medium: Oil
size: 22"x36"

3
artist: **A. Andrew Gonzalez**
title: Yemanja
medium: Acrylics
size: 18"x24"

4
artist: **Rick Berry**
title: Frost
medium: Oil
size: 32"x48"

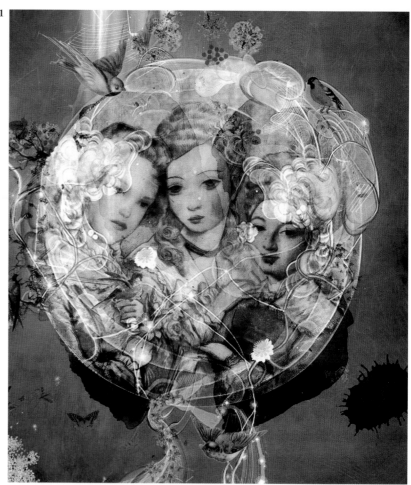

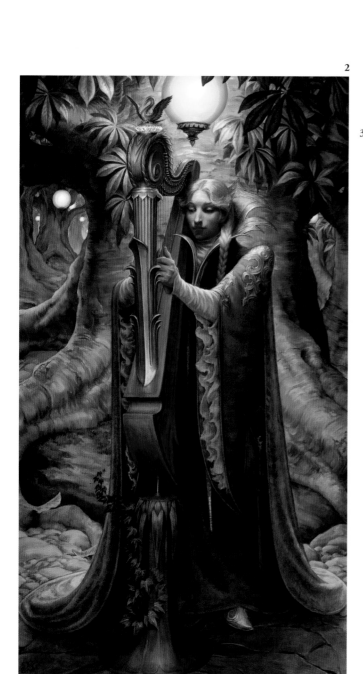

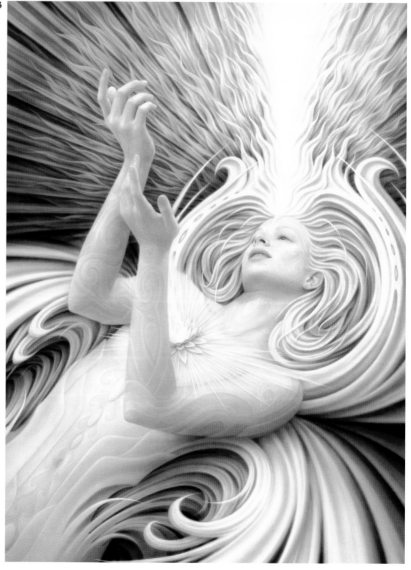

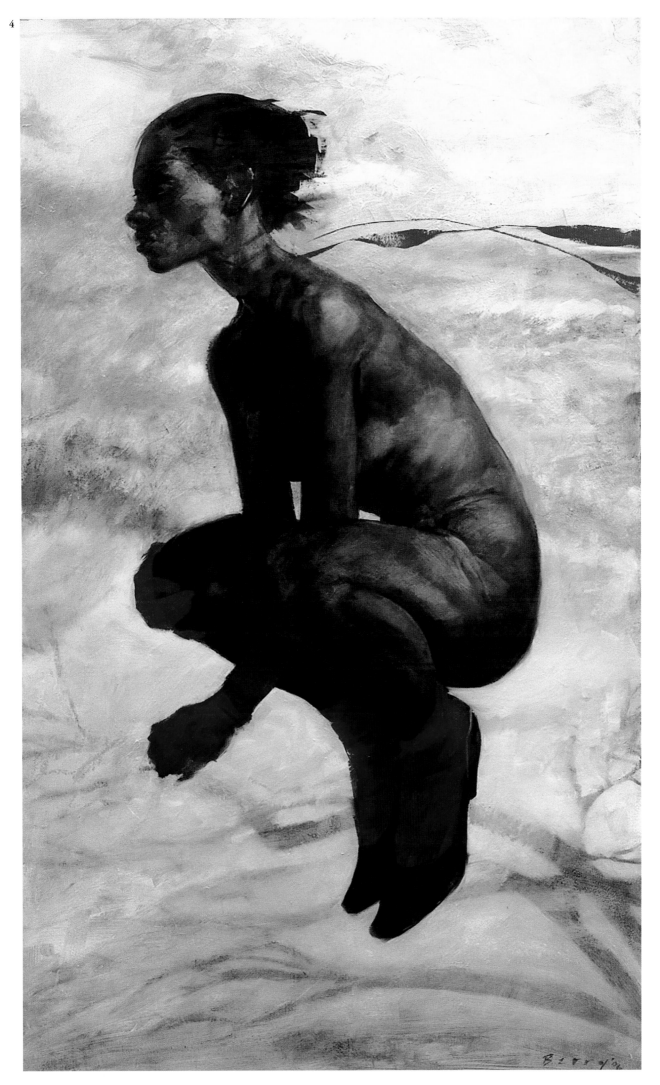

1
artist: **Ragnar**
client: Baby Tattoo Books
title: On Empty
medium: Digital
size: 8$^{1}/_{2}$"x8$^{1}/_{2}$"

2
artist: **Robin Chyo**
title: The Escape +
medium: Digital

3
artist: **Steven Stahlberg**
title: Abduction
medium: Photoshop

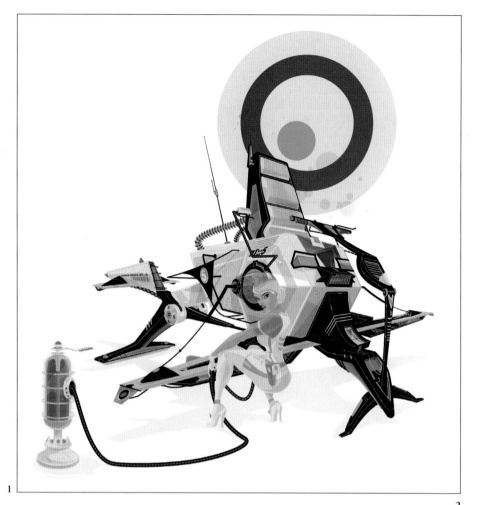

1

2

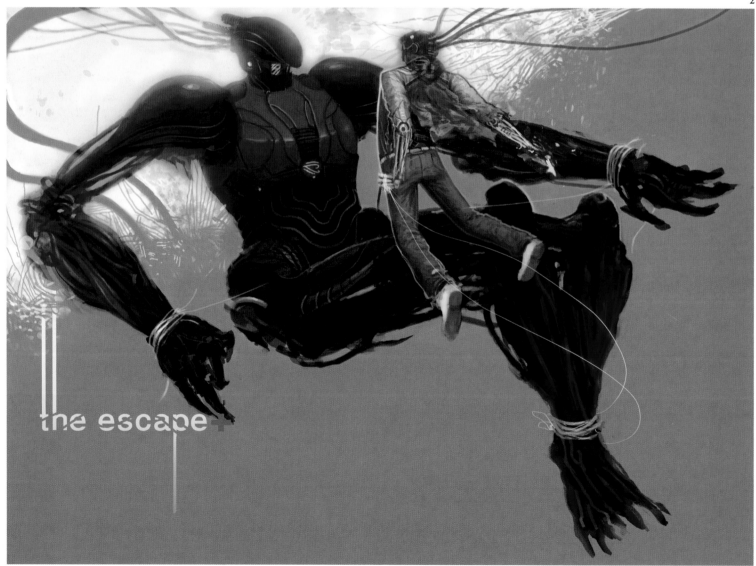

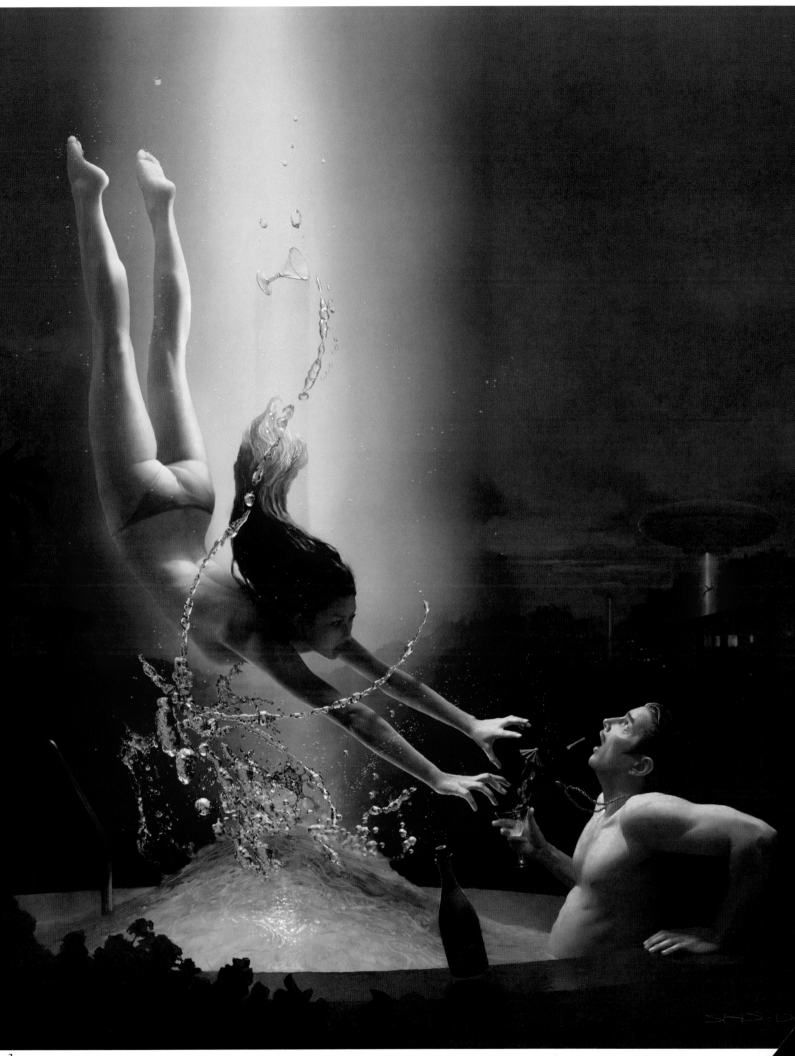

1
artist: **Melanie Delon**
client: Norma Editorial
title: Where Are You?
medium: Photoshop

2
artist: **Emmanuel Malin**
title: Last Ride
medium: Pencil/digital
size: 15^1/$_2$"x9^1/$_8$"

3
artist: **Justin Sweet**
title: Perseus
medium: Oil on canvas
size: 32"x45"

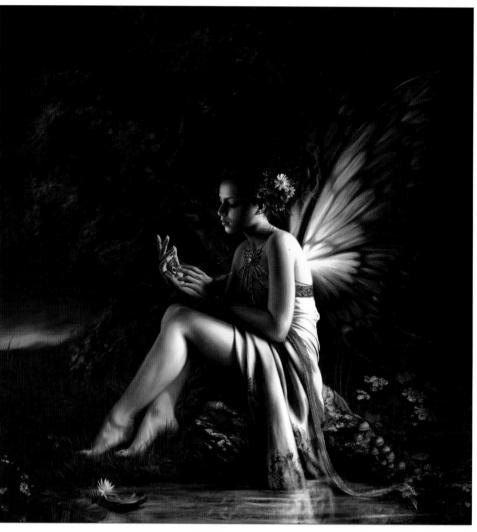

1

2

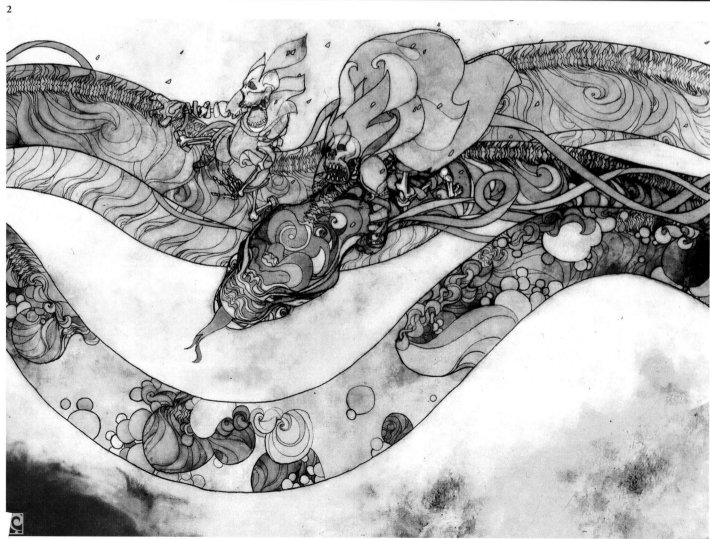

3

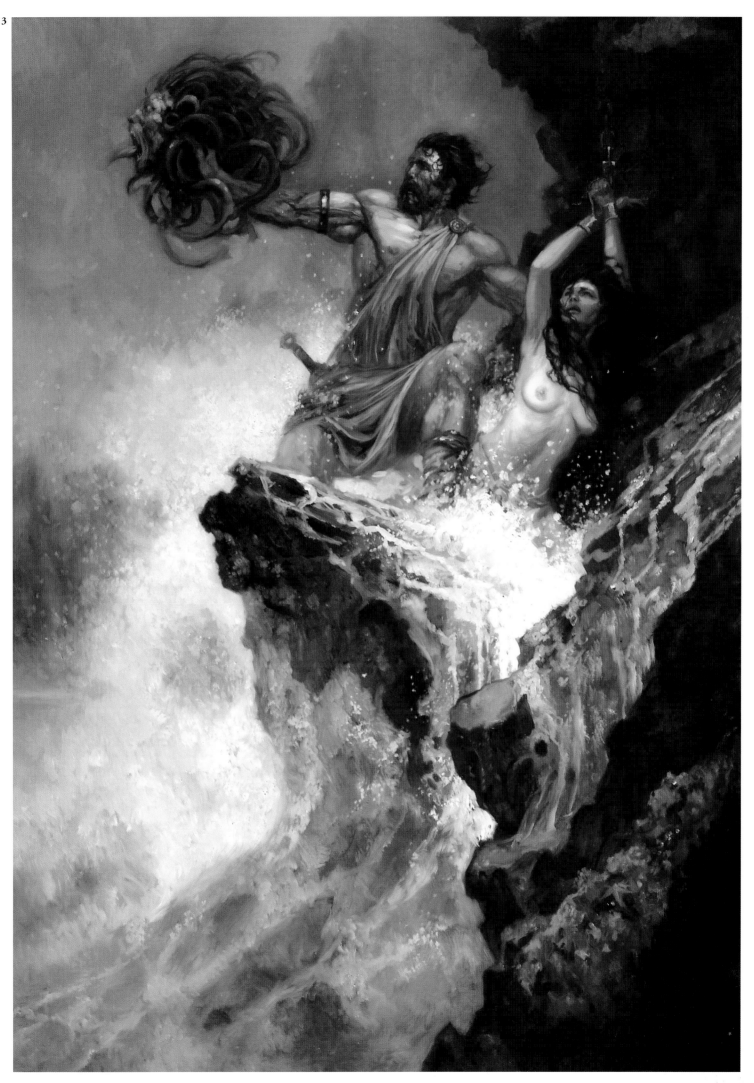

1
artist: **Nic Klein**
title: Escape
medium: Acryclics/digital

2
artist: **Nic Klein**
title: Discovery
medium: Mixed

3
artist: **Nic Klein**
title: Number 9
medium: Mixed

4
artist: **Nic Klein**
title: Gazooks
medium: Digital

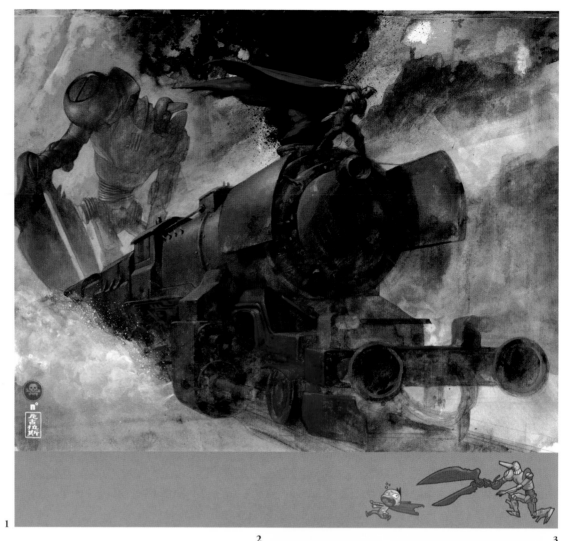

1

2

3

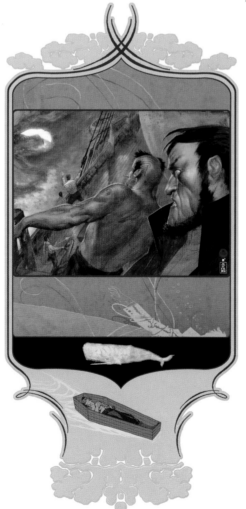

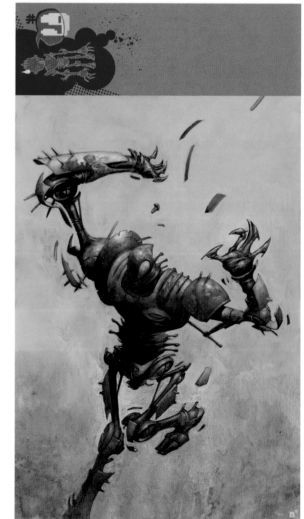

4

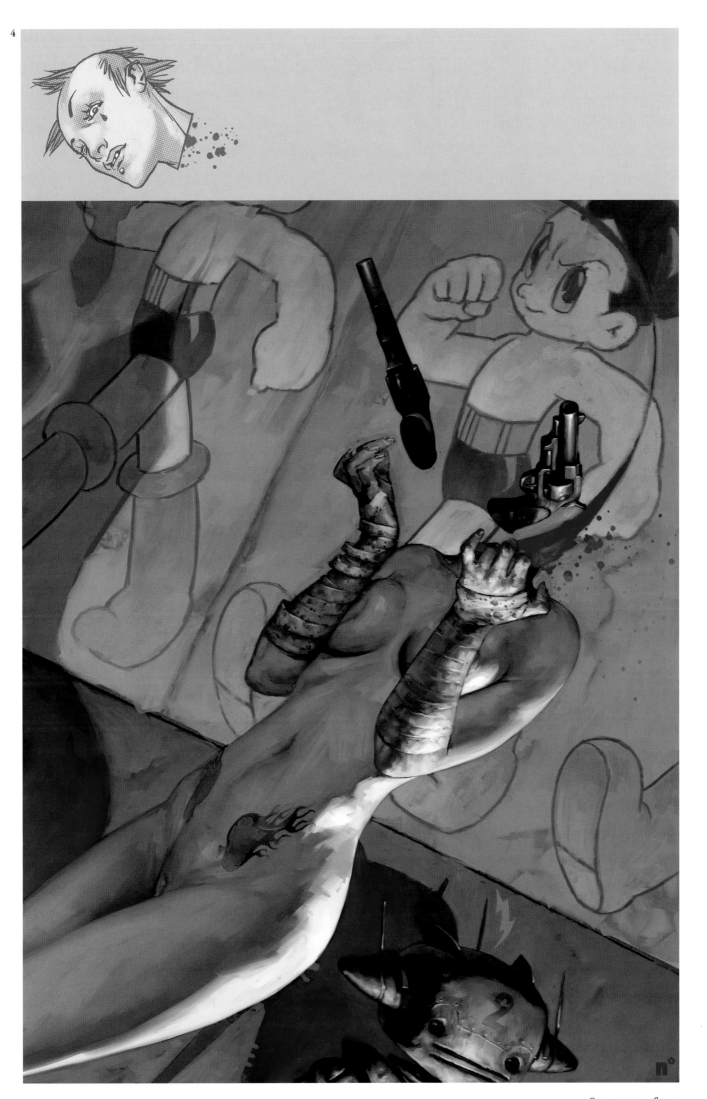

1
artist: **Vladimir Outcharov**
title: Dedicated to Lewis Carroll
medium: Oil on wood panel
size: 38"x30"

2
artist: **William Carman**
title: Fine Dining
medium: Acrylics
size: 4"x6"

3
artist: **William Carman**
title: Horned and Great
medium: Acrylics on antique book
size: 6"x8"

4
artist: **William Carman**
title: The Warrior Look
medium: Acrylics on wood
size: 7"x10"

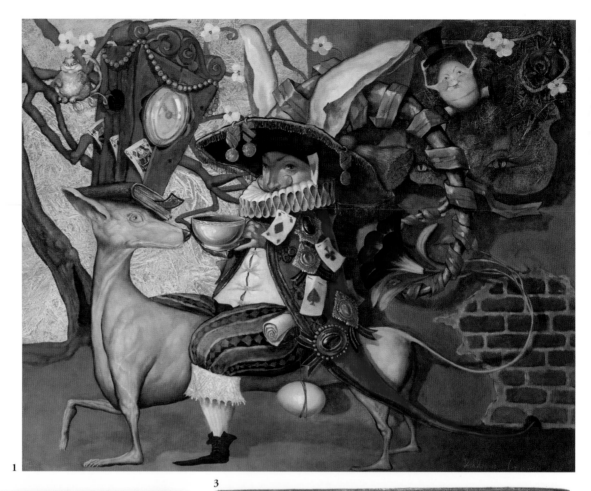

1

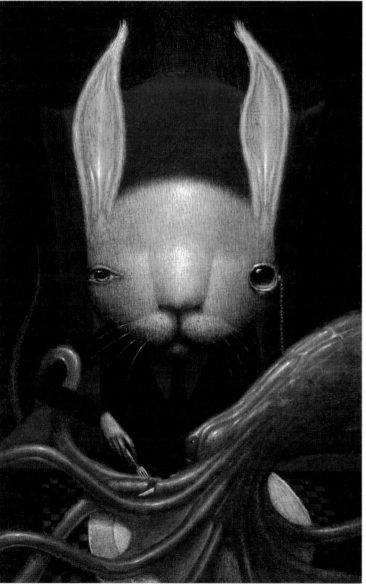

2

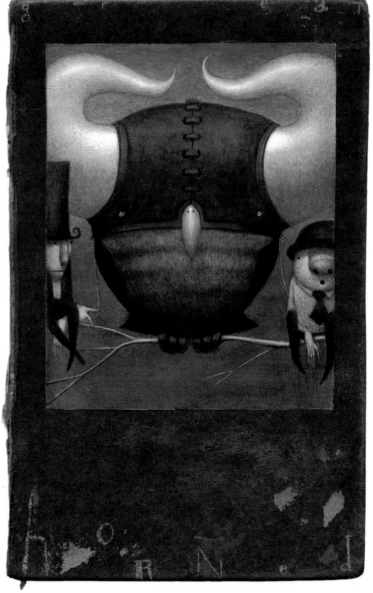

3

4

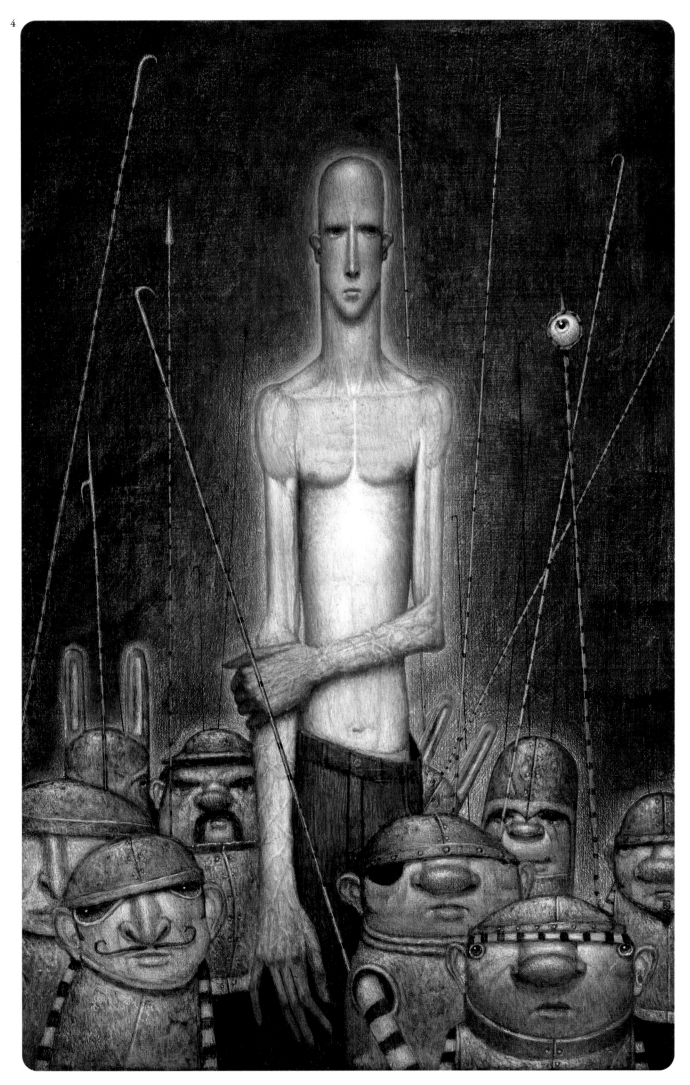

1
artist: **Rebecca Guay**
title: Eurydice Before Death
medium: Oil
size: 30"x22"

2
artist: **Drew Whitmore**
instructor: Joe Thiel
title: Ghost and the Ghoul
medium: Digital

3
artist: **Martin Wittfooth**
art director: Marshall Arisman
title: Castles
medium: Oil on linen
size: 30"x40"

4
artist: **Petar Meseldžija**
client: Zmaj, Novi Sad
title: The Legend of Steel-Bashaw G
medium: Oil
size: 19^1/$_2$"x27^1/$_2$"

1

2

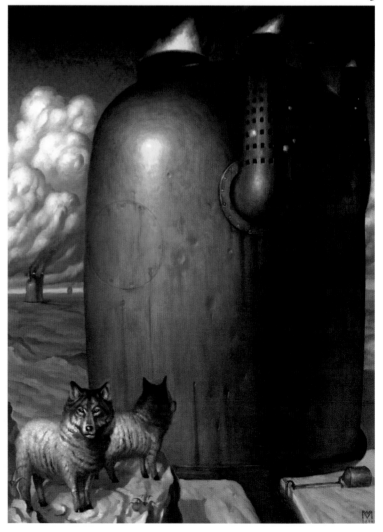

3

4

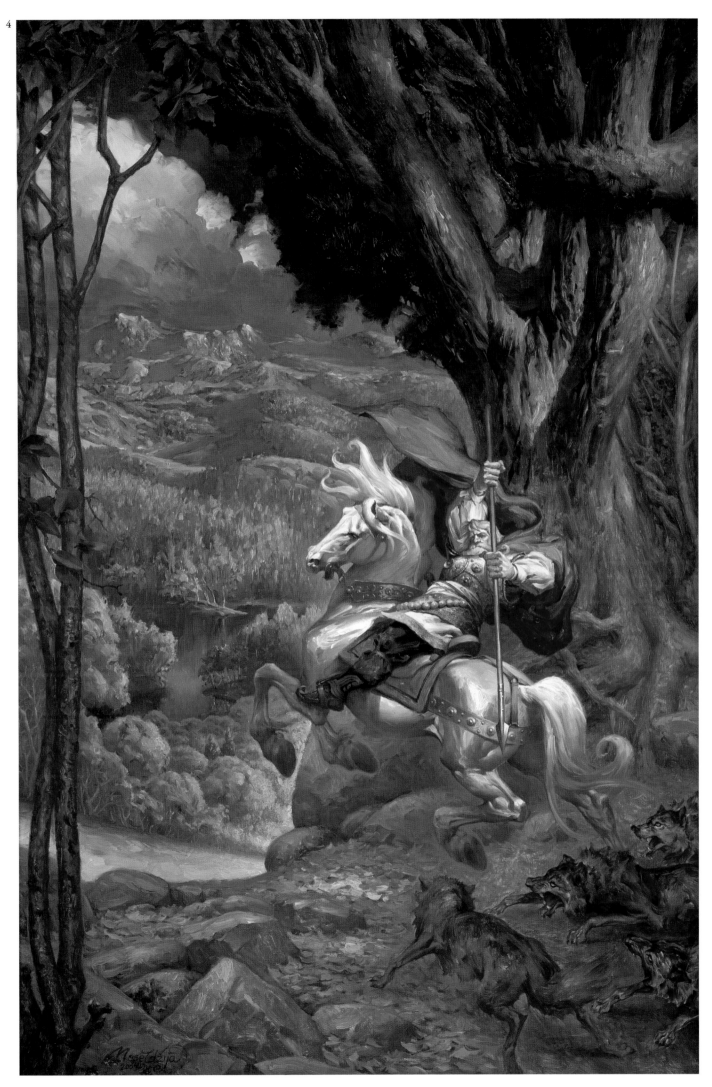

1
artist: **Michael Savas**
title: Arachnophobia
medium: Acrylics on panel
size: 32"x27"

2
artist: **Steven Kenny**
title: The Blindfold
medium: Oil on linen
size: 22"x30"

3
artist: **Donato Giancola**
title: Traveler II
medium: Oil on paper
 on masonite
size: 20"x30"

4
artist: **Steven Kenny**
title: The Departure
medium: Oil on linen
size: 22"x28"

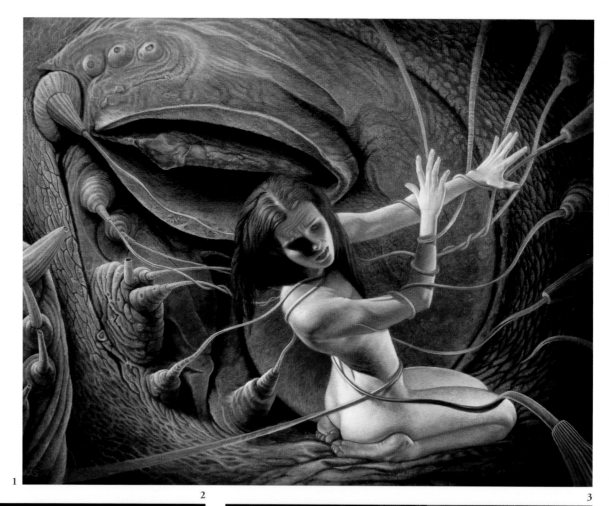

2

3

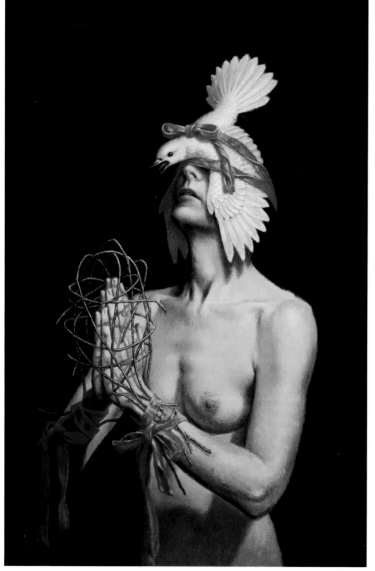

1

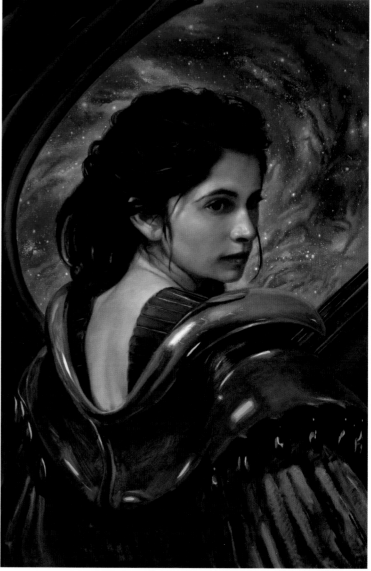

4

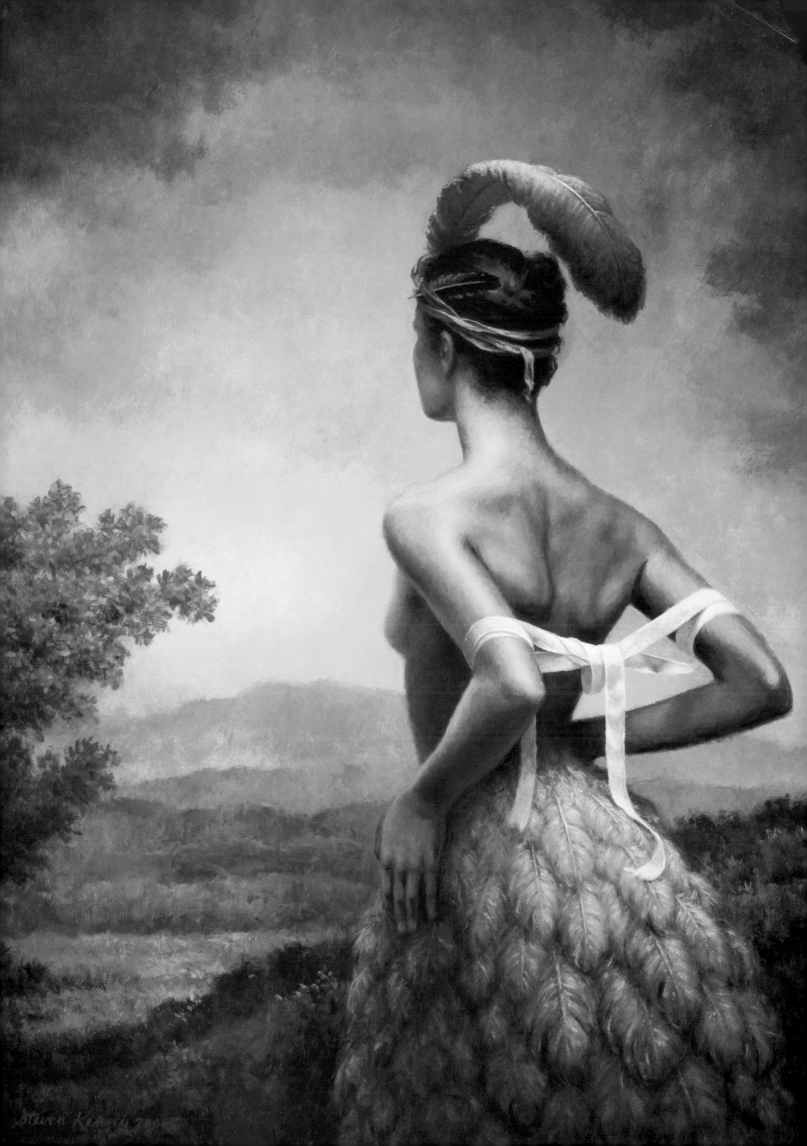

1
artist: **Elio Guevara**
client: www.elioguevara.com
title: Amá
medium: Mixed
size: 48"x38"

2
artist: **Raúl Cruz**
title: Copper Finishing Line
medium: Acrylics
size: 47^1/$_4$"x35^1/$_2$"

3
artist: **Thierry Labrosse**
title: Neve
medium: Pencil/digital
size: 17"x11"

4
artist: **Marc Gabbana**
title: Overkill
medium: Digital

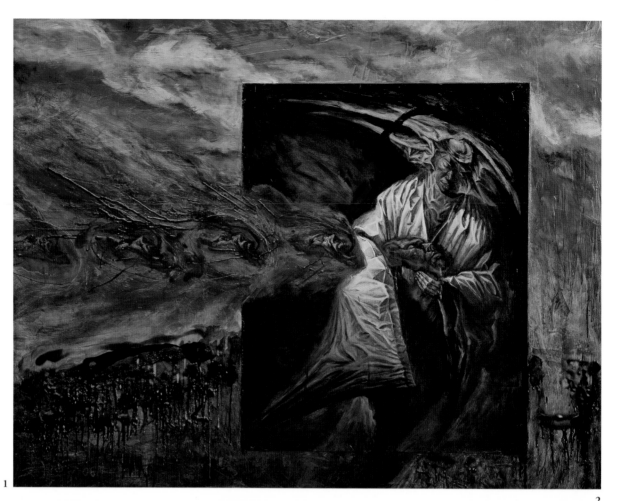

1

2

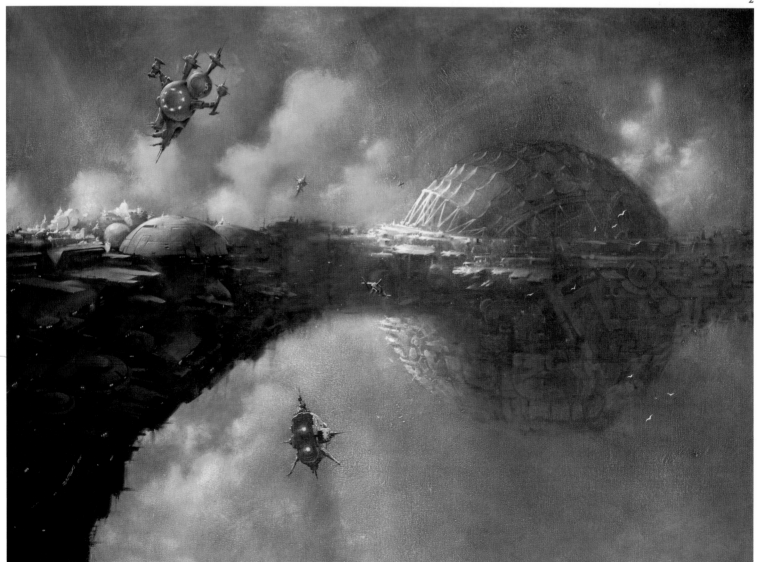

3

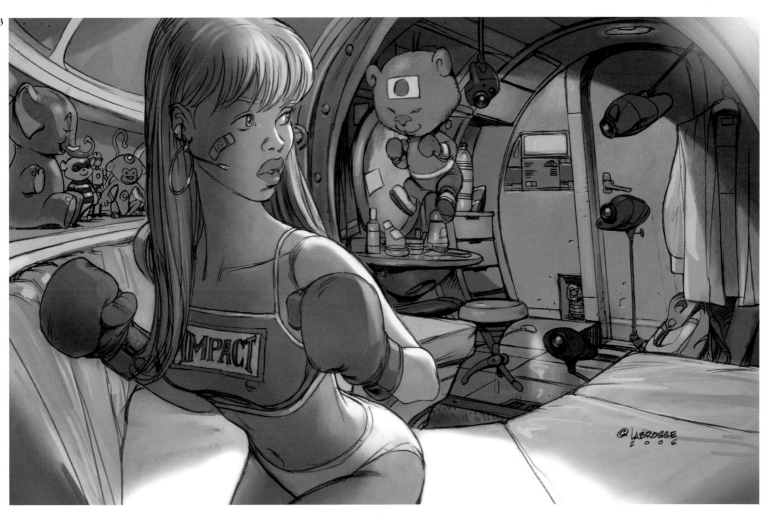

4

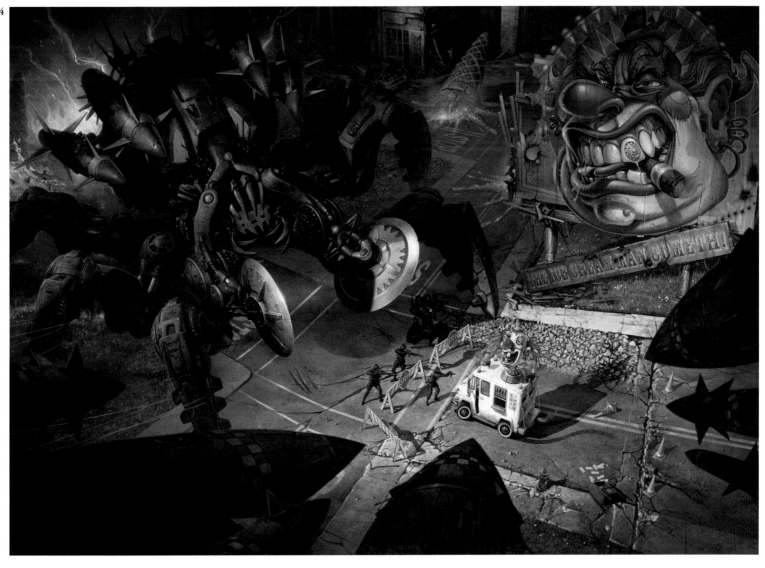

1
artist: **Viktor Koen**
title: Dark Peculiar Toy #21
medium: Digital
size: 24"x24"

2
artist: **Michael Walton**
title: Girl Vs Robot: Robot Fighter
medium: Mixed/digital
size: 7"x10$\frac{1}{2}$"

3
artist: **Michael Walton**
title: Girl Vs Robot: Head-Bot-Six
medium: Mixed/digital
size: 7"x10$\frac{1}{2}$"

4
artist: **Michael Walton**
title: Girl Vs Robot: Takedown
medium: Mixed/digital
size: 7"x10$\frac{1}{2}$"

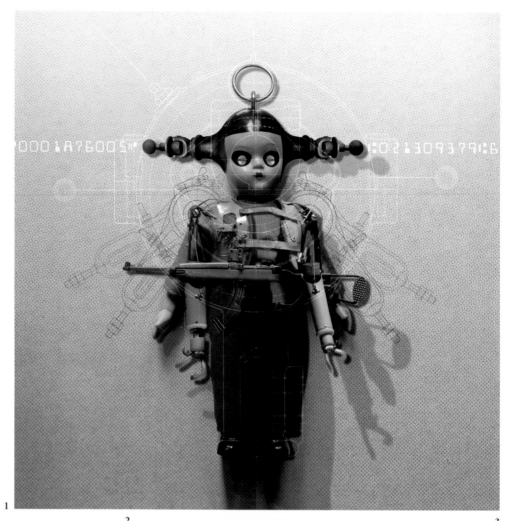

1

2

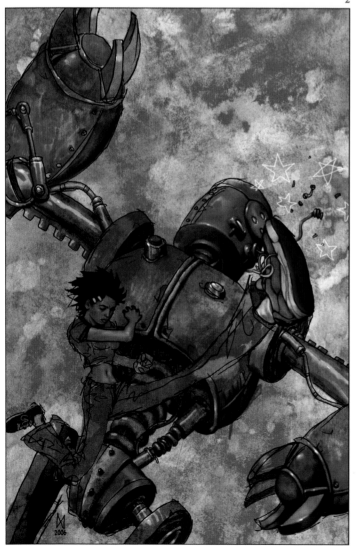

3

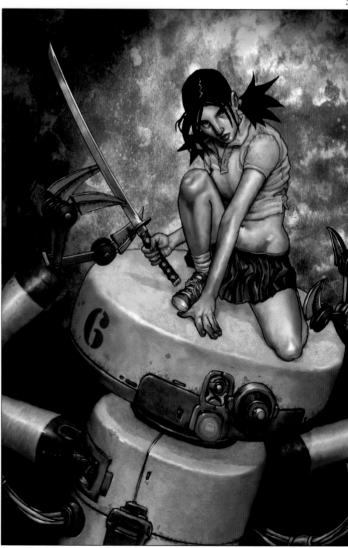

4

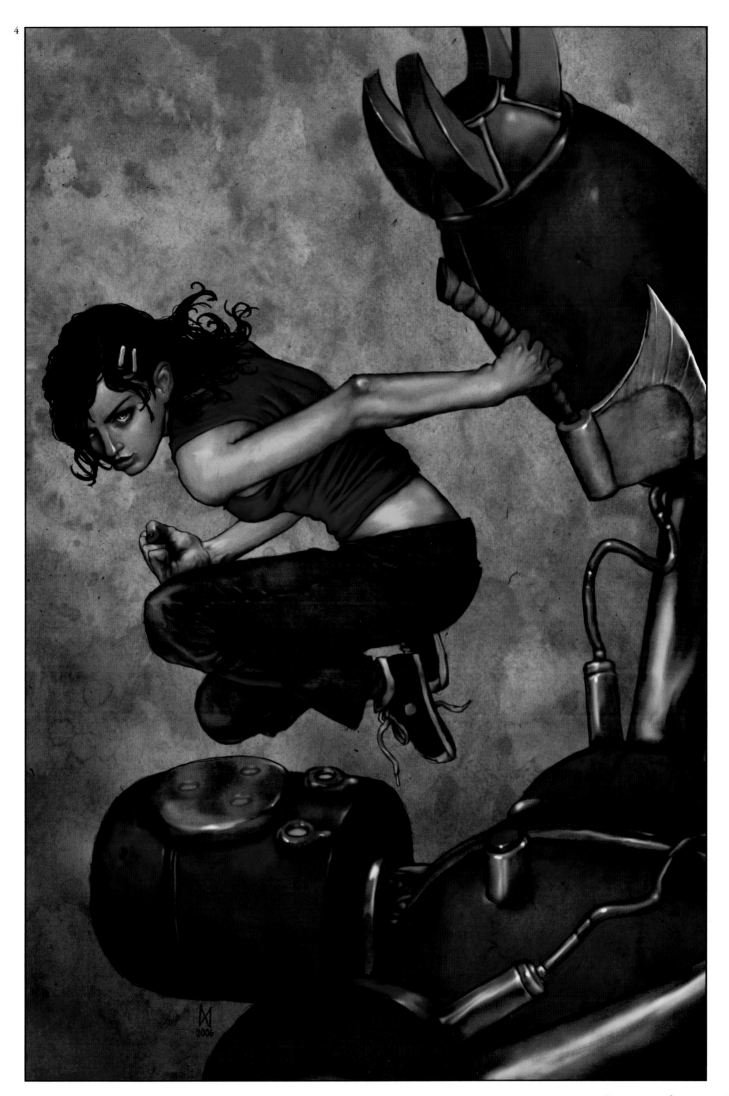

1
artist: **Martin Wittfoot**
title: The Western Express
medium: Oil on canvas
size: 30"x30"

2
artist: **Martin Wittfooth**
client: La Luz de Jesus Gallery/Patricia Arquette
title: The River to Arcadia
medium: Oil on canvas
size: 40"x30"

3
artist: **Martin Wittfooth**
title: Down House
medium: Oil on canvas
size: 16"x20"

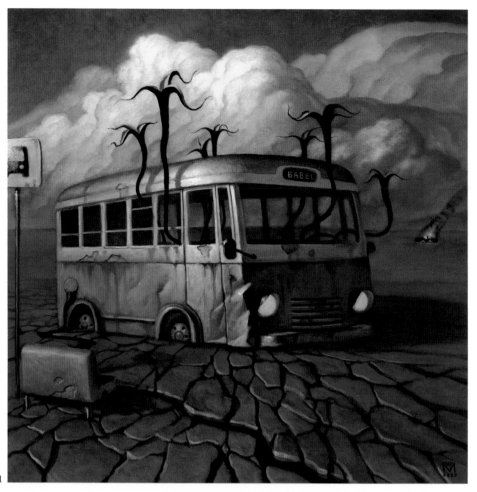

1

2

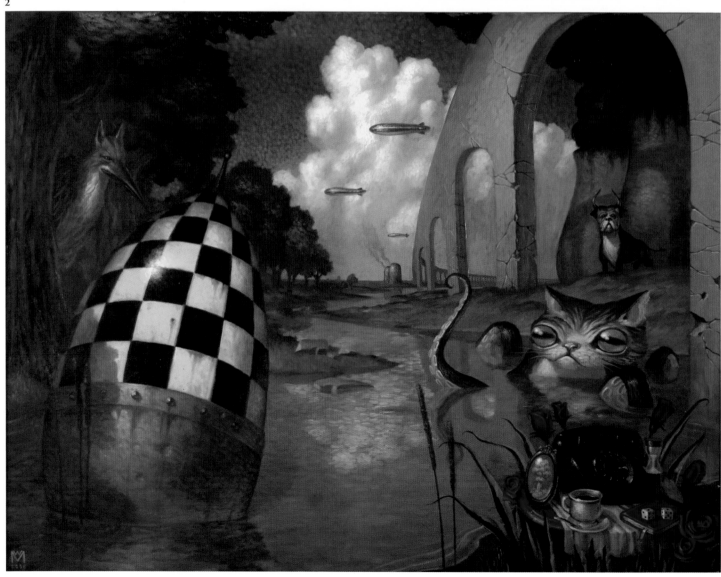

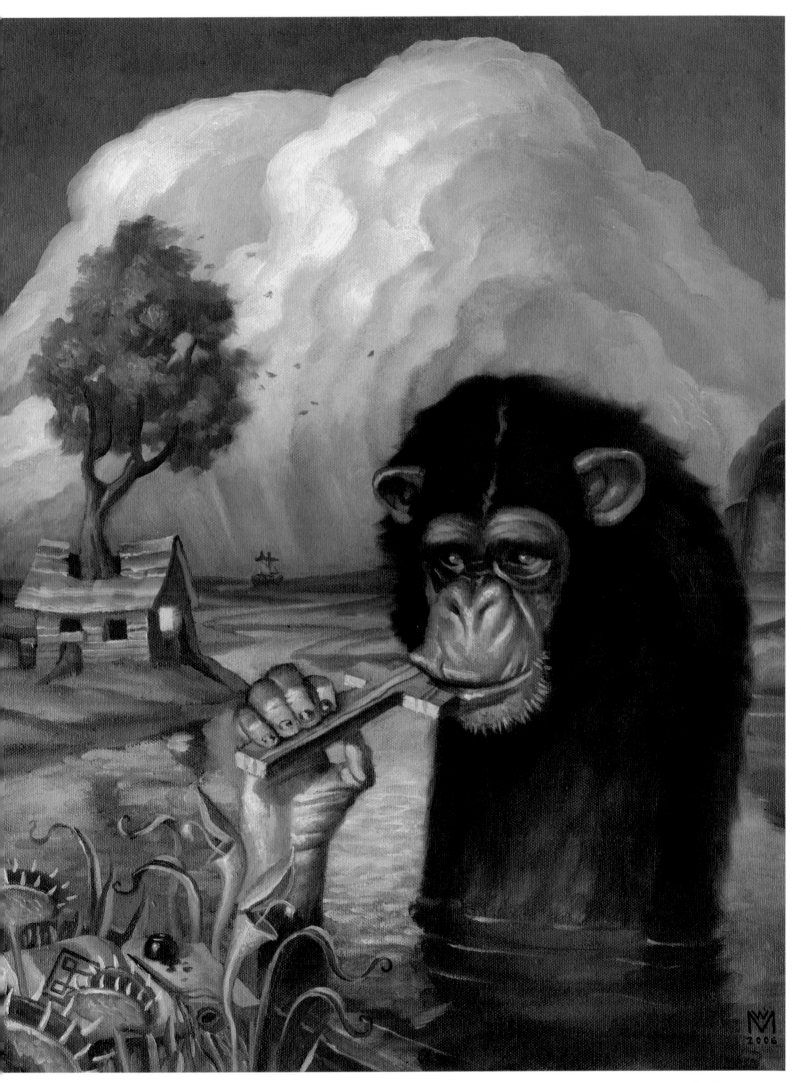

1
artist: **Eric Joyner**
client: Corey Helford Gallery
title: Just Another Day in L.A.
medium: Oil on wood
size: 98"x48"

2
artist: **Brian Despain**
title: Blood From a Stone
medium: Oil on board
size: 11"x14"

3
artist: **Joe Quinones**
title: Stegoseesaurus
medium: Ink/digital
size: 8"x8"

4
artist: **Andrew S. Arconti**
title: Comfort
medium: Digital
size: 16"x20"

5
artist: **David Hartman**
client: www.sideshowmonkey.com
title: Nail Mouth
medium: Ink/digital
size: 10"x15"

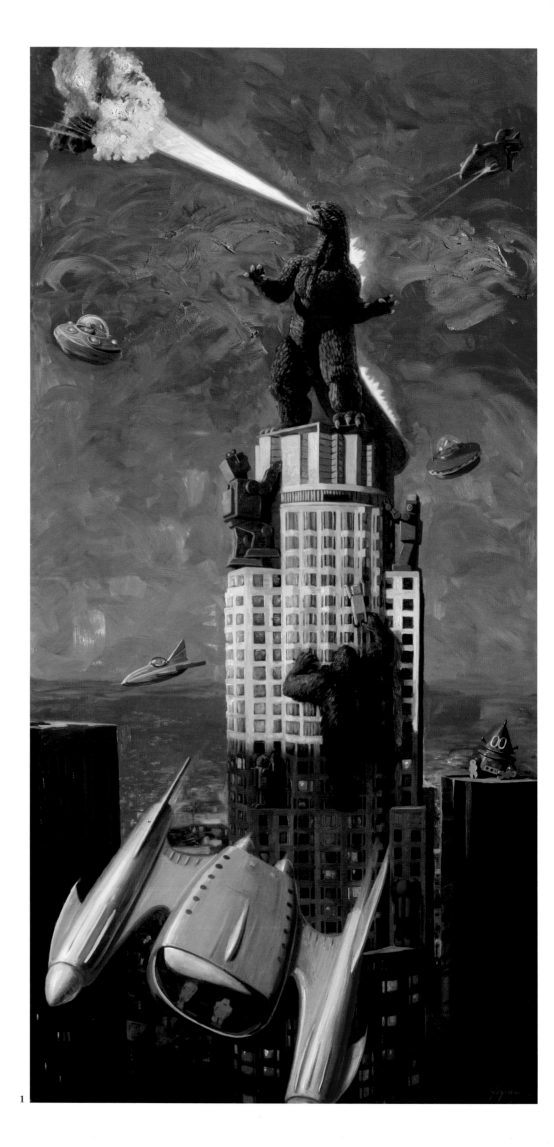

1

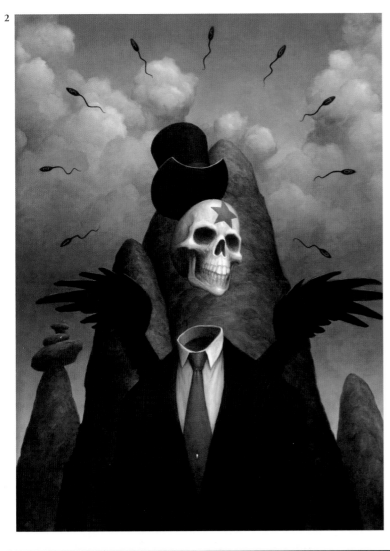

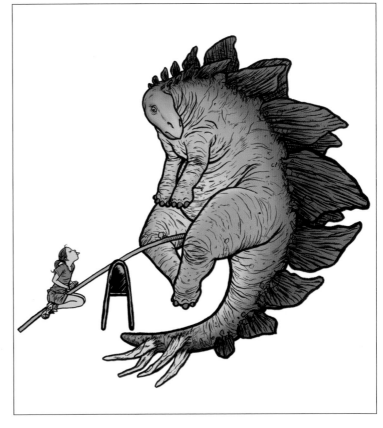

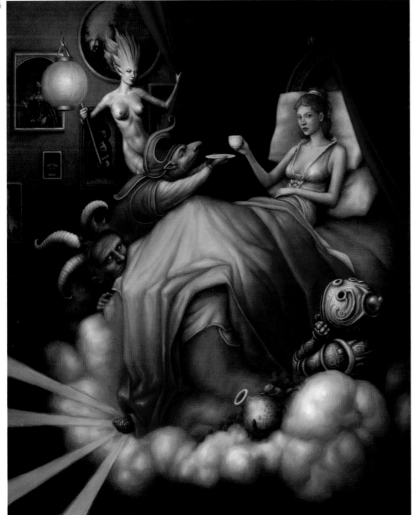

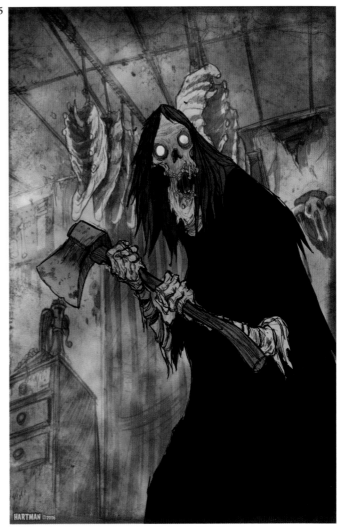

1
artist: **Shelly Wan**
client: ca.org "Girls Only"
contest
title: Circus
medium: Mixed
size: 5"x13"

2
artist: **Ryan Wood**
title: Queen of Diamonds
medium: Digital

3
artist: **Allen Douglas**
title: The Doomsday Oracle
medium: Digital

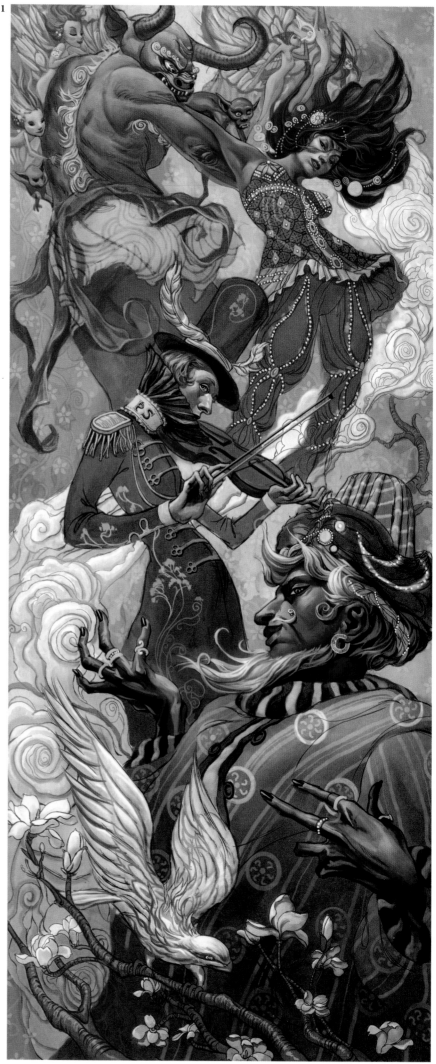

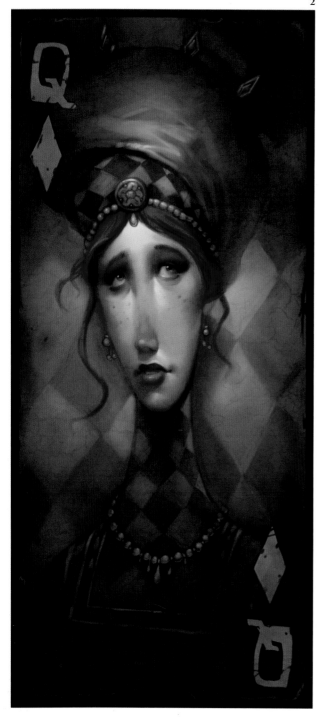

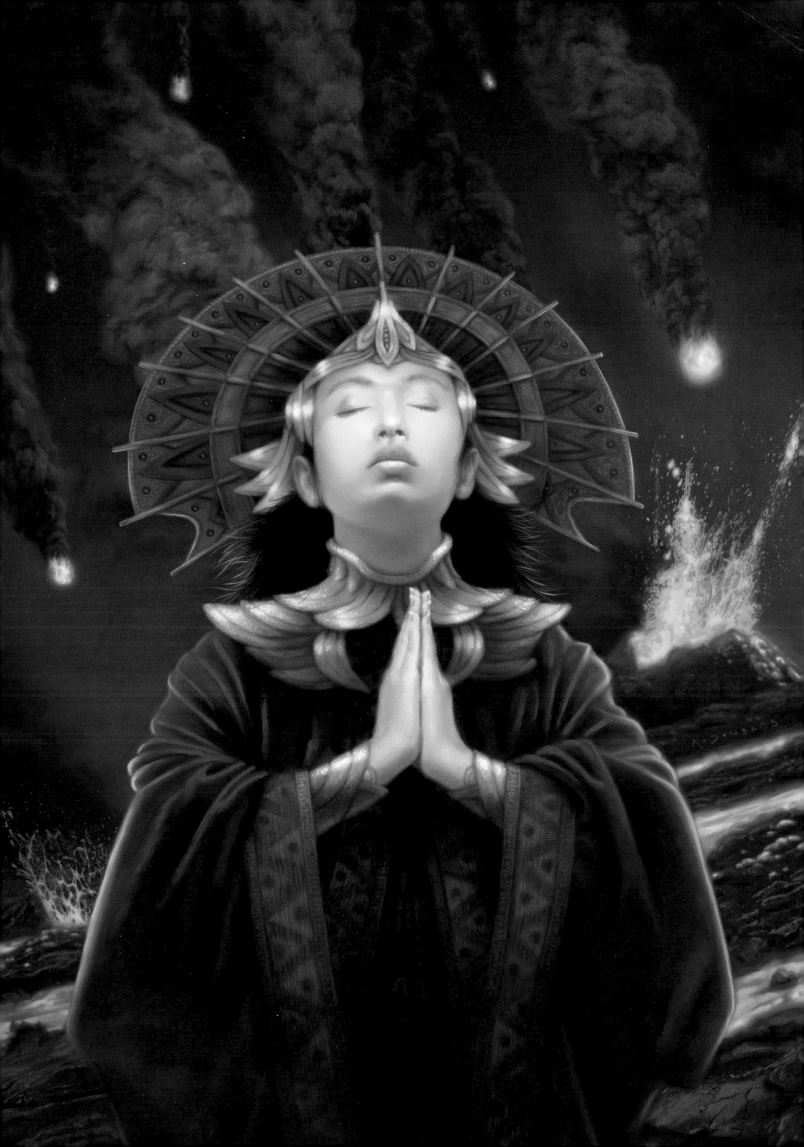

1
artist: **Eric Joyner**
client: Mmodern Gallery
title: It Doesn't Look Good
medium: Oil on wood
size: 54"x48"

2
artist: **Joe Vaux**
title: Lure-Id
medium: Acrylics on wood
size: 16"x11"

3
artist: **Hye Jeong Park**
title: Red Hood
medium: Acrylics on board
size: 20"x16"

4
artist: **Eric Bowman**
title: Everybody Was
 Kung Fu Fighting
medium: Oil
size: 16"x10"

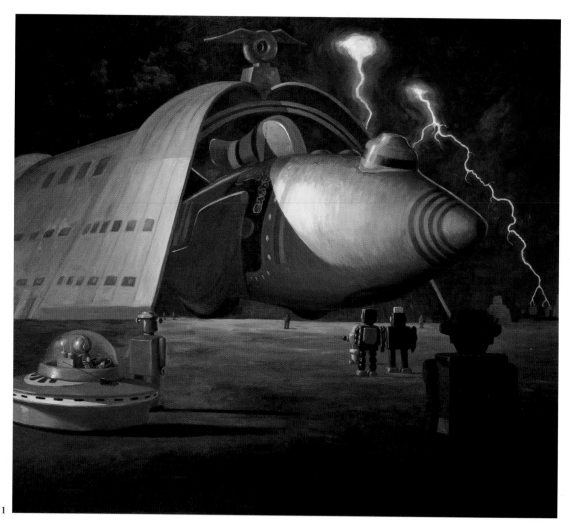

1

2

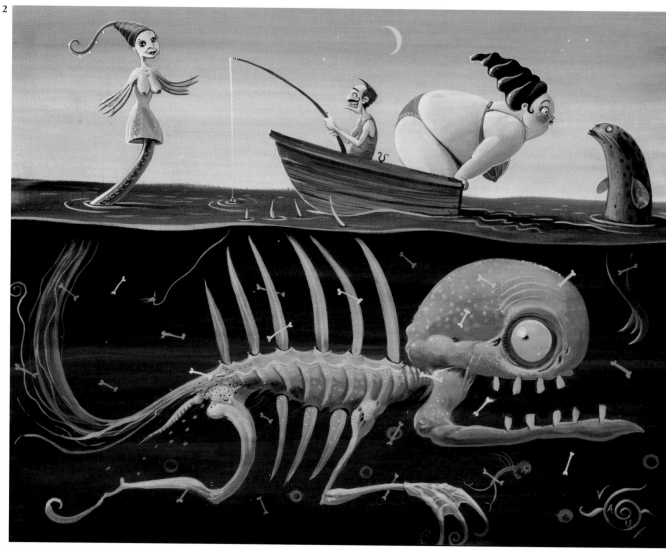

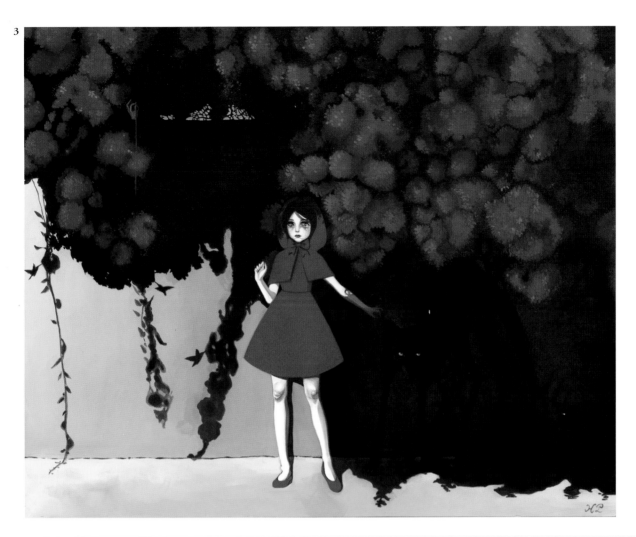

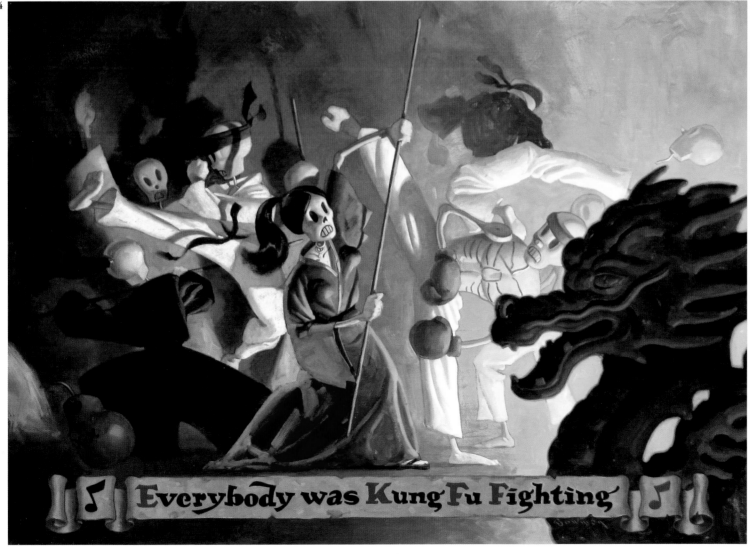

1
artist: **Steven Kenny**
title: The Wheel
medium: Oil on linen
size: 22"x28"

2
artist: **Francis Vallejo**
title: Game Time
medium: Digital
size: 14"x8"

3
artist: **August Hall**
title: Preparing for Halloween
medium: Mixed
size: 3'x4'

3

1
artist: **Michael Whelan**
client: Tree's Place Gallery
title: Emigré
medium: Acrylics on panel
size: 12"x12"

2
artist: **Joy Ang**
title: Terrosel
medium: Graphite/Photoshop
size: 13"x7"

3
artist: **Michael Whelan**
client: Glass Onion Graphics
title: Enlightenment
medium: Oil on panel
size: 24"x36"

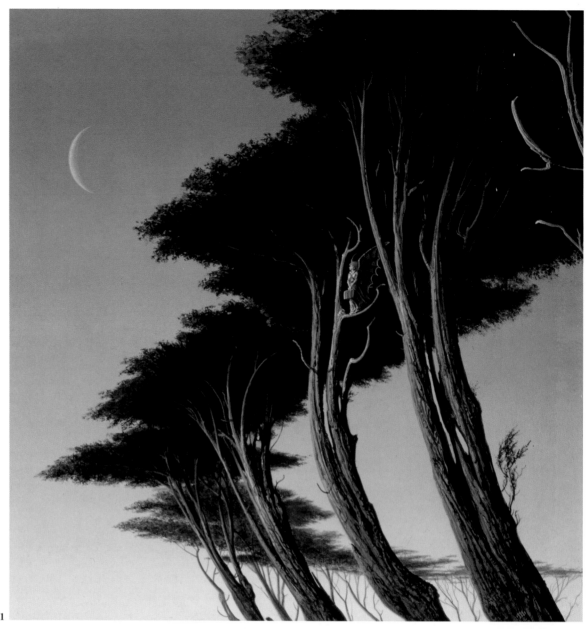

1

2

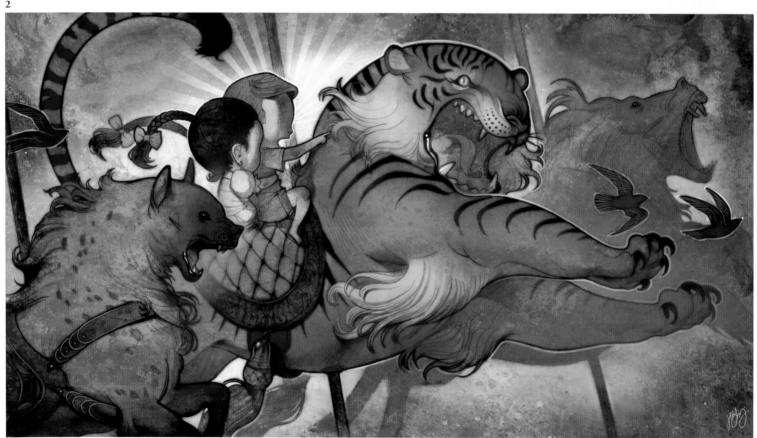

3

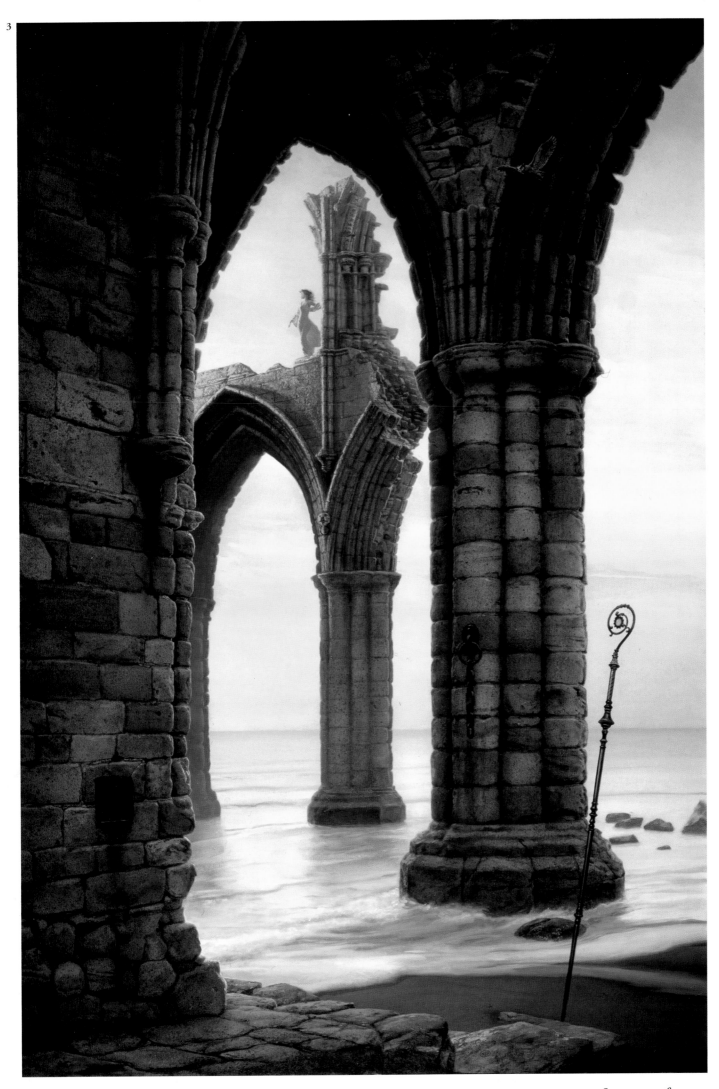

Robert Gonzales 31
c/o Origin Studios, Inc
5882 S. 900 E #303
Salt Lake City, UT 84121

A. Andrew Gonzalez 216
31545 Blanco Rd
Bulverde, TX 78163
210-379-5005
artifex@sublimatrix.com

Christian Gossett 100
11042 Camarillo St #9
N. Hollywood, CA 91602
818-754-0802
christian.gossett@gmail.com

Griesbach / Martucci 72
34 Twinlight Terr
Highlands, NJ 07732
griesbachmartucci@earthlink.net

David Grove 80
382 Union St.
San Francisco, CA 94133
415-433-2100

Nurö 114
5 av. Vincent d'Indy #206
Outremont QC Montreal
Canada H2V 2S7
514-223-9118
nurofen_92@hotmail.com

Rebecca Guay 226
www.rebeccaguay.com

Elio Guevara 230
100 Independence Way
Roswell, GA 30075
404-358-2037
www.elioguevara.com

James Gurney 52
P.O. Box 693
Rhinebeck, NY 12572
845-876-7746
jgurneyart@yahoo.com

Scott Gustafson 67, 75
773-725-8338
scott@scottgustafson.com
www.scottgustafson.com

Brian Jon Haberlin 97
28411 Rancho de Linda
Laguna Niguel, CA 92677
949-425-9622
bjhaber@aol.com

August Hall 72, 243
c/o Allen Spiegel Fine Arts
221 Lobos Ave.
Pacific Grove, CA 93950
831-372-4672
asfa@redshift.com

John Harris 76
c/o Alan Lynch
116 Kelvin Pl.
Ithaca, NY 14850
607-257-0330
alartists@aol.com

David Hartman 26, 237
P.O. Box 940863
Simi Valley, CA 93094
www.sideshowmonkey.com
hartman@sideshowmonkey.com

Daniel Hawkins 133
32817 Green View
Bulverde, TX 78163
830-438-5113
danhawkins25@hotmail.com

Jeff Haynie 110, 143
www.jeffhaynie.com

Dan L. Henderson 161, 181
197 Chelsea Dr
Decatur, GA 30030
dhenderson@aii.edu
www.danlhenderson.com

Mark Hendrickson 118
5034 Bradenton Rd
Sarasota, FL 34234
941-284-3179
art@markhendrickson.com

Richard Hescox 193
P.O. Box 61701
Reno, NV 89506
triffid@comcast.net
www.richardhescox.com

Stephen Hickman 216
10 Elm St.
Red Hook, NY 12571
845-758-3930
shickman@stephenhickman.com

Woodrow J. Hinton III 142
4650 Glenway Ave
Cincinatti, OH 45238
513-225-4067
woodrow@cinci.rr.com

David Ho 202, 214
3586 Dickenson Common
Fremont, CA 94538
510-656-2468
ho@davidho.com

David Hollenbach 67
3176 45th St
Astoria, NY 11103
718-726-6721
hdivad@verizon.net

Kuang Hong
352 Balestier Rd #15-03
Singapore 329780
noah@zemotion.net

Ralph Horsley 41
32 Parkside Crescent
W. Yorkshire Leeds
United Kingdom LS6 4JU
+44 113 2798848
email@ralphhorsley.co.uk

Mike Huddleston 92
c/o Allen Spiegel Fine Arts
221 Lobos Ave.
Pacific Grove, CA 93950
831-372-4672
asfa@redshift.com

Adam Hughes 84, 104, 105
P.O. Box 190823
Atlanta, GA 31119-0823
www.justsayah.com

Matt Hughes 64
3716 McGuire St
Kennesaw, GA 30144
770-595-1293
www.matthughesart.com

James Jean 20, 85, 98, 138
www.jamesjean.com
mail@jamesjean.com

Tim Jessel 41

Jeff Lee Johnson 163
5618 Regent Ave N
Crystal, MN 55429
763-537-7316
thejeff@comcast.net

Rob Johnson 146
15515 184th Pl NE
Woodinville, WA 98072
www.silverbackworks.com
silverbackrob@msn.com

Andrew Jones aka Android 29, 108
c/o Massive Black
842 Folsom St, 2nd Floor
San Francisco, CA 94107

Patrick J. Jones 71
www.pjartworks.com

Eric Joyner 236, 240
111 New Montgomery St. #402
San Francisco, CA 94118
415-305-3992
eric@ericjoyner.com

Michael Wm. Kaluta 48, 102, 103
212-873-7573
rotvang@earthlink,net

Erin Kelso 184, 198
106A High St
Carrboro, NC 27510
919-933-8854
ekelso@indiana.edu

Steven Kenny 228, 229, 242
3 Quail Roost Ln
Huntly, VA 22640
540-631-9026
www.stevenkenny.com

Tom Kidd 71, 151
59 Cross Brook Rd
New Milford, CT 06776
www.spellcaster.com
tkidd@snet.net

Kimberly Kincaid 192
185 E. 475 S
Kaysville, UT 84037
kimkincaidart@msn.com
www.artbykimkincaid.com

Nic Klein 98, 222, 223
Murhardstrasse 15
Kassel, Germany 34117
0049 178 232 9889
me@nic-klein.com

Rich Klink 121, 127
165 Fair St
Berea, OH 44017
440-826-4781
threeklinks@sbcglobal,net

Viktor Koen 232
310 E 23rd St. #11J
New York, NY 10010
212-254-3159
www.viktorkoen.com

Michael Komarck 54, 70
118 Deer Path Ln
Battle Creek, MI 49015
269-964-0593
mkomarck@comcast.net

Karl Kopinski 172
57 Bourne St
Netherfield Nottingham
United Kingdom NG4 2FJ
karl@karlkopinski.com

Vance Kovacs 30, 179
7072 Cedar Creek Rd.
Corona, CA 92880
951-272-0911
vance@vancekovacs.com

Jan Patrik Krasny 42
Smilovskeho 3
Prague 2
Czech Republic 120 00
patrik@aconet.cz

Hong Kuang 212
352 Balestier Rd #15-03
Singapore 329780
noah@zemotion.net
www.zemotion.net

Thomas S. Kuebler 123
520 Campground Rd
Selma, NC 27576
919-965-3130
www.tskuebler.com

Thierry Labrosse 231
6502A Ave Louis-Hebert
Montreal Quebec
Canada H2G 2G7
514-529-9240
tlabrosse@yahoo.fr

Raphael Lacoste 210
4402 Rue de Bordeaux
Montreal Quebec
Canada H2H 1Z7
514-529-5930
raphael.lacoste@gmail.com

Jody A. Lee 50
90 Longview Ave.
White Plains, NY 10605-1624
914-686-5834
jodylee@jodylee.org

Jesse Lefkowitz 148
520 Arlington Ave
Berkeley, CA 94707
540-335-1607
jesse@jesse-lefkowitz.com

Sonny Liew 86, 87
15 Carpmael Rd
Singapore 429762
65-97307076
sonny123@singnet.com.sg

Gary A. Lippincott 80
129 Hardwick Rd
Petersham, MA 01366
gary@garylippincott.com

Wayne Lo 22, 112, 113
Factor5 Art Dept.
4046 Ashbrook Cr
San Jose, CA 95124
waynelo.art@gmail.com

Todd Lockwood 51, 102, 156
20825 SR 410 E #186
Bonney Lake, WA 98390
www.toddlockwood.com
todd@toddlockwood.com

Jerry Lofaro 150
58 Gulf Rd.
Henniker, NH 03242
603-428-6135
jerrylofaro@mcttelecom.com

Travis Louie 186
18 Echo Valley Rd.
Red Hook, NY 12571
845-758-9460
louieart37@yahoo.com

Greg Lunzer 172
4237 Zenith Ave N
Robbinsdale, MN 55422
612-239-0846
glunzer@msn.com

Lawrence MacDougall 78
38 Jenny Ct
Stony Creek, Ontario
Canada L8G 4N8
905-662-7747
underhillstudio@cogeco.ca

Emmanuel Malin 118, 220
5 Rue Leon Dierx
Paris, France 75015
emanuel.bastid@hotmail.fr
www.emmanuelmalin.com

Gregory Manchess 45, 52
15234 SW Teal Blvd #D
Beaverton, OR 97007
503-590-5447
manchess@mac.com

Julie Mansergh 132
P.O. Box 6538
Santa Rosa, CA 95406
707-481-7212
julie@faeriesintheattic.com

Stephan Martiniere 38, 39, 51
754 William St.
River Forest, IL 60305
708-488-9937
martiniere@comcast.net

Jack Mathews 128
401-886-9922
jgmdesign@cox.net

Jonathan Matthews 136
407 N. Hubbards Ln
Louisville, KY 40207
502-413-6959
jonlmatthews@insightbb.com

Brian Matyas 127
318 A E. Fulton St
Columbus, OH 43215
704-560-5719
bmatyas.1@go.ccad.edu

Chris McGrath 68
chrismcgrath@mac.com
www.christianmcgrath.com

Dave McKean 38, 50
c/o Allen Spiegel Fine Arts
221 Lobos Ave.
Pacific Grove, CA 93950
831-372-4672
asfa@redshift.com

Jason Merck 199
5101 Bayberry St
Flower Mound, TX 75028
972-539-1391
jasonmerkartist@yahoo.com

Petar Meseldzija 199, 227
Kogerwatering 49
1541 XB Koog aan de Zaan
The Netherlands
petarmeseldzija@planet.nl
www.petarmeseldzijaart.com

Raven Mimura 76
raven@ravenmimura.com
www.ravenmimura.com

Miss Mindy 26
www.missmindy.com
info@missmindy.com

Wei Ming 96
Dong Cheng District
Gan Yu Hu Tong 33-2-101
Beijing, China 100006
86 10 65257421
i3version@yahoo.com

Christopher Moeller 24, 88, 174
210 Parkside Ave
Pittsburgh, PA 15228
412-531-3629
moellerc@verizon.net

Clayburn Moore 127
P.O. Box 695
Parkton, MD 21120
www.csmoorestudio.com
service@csmoorestudio.com

Michael Morris 208
5001 Crown Manor Pl Suite 202
Louisville, KY 40218
502-458-6632
mmdesign@bellsouth.net

John Mueller 215
12300 Painted Bunting Dr
Austin, TX 78726
512-219-7776
muellermail@gmail.com

Craig Mullins 178
www.goodbrush.com

Jeffery Dean Murchie 115
2001 East Spring Creek Pkwy.
#11301
Plano, TX 75074
jeffreymurchie@hotmail.com

Jim Murray 166, 167

Shawn Nagle 134
www.reelartstudios.com
artist@reelartstudios.com

Vince Natale 68, 71
18 Van De Bogart Rd.
Woodstock, NY 12498
845-679-0354
vnatale@hvc.rr.com

Mark A. Nelson 48
3738 Coachman Way
Cross Plains, WI 53528
608-798-3783
gdpmark@chorus.net

Ben Neuhart 207, 211
1457 N. Alta Vista Blvd
Los Angeles, CA 90046
323-851-1733
bneuart@ix.netcom.com

Jason Newhouse 173
801 Burnett Ave #1
San Francisco, CA 94131
415-956-1996
jasonsketchbook@yahoo.com

Mark Newman 122, 126, 131
newmanmark@sbcglobal.net
www.marknewmansculpture.com

Hoang Nguyen 28, 162
2202 Duvall Court
Santa Clara, CA 95054
408-727-9431
www.liquidbrush.com

Cliff Nielsen 45, 56, 57
674 S. Avenue 21
Los Angeles, CA 90031
323-223-4100
cliffnielsen@earthlink.net

Terese Nielsen 183
9661 Las Tunas Dr Suite C
Temple City, CA 91780
626-286-5200
artist@hiddenkingdom.com

Nilson 96
nils@raketula.de
www.raketula.de

Nox 112
c/o Massive Black
842 Folsom St, 2nd Floor
San Francisco, CA 94107

Ben Olson 99
41 Dravus St. Apt. S-6
Seattle, WA 98109
www.sketchthing.com
seematik@yahoo.com

Kip Omolade 207
62 Meadow Run Rd
Bordentown, NJ 08505
718-812-2681
kip@kipomolade.com

Jerome Opena 116
c/o Wayne Lo
waynelo.art@gmail.com

Glen Orbik 33
www.orbikart.com
glenandlaurel@earthlink.net

Chris Ortega 208
c/o Alan Lynch
116 Kelvin Pl.
Ithaca, NY 14850
607-257-0330
alartists@aol.com

Vladimir Ovtcharov 224
1113 Westerfield Dr NE
Albuquerque, NM 87112
505-323-0596
daniela64@msn.com

Augie Pagan 194
augiejp@gmail.com
www.augiepagan.com

John Jude Palencar 58, 69, 192
ninestandingstones@yahoo.com
www.johnjudepalencar.com

Karen Palinko 129, 136
karen1902@zoominternet.net

David Palumbo 202
1324 S. 9th St
Philadelphia, PA 19147
610-762-0125
www.dvpalumbo.com

Dustin Papow 212
29615 Greenland
Livonia, MI 48154
248-982-0004
dustinpapow@gmail.com

HyeJeong Park 210, 241
32-78 35th St #1B
Astoria, NY 11106
hyegallery@hotmail.com
www.hyegallery.com

Ted Pendergraft 25
ted@tedwork.com
www.tedwork.com

Brandon Peterson 100
327 Tavernier Dr
Oldsmar, FL 34677
813-843-1011
brandonpeterson@aol.com

Mike Petryszak 125
www.reelartstudios.com
artist@reelartstudios.com

Painting by Joe DeVito

Artists, art directors, and publishers interested in receiving information for the SPECTRUM 15 competition should send their name and address to:

Spectrum Design
P.O. Box 4422, Overland Park, KS 66204

Or visit our website for information: **www.spectrumfantasticart.com**